D1611190

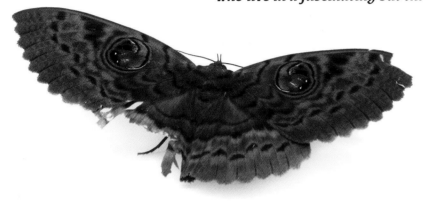

The book is dedicated to the people of Madagascar,

who live in a fascinating but threatened natural paradise.

The loudly raging storm has spent almost all its rain. Since daybreak it had loomed threateningly overhead and – as almost every evening – it was following the coast and was now drawing near to my small bay. It was so close that with each clap of thunder the walls of the tent billowed inward. Shortly after 2:00 am, I make my way, alone, out along the path to the light trap, accompanied by the screeching of the bamboo lemurs (Hapalemur) and the croaking of the frogs. Very soon I'm soaking wet from the rain and the oppressive heat. I scan my path with the headlamp, with its light cone searching back and forth, but the Madagascar tree boa (Sanzinia madagascariensis) that had been lying there motionless all day is gone. I don't want to tread on it and injure it, much less get bitten myself. A family of Lowland streaked tenrecs (Hemicentetes semispinosus) rustles rank and file through the leaf litter on the ground. I make my way out past the huts to the clearing in the forest, and now I can see the green-blue-violet beam from my moth lamp which transforms a previously set-up mosquito net into an illuminated canopy. The teeming confusion of colors heightens the suspense. I'm stopped in my tracks as if thunderstruck because suddenly a huge shadow moves around the canopy – as big as a German shepherd but sleek, like a cross between a cat and a marten. The creature stops too, then raises its head, and two shining, golden yellow eyes are staring at me – a fossa (Cryptoprocta ferox) was investigating my light trap and snatching at the moths attracted there. My skin turns to goosebumps and I go weak at the knees at this close encounter in northern Madagascar with a species of a quite different kind.

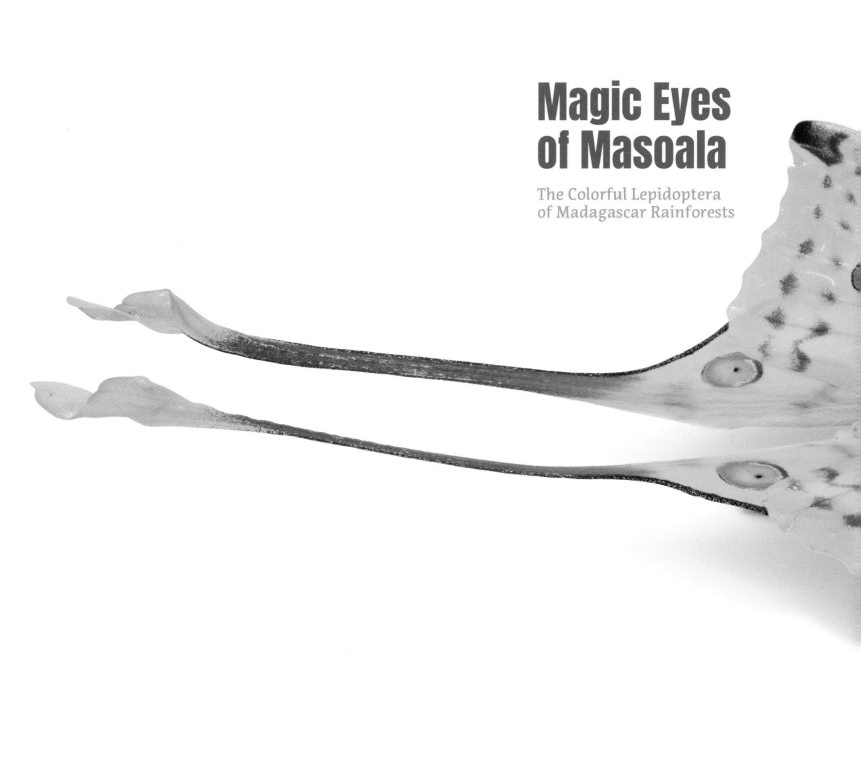

Magic Eyes
of Masoala

The Colorful Lepidoptera
of Madagascar Rainforests

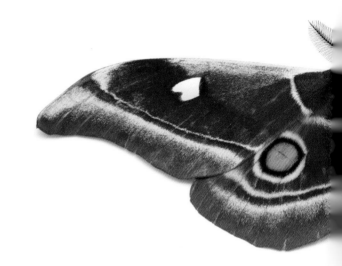

Papilionoidea	72 – 85
Cossoidea	86 – 87
Zygaenoidea	88 – 97
Gelechioidea	98 – 101
Thyridoidea	102 – 105
Pyraloidea	106 – 123
Bombycoidea	124 – 191
Lasiocampoidea	192 – 203
Geometroidea	204 – 243
Noctuoidea	244 – 343

Contents

Dedication 1

Prefaces 6 – 9
 Zoo Zurich 6 – 7
 Wildlife Conservation Society (WCS) 8 – 9

Tropic Fever 10 – 25
 Introduction and setup 12 – 25

The Eighth Continent 26 – 55
 Eyes of Masoala 28 – 45
 MaMaBay Landscape 46 – 49
 In the Stranglehold of Cyclones 50 – 55

Encounters 56 – 351
 Gallery of Lepidoptera and their predators 58 – 377
 Mantises – Alien predators 344 – 351
 Amphibians and Reptiles of Makira 352 – 377
 Why museum collections are vitally important 378 – 385
 How taxonomists identify species 386 – 389

 Acknowledgements 390 – 405
 Wildlife Conservation Society (WCS) 390 – 395
 Local guides 396 – 397
 Mentors and authors 398 – 405

 Species list 406 – 409
 Bibliography 410 – 414

 Publishing details and references 415

Ambassador for Biodiversity and Nature Conservation

Dr. Severin Dressen, CEO of Zoo Zurich

In its capacity as ambassador for the beauty of Masoala, Zoo Zurich fosters the appreciation of the rainforest both in Switzerland – in its own small Masoala Rainforest – and also in Madagascar. In both cases the objective is the long-term preservation of the enormous diversity in and around the Masoala National Park and the safeguarding of the ecosystem services, such as protecting against erosion, providing clean water, and ensuring the fertility of the agricultural crops outside the park for the long term.

Zoo Zurich has been supporting the operation of the Masoala National Park for more than 25 years and is committed to numerous projects that extend far beyond the National Park boundaries. For example, the zoo supports projects for the conservation of the rainforest, for reforestation in the context of sustainable agriculture, water supply and hygiene, as well as for children's education.

One significant milestone was the opening of the MaMaBay Environmental Campus in Maroansetra. The Campus includes an Information Center for the Masoala National Park and the Makira Nature Park, an Open Classroom for the local schools, and an Ecoshop for local handicraft products, and it is designed to be a gateway to the National Park. Here is where children come into contact with ecological issues, where they discover the beauty and fragility of nature, and where young people undertake their first research into nature. Perhaps even future butterfly researchers will visit the Open Classroom.

This book is expected to take pride of place in the school library. It reveals hidden treasures: the great diversity of butterflies and moths, which occupy an irreplaceable position in the ecology of Masoala. Every single one of the more than 400 species described represents living proof of Masoala's unique biodiversity.

It is simply staggering to see that evidently this biodiversity has to this day been preserved, because this means in turn that together with our associates we have been able to protect the National Park against clearcutting, exploitation and destruction. This fills me with enormous gratitude and brings me the encouragement to continue with commitment on our path towards the long-term protection of the last, fully unspoiled habitats.

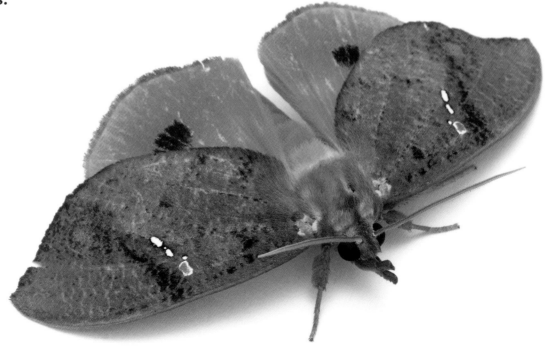

Another Facet of the Masoala National Park

By Dr. Lovy Rasolofomanana

The idea to create the book "Eyes of Masoala – The Colorful Lepidoptera of Madagascar Rainforests" was raised in 2018 at a meeting between Zoo Zurich and Armin Dett, a great moth enthusiast. After having published the book "Moths of Costa Rica's Rainforest", Armin was also interested in the moths of Madagascar. As a reminder, the Zoo Zurich and the Wildlife Conservation Society have established a partnership for the Masoala National Park since 2000. WCS and Zoo Zurich share the same objectives for the conservation of Masoala's biodiversity through the cre-ation of a sustainable funding mechanism. The conservation of Masoala's wildlife species through an in-depth knowledge of the different species habitats in this National Park. The moths are part of these species and Masoala National Park has identified several hundred species and subspecies so far.

Nature does things well, because good intentions have coincided in bringing together in partnership Zoo Zurich and an expert in photography of moths in the person of Armin Dett. After Armin Dett's first mission to explore Madagascar in 2019, his project to write a book on Masoala moths entitled "Eyes of Masoala" finally materialized in 2022. Scientists and field workers such as Dr. David Lees, Dr. Frank Glaw, Dr. Rodolphe Rougerie, Dr. Aristide Andrianarimisa and Dr. Alexander Schintlmeister, Dr. Martin Bauert, Marcin Wiorek and Dr. Roland Hilgartner, Moritz Grubenmann and Lovy Rasolofomanana contributed to this book. Indeed, more than 400 species of Lepidoptera, predominantly Macrolepidoptera, are highlighted in this book.

Personally, I am amazed by the way Armin Dett has placed the spotlight on these truly exceptional creatures – moths.

I am confident that this book will bring them to the attention of scientists and enthusiasts of these Lepidoptera species. It will also allow a wider public to be shown another facet of the Masoala National Park whose natural wealth is legion. The book will demonstrate the importance of conserving moth habitats in the rainforests of Masoala. It should be noted that Lepidoptera can only live in well-defined ecological conditions. In their environment these species not only play a role as pollinators, but they can also be bioindicators for the ecosystem.

We are aware of the various threats that Lepidoptera are facing in Masoala National Park and the neighboring park of Makira. Agricultural practices, especially slash-and-burn farming, lead to fragmentation of Lepidoptera habitats and deforestation. The conservation measures carried out by WCS are therefore crucial to prevent environmental degradation and, most importantly, to conserve sensitive and vulnerable Lepidoptera host plants and their habitats in general. These measures will contribute to the fight against the disappearance of Lepidoptera.

It is even crucial in the long run to extend these measures to include the adaptation of the habitat of Lepidoptera to ensure their survival since their life depends on the existence of certain species of plants and a specific type of habitat.

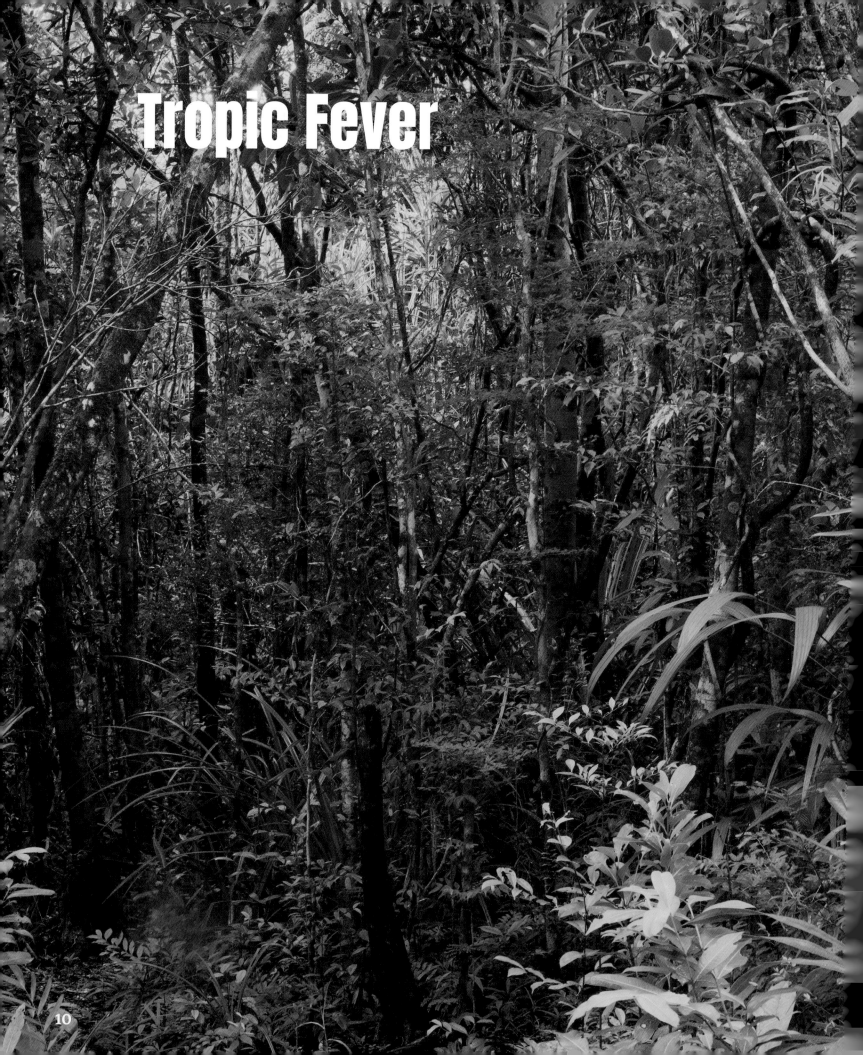

Tropic Fever

Introduction and set-up

Text by Armin Dett

I can still remember very precisely when I was first seized with a bout of 'Tropic Fever'. I remain under its spell to this very day. It is contagious, as you will see from this book. Here's a simplified reconstruction of events ...

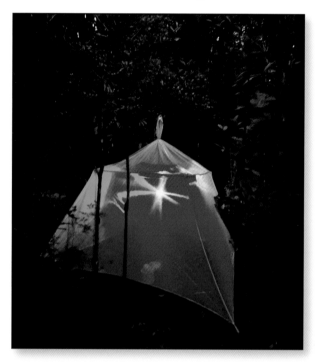

Light trap setup consisting of UV lamp and mosquito net
This mobile, self-made construction has proven its worth in the dense rainforest of Masoala. Placed about 50 cm above the ground, it afforded the moths a big surface area on which to land while at the same time giving them plenty of opportunities to fly in and settle. The canopy also offered me protection against stinging pests.

Tarzan and wild animals

My Tropic Fever began in earliest childhood and was black and white. Tarzan was on tv in the evening and I sat there on the sofa, spellbound – fascinated by fighting gorillas, tigers, giant snakes, lions, and elephants interspersed with zebras and hippos, on whose backs Johnny Weissmuller leapt across rivers. Even back then I had a vague idea that the mix of species wasn't quite right. Nonetheless, and despite the goose bumps, the childhood fantasy was born of someday being "Tarzan in the jungle" – because of the wild animals, although Jane did look seductively beautiful. Over the years, naturalist stars on tv kept my Tropic Fever near boiling point: people like Eugen Schumacher, Malcolm Douglas and Austin Stevens who made wildlife films in the vast expanses of Asia and Australia; Heinz Sielmann and, of course, the Grzimek family, whose wildlife films we experienced as family events that took up the whole evening. And I soaked up like a sponge every piece of reading matter that had to do with the rainforest of course ... yet just as thrilling for me were the animated images and the actual making of each film.

Sunset moths

At some time or another in the early 80s my father bought a tropical butterfly collection and my Tropic Fever peaked for a good while. I studied each of the 40 boxes whenever I could – and whenever I was allowed. Because my father treated the collection as if it were classified material! I suppose that's where I got my ability to distinguish so many colors, forms and patterns and commit them to memory. Among the boxes of butterflies there were two that

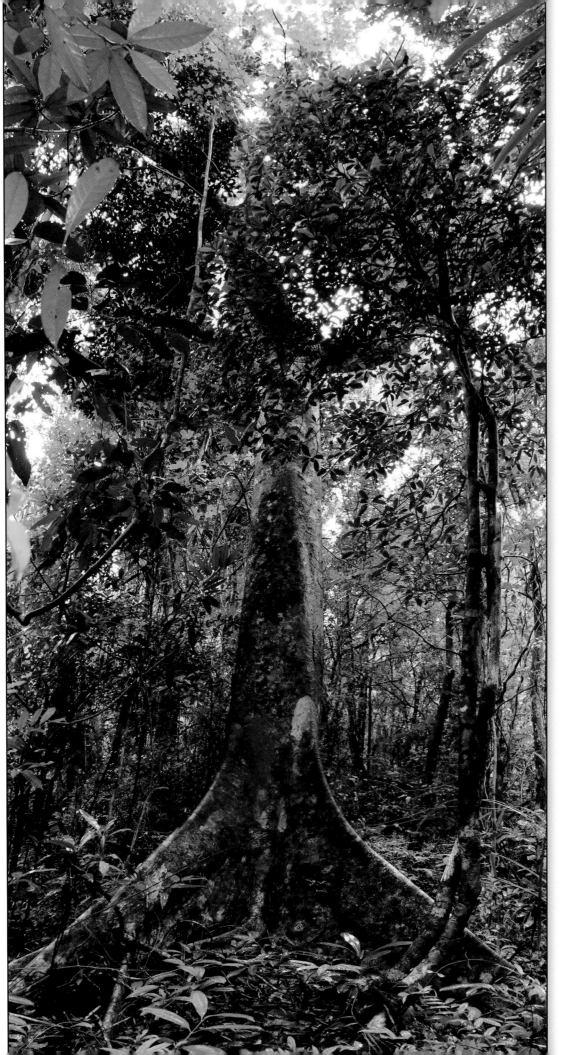

Giant buttress tree

Canarium sp., known locally as "ramy," can be easily recognized by its prominent buttress roots and can grow up to 40 meters in height. These trees play an important role in the composition of lowland humid forests. The wood is utilized for various purposes, such as constructing pirogues (dugout canoes). The edible fruit pulp and seeds are often sought after by children and various lemur species. The aromatic resin is vaporized during ceremonies and partly used as glue to trap birds. The resin is also utilized for sealing pirogues and boats and is nowadays cooked with used motor oil to delay biodegradation.

13

stirred in me deep yearnings. One sheltered a pair of *Argema mittrei* with cocoon, while the other was home to three *Chrysiridia rhipheus*. I still had no idea that one day – actually in the the night – I would be roaming through the rainforests of Madagascar in search of them.

Design vs. biology

My enthusiasm for colors, forms, and patterns evolved into a durable artistic talent which led to my studying graphic design at university. The application portfolio and entrance exam posed no great problem – all I had to do to make beautiful designs was rekindle in my mind those butterfly boxes. I wanted to study tropical ecology but my high-school final exam grade did not immediately suffice, and so I concentrated on the talent I had and became a designer. A new world opened up to me, one that overlaps with biology and evolution at a surprising number of points. Then came the career stages typical of someone now 57 years of age: graduate degree, a self-employed career start-up, marriage, starting a family, house construction – but

the Tropic Fever still smoldered inside. It fired me up for my first backpacking trips into the tropics, with sketchbook, binoculars, camera, and bad gear: these led me, traveling on my own, through Costa Rica, Venezuela, Bolivia, and Brazil. These were the way stations for my Tropic Fever.

Moths – meaningful sleepless nights

Meanwhile, the career stages underwent some positive – and some not so positive – developments. I taught graphic design for 18 years, the two daughters grew up into adulthood – but the marriage failed spectacularly. My Tropic Fever evolved into moth fever and shook me out of my misery. I began to fill sleepless nights with light-trapping and wrote my first moth book with observations made in my own garden. It received an internationally highly prestigious design award. This book was pretty much the test run for my childhood dream: aged 50 I finally wanted to become a rainforest researcher and surrender myself utterly and completely to my Tropic Fever. I conceived the idea of writing a moth book for Costa Rica! A different continent, a different language and an unknown world of plants and animals – this brought huge challenges, not to mention how to finance this undertaking myself. All that was familiar to me were just a few neotropical moths and butterflies from the tropical collection. Several research trips to Costa Rica ensued, and a project was born

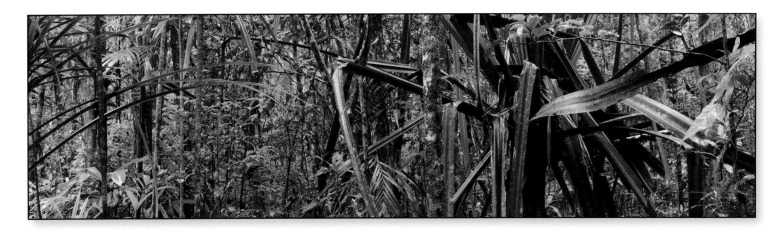

that was to take the best part of five years, working independently and managing in the end to finance the book myself by creating and then renting out a traveling exhibition. It also led to my close friendship with Paul.

First contact with „Masoala"

"For every animal you discover you'll get a scoop of ice cream". With this wholehearted statement I persuaded my family one day to take a trip to the Masoala Rainforest House at the Zoo Zurich. It ended up being 13 scoops per child – and today I still owe my daughters a few scoops ... Well, the trip to the Masaola House gave me another intense bout of Tropic Fever, and so in 2018 I plucked up the courage to introduce myself in person at the Zoo. I took with me in my hand luggage my two specially designed moth books. There, luckily, I bumped into Martin Bauert – with whom my idea for a 'Masoala moth book' fell like a seed on particularly fruitful soil, easily able to germinate.

Eyes of the forest

Eventful years followed. Both my parents died and I inherited the tropical butterfly collection. My marriage ended in divorce, and after I spent eight years as a single father my daughters moved out. I ended my teaching post, paid off my house, and gathered my strength and money for the first research trip to Masoala. My Tropic Fever now hit top temperature: Despite previous experien-

Secondary lowland rainforest at Masoala

Almost all flat, coastal lowland rainforests in the Masoala region were selectively logged until the mid-20th century through hard manual labor. Especially the large, old hardwood trees were targeted at that time. On the east coast of the Masoala Peninsula even a small hand-operated railway was installed between Antalaviana and Tampolo to facilitate the transport of the logs. Even today, occasionally one can find logs left behind from that time with their core wood still largely intact, despite lying in the soaking rainforest for almost 100 years. Despite beeing stripped of the large, emergent trees, these forests have hardly lost any of their original biodiversity. Remarkably, there is a very high density of young trees striving towards the sunlight to overshadow their competitors. In the lower and middle layers of these highly diverse secondary forests, palms and "screw palms" (*Pandanus* sp.) are particularly abundant with numerous species.

ce in the tropics, my impression impression was that of landing on another planet. Intense weeks at Pierre and Marie's Masoala Forest Lodge came next – intense both in substance and emotionally. I had enough hours of solitude in which to work through my anguish and work on a concept for this book as well. Because for Masoala I didn't want to do just a standard moth book. I meant it to be artistic, encompassing all issues so that it would be a total experience for its readers. I wanted it to infect people with Tropic Fever!

Authors and mentors

Once back from Masoala (2019), evaluation commenced of the moths I had photographed and the result was my first digital species collection. Martin Bauert was with me as a mentor constantly, and for the first time I was able to come into contact with scientists who were doing research on Madagascar butterflies and moths in famous museums in London, Paris and Munich. Once again, I was unbelievably lucky because David Lees, Axel Hausmann, Rodolphe Rougerie, Alexander Schintlmeister and others were open to questions and enormously helpful. David Lees especially was surprised at the wealth of species and the quality of the images. Because the biggest sensation was that I had in fact documented *Malaza fastuosus*, which had supposedly been extinct for about 50 years. I would not have begrudged David this rediscovery – for he would have deserved it. It became clear to me that I had to share the book and its contents with experts, and I wished to do so as well. Accordingly, I designed a draft for the subject areas and sent invitations for authors to write pieces. How helpful for the book's enrichment and for its technical quality that all the specialist authors agreed to do so and wrote contributions – without charging any professional fees! My great thanks go to them. Thanks also go to the young researcher Marcin Wiorek from Kracow who assisted me greatly. He will certainly go on to make and describe many more discoveries. Neither would I have been able to complete the book without my friend Paul. I knew that I could rely on his talent for languages and on his commitment. His support was greatly encouraging

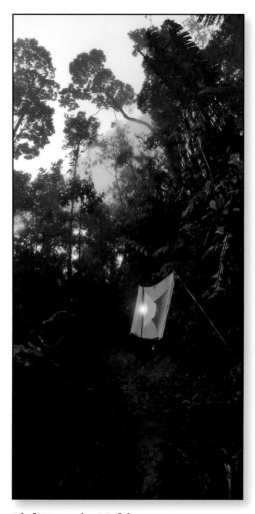

Lighttrap in Makira
Paths in the Makira Rainforest are narrow and slippery and often they fall away steeply into gorges. At night in the rain and afflicted by moth fever caution is advised!

and motivating. Thank you Paul.

On the second research trip I was able to develop the concept for the book further and at the same time investigate Makira, another rainforest adjacent to Masoala, for butterflies and moths. After an almost two-year break caused by the COVID pandemic, I was able to travel to Madagascar again for a few weeks together with Zoo Zurich and Frank Glaw. Not even the constant downpours, which persisted for four weeks and were caused by the cyclone "Batsirai", could quell my tropical fever. Meanwhile, I was in contractual negotiations with Benteli Publishers and was again financially supported by Martin Bauert and Zoo Zurich. The concretization phase of "Eyes of Masoala" came next.

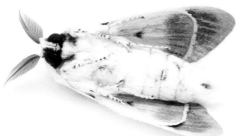

Study area in Makira
Apart from the flat coastal plains, the topography of the Masoala and Makira regions is very rugged. The valleys and gorges are steep and deep, making access difficult and arduous. At first glance, the living conditions in a tropical rainforest may seem fairly uniform: hardly a day goes by without sunshine followed by rain. However, the microclimate in the different layers of the forest can be vastly different for the organisms that are adapted to different strata.

The epiphytes in the canopy layer, for example, must protect themselves against the relentlessly burning, almost vertically standing sun in order to survive periods of low relative humidity and high temperatures. Trees and vines in the canopy layer must absorb enough water from the shallow soil with their root systems to replace the water lost through leaf transpiration.

Only a small fraction of the blazing tropical sunlight reaches the understory and ground vegetation. These plants must rely on this scant solar radiation to produce their photosynthetic products. Herbacous plants growing in the shaded understory often have red or purple leaf undersides that allow them to absorb reflected light, or light with longer wavelengths, and leaf forms that align and maximise exposure to light at different times of day.

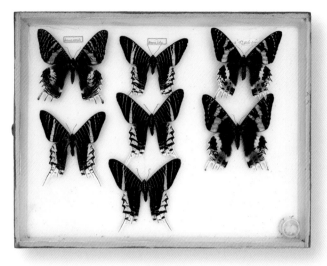

The path described here leading to this book is of course compressed and ignores many sideshows and their actors. But it shows what happens in fractions of seconds, emotionally and mentally inside me, at the sight of an 80-year-old butterfly showcase with giant butterflies. Then I feel like the little boy running after a swallowtail butterfly in the high grass of a flowering meadow on a hot summer's day – alive, bold and inquisitive. Present in the here and now. All worldly cares become as light as a butterfly's wingbeat. Wolfgang Roell understands this internal transformation and strength and gave this book his generous support.

Book concept – Opportunities and goals

The three big main chapters describe, you might say, the structure of my Citizen Science Project. The chapter 'Tropic Fever' is about my motives and goals and the forests in which the field research took place – almost a brief 'The Making of'. 'The Eighth Continent' gives an insight into the natural history of Madagascar, and in the longest chapter, 'Encounters', the research results are shown in the form of images of direct confrontations or incidents with species. It also serves as a identification tool for 400 moth species.

The more intensively and meticulously I worked on the book concept, the more I realized that this book brings me not only great opportunities but also great responsibility. Outstanding specialist authors took joint responsibility and helped me to prepare texts that are just as multifaceted and interesting as the plant and animal world of the island of Madagascar itself. Martin Bauert first introduces Madagascar's natural history and how the species diversity came about and how to protect it. David Lees and Marcin Wiorek start by presenting readers with the moth superfamilies dealt with in the identification section, while Alexander Schintlmeister, Axel Hausmann and Rodolphe Rougerie give insights into the specific moth families and research areas in which they specialize. In his article, Aristide Andrianarimisa persuades readers – and hopefully also many decision-makers in the future – how important it is to collect plants and animals if we are to understand and protect nature. Lovy Rasolofomanana paints brief portraits of Masoala and Makira, the two big rainforest areas in which the moths were surveyed. Thomas Bucheli humorously describes the local weather conditions, and Moritz Grubenmann comments on seldom-observed praying mantises that turned up at the light traps, while reptile researcher Frank Glaw introduces a variety

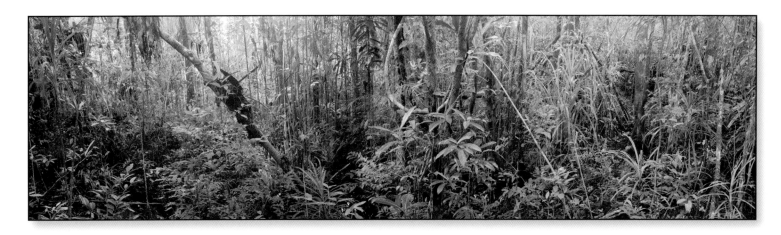

of amphibians and reptiles that I encountered while light-trapping at night. I was permitted to share my hut in Makira with him and his frogs until deep in the night and to learn a great deal about about these amphibians. Interspersed in the technical moth section of the book are curious stories that serve to introduce a few superfamilies. Take for instance Roland Hilgartner's sensational account of the discovery of the tear-drinking moths. Also introduced is the Wildlife Conservation Society (WCS), which sets itself the ambitious goal of protecting the biodiversity of our planet. I thank these authors most wholeheartedly.

This is how this possibly unique book was created, making it at the same time my personal plea for the moths of Madagascar. There are double pages that look like collection showcases displaying a wealth of species and a rich variety of variants. But there are also some that portray moths as personalities and invite a study of their beauty and anatomy. On each double page the moths are illustrated proportionate to each other in size. I am quite sure that because of its design and the prepared list of species it constitutes a thus far unique, visual historical document. But what will the species list look like in five, ten or 20 years? What will be the effects of climate change and population growth?

The book is a living, visual report on intensive weeks of natural field research. It documents and visualizes which moth species were found alive in the research periods in 2019 and 2022 in the two rainforests, Masoala and Makira. The book will also be able to contribute in future to sight identification of 400 Madagascan moth species and will update the previous species lists for the two regions. Perhaps the book will also serve as an initial impulse and basis for further research into the moths of Madagascar. The following objectives, at a minimum, are intended: To bring joy, to cause astonishment at nature and its biodiversity, and to make each of us aware of our own responsibility.

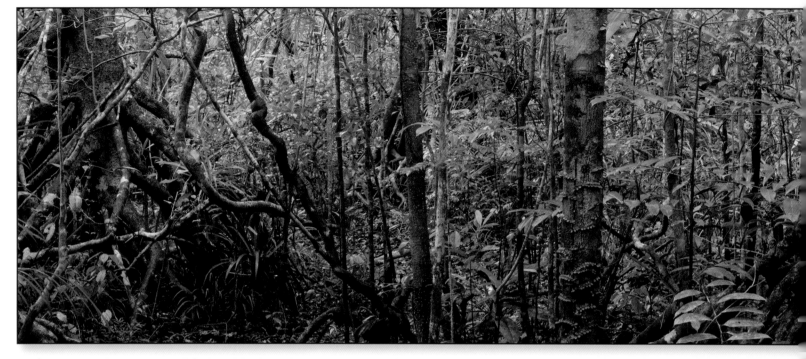

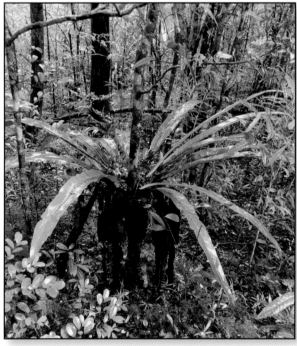

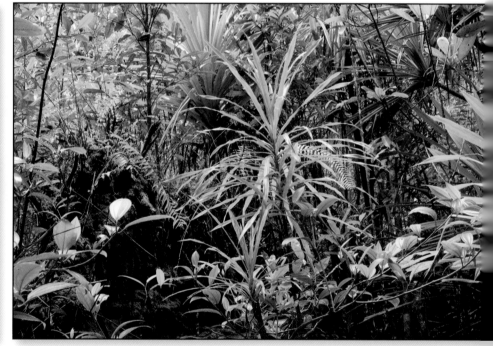

Rainforests: the Battle for Sunlight

Every plant needs light to grow, bloom, and bear fruit. The competition for light is the dominant issue for all plants in the rainforest that cannot directly unfold their leaves in the canopy layer, such as emergent trees, lianas, or epiphytes. Many palms (*Dypsis* sp.), dragon trees (*Dracaena* sp.), and screw pines (*Pandanus* sp.) grow like an umbrella as an adaptation to the scarce light conditions in the understory.

Palms in the lowland rainforest at Masoala in the study area

Madagascar, and in particular the Masoala Peninsula, is a significant center of global palm diversity: over 170 species of palms are known, with all but 5 species being endemic. Over 100 palm species occur on the Masoala Peninsula. This is a strong contrast to the approximately 70 species documented across the entire African continent.

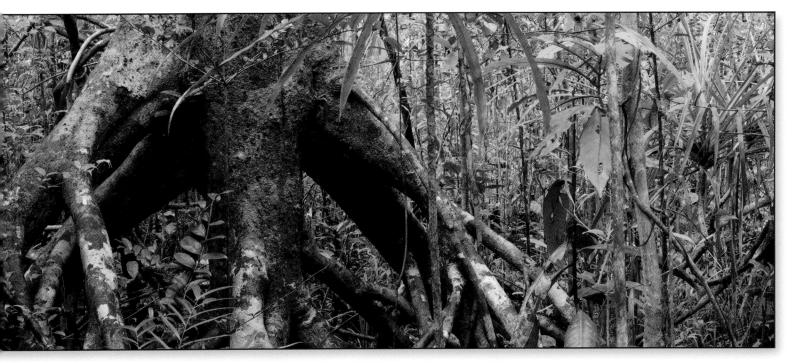

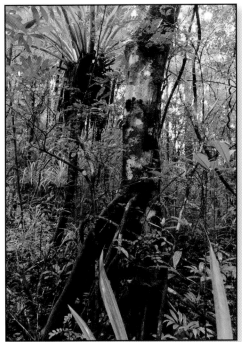
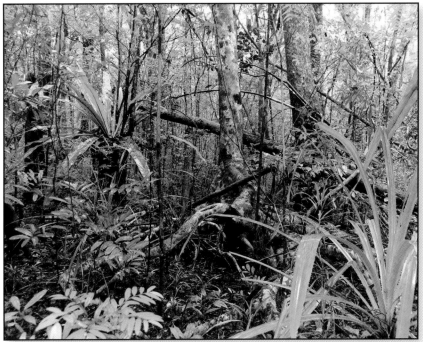

Lowland rainforest at Masoala in the study area

Uapaca sp. trees can be identified by their well-developed and prominent stilt roots. The genus is found in Madagascar in humid evergreen forests ranging from sea level to over 2,000 meters in elevation, as well as in semi-deciduous forests in the central highlands. *Uapaca* is an African-Malagasy genus with roughly 12 endemic species in Madagascar. Previously classified in the Euphorbiaceae family, *Uapaca* is now grouped with the Phyllanthaceae. *Uapaca* bears fleshy fruits that are heavily consumed by various lemur and bird species. Several species, such as *Tapia (U. bojeri)*, the host of the Malagasy silk moth, have edible fruits.

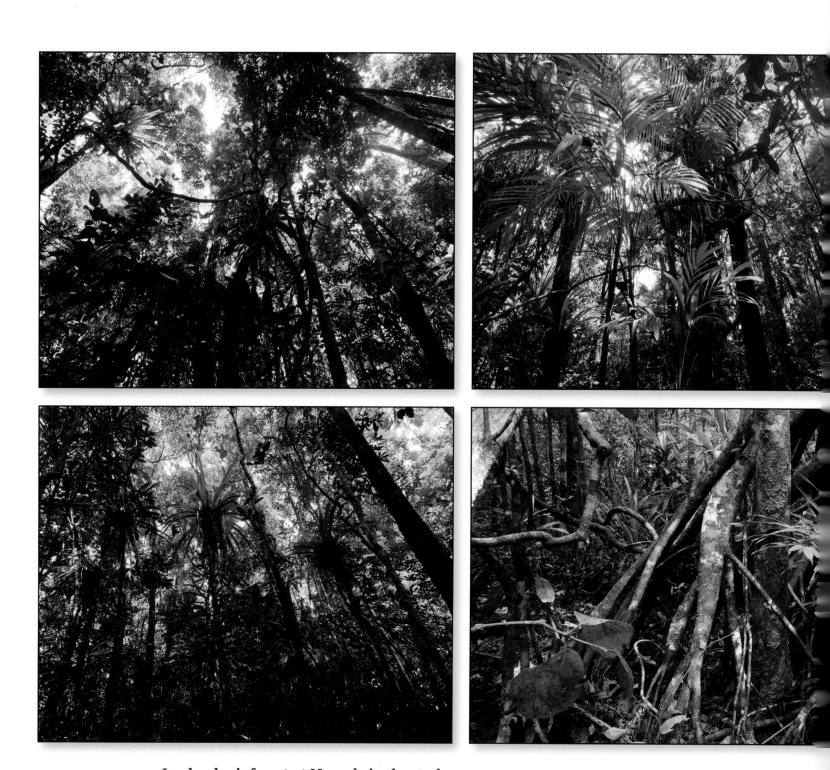

Lowland rainforest at Masoala in the study area

The lowland rainforests have different strata and there is strong competition for light. The canopy of the forests is dense; only a relatively small amount of sunlight reaches the undergrowth on the ground. Epiphytic Bird's nest ferns growing on the trunks are very typical for the Malagasy rainforests. Vines wind from the ground up to the canopy layer to unfold their leaves and flowers in full sunlight. Vines are one of the least explored plant groups in the rainforest, as they pose major difficulties for botanists. On the ground only roots and the winding wooden stems can be studied, because the leaves, flowers, and fruits that are essential for scientific research are often out of reach for scientific analysis.

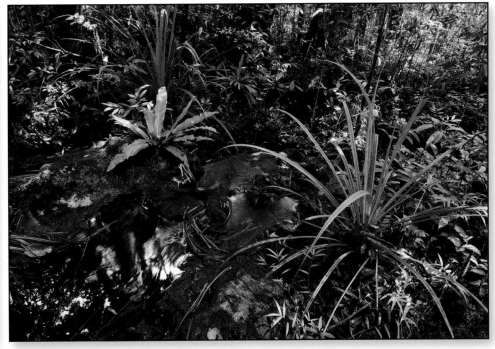

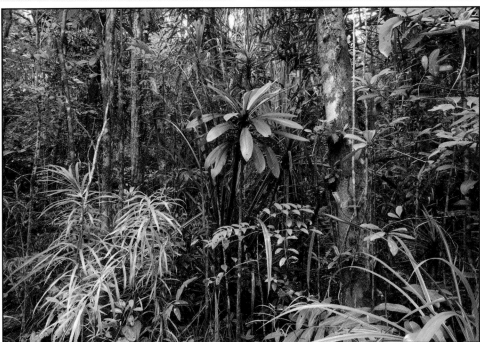

Habitats for various frogs

Small streams are a unique habitat in rainforests, particularly used by various frog species. On the moss-covered rocks, begonias are often found, which can thrive with limited access to light. But even Bird's nest ferns (*Asplenium* sp.), which usually grow epiphytically, and screw palms (*Pandanus* sp.) find suitable conditions here.

Rainforests: the Battle for Sunlight

Young trees invest as little as possible of their scarce photosynthesis products in their trunks, as wood is not productive. Instead, they try to align their leaves optimally and grow towards the light as quickly as possible. In the German language, the term "Schopfbaum" (tufted tree) was coined for this growth form: Small trees with thin trunks extend a whorl of leaves as high as possible towards the sun. *Oncostemom* sp. with its large, dark-green leaves that hardly shade each other is a typical example.

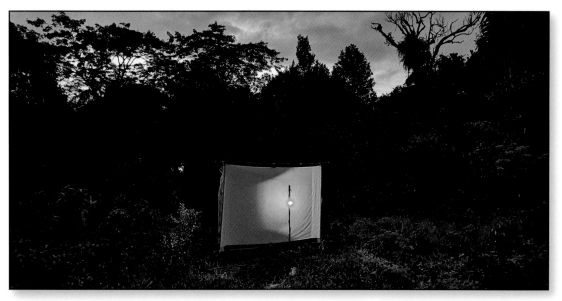

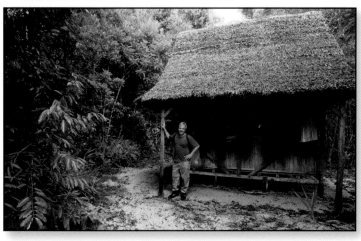

Setting up in the twilight

Above can be seen the light traps employed: A bed sheet with sown-on tabs, a mosquito net converted into a canopy and a professional light tower made of gauze fabric are what I used. In this way a suitable mobile construction could be used for any site. Below, my research hut in Masoala – my heaven on earth. It offered me everything I needed: a dry roof over my head, cool during the day and secure at night.

Bites, scratches and fever

The long weeks of light-trapping and nightly excursions left their mark. The strenuous day-night rhythm with little sleep, biting pests at the light trap, leeches and plants armed with thorns and stinging hairs brought mental and physical stress. All that could help to keep me going was rest and to concentrate on the next night's light-trapping. Also a few SMS messages from my partner Sigrid, from my sister Manuela or from my daughters Amelie and Helena proverbially healed my wounds.

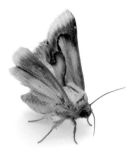
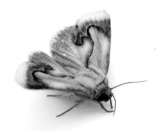
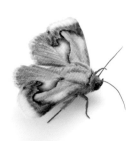
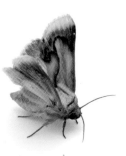

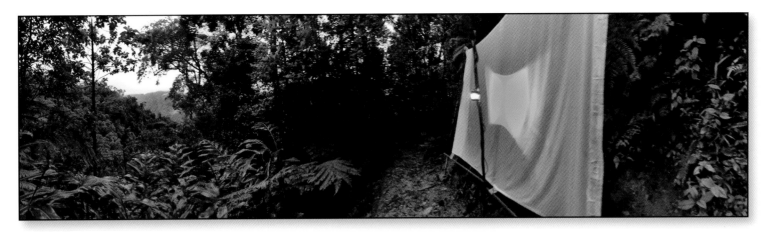

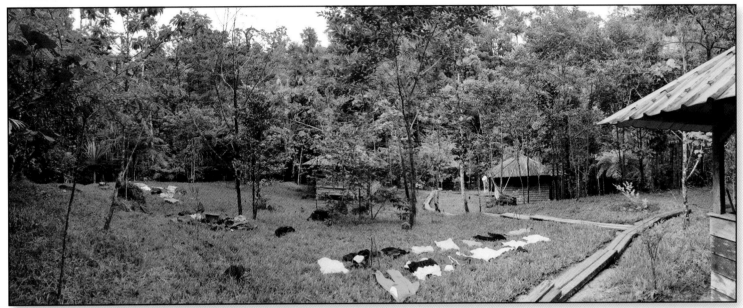

Sunshine at last – washday in Makira

Whenever heavy rain wasn't pounding deafeningly on the corrugated roofs, the time could be used to wash clothes, clean equipment, and, especially, to charge batteries for camera and UV lamp. After just a few days of rain shoes were covered with an overlay of mold and the equipment was damp and musty. Half-charged batteries increasingly shortened the fluorescent time of the UV lamp and the light strength of the flash. Each photo had to be carefully considered.

Flight activity during cyclone rains

Animals and plants are adapted to this wet and hot climate and so flight activity is good despite heavy rain. But evaluating the captures at the light trap became more difficult with each passing day and my own strength began to wane.

Time and commitment

The isolation of my two "research stations" gave me intensive periods of time in which to concentrate fully on the moths. This resulted in a picture archive of more than 500 species and 10,000 photos.

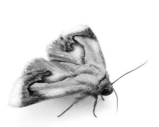
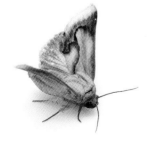
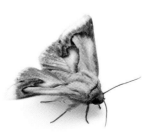

Acontia viettei Hacker, 2010

The Eighth Continent

Brookesia vadoni Brygoo & Domergue, 1968

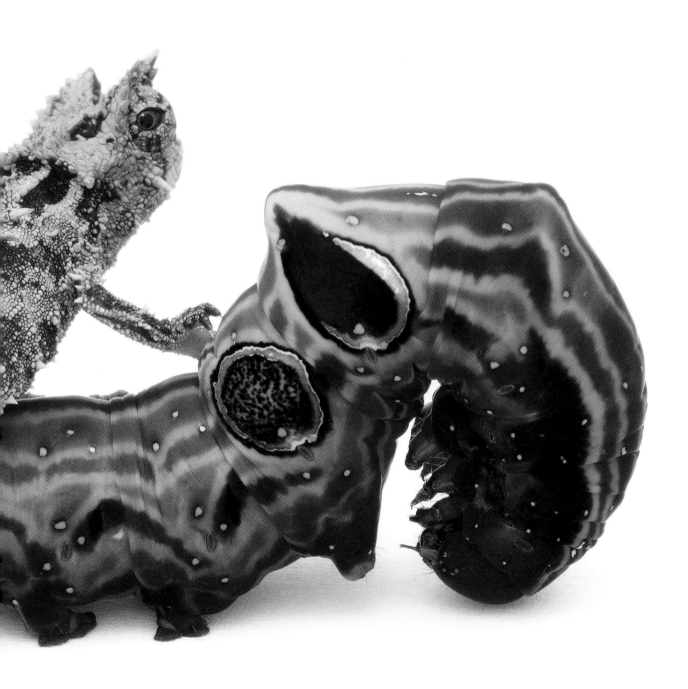

Eudocima sp. Billberg, 1820

Eyes of Masoala

Text by Dr. Martin Bauert

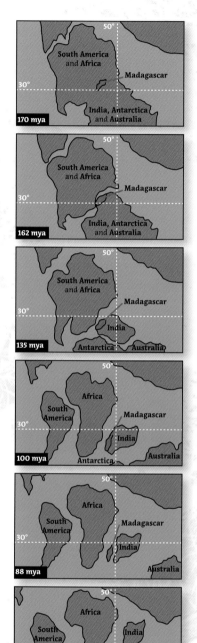

Many biologists refer to Madagascar as the eighth continent because this island harbors an incredibly unique flora and fauna that is outstanding and quite different from the biodiversity on the seven recognized continents. Madagascar's species richness surpasses that of entire continents in various respects: despite being fifty times larger, Africa has only about 70 palm species compared to the more than 170 palm species that are known to exist in Madagascar. A similar case is the distribution of the legendary Baobab trees: Only one species is found growing on the continents of Africa and Australia, but Madagascar features six endemic Baobab species.

Madagascar: Isolated in the Indian Ocean eons ago

The outstanding diversity of plants and animals in Madagascar is the result of its isolation for eons as an island off the coast of Africa. Roughly 220–150 million years ago, the Mozambique Channel was formed and eventually separated Madagascar from the African mainland. Madagascar remained connected to the landmass that now forms the Indian subcontinent for another 60 million years. Around 90 million years ago, the Indian continental plate began moving north, separating from Madagascar, and eventually colliding with the Eurasian plate, creating the tallest mountain range on our planet – the Himalayas.

Evolution in relative isolation

For almost 90 million years – a duration that is hardly comprehensible on a human timescale – the plants and animals in Madagascar outlasted and evolved in relative isolation from the evolution that burst into flame on the continents after the extinction of the dinosaurs. Dinosaurs disappeared only relatively recently in geological timescales – the impact of an asteroid 66 million

years ago put an end to their dominance. Madagascar's position near the equator remained stable over this vast time span, resulting in relative climatic stability throughout the geological turnovers.

Occasional immigration of species

Despite being situated 420 km off the coast of Africa, Madagascar was still accessible to species adapted for long-distance migration. Madagascar shares with Africa and the entire Indo-Pacific region many species of migratory birds and coastal plants that have seeds adapted to water dispersal. However, some plants and animals that are not adapted to water dispersal or long-distance migration must have colonized Madagascar occasionally.

Lemurs, for instance, which evolved in Africa after the accidental extinction of the dinosaurs, are thought to have been dispersed to Madagascar on plant rafts that were washed from rivers into the Mozambique Channel. Lemurs represent the most basal group of primates and today are known on the African continent only from fossils. However, on Madagascar, they thrived until the arrival of humans.

Amazing adaptive radiation

The ancestors of today's lemurs underwent astonishing development upon their arrival in Madagascar. In the absence of the many other competing mammal species found in Africa, they developed amazing adaptations to their new habitat. More than 100 distinct lemur species evolved and adapted to extremely specialized niches.

Bamboo lemurs feed almost exclusively on bamboo, which is toxic to most species due to its cyanide content. Indris have adapted to eating the leaves of *Uapaca* tree species, which belong to the often notoriously poisonous family Phyllanthaceae.

Center of Gondwana
The landmass that forms Madagascar originally lay in the center of the ancient continent Gondwana. This also explains why some groups of organisms have their closest relatives in South America, while others have them in Asia or Australasia.

The Aye-aye is one of the most unique species of animals in Madagascar and is also one of the most unusual primates globally. With a weight of approximately 2.5 kg, it is a medium-sized lemur species that has adapted to very specific food niches that are used by woodpeckers in other parts of the world. The Aye-aye, which is nocturnal, is characterized by bony, elongated fingers (excluding the thumb) that bear claw-like nails. The middle finger, in particular, is thin and skeletal. The incisors are rodent-like and continue to grow throughout their entire life, which is unique among primates. The Aye-aye uses its strong, sharp incisors to feed on very hard seeds and also to track down beetles and larvae in wood. Like a woodpecker with a strong beak and long tongue, the Aye-aye probes for beetles and larvae in gnawed burrows using its thin middle finger. Adaptive radiation into unoccupied niches is typical of isolated habitats and was most prominently first described for finches on the Galapagos Islands by Darwin. The relative isolation of Madagascar also enabled many ancient plant and animal groups to survive until the present day.

Aye-aye (*Daubentonia madagascariensis*)
The Aye-aye is a unique and fascinating species of lemur. It is known for its distinctive appearance with large, round eyes and long, bony fingers. Photo: © Joel Sartore / Photo Ark

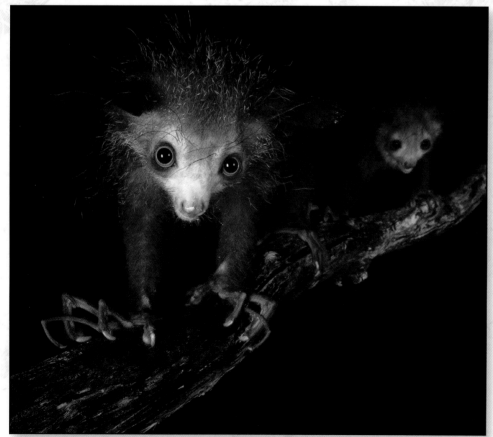

"A World Like Our Own"

Alison Jolly, a primatologist known for her studies of lemur biology, depicts Madagascar in her book "A World Like Our Own" as a sort of parallel reality in which the same biological rules apply, but the outcome is as different as if it were another world. The fauna that exists in Madagascar today is remarkable, but it was even more so a mere instant in geological time ago when the first people arrived. Herds of small hippopotamuses and groups of giant tortoises grazed on short grass patches within forests and bushland. In the tall grass and brushy areas, huge elephant birds (*Aepyornis*) scratched and pecked for food. *Megalodapis* lemurs – similar to giant koalas the size of female gorillas – slowly and carefully climbed up trees. Deeper in the forest, chimp-sized *Palaeopropithecus* moved along the branches like sloths. These herbivores kept parts of the land neatly trimmed, just like in an African game park today. However, typical African herbivores such as antelopes and elephants never arrived in Madagascar.

Madagascar's megafauna

After the arrival of humans, the fauna in Madagascar changed very quickly: large animals were hunted, and landscapes were altered by agricultural activities. This led to the extinction of the entire megafauna in a relatively short period of time. Artworks: Peter Schouten

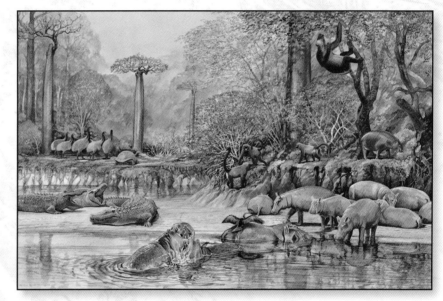

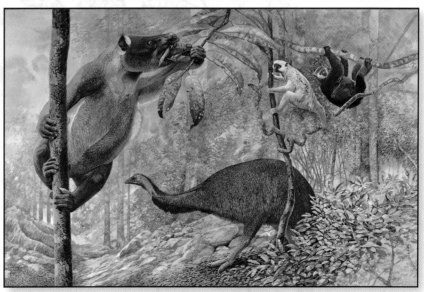

Climate and geography shape the vegetation cover

Madagascar extends over 1,600 km from 12°S to 25°S. An old granitic mountain range runs north to south throughout the length of the island with peaks exceeding 2,600 m. The terrain and the primarily westerly winds are the primary drivers of its climate. Madagascar experiences dry trade-wind conditions in winter (May–September) and monsoon-driven tropical storms in summer (December–March). The uplift of the westerly monsoon winds along the mountain ranges results in regular and heavy rainfall, leading to a dense covering of tropical rainforest on the east coast. The western regions, which are leeward, have lower rainfall and drier vegetation formations, with subarid conditions even occurring at the southwestern end of the island.

Tropical cyclones frequently occur between mid-January and mid-March. Many of them make landfall on the northeast coast of Madagascar. Unfortunately, an unprecedented accumulation of cyclones has been hitting the Masoala region since 2000, with the region being hammered by extraordinary storms almost every second to third year. The average annual rainfall for rainforest stations on the east coast is around 3,500 mm. However, this is exceeded by 6,000 mm measured at Andranobe on the Masoala Peninsula.

Madagascar
A mountain range stretches along the east coast from north to south. The east coast drops steeply into the sea, unlike the west coast, which slopes gently.

The Masoala and Makira region: one of the world's hottest biodiversity hotspots

Biodiversity hotspots are defined as areas with exceptional species richness and concentrations of endemic species. Madagascar holds roughly 5% of the world's biodiversity, despite covering only 0.4% of the Earth's land mass. Biodiversity culminates in the forests of the Masoala and Makira regions, where more than 50% of all plant

Organism group	Approximate number of known species	Percentage endemic
Lemurs	103	100
Carnivores	8	100
Rodents	24	100
Tenrecs	28	100
Bats & Fruitbats	36	66
Birds	310	35
Reptiles (non-marine)	363	92
Frogs	365	99
Terrestrial Snails	651	100
Scorpions	40	100
Spiders	459	85
Dragonflies & Damselflies	200	93
Lacewings	163	75
Tiger beetles	233	99
Scarab beetles	148	100
Freshwater Crayfish & freshwater Shrimp	32	100
Flowering Plants	12,000	85
Trees & large shrubs	4,500	95
Lepidoptera	5,016	80–90
Butterflies	317	72–74
Moths	4,699	

New species are constantly being described in Madagascar and their distribution areas are being better investigated. The percentage of endemism varies between publications and the detailed delineation of the organism groups.

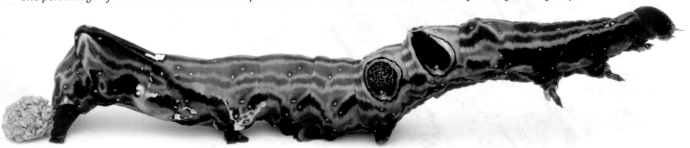

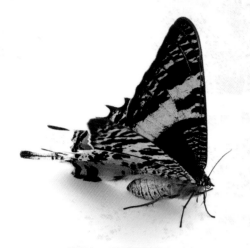

species in Madagascar can be found. The forests of the Masoala and Makira region (MaMaBay) represent the last vast tropical forest blocks that were able to be preserved, with still many scientifically undiscovered and undescribed species. Almost every year, new species of amphibians, reptiles, plants, and even lemurs are discovered and published in scientific literature.

The Rainforests of the Masoala region

The most beautiful and least disturbed lowland forests in Madagascar are found today around Antongil Bay. In a few places forest still can be found from sea level on the coast up to the summits of the mountain ranges from 400 to 1,200 m above sea level.

The lowland rainforests occur from sea level up to about 800 m elevation. Around this rather arbitrary altitude an almost imperceptible transition from lowland forest to submontane forest occurs. The rainforests of Madagascar are still today a wonderland of tall canopy trees, dripping and densely covered with epiphytic ferns, mosses, and orchids. The tree flora consists of about 4.500 species, of which 95 % are endemic. Some families are of Gondwanaland origin, reflecting the ancient connection with South America, Africa, and Australia. The botanical richness of Madagascar's rainforest surpasses that of most sites in Africa.

The bioclimatic regions of Madagascar
Simplified representation of the four major bioclimates. From west to east, the climate becomes wetter. However, from north to south, it becomes drier. Derived after Comet, 1974

The lowland rainforest is 25 to 35 meters high, relatively dense and compact compared to the rainforests on the African continent or in South America. The height of the tree canopy gradually decreases with increasing altitude. Above about 800 meters, the trees become gnarled and are even more densely covered with mosses and lichens and grow just a few meters high.

34

The extraordinary diversity of species in the Madagascan rainforests is not immediately noticeable. Many trees and shrubs have similarly shaped leaves and the differences in bark between the various species can only be discerned by the eye of a trained specialist. There is a particularly great abundance of screw palms (*Pandanus* sp.), which present an unusual sight with their differently formed stilt roots depending on the species. The sheer quantity of epiphytic ferns (Bird's nest ferns, *Asplenium* sp.), mosses and orchids, as well as tree ferns (*Cyathea* sp.) – contemporaries of the dinosaurs – creates a unique ambiance. As the rootable soil layer is very thin, a dense layer of roots covers the thin layer of topsoil, loosely covered by a surprisingly thin layer of litter consisting of dead leaves and branches.

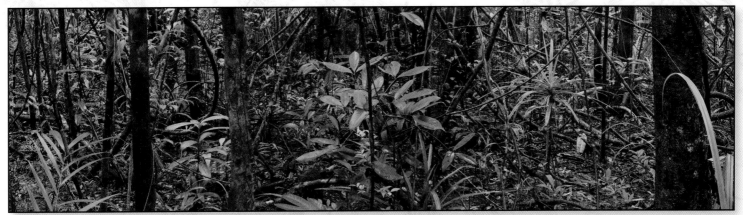

The high density of young trees is also striking, often with stems no thicker than a thumb, waiting in the shade of the large trees for a gap in the canopy to open so that they can have a chance to emerge. Many tree species develop buttress roots and stilt roots to provide the necessary stability to withstand the strong winds of cyclones.

In contrast to the rainforests of South America or Asia, Madagascar does not have any reptiles or amphibians that are fatally poisonous to humans or particularly dangerous insects and ants. This allows one to explore the forests, which are filled with the sounds of various voices especially during the rainy season, bare-

Race to full sunlight
Bird's nest ferns, which usually grow epiphytically, occasionally thrive on the forest floor (photo above). There is no seed bank in the soil of the rainforests. The seeds germinate immediately and try to grow upwards as quickly as possible as soon as a giant tree falls and the canopy opens.

Lowland Streaked Tenrec
There are more than 30 species of this endemic mammal family in Madagascar. They are an example of adaptive radiation: all species are believed to have originated from a common African ancestor and have separated into different species in a relatively short period of geological time, specializing in the use of different niches.

Elephant bird
(Aepyornis maximus)
With a height of three meters and a weight of half a ton, it is the largest bird of all time. DNA studies have shown that *Aepyornis* is more closely related to the flightless birds of Australia and New Zealand than to the ostriches of Africa.
Artwork: Peter Schouten

foot like the local residents or perhaps better in sandals. Cicadas, frogs, birds, and lemurs create a unique and partly astonishingly loud background sound, which changes constantly throughout the day. The forest often becomes quieter around noon and then picks up again for a "Furioso" during dusk.

Small terrestrial leeches are also part of the Madagascan rainforests and are an excellent indicator of undisturbed forests: the more leeches, the more pristine the forest. Thankfully, they do not transmit any diseases but are rather annoying and particularly active above an elevation of around 50 meters and on rainy days. Among the local population, who generally know the behavior and occurrence of any animal and plant species very well, there is much disagreement about what the leeches feed on when no humans are roaming the forest. Some believe that leeches only seek out animals without fur for their blood meal, while others firmly believe that even lemurs and birds are part of the leeches' prey. The terrestrial leeches of Madagascar still represent an understudied group, despite every researcher of Malagasy rainforests inevitably sacrificing at least a few drops of their blood. Four species of leeches are known to exist, but there is morphological and genetic evidence that more species exist. While generally thought to be mammalophilic, recent DNA studies have revealed that leeches feed on mammals, birds, reptiles, and amphibians.

The loss of Madagascar's megafauna due to human settlement

The first human settlers of Austronesian origin arrived in Madagascar about 1,300 years ago. Following the Indonesian settlers, Muslim traders were likely to have been regular visitors by the 13th century. These first settlers encountered one of the most unusual fauna on earth. Although our knowledge of the fossil and

subfossil records of Madagascar's terrestrial life forms is still very incomplete, we must conclude from traces on excavated bones and analysis of archaeological sites that Madagascar's outstanding megafauna was over-hunted and consumed by human settlers.

Archeological records show that human activities varied temporally and regionally, and that impacts on endemic fauna were far greater after the arrival of farming and pastoralism around 1,000 years ago. As Marco Polo traveled back through the Persian Gulf from his famous journey to the Far East in the early 1290s, he heard accounts of a huge island named Madagascar. The legend of the 'roc' in the story collection "One Thousand and One Nights" is almost certainly referring to the flightless Elephant bird *Aepyornis*, which was driven to extinction after the arrival of humans in Madagascar. Despite losing its most spectacular megafauna relatively recently, Madagascar's richness in lemurs, tenrecs, and taxonomically isolated plant species remains outstanding even today.

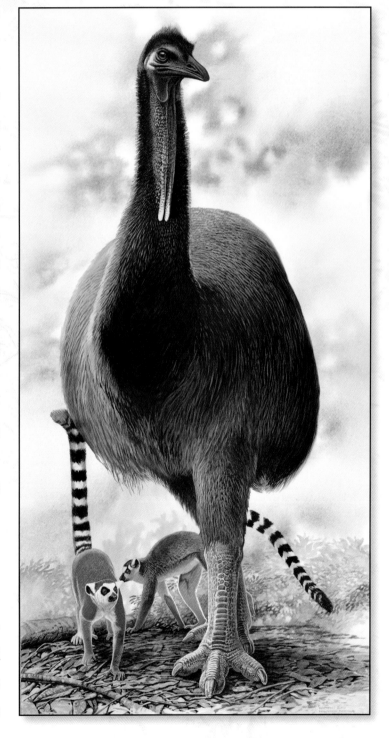

High rates of deforestations and degradation of natural resources

Unfortunately, the human inhabitants of Madagascar have devastated their land through shifting agriculture and the use of fire. Deforestation rates

have been increasing since the 1920s. The practice of slash-and-burn agriculture, known as tavy, has been accelerated by the exponential increase of the human population over the last century. As a result, up to 95% of Madagascar's forested areas have been cleared or drastically altered, leading to a significant impact on biodiversity.

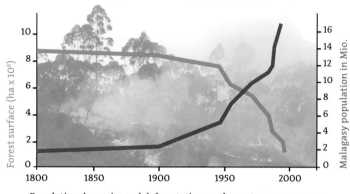

Population dynamics and deforestation on the eastern escarpment (derived from Messerli 2002).

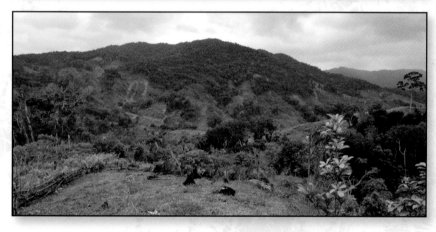

Tavy: Slash-and-burn agriculture
Clearing steep slopes makes the soil vulnerable to erosion, which in turn leads to a rapid depletion of the soil. This causes floods, rice fields in the valley bottoms become silted, drinking water sources dry up, and even coral reefs in the nearby sea are damaged by the sediments washed away.
Photo: Martin Bauert

Repetitive use of fire to clear tavy results in vast, unproductive grasslands that are particularly susceptible to erosion during heavy rainfall. Despite numerous efforts supported by international organizations to prevent the loss of forests and mitigate tavy, the increasing human population that is dependent on subsistence farming has prevented the forest loss from being halted throughout Madagascar.

After the forest has been cleared secondary scrub (savoka) develops, often dominated by the traveller's palm, *Ravenala madagascariensis* and invasive weeds, which hinder reforestation.

History of the Masoala region

There are several explanations for the origin of the name Masoala: often, the creation of the term is thought to be derived from the Malagasy words **maso** (eye) and **ala** (forest) meaning "Eye of the Forest". Another interpretation derives the name from the terms **masina** (sacred) and **oala** (lagoon). Even today, the lagoon in

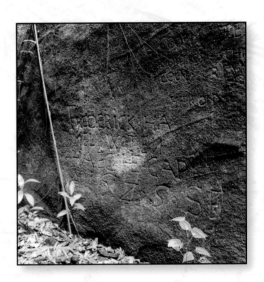

front of Cap Masoala is considered sacred by the locals, and many taboos regulate access and usage.

Some early traces of humans found in Madagascar have been discovered on Nosy Mangabe, an island at the base of the Antongil Bay. Accumulations of soil eroded from hill slopes, attested in archaeological soundings, suggest a fairly dense human occupation of the region until some time after the arrival of Europeans in the early 16th century. Historical accounts of European visits to Antongil Bay are documented from 1595 onwards. Engraved messages from Dutch sailors can still be found today on granite rocks at the "Dutchmen's Beach" on Nosy Mangabe.

In the absence of spices, gold or abundant supplies of food, it turned out that the most sought-after commodity was its human population, which became the focus on an active slave trade that linked Antongil Bay to Dutch colonies in Mauritius, South Africa and southeast Asia.

The economic potential of the forests of the Masoala region began to be realized during the 19th century. The French seized power in 1896 and commercial logging was first set up in the Cap Est region while the Masoala peninsula also swiftly became renowned as a source of latex for rubber production. Commercial logging continued under the French administration and was extended in particular on the flat coastal plain south of Cap Tampolo on the east coast of the peninsula, which appears to have been largely clear-cut in the 1930s.

Short messages
The messages left by the Dutch sailors for each other 400 years ago can still be read today, as they are engraved on rock boulders at „Dutchmen's beach" on the island of Nosy Mangabe.
Photo: Martin Bauert

Creation of the Masoala National Park

By the mid 1920s scientists who were part of the French colonial administration started to understand the unique wealth and value of Madagascar's flora and fauna and of the Masoala peninsula in particular. In 1927 Madagascar's first nature reserves were

established, including the Réserve Naturelle Intégrale de Masoala comprising 27,682 hectares of lowland tropical forest in the northeastern part of the Masoala Peninsula inland from Cap Est.

After the independence of Madagascar from the French colonial power in 1960, the Réserve Naturelle Intégrale de Masoala was declassified in 1964 and granted in 1967 as a logging concession to the company Grands Moulins de Dakar. When Grands Moulins left in the 1970s, the lowland forests of the region had been further destroyed.

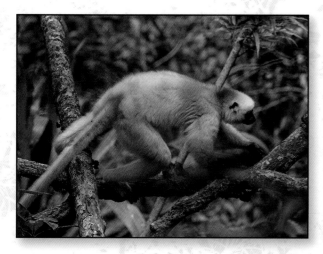

Silky Sifaka
The IUCN lists the Silky Sifaka as critically endangered. There are only about 250 adult individuals left of this splendid lemur with white and silky fur. Photo: Martin Bauert

The first attempt to address broad natural resource management issues was initiated by the Missouri Botanical Garden in partnership with the Ministry for Water and Forests. The Masoala Project with funding from the United States Agency for International Development USAID, initiated a series of botanical surveys on the peninsula. First attempts were made to combine rural development in local communities on the peninsula with a package of conservation measures, whose goal was to create a national park.

In 1992, a group consisting of CARE International, the Wildlife Conservation Society (WCS), the Peregrine Fund, the newly established national parks service, Association Nationale pour la Gestion des Aires Protégées (ANGAP, today branded as Madagascar National Park; MNP), and the Ministry of Water and Forest (MEF) joined together to submit a proposal to USAID for an ambitious Integrated Conservation and Development Project (ICDP) at Masoala. CARE tackled the development needs of the people, while WCS and the Perigrine Fund worked in close partnership with ANGAP and MEF to create and design a new national park.

After a long process of public consultation the final park delimitation proposal represented a compromise between what would have been ideal boundaries from the ecological point of view and what was possible given the reality on the ground and the needs of the villages around the proposed park. Preparations were made to inaugurate the new national park on June 5th, 1996, as part of Madagascar's celebration of World Environment Day. However, on June 2nd the creation of the park was suspended by the government with the bland explanation that the creation of a national park at Masoala was no longer in the national interest. A few weeks later, after a change in the central government, the real reason for the cancelled inauguration was rumored to be that negotiations of the former government had been under way to issue big logging concessions at Masoala as part of a contract with a Malaysian company to build roads in the capital.

The inauguration of the Masoala National Park finally went ahead in September 1997 with the approval of local residents by a national decree. The consideration of local needs and the national economy was a key element in gaining approval for the Masoala National Park which encompasses 2,100 square kilometers of rainforest and three satellite marine reserves with a surrounding multiple-use zone of approximately 1,000 square kilometers.

Today the Masoala National Park is co-operated by Madagascar National Parks (MNP, formerly ANGAP) and WCS. Zoo Zurich has been supporting the establishment and the functioning of the Masoala NP since 1997, when the first MoU with the Ministry of Water and Forest (MEF) was signed.

Establishment of Makira Nature Park

In 2001 the Ministry of Environment and Forests, in collaboration with the Wildlife Conservation Society, launched a program to protect the dwindling forests north-west of the Masoala National Park. In 2012 the Makira Natural Park was established encompassing 3,720 square kilometers of strictly protected forest buffered by more than 3,500 square kilometers of community-managed forests. The Makira Nature Park is today managed by WCS on behalf of the government of Madagascar in collaboration with 75 community associations. Makira Nature Park provides natural resources and ecological services to the surrounding populations of around 90,000 people, including land for agriculture, timber, bushmeat, non-timber forest products and water supply. Makira is a functioning REDD+ project that sells emission reduction credits on the voluntary markets with revenues from sales used to finance Park management and community development activities around the Park.

Zoo Zurich's engagement for Masoala: Vision and mission

The Masoala Rainforest, located at Zoo Zurich, is a greenhouse measuring 1,100 square meters and standing more than 30 meters tall. It serves as an exceptional animal enclosure, allowing the public to experience the world of rainforest animals and plants outside of their typical context. The Masoala Rainforest is designed to replicate the natural habitat of a Malagasy rainforest as faithfully as possible, providing a unique opportunity for visitors to witness the interplay between animals (from insects to mammals) and plants in their native environment. Through this experience, visitors can learn to value rainforests and engage in their protection.

The Masoala Rainforest project at Zoo Zurich is built on two foundational pillars. The first is the construction of the Masoala Rainforest in Zurich, which acts as an ambassador for the beauty and uniqueness of this region. The second pillar is the support given to partners in Madagascar for the long-term conservation of rainforests that are in peril. The main aim of Zoo Zurich's agreements with the Wildlife Conservation Society and the Ministry of Water and Forests is to contribute to biodiversity conservation in the Masoala region, as well as ensure the sustainable use of natural resources in the area around the national parks.

Since 2003, Zoo Zurich has been contributing 25 % of the annual operating costs of the Masoala National Park and investing in an endowment fund that will ensure financial support for the park indefinitely through the financial returns it generates. In addition to supporting the management of the Masoala National Park, Zoo Zurich also finances projects such as the Open Classroom in Maroantsetra, supports public schools around the Masoala National Park, and invests in sustainable agriculture techniques, agroforestry, and the reforestation of critical corridors for wildlife.

Furthermore, Zoo Zurich supports humanitarian projects including providing access to clean drinking water and healthcare services as well as family planning. To date, over 43,000 people in the Masoala and Makira regions have directly benefited from these initiatives. Zoo Zurich has invested $7.5 million in its community-centered conservation approaches in the MaMaBay region. This sum is composed of revenue from the zoo gastronomy, donations by zoo visitors, and contributions from foundations. The projects and initiatives are implemented by the Wildlife Conservation Society and by the team of the Masoala National Park, which acts as the local partner and representative of Zoo Zurich in Madagascar.

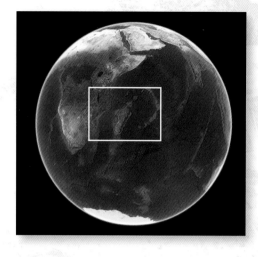

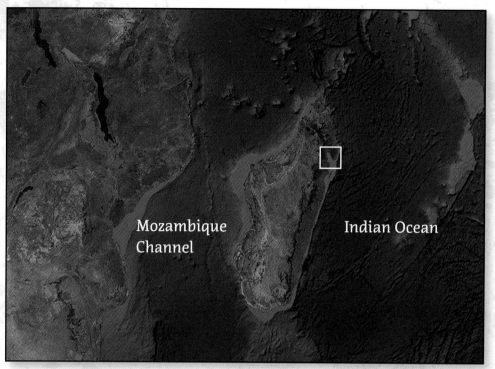

Mozambique
Channel

Indian Ocean

Isolated in the Indian Ocean

The Mozambique Channel, which is 420 to 1,200 km wide and 1,500 km long, separates Madagascar from the African continent. For about 200 million years, Madagascar has been isolated from other land masses in the Indian Ocean and is exposed to the region's monsoon and trade winds.

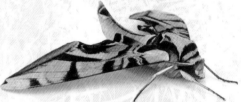

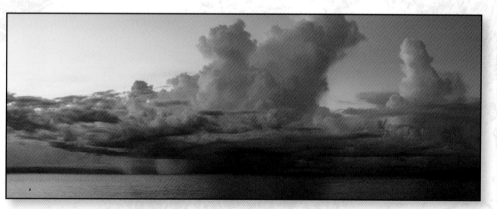

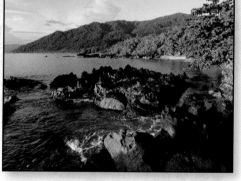

Zenithal Rains

Almost daily, thunderstorms occur in the afternoons over the rainforests of the Masoala and Makira regions. Zenithal rains are typical of tropical regions. The water that has evaporated from the dense rainforest vegetation as a reaction to sunshine rises in the atmosphere throughout the day and condenses. A significant portion of the tropical rainfall comes from this cycle.

Primary investigation area

A narrow coastal strip characterized by sandy beaches interspersed with sharp-edged granite blocks, as well as river mouths and mangroves, forms the contact zone between the sea and the steep rainforests of Masoala National Park. Here, idyllically situated, is the Masoala Forest Lodge, which served as the main base for this moth study.

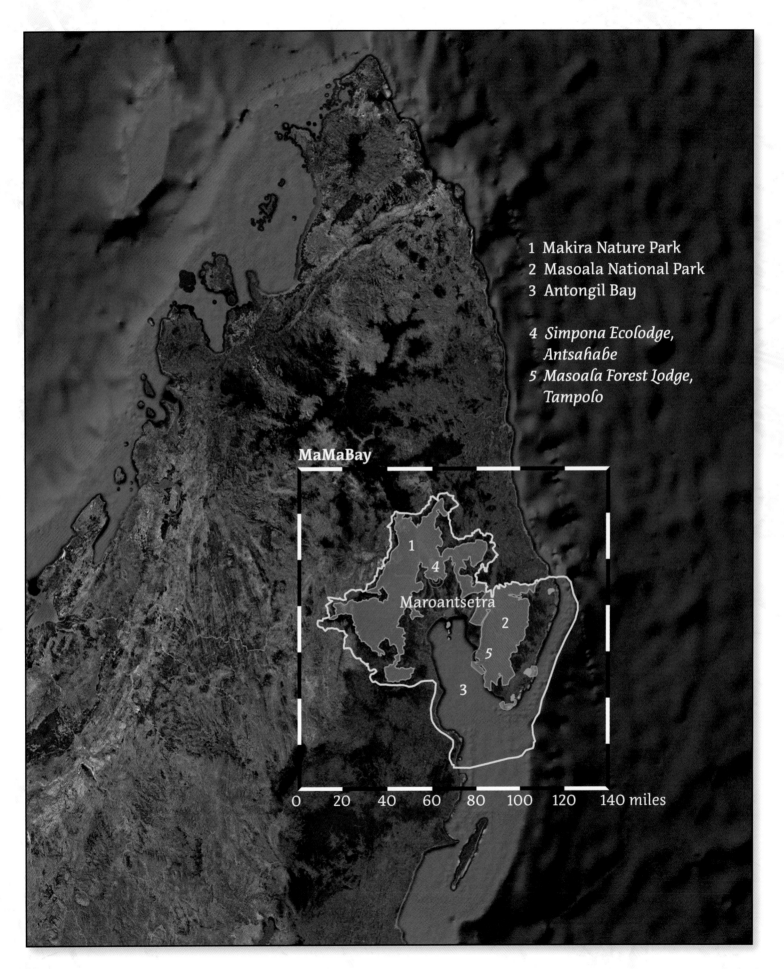

1 Makira Nature Park
2 Masoala National Park
3 Antongil Bay

4 *Simpona Ecolodge, Antsahabe*
5 *Masoala Forest Lodge, Tampolo*

MaMaBay

1

4

Maroantsetra

2

5

3

0 20 40 60 80 100 120 140 miles

MaMaBay Landscape

Text by Lovy Rasolofomanana

Rainforests

The water flow of the creeks and streams in the Makira and Masoala regions fluctuates extensively. For the station Andranobe on the west coast of the Masoala Peninsula, precipitation amounts of more than six meters per year have been measured. Places where streams might still be easily crossed when the sun is shining can quickly become an obstacle during heavy rain. These two screw pines (*Pandanus* cf. *macrophyllus* Martelli, and *Pandanus* cf. *guillaumetii* B.C. Stone, to the right, behind) are growing on a small sandbank. During heavy rain they suddenly find themselves in the middle of a raging stream.

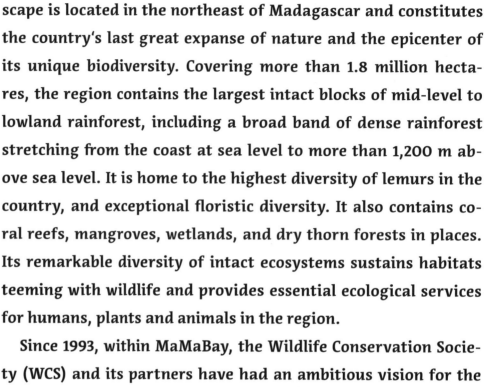

Comprising Makira Nature Park, Masoala National Park, Nosy Mangabe National Park and Antongil Bay, the MaMaBay Landscape is located in the northeast of Madagascar and constitutes the country's last great expanse of nature and the epicenter of its unique biodiversity. Covering more than 1.8 million hectares, the region contains the largest intact blocks of mid-level to lowland rainforest, including a broad band of dense rainforest stretching from the coast at sea level to more than 1,200 m above sea level. It is home to the highest diversity of lemurs in the country, and exceptional floristic diversity. It also contains coral reefs, mangroves, wetlands, and dry thorn forests in places. Its remarkable diversity of intact ecosystems sustains habitats teeming with wildlife and provides essential ecological services for humans, plants and animals in the region.

Since 1993, within MaMaBay, the Wildlife Conservation Society (WCS) and its partners have had an ambitious vision for the conservation of Madagascar's last great natural expanse, with its abundant and diverse flora and fauna protected and linked by community areas for sustainable forestry, agriculture, and fisheries.

Makira Nature Park

The Makira Nature Park, an IUCN category II site, is the largest terrestrial protected area in the country, covering 372,000 hectares. Its lush, low- and mid-altitude forests contribute to high rainfall and support a watershed covering a vast area of 2.5 million hectares. The park is home to more than 60 species of mammals, including 17 species of lemurs, more than 120 species of birds, at least 200 species of reptiles and amphibians, and 450+ species of plants.

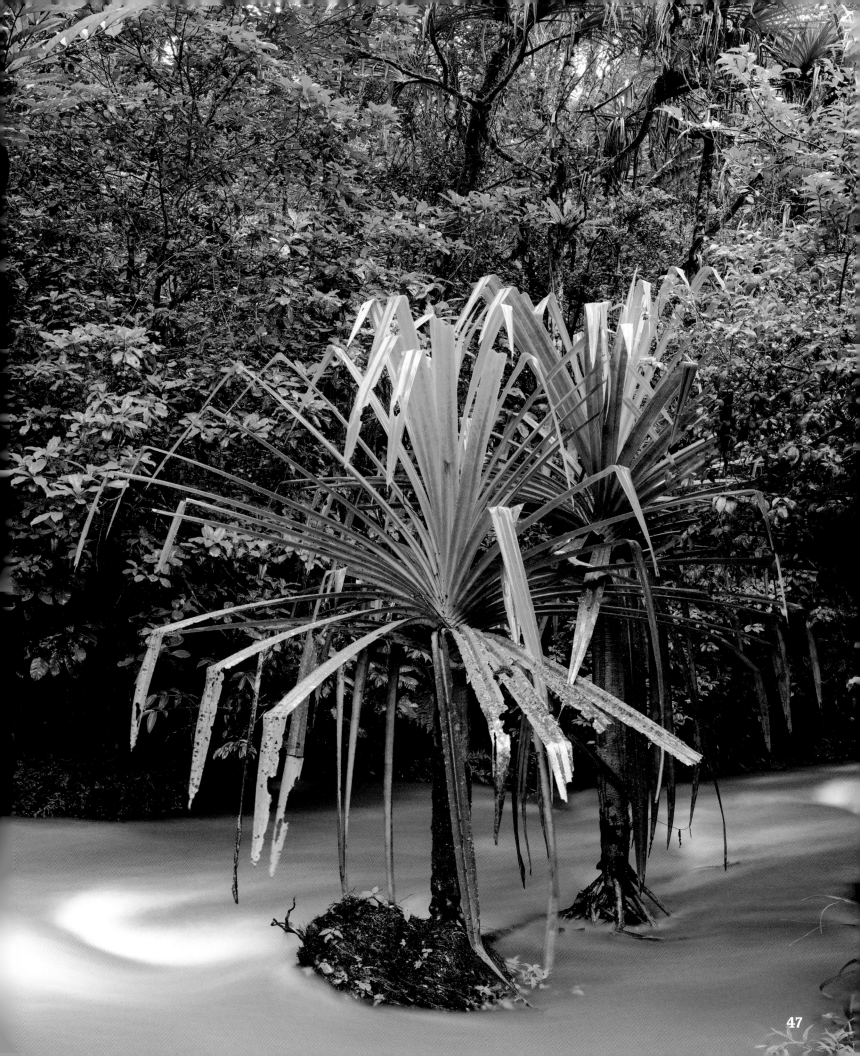

Threats mainly include deforestation due to slash-and-burn agriculture, cutting of hardwood trees and expansion of agricultural land as the population gradually increases and people move into the park in search of land and resources.

Since its inception WCS has continued to manage Makira Nature Park on behalf of the Malagasy government and, as part of this process, it has implemented the REDD+ pilot project to develop a sustainable financing mechanism for supporting conservation and development. The project has established 80 community-managed forests around the park and continues to provide technical and financial support to improve resource management. In addition to protecting the park and supporting good community forest governance, WCS has a range of other community-based projects, including sustainable agriculture (agroforestry, cash crops, livestock), health and education, and reforestation to reduce pressure on the forests.

Masoala National Park and Nosy Mangabe National Park

Masoala National Park is one of the jewels in Madagascar's crown and represents one of the most biologically diverse protected areas in the world. The 230,000-hectare park was created in 1997 and consists of distinct units, including three marine parcels, three detached parcels, and most of the tropical forest of the Masoala Peninsula. As for Nosy Mangabe National Park, created in 2016 it covers an area of 697 ha and is an important focal point for ecotourism in Antongil Bay. The natural habitat of the region is the tropical rainforest, which is found from sea level to the highest peaks, at 1,300 m. It is the wettest region of Madagascar, with some places receiving 7,000 mm of rain per year.

Lowland rainforest in Masoala

The lowland rainforest, which reaches a height of 25–30 meters, consists of multiple strata and has a dispersed understory. These forests are abundant in species. Screw palms, such as this small group of *Pandanus* cf. *oligocephalus* Baker, are a characteristic element which is often found in the middle stratum.

In the stranglehold of cyclones

Text by Thomas Bucheli

The ancient Greeks termed it 'tropoi heliou'. These days we call it 'the tropics' – the region between the northern and southern solstices, the 'solstice zone'. Lying south of the equator in the western part of the huge Indian Ocean, Madagascar is situated almost entirely within the tropics. Only the most southerly tip of this island's length of almost 1,600 km protrudes beyond, and with its thornbush savannah it is then already part of the subtropics and the driest region of Madagascar.

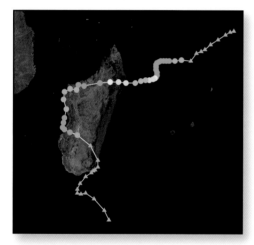

Cyclone Bingiza seen from space and its path in February 2011

It made landfall with full fury on the Masoala Peninsula and raged across Madagascar twice. Its masses of rain and winds of up to 185 km/h damaged more than 400 km² of rice fields, 25,000 houses, and 36 schools; 34 people lost their lives and around 26,000 people were left homeless. Major portions of the roads and infrastructure were destroyed. Track by Keith Edkins.

But this is not what we should be talking about. The focus of our gaze points us elsewhere, to the area around the Masoala rainforest in the northeast, one of the island's wettest zones. This is where the southeast trade wind and the northwest monsoon shake hands and where tropical cyclones are particularly fond of making landfall: this is the home of the often endemic species of moths and butterflies that are our topic of interest here.

"This unique photo book designed by Armin Dett ought to be further enhanced by facts regarding the weather and climate in Madagascar. Why don't you write something about that!?". This is what Martin Bauert of the Zoo Zurich said to me some time around the beginning of May during a journey that we undertook together through this impressive island. I felt very honored by this request – as well as professionally prepared for the task. I am no stranger to terms such as subtropical high, southeast trade wind, intratropical convergence zone or northwest monsoon. I am fully aware of the cycle of wet season/dry season in the island of Madagascar. I am familiar with the mechanism for the formation of tropical hurricanes (cyclones as they are called here), in which areas they prefer to strike and when. During the trip I gave lectures on the Indian Ocean

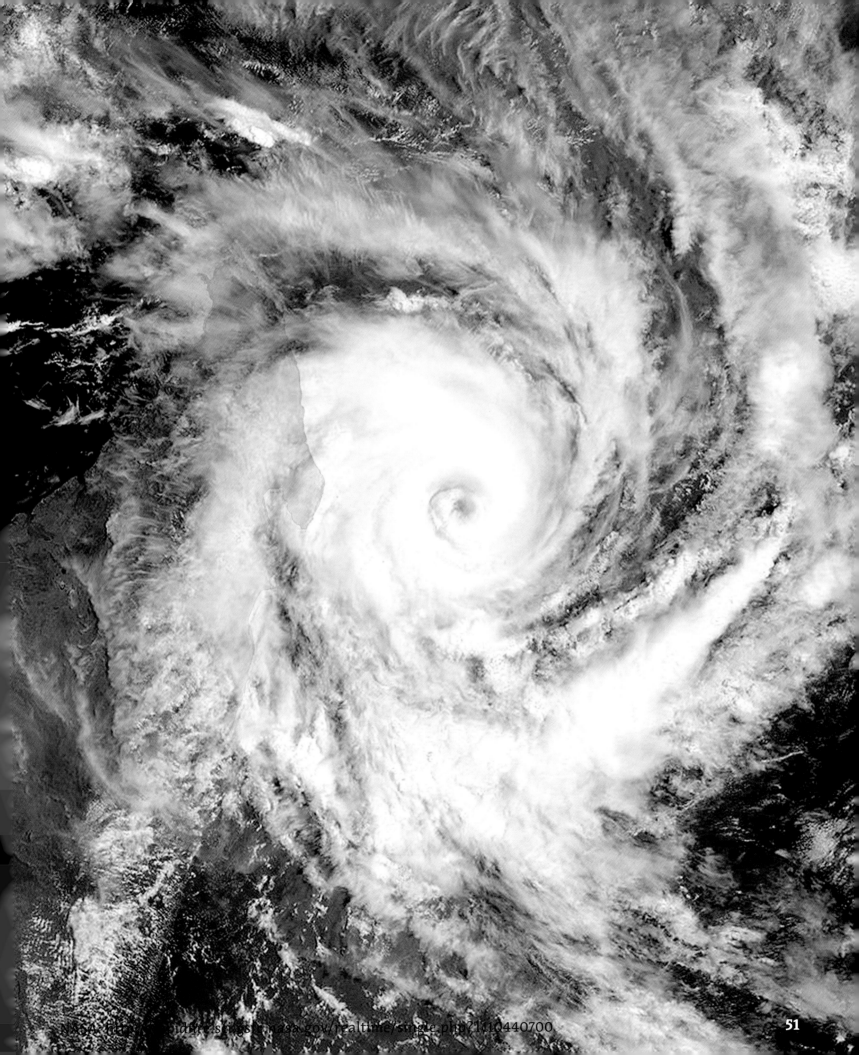

NASA http://rapidfire.sci.gsfc.nasa.gov/realtime/single.php?1110440700

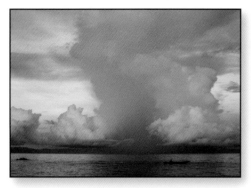

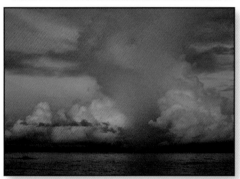

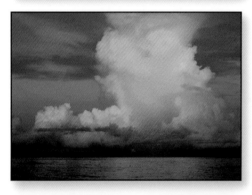

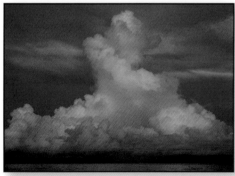

Dipole, a kind of appendage to the ENSO circulation, and I even ventured to hazard an explanation of the Madden-Julian oscillation – albeit purely theoretically and merely "in principle". I shall write about most of this, I thought – and I agreed to do so.

Pretty soon I had a good idea of to how to get started on my treatise, viz.: Over the course of the year, as seen from the perspective of the Earth, the Sun swings back and forth between the northern and the southern tropic. For several days around about September 24 it crosses the equator from the north and shines down from the sky there from an exactly vertical position overhead. Somewhere around the end of October Madagascar increasingly becomes a focal point for the sun – summer is approaching. Summer here means the most intensive solar radiation, maximum heat and an oppressive mugginess – everything is soaking wet: This is the rainy season. It reaches its peak between November and February in Madagascar's summer months when, with the sun high in the sky, the thermally induced depression zone – known as an 'intratropical convergence zone' [ITC] with its clouds, deluges, and storms, and soon also with the first cyclones – reaches the northern tip of the island.

This is how I imagined I would begin my text, exactly the way that meteorologists think: globally at first, then by hemisphere and in in seasonal orders of magnitude, and then gradually plunging into the regional peculiarities and specifics of the local climate. And so this is how we have ended up here at the Masoala Rainforest and Armin Dett's wondrous moths and butterflies.

Next, I would go into a detailed climatological examination of the habitat of these insects with their erratically fluttering flight. This would demonstrate how inhospitable and dangerous are the weather conditions for them to fly here: On the one hand the southeast trade wind is constantly thrusting air saturated with moisture toward the eastern side of the island where it is uplifted on the mountain slopes along the coast and then forced to fall as precipitation in the form of rain – which explains the rainforests located there. Yet on the other hand, in the summer months and the first months of fall (i.e., from November to about March), the ITC has the north of the island in its grip. With the northwest monsoon in tow, it sucks up the now even warmer air and pushes powerful storm clouds across the land, attended by intense rainfall. But that's not all: Here, in the tropics, the raindrops can be especially big and heavy. This is because at such high temperatures and with an equally high zero-degree line they have a long way to fall. The raindrops of different sizes falling at different speeds bump into each other repeatedly, merging as they collide, and they may therefore constantly grow in mass (a process called 'collision coalescence'). These water bombs must be extremely unpleasant, I tell myself, even life-threatening for sensitive insects with their large wings.

I would have saved the cyclones for the definitive conclusion to my observations. Madagascar is not only situated in the tropics but furthermore (unfortunately) is also located at quite a distance from the equator. This is important because it means that tropical cyclones can strike here with full force. Because in actual fact there are no cyclones right at the very equator. Here, the sea does indeed reach the required minimum temperature of 25 degrees and thus produces enough vapor to trigger tropical storms. But at a geographical latitude of zero degrees the Coriolis force – namely the deviation force produced by the earth's rotation and exerted on large-scale movements of air – is also zero: no deviation and thus no rota-

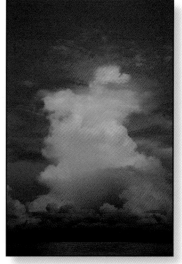

Differing development stages of a thunderstorm over Angontil Bay
In the tropics, cumulus clouds become more powerful than in other parts of the world. The vertical expansion of each thundercloud ends at the uppermost limit of the weather-creating layer at what is known as the tropopause. In middle latitudes this is at a height of about 10 kilometers, whereas in the tropics it reaches a height of up to 18 kilometers.

tion. Even at a latitude of, say, 5 to 8 degrees south and north the deflective force is still too weak for rotating weather systems to form. Only beyond this zone does the deflection of the Coriolis force begin to gain strength and have the capability to set the tropical depressions and their embedded sets of thunderstorms into rotation over the warm tropical seas – to the left in the southern hemisphere, i.e., clockwise. Madagascar lies exactly within this zone in the Indian Ocean, where high sea temperatures and the Coriolis force combine with the ITC to spark these destructive cyclones from small areas of low-pressure. The result is that time and again this island is beset by hurricanes, torrential rains, floods, and mudslides. And because the seas in the tropics keep getting warmer, Madagascar must expect cyclones of increasing strength and duration. In fact, Cyclone Freddy in February and March 2023 was one of the most persistent and powerful tropical cyclones ever recorded.

Back in May, all of this was running through my mind when I was asked to write a text for this book: The climate here in Madagascar makes life extremely difficult for moths and butterflies. This is particularly true from October through April, which means between fall and spring – precisely the time when these winged insects are most likely to flutter happily around hoping to enjoy the long days of summer. That's what I want to write about!

First, though, as a non-biologist I wanted to gain more insight into the life of these winged insects. And what I discovered horrified me: When these creatures finally emerge from their protective pupae and unfold their large wings for the first time in their life, after just a few short days they will die a natural death! This fluttering life of theirs is extremely brief! But with such short timespans what counts is the local weather prevailing at that moment in time. Long drawn-out weather reports are simply out of place.

That's why I opted for a brief text: In Madagascar, even in the middle of the rainy season, there are seldom any weather conditions fit for moths and butterflies to take to the wing. Armin Dett's photographs are the proof of this.

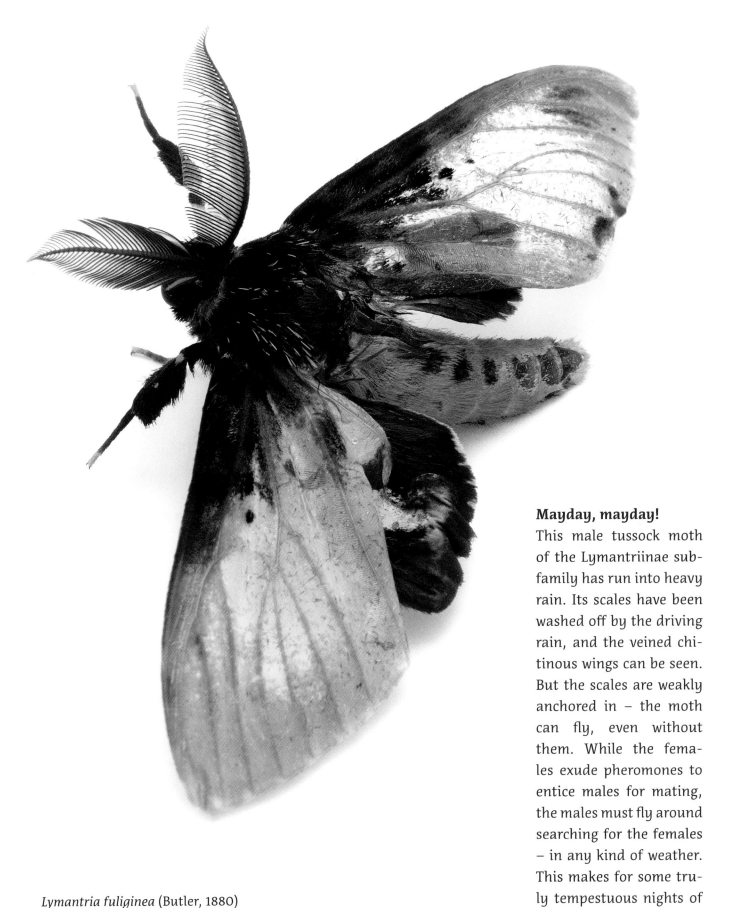

Lymantria fuliginea (Butler, 1880)
male

Mayday, mayday!
This male tussock moth of the Lymantriinae sub-family has run into heavy rain. Its scales have been washed off by the driving rain, and the veined chitinous wings can be seen. But the scales are weakly anchored in – the moth can fly, even without them. While the females exude pheromones to entice males for mating, the males must fly around searching for the females – in any kind of weather. This makes for some truly tempestuous nights of love!

Encounters

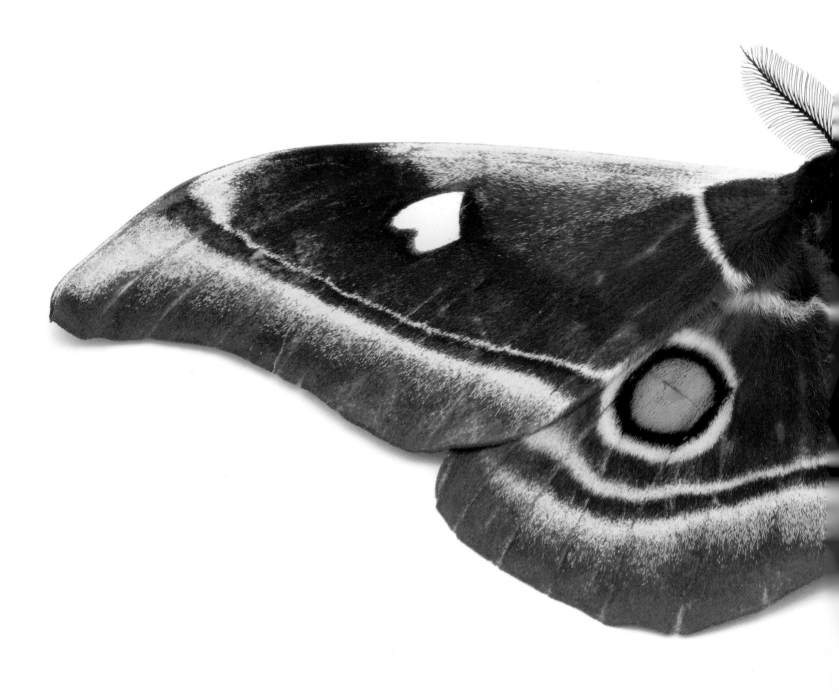

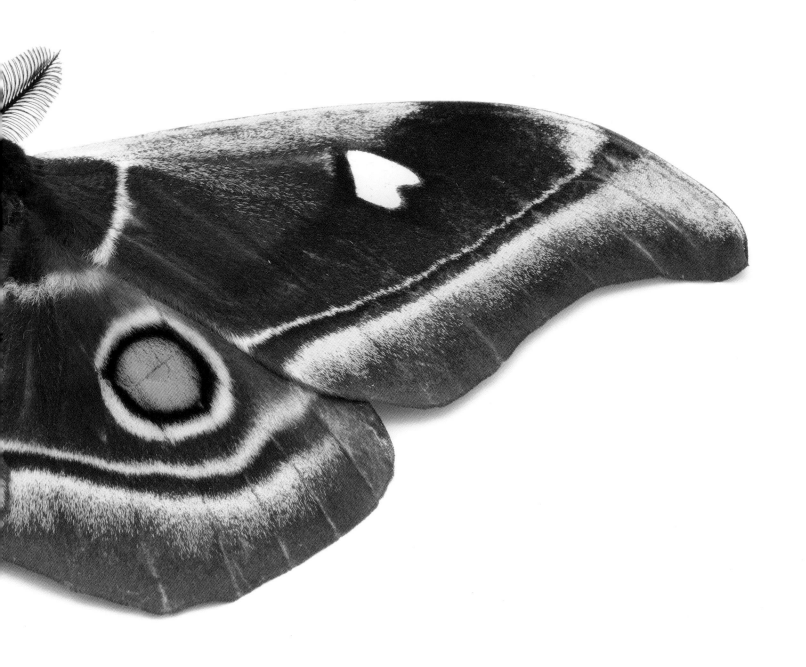

Bunaea aslauga Kirby, 1877

Micromoths and Macroheterocera

Text by David Lees

In Madagascar, at the most recent count in 2021, there were 1,418 genera and 5,016 species of Lepidoptera. Of these, 681 genera and 2,989 species are classified as Macroheterocera (these are a natural group, loosely known sometimes as Macrolepidoptera, although those may include some micromoths like cossids too); the remaining 744 genera and 2,051 species are a really heterogeneous group that comprises both micromoths and butterflies.

Micromoths comprise 22 heterogeneous superfamilies, butterflies (Papilionoidea) are added.

Macroheterocera are divided into just five superfamilies, whereas the others in Madagascar, most of which are micromoths, comprise approximately 22 superfamilies and 70 families, only one superfamily of which (Papilionoidea) represents butterflies, of which there are six families in the fauna. So micromoths are very much more diverse, and include undoubtedly also the highest percentage of undescribed species. There are no good characters to separate macromoths from the other Lepidoptera. However, in the DNA barcode of Macroheterocera, the 177th complete codon is almost invariably Phenylalanine (F) rather than another amino acid state (typically Leucine; L).

Stathmopoda cf. *vadoniella*

This book concerns itself principally with the macromoths of the Madagascan rainforest. On the left is a micromoth, a Stathmopodidae *(Stathmopoda* cf. *vadoniella)* species in its typical defensive posture, with one of the hindlegs sticking up like the warning sign of a stinging insect. On the right is a typical macromoth, an Erebidae in the subfamily Arctiinae, *Madagascarctia madagascariensis* (Butler, 1882). Sometimes such tiger moths pretend to play dead, on their back.

The Macroheterocera are divided into five super-families:
– Drepanoidea
 (hook tips)
– Noctuoidea
 (owlet moths)
– Geometroidea
 (inchworms)
– Lasiocampoidea
 (lappet moths)
– Bombycoidea
 (bombycoid moths)

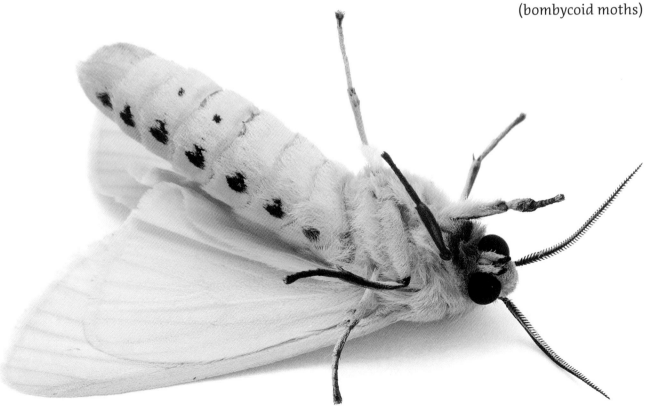

Madagascarctia madagascariensis (Butler, 1882)

What is the difference between a butterfly and a moth?

Text by David Lees and Armin Dett

While there are around 18,500 species of butterflies worldwide, there are around 143,000 described species of moths. Thus around 11.5 % of all Lepidoptera worldwide are butterflies, although this is an upper estimate as more moths must be undescribed. Butterflies are underrepresented in Madagascar: only about 6.5 % of all Lepidoptera in Madagascar are butterflies. But how can butterflies be distinguished from moths? The following typical butterfly characteristics, which can also be observed in nature with the naked eye, serve to simplify allocation in the field.

Sensory apparatus

Butterflies have antennae that are knob-like or at least slightly thickened at the end. Indeed the Latin term Rhopalocera means club horns. In Madagascar, the antennae of moths do not exhibit such thickening, except in rare cases. The most spectacular exception is the male of *Pemphigostola synemonistis* Strand, 1909 (Noctuidae, Agaristinae), narrowly endemic to southwestern Madagascar.

Wing coupling

The forewing of butterflies overlaps with an expanded 'humeral' area at the base of the hindwing but they are not physically coupled to each other. This allows butterflies to fly more erratically and to be highly manoeuvrable aganst pursuit by predators. By contrast, in the majority of moths (but not some primitive ones, outside the main grouping called Ditrysia) the forewings and hindwings of a single wing pair in moths are coupled to form a functional unit. A strong bristle (frenulum) on the upper edge of the hindwing engages with a hook-like, curved band below the upper edge of the front wing (retinaculum). This flexible coupling is formed differently in males and females of most moth families. The wings can quite easily be unlinked, but can be reconnected.

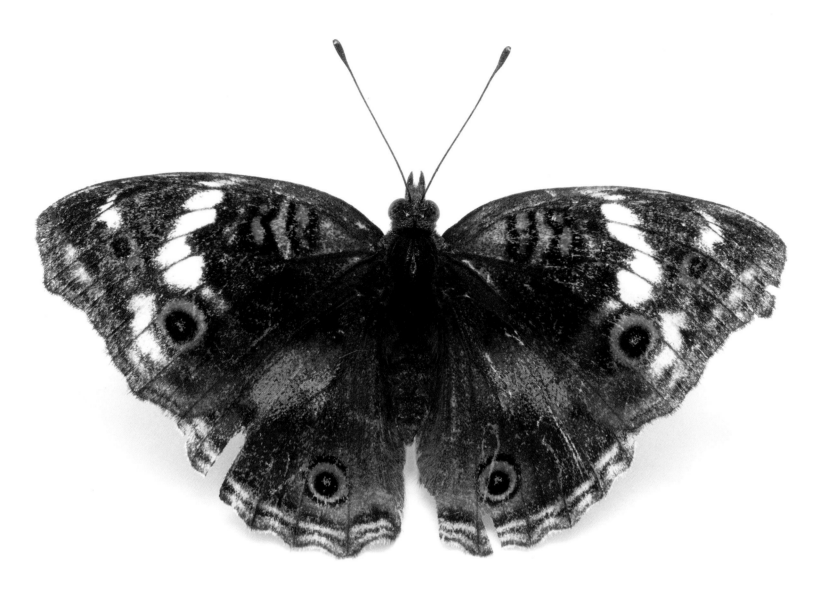

Junonia oenone epiclelia (Boisduval, 1833)

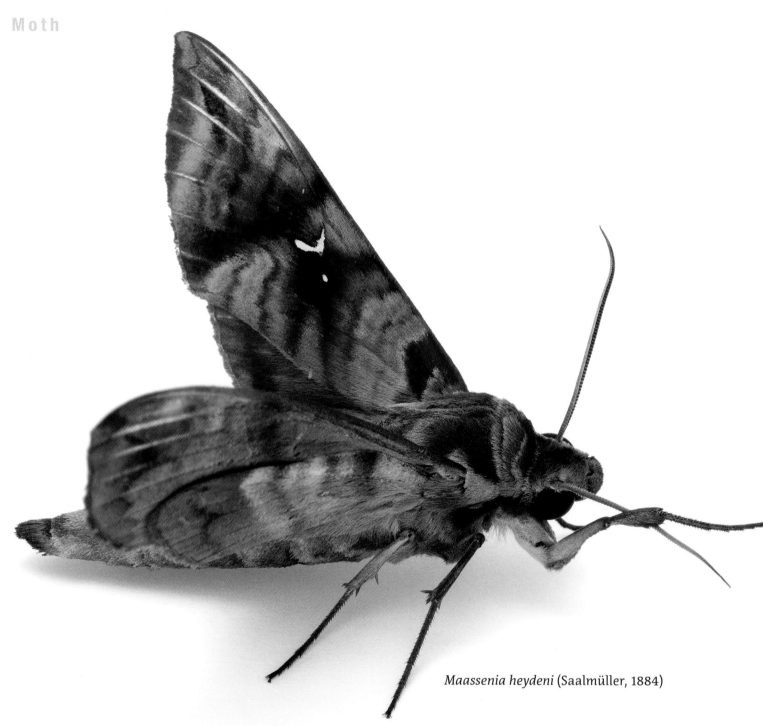

Maassenia heydeni (Saalmüller, 1884)

Antennae – cleaning important sense organs

The antennae of moths are important sensory organs and are covered in tiny sensillae and minute pores used to detect chemicals such as trace quantities of female pheromones in the air. To keep them in top condition many species use a cleaning hook and brush (the epiphysis) on the foreleg tibia, which is the perfect shape for the antenna to slip through.

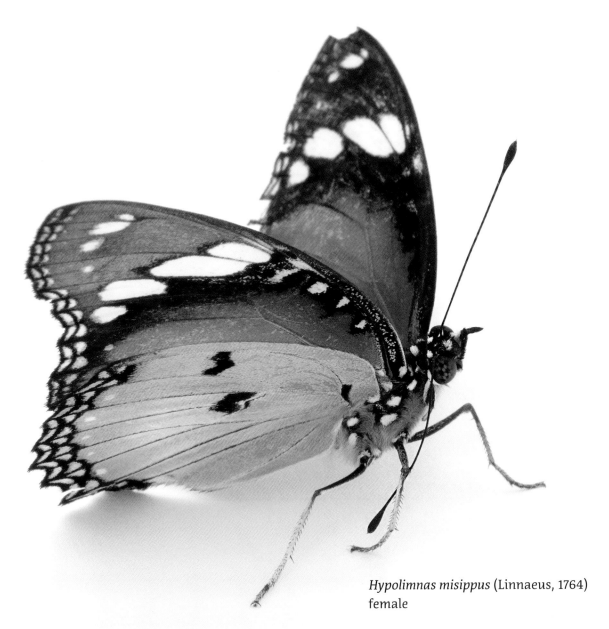

Hypolimnas misippus (Linnaeus, 1764)
female

Cleaning the antennae
This mimic butterfly is using her right midleg
to clean the antenna. Like other nymphalids,
the foreleg is reduced. Some nymphalids can
also clean the compound eyes using a side-
ways movement of the labial palps.

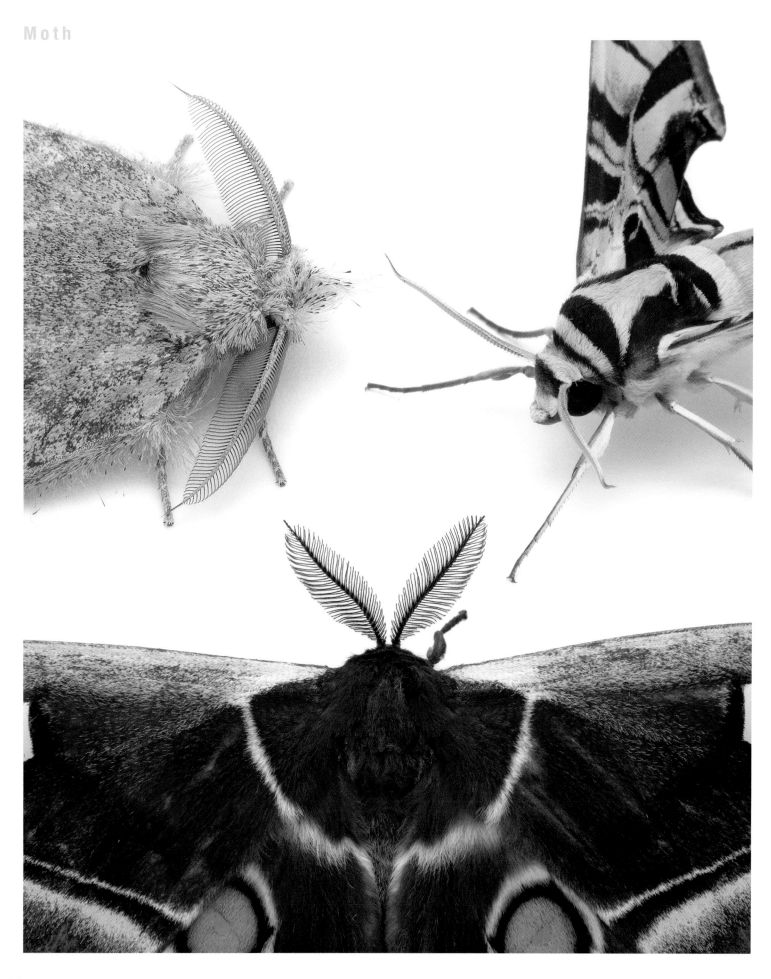

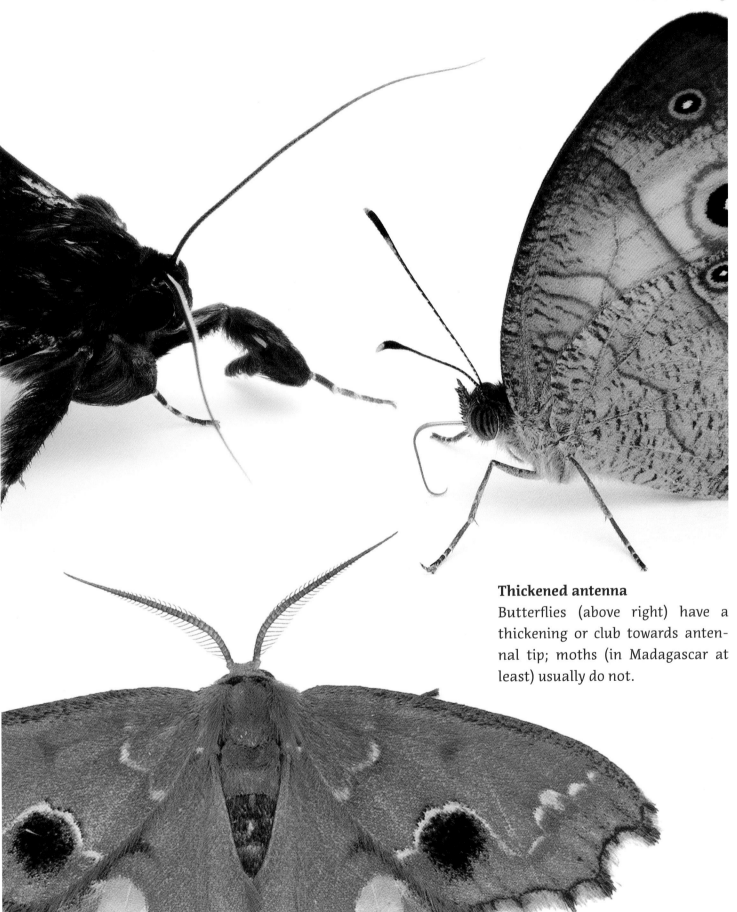

Thickened antenna

Butterflies (above right) have a thickening or club towards antennal tip; moths (in Madagascar at least) usually do not.

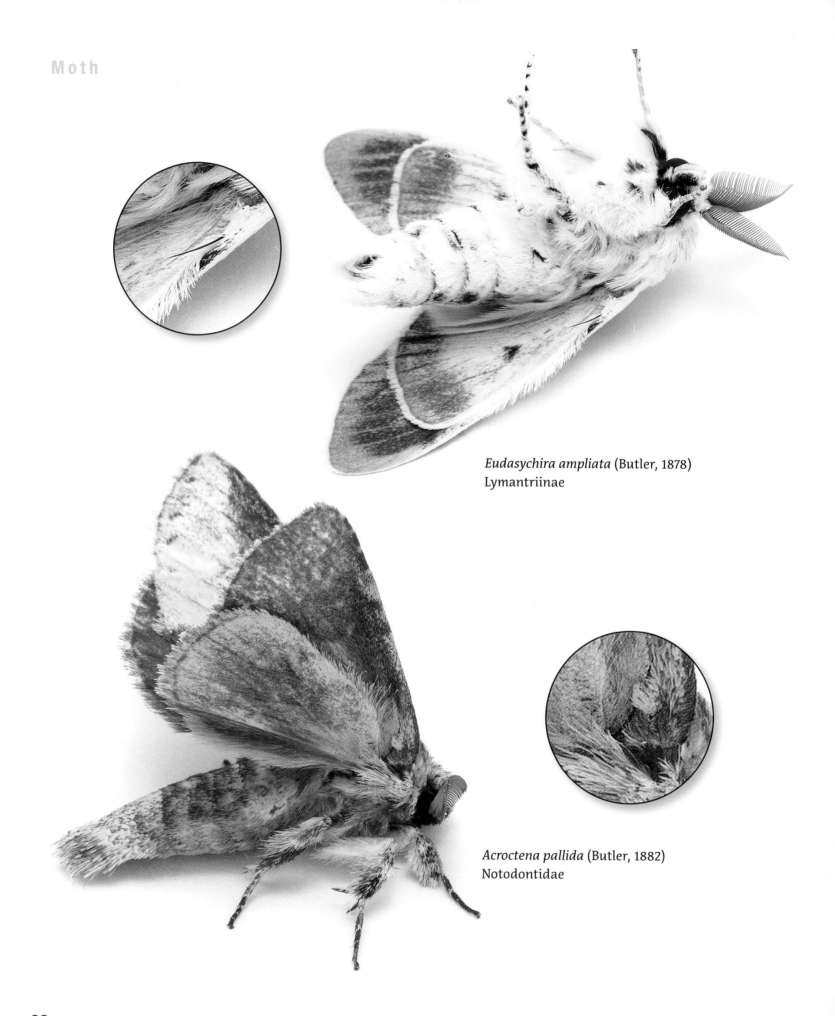

Eudasychira ampliata (Butler, 1878)
Lymantriinae

Acroctena pallida (Butler, 1882)
Notodontidae

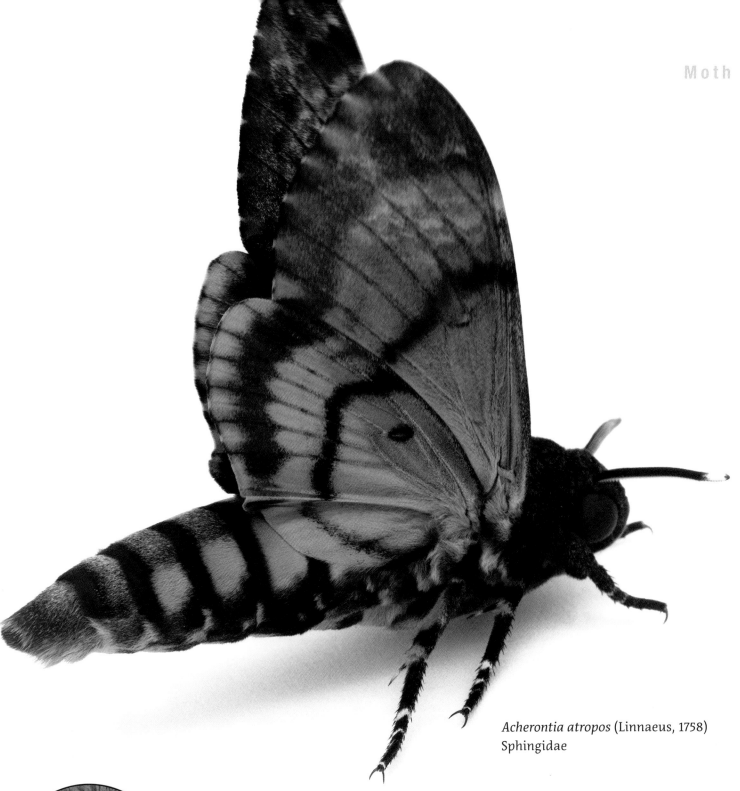

Acherontia atropos (Linnaeus, 1758)
Sphingidae

Wing coupling between forewing and hindwing

Examples of paired wings are shown from different Lepidoptera families. Unlike butterflies, which have no such linking system, the strong, curved and pointed bristle or frenulum at the base of the leading edge of the hindwing upperside of a vast variety of moths is hooked into a flexible band or retinaculum on the forewing underside, which can be clearly seen in these moth examples from Sphingidae, Erebidae: Lymantriinae and Notodontidae. This purely mechanical connection can come loose and even be rethreaded by the moth. In many cases the number of bristles can be greater in females.

Activity

Butterflies are for the vast majority only active during the day – while there are also species of moths in several families that are active during the day. Butterflies are not usually attracted to artificial light, which is due to the way their eyes are adapted. Lepidoptera eyes generally consist of many individual lenses (ommatidia), which together form a compound eye. In butterflies, the individual eyes are completely surrounded by pigment cells (the apposition eye type). Light only reaches the light entering through the lens, while the surrounding pigment cells absorb a large proportion of the light. In moths, the pigment cells around the individual eyes can be reduced (superposition eye). Incident light then also hits the neighboring individual lenses or ommatidia – the moth can then see less clearly, but perceive more light.

Proboscis

Butterflies always have a functional proboscis and use it to suck up liquids as food. Among the moths, however, there are families (see e.g. Bombycoidea) that do not feed as adults and have the proboscis reduced or absent.

Resting posture

Butterflies typically hold their wings upright and closed over the body when at repose or sleeping. Moths usually rest with their wings folded over the body like a tent, but some, like many geometrids, rest with the wings very flat to the surface.

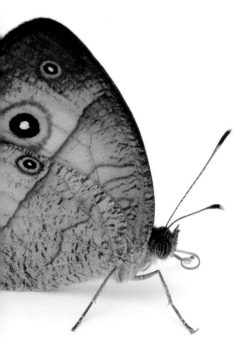

Heteropsis fraterna (Butler, 1878)

Auditory organs

Butterflies lack typical tympanic structures, or ears. However, they are very sensitive to vibrations and also some, like Satyrinae, have balloon-like veins at the forewing base that may allow them to enhance sounds. Some moths have hearing organs, particularly

among the Pyraloidea and the Macroheterocera, which are developed differently depending on the family and are located on different parts of the body (In Uraniidae on different abdominal segments!). This allows, for example, bird beak clicks or the sonar of nocturnal bats to be perceived. However, this is already a specialization that arose more than once against predators, because research has shown that moths were able to hear around 30 million years before the first bats appeared. Some moths also produce sounds, but clicking is unusual in butterflies.

Developmental stages

All Lepidoptera are holometabolous, that is to say, they have four developmental stages, eggs, larvae (usually with five growth stages or instars, sometimes more), pupae and adults. The early stages of Malagasy Lepidoptera are only known for a small proportion of species. Eggs and caterpillars are very varied in morphology, and without a guide rearing is usually necessary to identify them (some butterfly families though can be readily identified by particular structures, such as a pungent organ called an osmeterium extruded on disturbance and unique in swallowtail butterflies). Butterfly pupae are most often free, but Papilionidae and Pieridae have a silken girdle like a few Geometridae (Sterrhinae), and in Madagascar they are always without a cocoon and never under a silken web. Moth pupae are often hidden in cocoons, silked together in leaves or buried naked in the ground.

It should be noted that all Lepidoptera that are not butterflies are called moths. Only butterflies, in an evolutionary sense, are a natural group. In view of the huge diversity of species among the Lepidoptera, however, there are almost always exceptions and specializations and so not all characteristics can be truly diagnostic. Diurnal activity and coloring of the moths are not suitable as systematic distinguishing features, for example. Butterflies are often considered more "colorful" than "moths": but this is mainly due to the cryptic, hidden way of life of moths. This book sheds light on the secret life and comportment of adult moths, in particular.

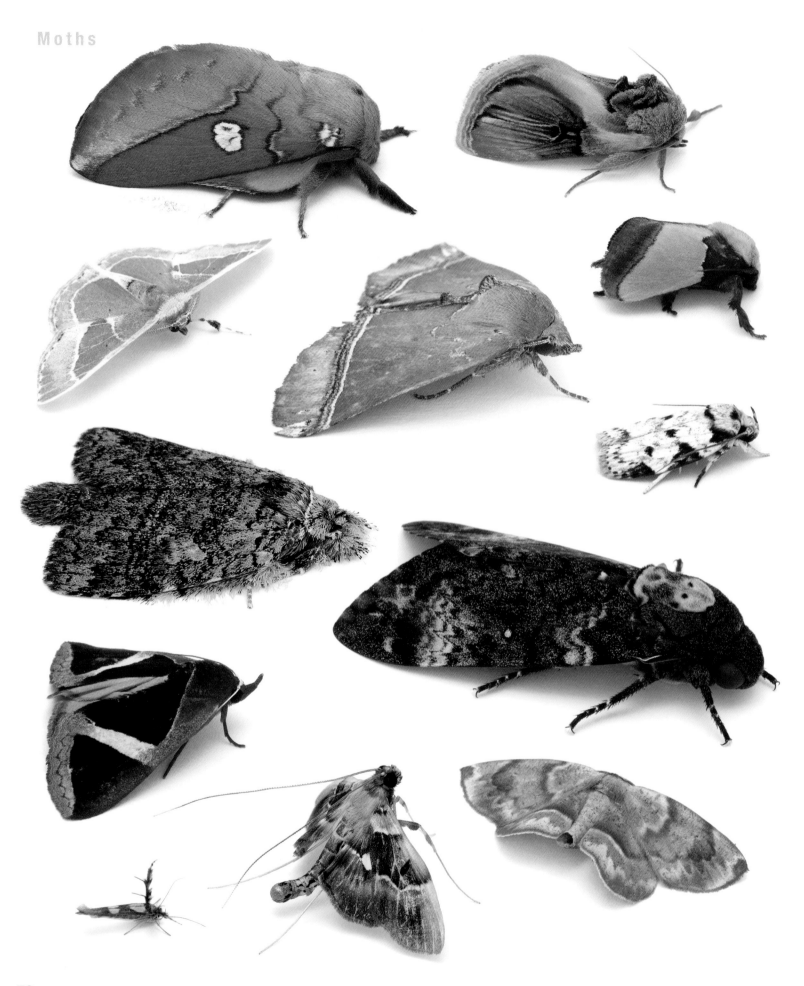

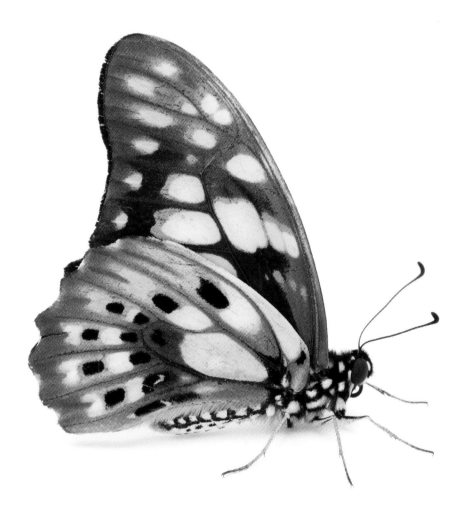

Resting posture
Butterflies usually hold their wings closed over their back when at rest (moths rarely do; an exception is *Chrysiridia* at night as well as a few geometrids). When feeding, some skipper butterflies hold their wings flat.

Papilionoidea (Butterflies)

Text by David Lees

The superfamily Papilionoidea includes seven families within the Lepidoptera, six of which occur in Madagascar (Hedylidae is absent). The shape, formation and position of certain hard parts (sclerites) of the chitinous exoskeleton of moths as well as butterflies and the branching of their wing veins are anatomical features that serve, among other things, for taxonomic family classification.

Papilionoidea include seven families:

– Hesperiidae (skippers)
– Lycaenidae (Blues, coppers, hairstreaks)
– Nymphalidae (brush-footed butterflies)
– Papilionidae (swallowtails)
– Pieridae (whites and allies)
– Riodinidae (metalmarks)
– Hedylidae (New world butterfly moths)

In Masoala and Makira well over 200 butterfly species are known. They vary from the the rather small blue butterfy *Cacyreus darius* (Mabille, 1877) and the skipper *Fulda rhadama* (Boisduval, 1833) to quite large and strikingly colorful species such as the papilionid *Graphium cyrnus* (Boisduval, 1836).

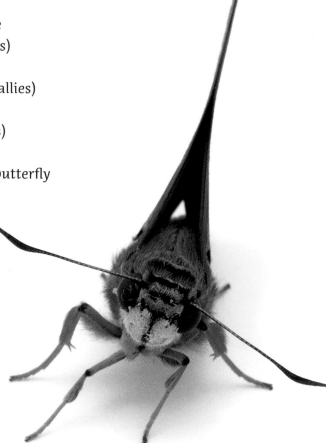

Malaza fastuosus (Mabille, 1884)

Skippers

For a long time Hesperiidae or Skippers were distinguished from so-called 'true butterflies'. In fact, Hesperiidae are an important and integral family of butterflies worldwide, with over 4,100 species, and in Madagascar, where about 57 species are known, some seven of the nineteen genera are endemic, including the genus *Malaza* (Malazinae, also endemic). There are also endemic radiations of forest skippers in the subfamilies Hesperiinae and Heteropterinae *(Hovala)*.

The antennae of skippers frequently feature a crochet after the club. Adults rest with the wings over the back or sometimes hold them flat when nectaring. The larvae of most species feed on grasses / bamboos.

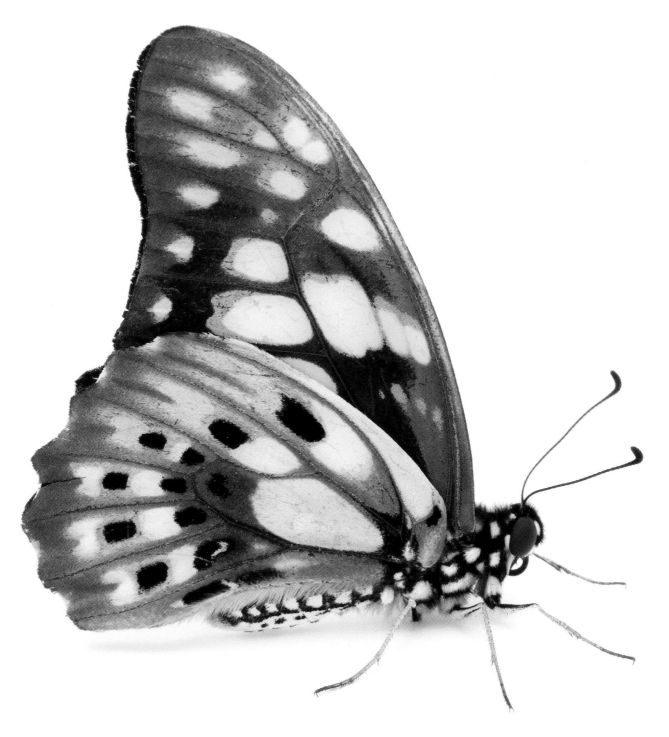

Graphium cyrnus (Bosiduval, 1836)

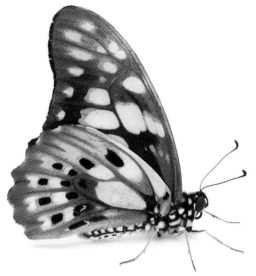

Graphium cyrnus (Bosiduval, 1836)

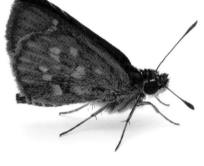

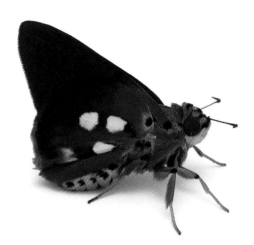

Fulda rhadama (Boisduval, 1833)

Malaza fastuosus (Mabille, 1884)

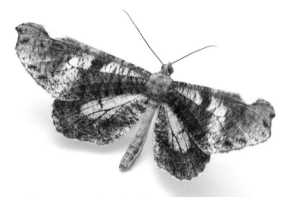

Macrosoma hyacinthina (Warren, 1905)

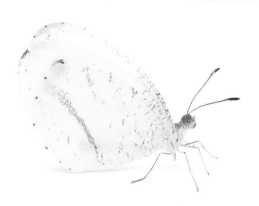

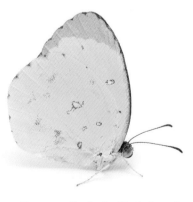

Leptosia alcesta sylvicola (Boisduval, 1833)

Eurema floricola (Boisduval, 1833)

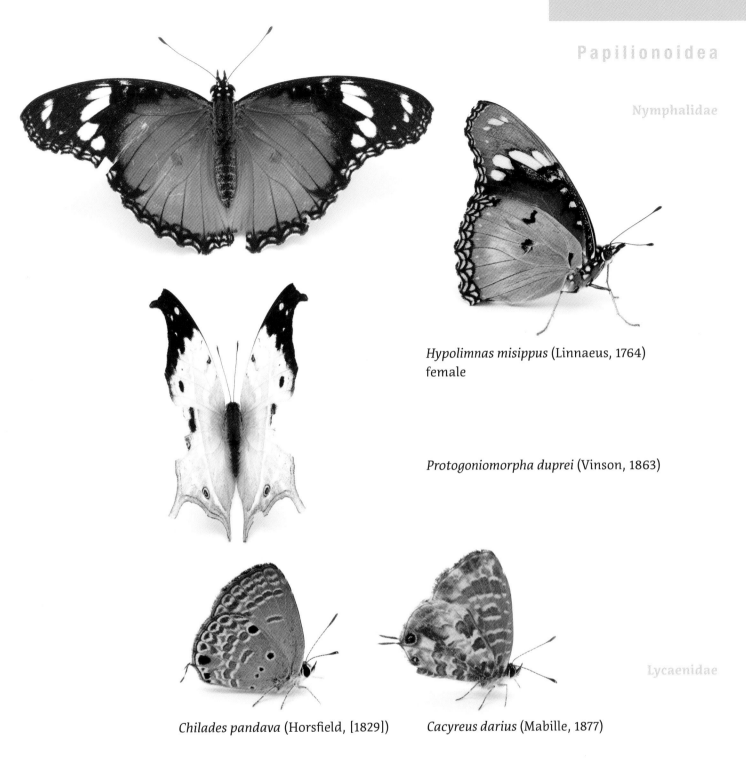

Hypolimnas misippus (Linnaeus, 1764)
female

Protogoniomorpha duprei (Vinson, 1863)

Chilades pandava (Horsfield, [1829])　　*Cacyreus darius* (Mabille, 1877)

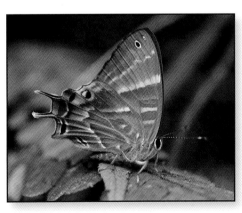

Saribia perroti Riley, 1932
Photo: David Lees

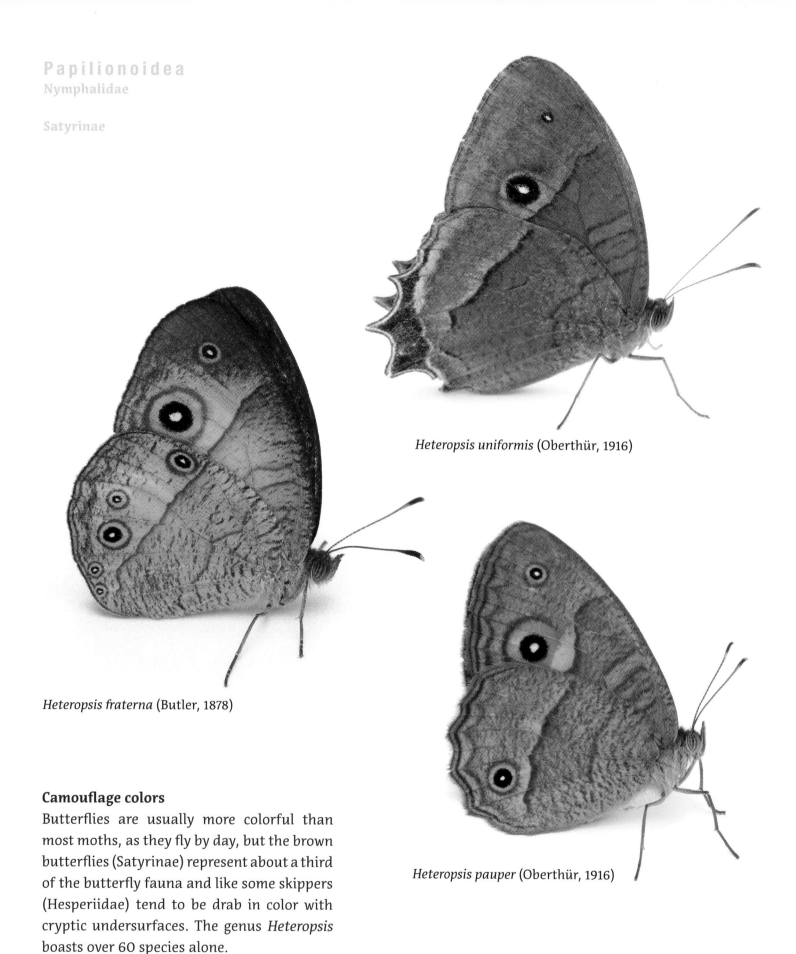

Heteropsis uniformis (Oberthür, 1916)

Heteropsis fraterna (Butler, 1878)

Heteropsis pauper (Oberthür, 1916)

Camouflage colors

Butterflies are usually more colorful than most moths, as they fly by day, but the brown butterflies (Satyrinae) represent about a third of the butterfly fauna and like some skippers (Hesperiidae) tend to be drab in color with cryptic undersurfaces. The genus *Heteropsis* boasts over 60 species alone.

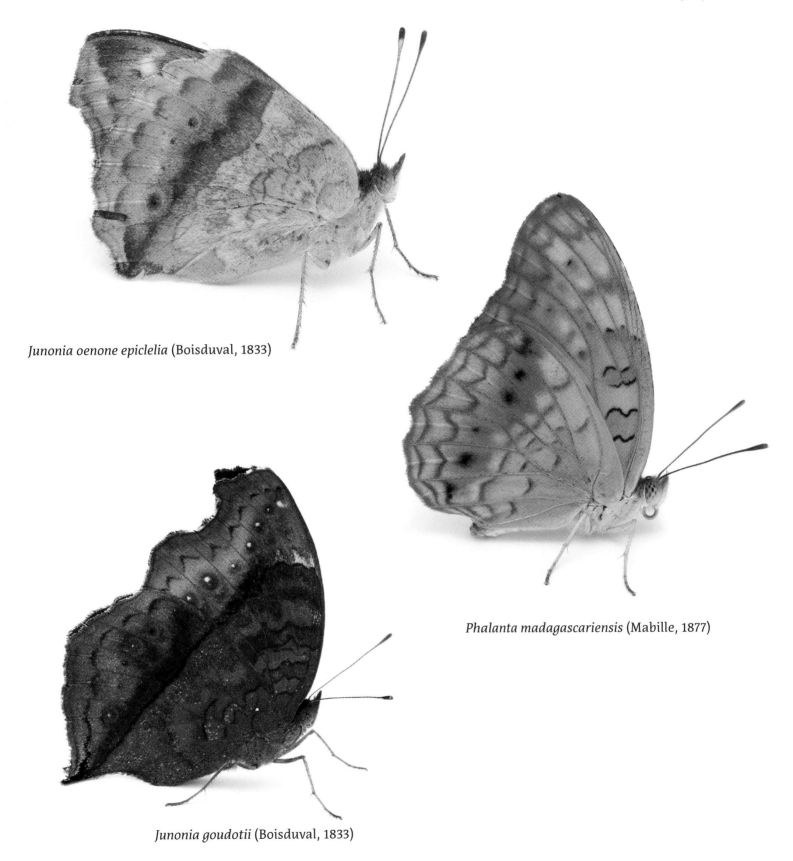

Junonia oenone epiclelia (Boisduval, 1833)

Phalanta madagascariensis (Mabille, 1877)

Junonia goudotii (Boisduval, 1833)

77

Missing for five Decades - rediscovered in 2019 *(Malaza fastuosus)*

Text by David Lees

One of the most exquisite and yet seldom seen skippers (Hesperiidae) in Madagascar is the so-called Lavish Malaza, *Malaza fastuosus*. Apparently the last known specimen was collected in 1971 in Ankarafantsika National Park. To find the pupa and then to observe an adult emerging of this species in Masoala, after a half century without observations, is perhaps the breathtaking experience for a butterfly photographer. What is more, the butterfly belongs to a subfamily that was only recently recognized as novel for the World, and also endemic to Madagascar. Few Malagasy Lepidoptera families or subfamilies have this special honor, two others being Whalleyanidae and Griveaudiinae.

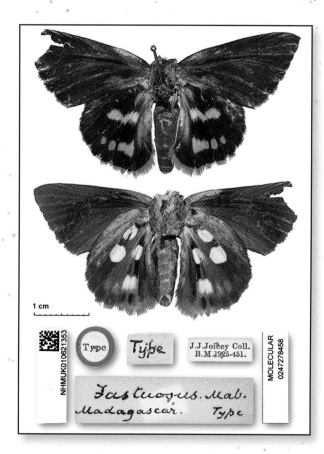

Picture: Courtesy Trustees of the Natural History Museum, London
Photo: Nick Grishin

A team led by Jian Zhang and Nick Grishin at the University of Texas Southwestern Medical Center and David Lees at the Natural History Museum in London, published a study in Genome in 2020 where they were successful to sequence the mitochondrial genome of the holotype specimen of this species from a single foreleg. Because the holotype is the specimen on which its nomenclature is based, it is very precious (even though this specimen lacked a head!), so the partially digested leg was returned to the specimen after minute quantities of the DNA were extracted. This type specimen, although its exact collection details were not recorded on its label, was collected well before 1884 when it was described by Paul Mabille, in fact before 1878 when it had been thought to be the female of a smaller species, *Malaza empyreus*. The DNA of this specimen was therefore very degraded, present in only tiny pieces, and so the fragments

were stitched together into a complete mitochondrial genome of 15,579 nucleotides using the power of modern technology (Next Generation Sequencing). Their analysis showed that the genus *Malaza*, which contains two other described species, did not belong to any known Hesperiidae subfamily. It appeared closest to Heteropterinae and the Australia subfamily Trapezetinae. Like some other Malagasy skippers, the species was originally described in the genus *Trapezites*. Its compound eyes exhibit a very fine layer of setae or hairs. Hairy compound eyes are rare in skippers, known from a couple of other genera. Zhang et al. (2020) provide many more details.

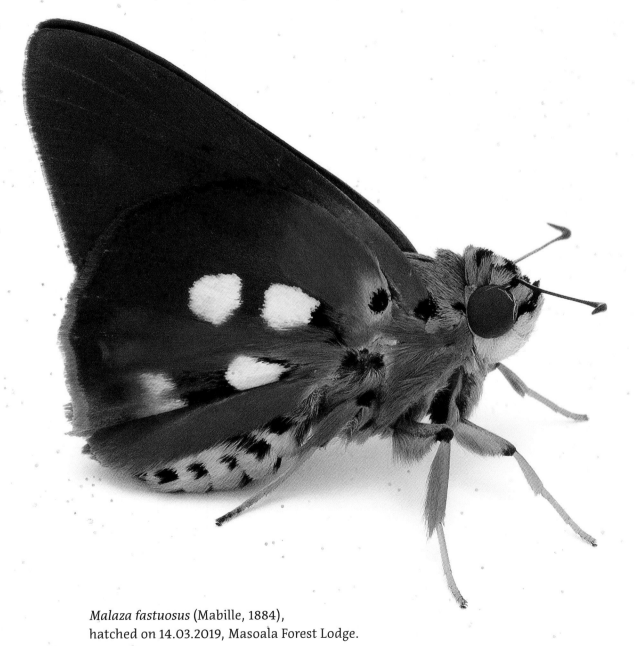

Malaza fastuosus (Mabille, 1884),
hatched on 14.03.2019, Masoala Forest Lodge.

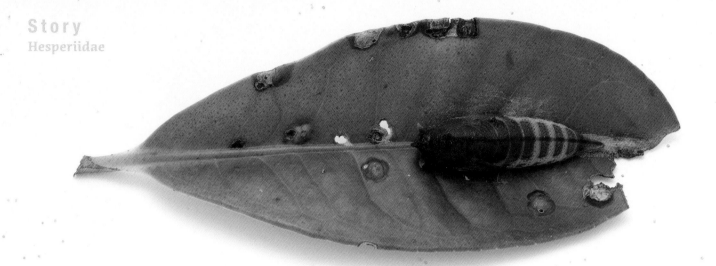

Unusual pupa

The pupa was found on a leaf of *Toddalia* sp. (Rutaceae), but it seems questionable that this was the larval foodplant. It is unusual among skipper butterflies in that the front of the pupa has three horns, two of them lateral. Before emergence, yellow bands from the abdomen show through strongly. It is not known if *Malaza* might contain toxins against predators, but this is often the case for brightly colored butterflies. The resting posture of the genus is unknown, but they fly by day and take nectar from flowers.

The hostplants of Malazinae have never been reported, but are thought to be monocotyledons, because of the phylogenetic position of the subfamily which in the study of Zhang et al. was close to the grass-feeding Heteropterinae (the genus *Hovala* occurs in and is endemic to Madagascar). Probably then Malazinae are an ancient lineage of skipper butterflies.

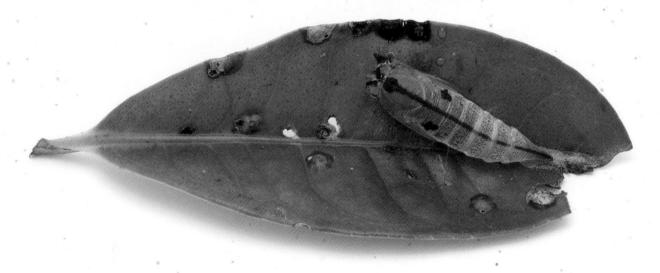

Malaza fastuosus (Mabille, 1884)

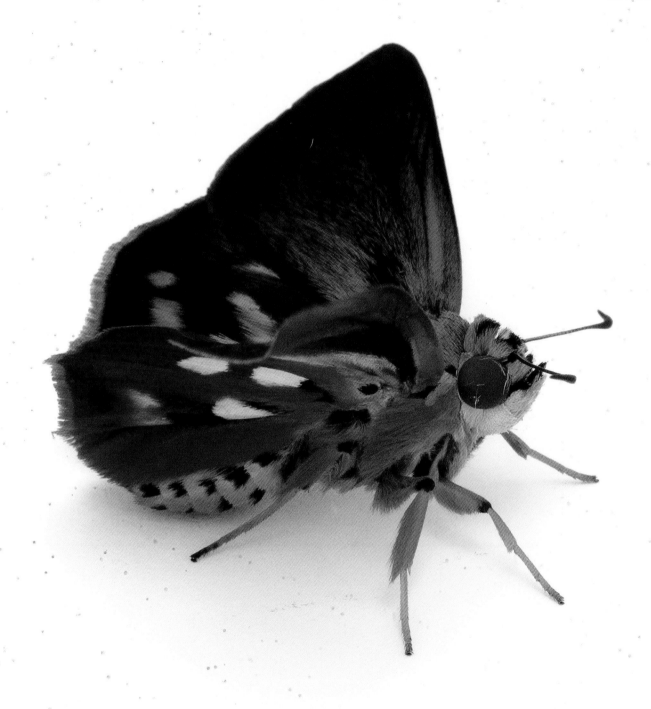

Malaza fastuosus (Mabille, 1884),
hatched on 14.03.2019, Masoala Forest Lodge

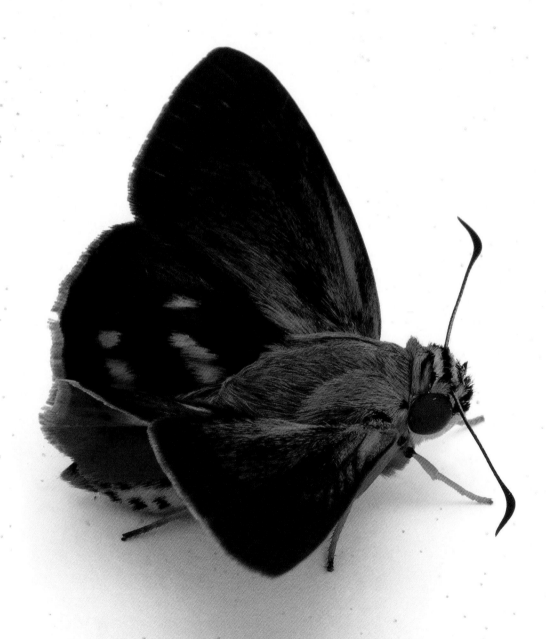

Malaza fastuosus (Mabille, 1884),
hatched on 14.03.2029, Masoala Forest Lodge

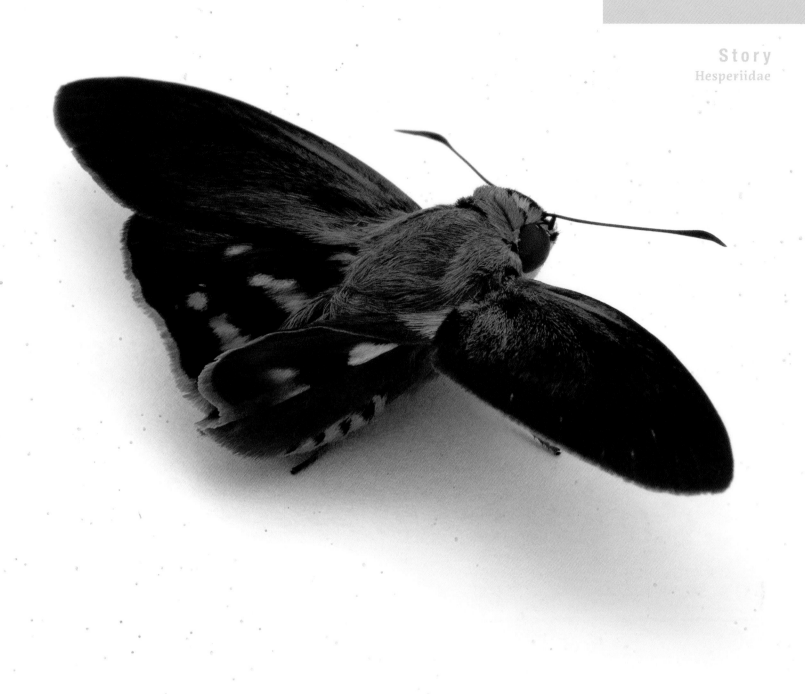

Malaza fastuosus (Mabille, 1884),
hatched on 14.03.2029, Masoala Forest Lodge

Dangerous Neozoa to endemic Cycads

Text by David Lees

The arrival of the Cycad Blue *Chilades pandava* in the Masoala peninsula not only adds a new lycaenid butterfly species to the fauna, which was previously documented to have 135 butterfly species by Claire Kremen and colleagues in 2001, but it also adds a potential threat.

Feeding pattern and caterpillars of *Chilades pandava* on the foliage of *Cycas thouarsii*
Photo: Martin Bauert, Masoala, Tampolo, 2019

That is because not only does the butterfly larva feed on the young fronds of the introduced Sago Palm (actually a cycad!), *Cycas revoluta*, popular for planting in hotel gardens, but it is also known, according to observations by Steve Collins, to feed on the Madagascar Cycad *Cycas thouarsii*. A population of this rather rare plant occurs on the western side of the Masoala Peninsula, and in 2001 D. Lees examined these plants and found no herbivores on them. However, the plant also is found in the Comoros, Seychelles and Eastern Africa.

Chilades pandava was first observed in Madagascar on Île Sainte-Marie in 2006 and has since been observed in several places along the eastern coast, where it can severely defoliate the young leaves of cycads. It has not, however, colonised the uplands. The study by Li-Wei Wu and his coauthors in 2010 showed that the Malagasy population probably originated in Southeast Asia, occurring to its mitochondrial haplotype. It is likely to have arrived via the ornamental plant trade, rather than of its own accord.

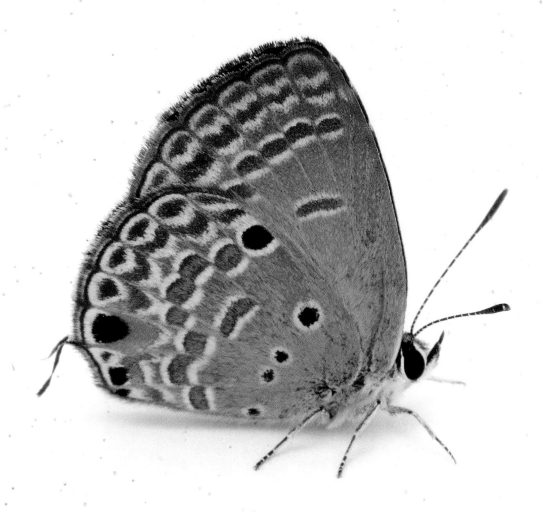

Chilades pandava (Horsfield, [1829]),
photo taken on 28.02.2019, Masoala Forest Lodge

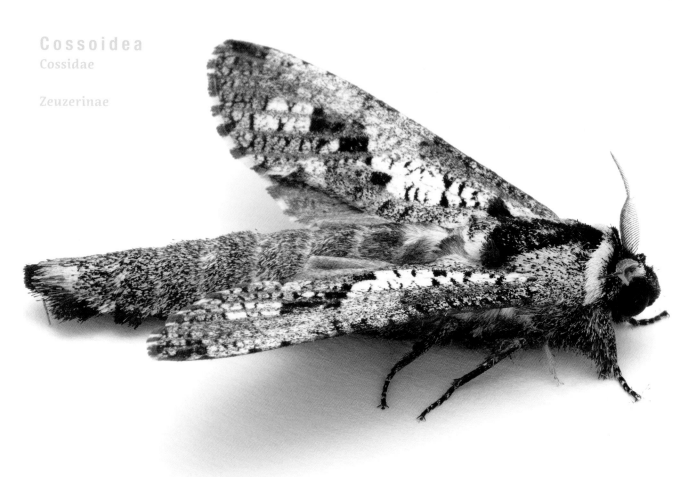

Zeuzeropecten sp. Gaede, 1930

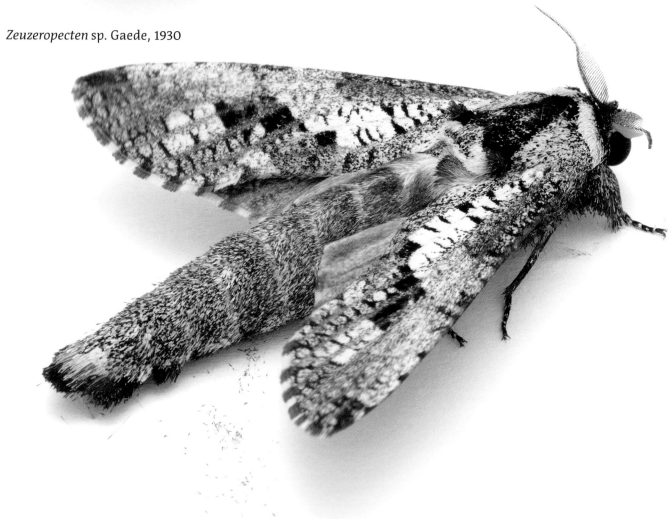

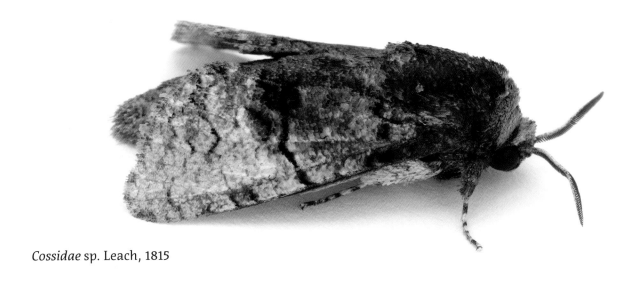

Cossidae sp. Leach, 1815

Cossidae sp. Leach, 1815

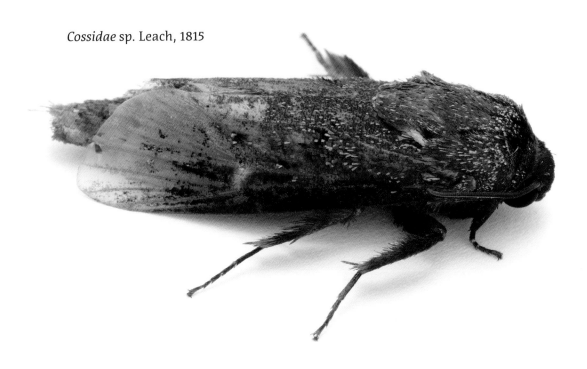

Zygaenoidea

Text by Marcin Wiorek

The superfamily Zygaenoidea with its around 3,300 species is a rather small group of moths, occurring worldwide, but mostly in the tropics. From Madagascar some 85 species are known. An interesting feature of this superfamily is that it comprises around 12 families, but most of them comprise only a couple to a few dozen species. Their representation in Madagascar also looks interesting. Only three species of Epipyropidae, nine Lacturidae, one Somabrachyidae, and five Zygaenidae have been described – the latter actually represented only by the subfamily Procridinae. The most species-rich family in Madagascar, as also worldwide, is Limacodidae with around 65 species, and some of them are displayed in this chapter.

An interesting thing about Zygaenoidea is that some species, like *Pseudolatoia oculata*, *Ximacodes pyrosoma* or *Parasa reginula* are somewhat aposematically colored (even more so the strangely, shaped caterpillars, in the case of Limacodidae, here, giving the popular name of Slug Moths), which means that they may contain toxic substances, as you can learn elsewhere in this book. And indeed, some Zygaenoidea are known to contain in their bodies cyanogenic glycosides, which are extremely poisonous as they transform into hydrogen cyanide in the predator's organism. However, the moths themselves have special enzymes that protect them from self-poisoning. The low numbers of Zygaenoidea species recorded from Madagascar do not necessarily derive solely from the evolutionary history of that group – for example the subfamily Zygaeninae has passed Madagascar by. Some of them, like procrinines, for which there are five known species, are elusive forest moths, so more species remain to be discovered.

An unrecognized feature of Madagascan Procridinae is that they include presumed mimics of other insects. Some of them resemble Lycidae beetles, known also as net-winged beetles, and the others perhaps imitate tiger moths from the tribe *Syntomini*, mentioned later. Actually, mutual similarities between certain Zygaenoidea and Arctiinae species are observed worldwide, but this phenomenon is still not fully studied.

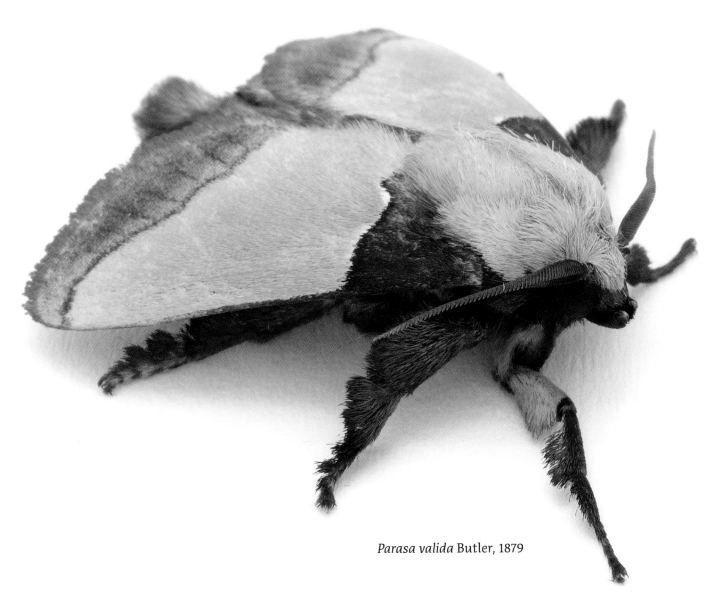

Parasa valida Butler, 1879

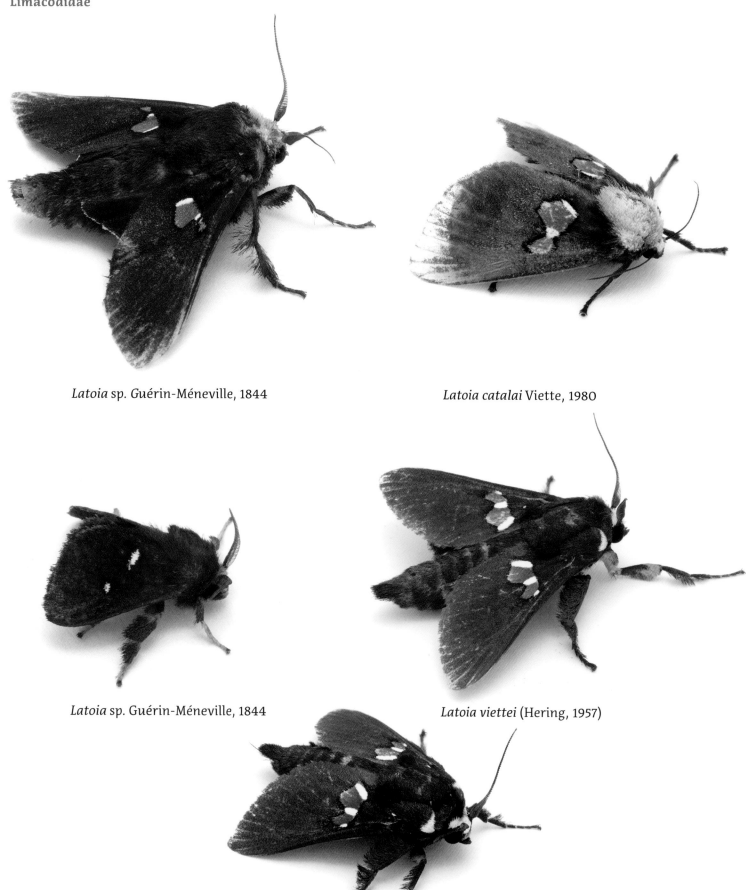

Latoia sp. Guérin-Méneville, 1844

Latoia catalai Viette, 1980

Latoia sp. Guérin-Méneville, 1844

Latoia viettei (Hering, 1957)

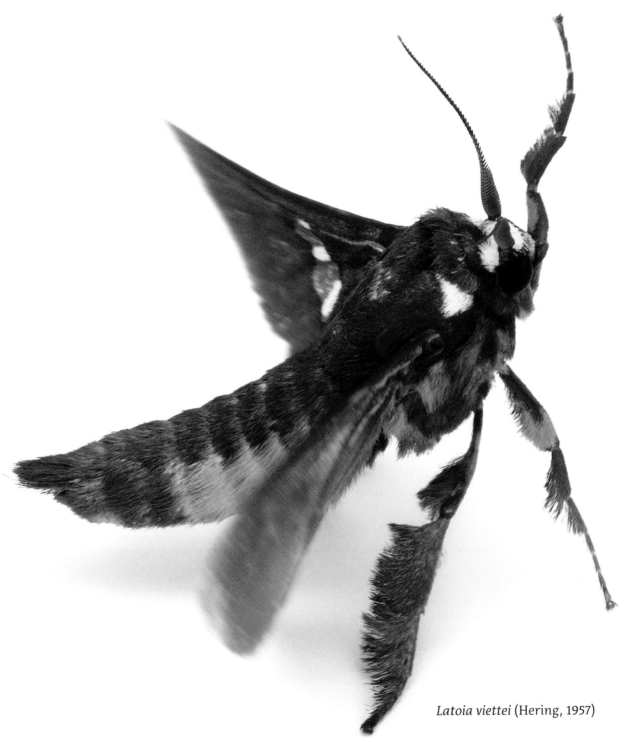

Latoia viettei (Hering, 1957)

Zygaenoidae
Limacodidae

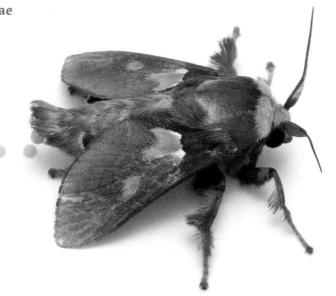

Parasa ankalirano Viette, 1980

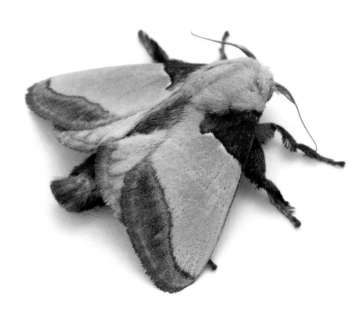

Parasa valida Butler, 1879

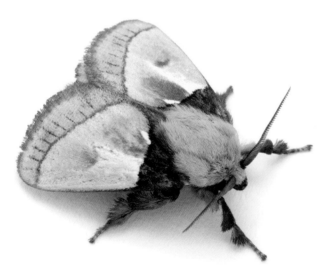

Parasa reginula Saalmüller, 1884

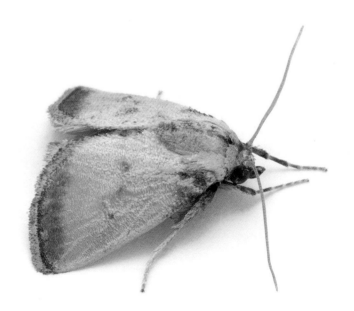

Ximacodes sp. Viette, 1980

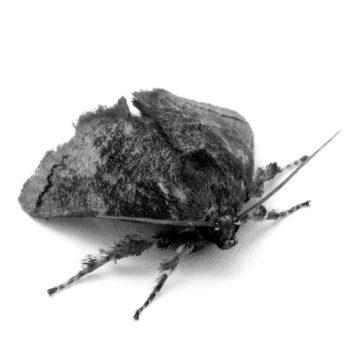

Thliptocnemis barbipes Mabille, 1900

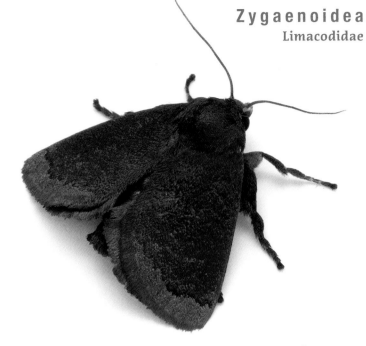

Thliptocnemis pinguis (Saalmüller, 1880)

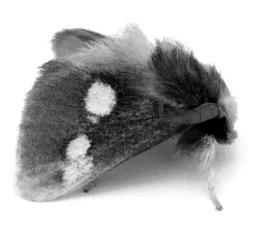

Pseudolatoia oculata Hering, 1957

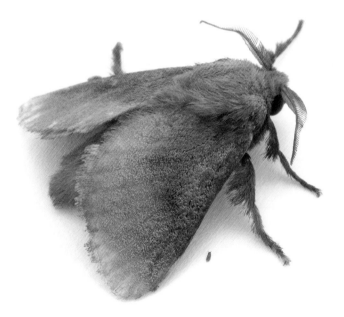

Ximacodes pyrosoma (Butler, 1882)

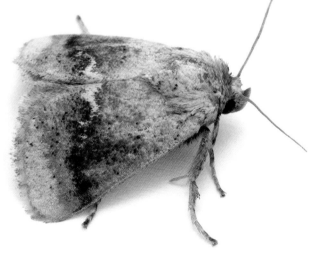

Ximacodes sp. Viette, 1980

Zygaenoidae
Limacodidae

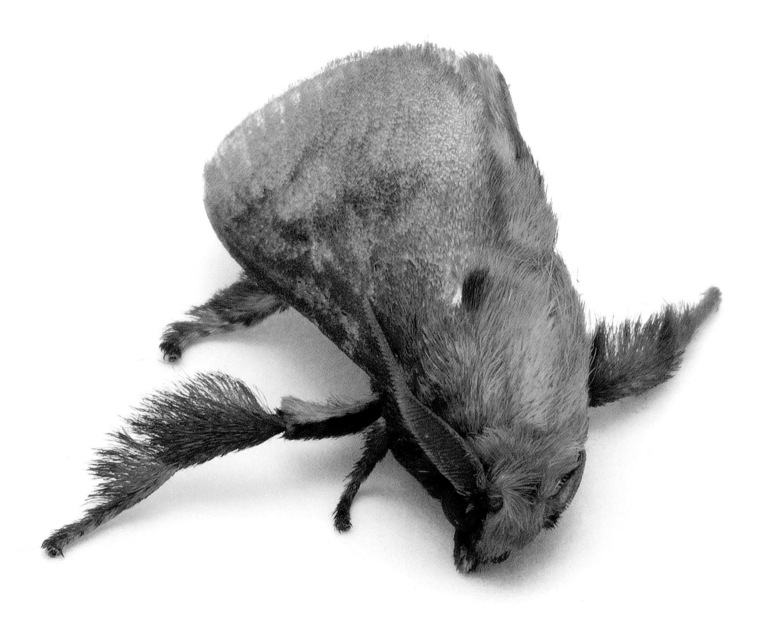

Ximacodes pyrosoma (Butler, 1882)

Scaly legs

The moths of species *Ximacodes pyrosoma* here, similarly as with those of *Parasa reginula* mentioned previously, are shown in their defensive poses. First, they spread wide their legs, densely covered with hairy scales, which make them resemble a spider. Additionally, they expose their vividly colored back. Perhaps this combination of this unusual shape and aposematic coloration is meant to discourage the potential predators.

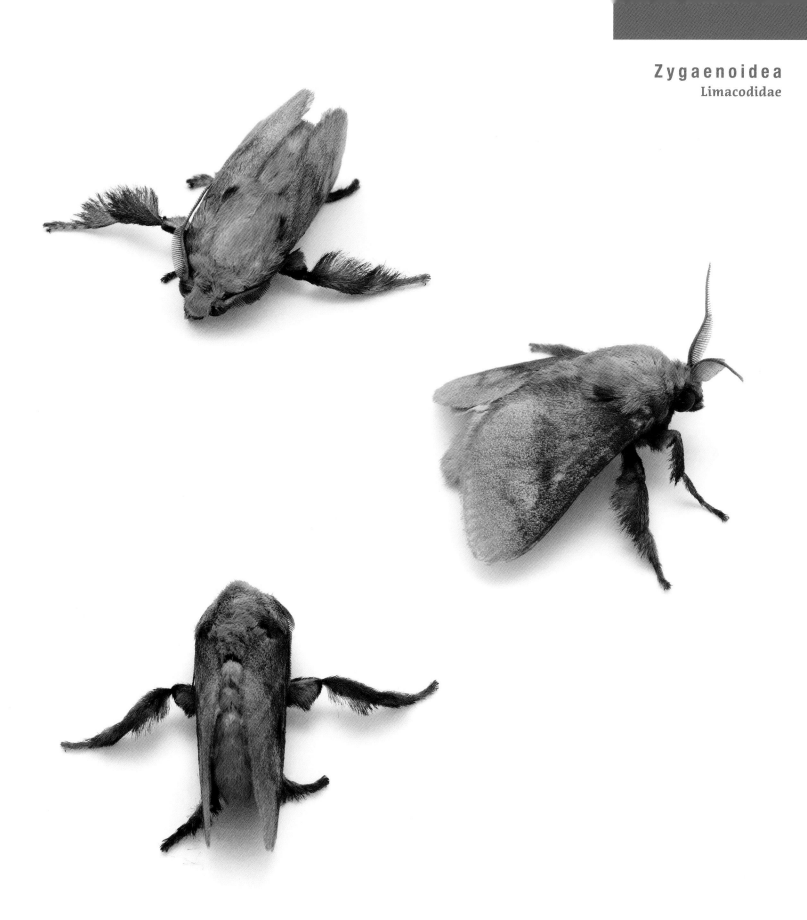

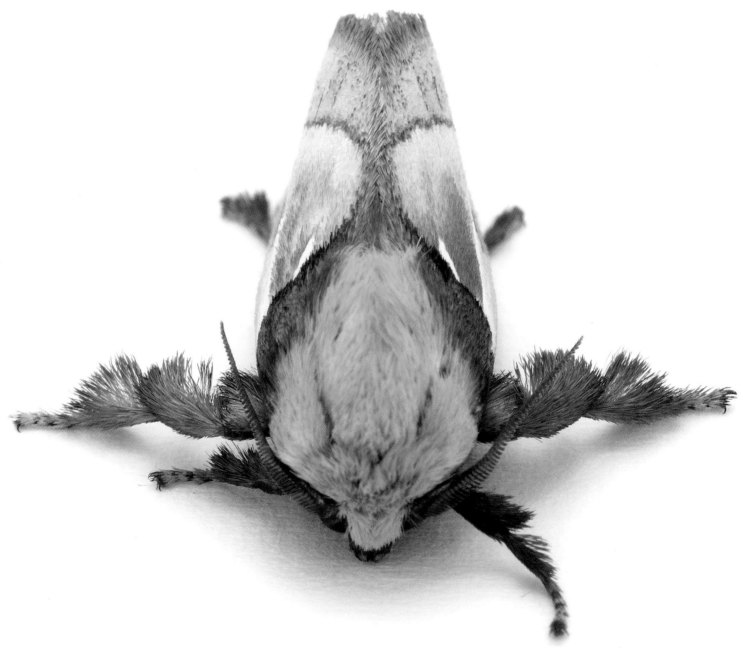

Parasa reginula Saalmüller, 1884

Spider or moth?
Parasa reginula shows its defensive poses: it has spread wide its legs, densely covered with hairy scales making it resemble a spider.

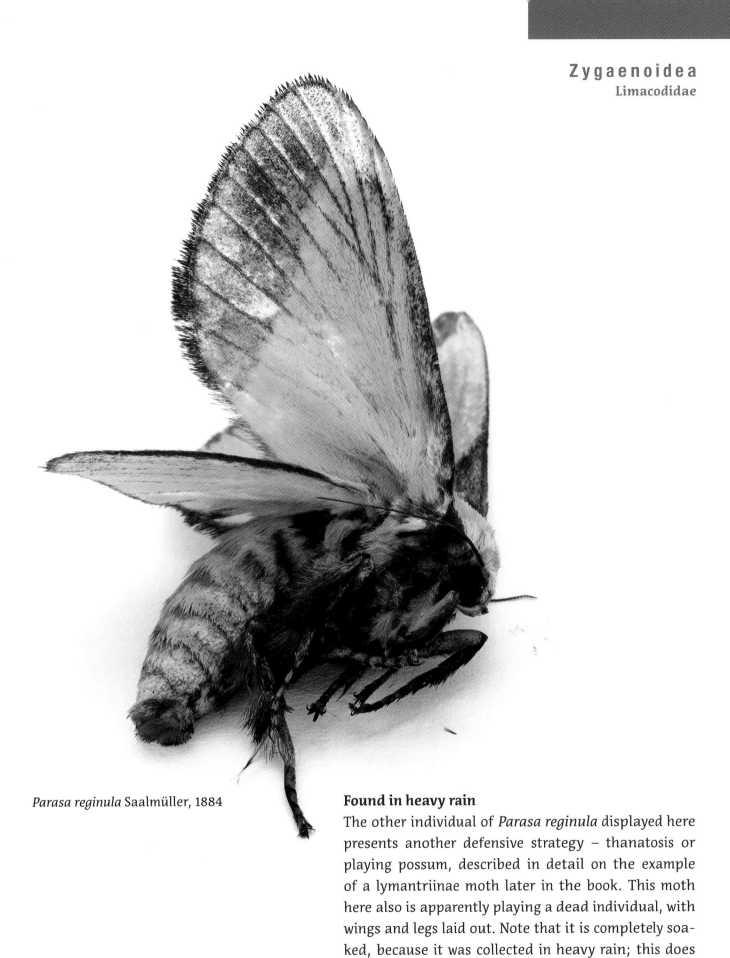

Parasa reginula Saalmüller, 1884

Found in heavy rain

The other individual of *Parasa reginula* displayed here presents another defensive strategy – thanatosis or playing possum, described in detail on the example of a lymantriinae moth later in the book. This moth here also is apparently playing a dead individual, with wings and legs laid out. Note that it is completely soaked, because it was collected in heavy rain; this does not stop the flight activity in many moths.

Stenomatidae and Peleopodidae (curved-horn moths)

Text by David Lees

Sometimes classified as a subfamily of Depressariidae and sometimes as a distinct family, Stenomatidae, the genus *Herbulotiana* is considered to be the only Malagasy representative of a largely Neotropical group.

Mnarolitia is a member of Peleopodidae, subfamily Oditinae. These belong to the superfamily Gelechioidea, as can be seen by the strongly recurved palps, but the body is more robust in shape than in the vast majority of micromoths. Unfortunately nothing is known of their biology.

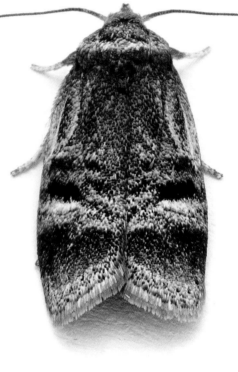

Herbulotiana sp. Viette, 1954

Mnarolitia sp. Viette, 1954

Small, quick and agile

These small moths are agile and swift fliers. They manage to reach almost every blossom in the rainforest, no matter whether flowering in the dense foliage of the treetops or on the trunks of trees. They are found regularly at the light trap in Masoala and Makira but they are agile, always in motion, and difficult to photograph. Little is known of their biology and the numbers of species. *Herbulotiana* has a short proboscis.

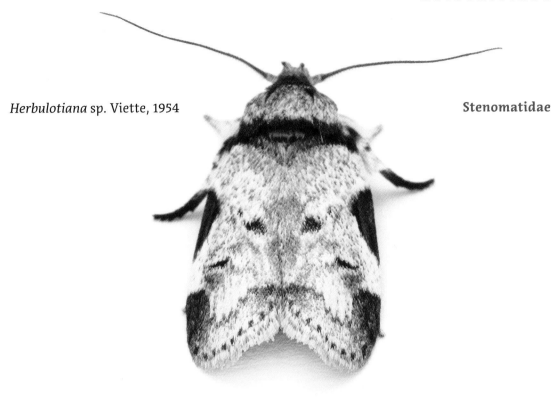

Herbulotiana sp. Viette, 1954

Stenomatidae

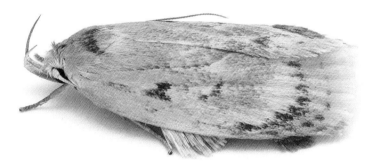

Peleopodidae

Mnarolitia sp. Viette, 1954

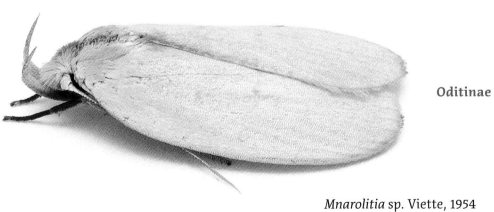

Oditinae

Mnarolitia sp. Viette, 1954

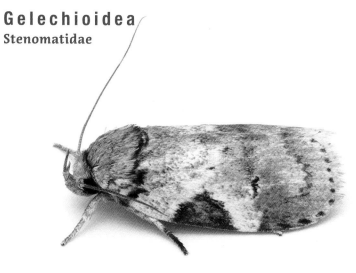

Herbulotiana sp. Viette, 1954

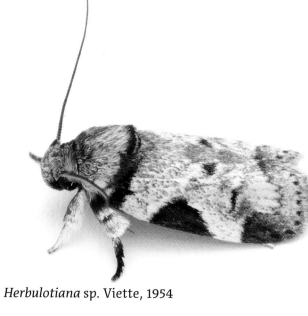

Herbulotiana sp. Viette, 1954

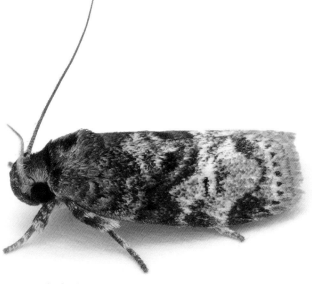

Herbulotiana sp. Viette, 1954

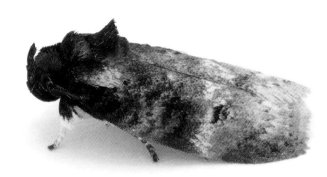

Herbulotiana sp. Viette, 1954

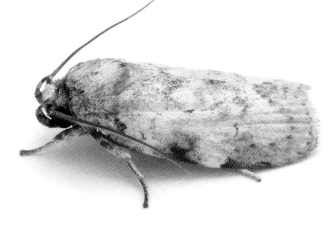

Herbulotiana sp. Viette, 1954

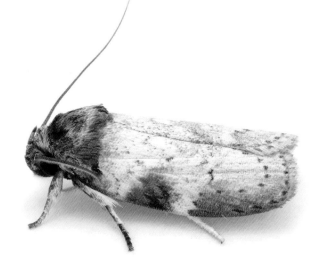

Herbulotiana sp. Viette, 1954

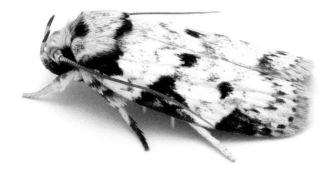

Herbulotiana cf. *bicolorata* Viette, 1954

Herbulotiana sp. Viette, 1954

Herbulotiana sp. Viette, 1954

Herbulotiana sp. Viette, 1954

Herbulotiana longifascia Viette, 1954

Radiative adaptation

Herbulotiana is a nice example of an evolutionary species radiation. The genus is unique to Madagascar and the only Afrotropical representative of the giant, mainly Neotropical, moth family Stenomatidae. It has radiated into numerous different color variations on the same basic body structure. Many species must be undescribed.

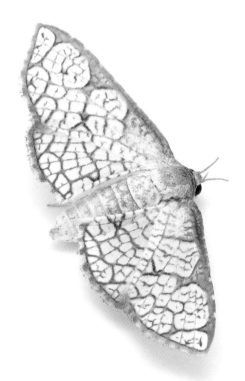

Rhodoneura opalinula (Mabille, 1880)

Rhodoneura sp. Guenée, 1858

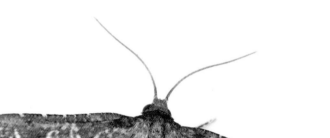

Rhodoneura sp. Guenée, 1858

Rhodoneura zophocrana Viette, 1957

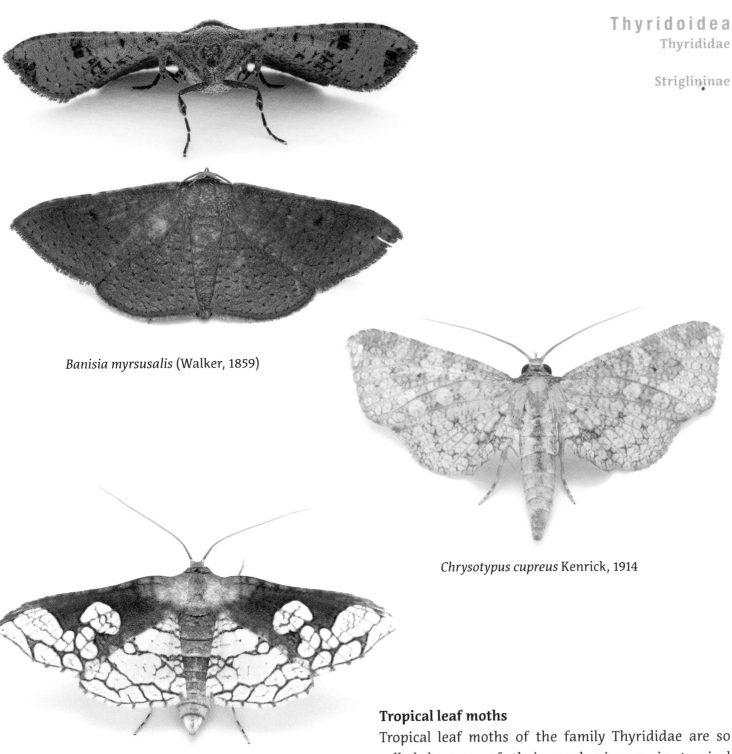

Banisia myrsusalis (Walker, 1859)

Chrysotypus cupreus Kenrick, 1914

Rhodoneura cf. *werneburgalis* (Keferstein, 1870)

Tropical leaf moths

Tropical leaf moths of the family Thyrididae are so called because of their predominance in tropical forests and the resemblance of some to dead leaves or leaf skeletons. At the light trap they are delicate and rather inconspicuous guests that settle down quickly and stay motionless. Parts of their wings are often scaleless and translucent, which helps in the imitation of decaying leaves. In Madagascar there are 32 known species in the subfamily Siculodinae, compared to at least 940 species worldwide.

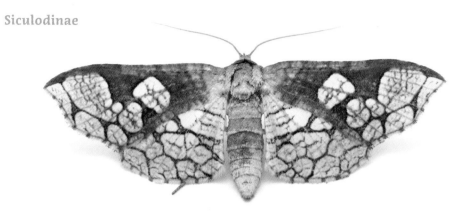

Rhodoneura cf. *werneburgalis* (Keferstein, 1870)

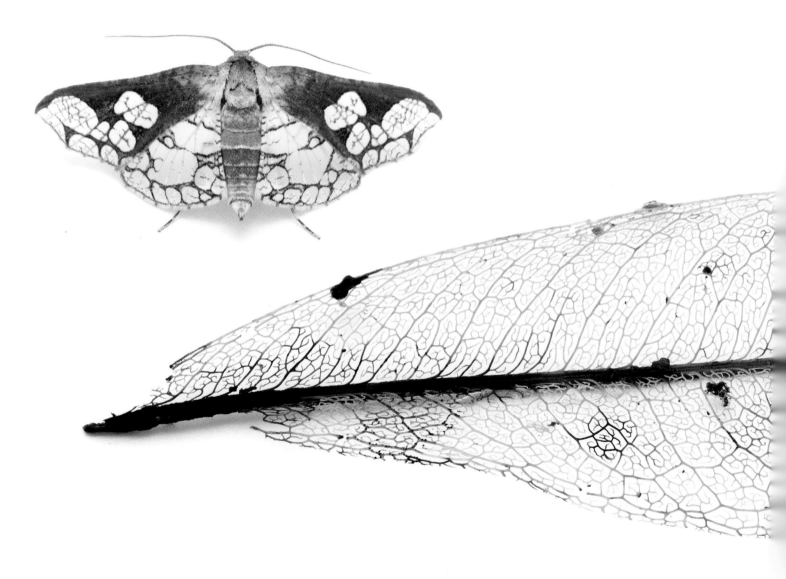

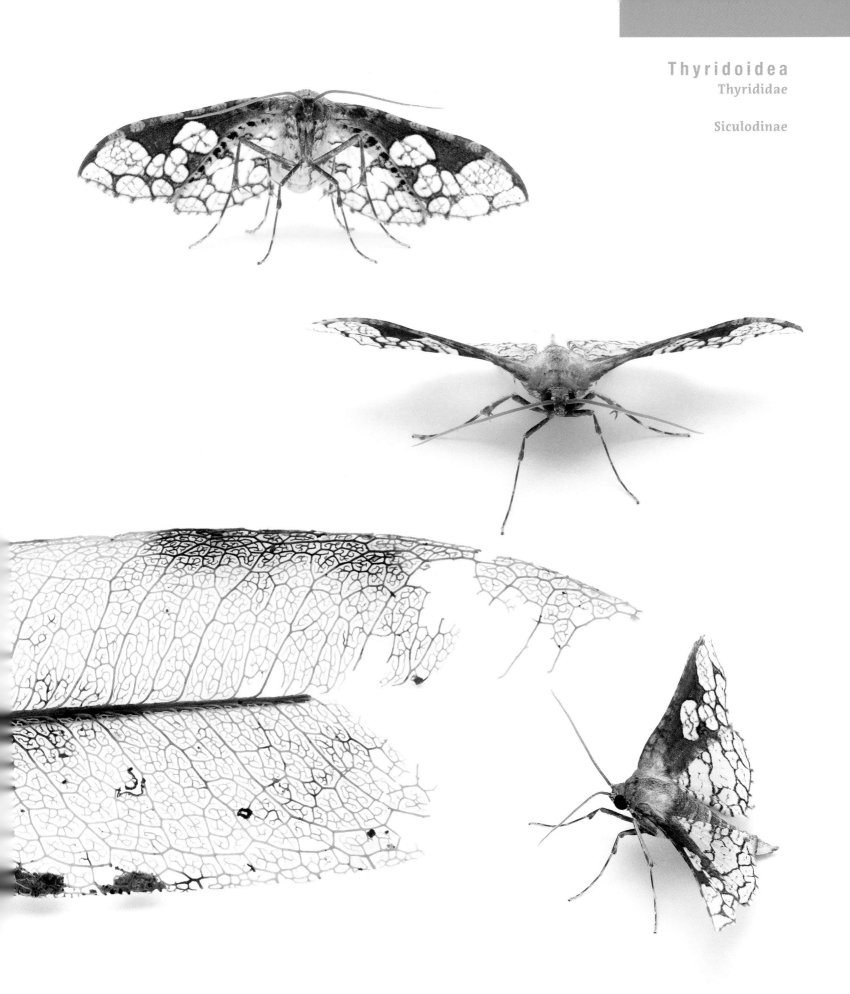

Pyraloidea (Snout moths)

Text by Marcin Wiorek & David Lees

The family Pyraloidea, comprising around 16,000 known species, is one of the most diverse groups of Lepidoptera. Currently it comprises two main families: Pyralidae and Crambidae, with around 6,000 and 10,000 species respectively. In Madagascar, there are around 370 known species of pyralids and 350 crambids.

In moths generally, assignation of a species to family or even superfamily based solely on superficial characters, like body shape and coloration, can be quite tricky and very often misleading. However, the members of Pyraloidea are usually relatively easy to distinguish. These moths most often have elongate, subtriangular body shape in resting position, with very long and threadlike antennae oriented backwards (e.g. *Megatarsodes baltealis*), and sometimes with elongate labial palpi on their heads. Some species, especially in Spilomelinae, have striking, pearly and glittering wings that can either be almost unicolorous (e.g. *Palpita jacobsalis*, *Parotis prasinalis*) or covered with a pattern of subrounded or subtriangular blotches. Within this superfamily has evolved also a huge diversity of different life strategies. The larvae of Pyraloidea feed not only on leaves, but also e.g. inside plant stems. Moreover, some of them develop under water on aquatic plants (e.g. probably Acentropinae sp., and *Eoophyla* sp.), or even scavenge in ant nests. *Acracona pratti* has been recorded in Madagascar to live in the large carton nests of *Crematogaster* sp., Formicidae!

A number of species within this subfamily are considered serious pests on crops (e.g. *Spoladea recurvalis* and *Maruca vitrata*) and stored products.

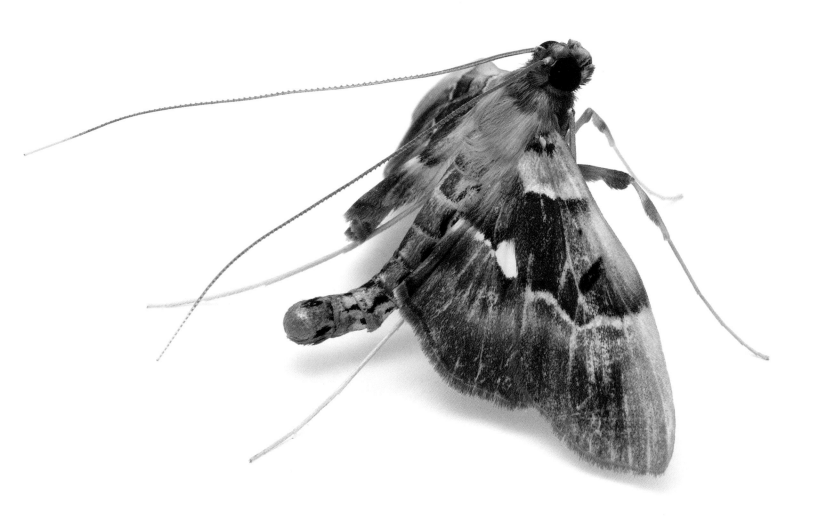

Megatarsodes baltealis (Mabille, 1881)

107

Pyraloidea
Crambidae

Subfamilies covered in this book

The subfamilies of Crambidae covered in this book include: Acentropinae (these are the ones living in aquatic habitats), Gallerinae (caterpillars of some species are known as waxmoths), Odontiinae and Spilomelinae. Regarding Pyralidae, depicted here are some members of Pyralinae.

Acentropinae

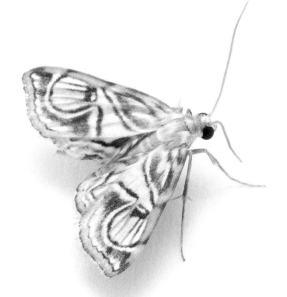

Acentropinae sp. Stephens, 1836

Galleriinae

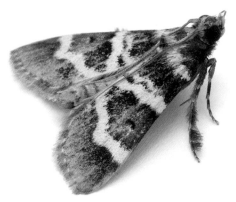

Yxygodes vieualis (Viette, 1960)

Odontiinae

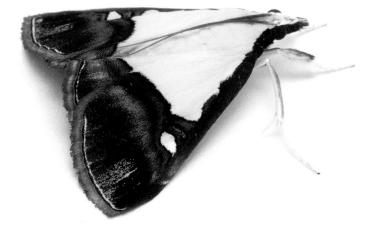

Viettessa bethalis (Viette, 1958)

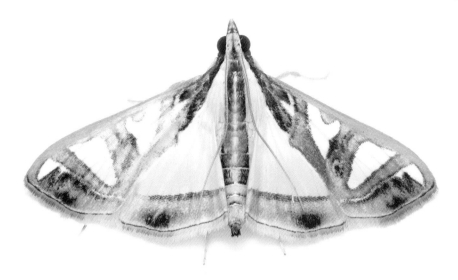

Spilomelinae

Glyphodes sp. Guenée, 1854

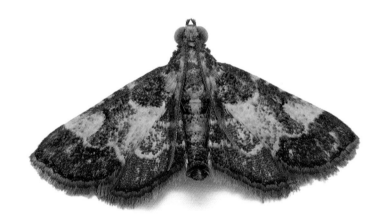

Pyralidae

Pyralinae

Zitha sp. Walker, 1866

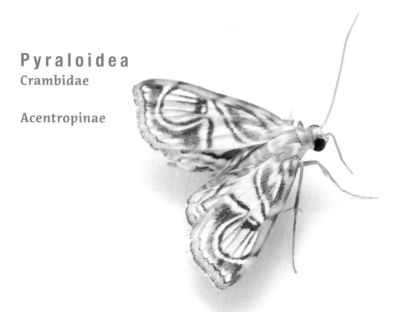

Acentropinae sp. Stephens, 1836

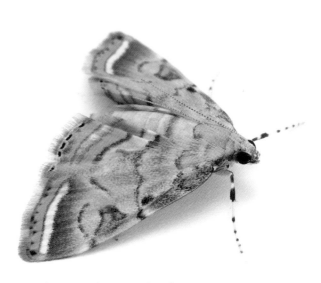

Acentropinae sp. Stephens, 1836

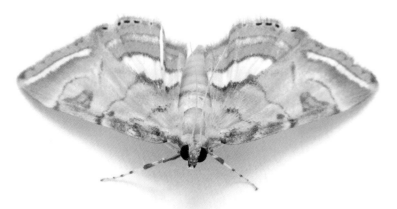

Acentropinae sp. Stephens, 1836

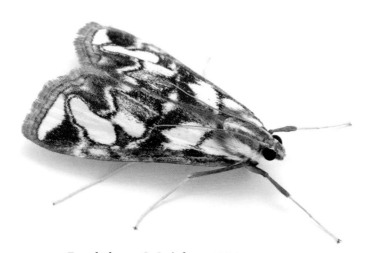

Eoophyla sp. C. Swinhoe, 1900

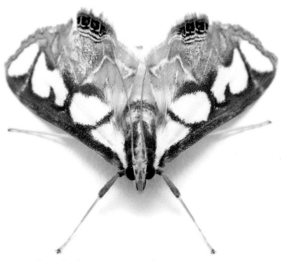

Eoophyla sp. C. Swinhoe, 1900

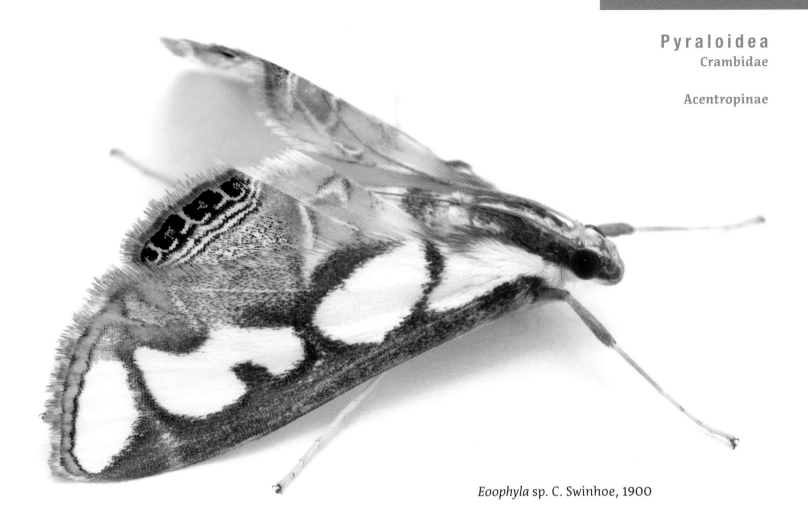

Eoophyla sp. C. Swinhoe, 1900

False eyes on the hindwings

As you can learn reading other chapters of this book, many moths have developed special patterns on their wings, protecting them from predators by resembling the body parts of other animals – such as, apparently, lemur eyes in Saturniidae. Perhaps the most amazing example of such strategy in micromoths is the mimicking of jumping spiders (family Salticidae). This strategy has been brought almost to perfection by the metalmark moths (family Choreutidae, not covered in this book), but has appeared independently in the crambid subfamily Acentropinae. Perhaps it is not so obvious when looking at a spread specimen in a collection, but living moths display their multiple eyespots clearly, as here in *Eoophyla* species.

Folded wings seen from the right angle look like a salticid spider: the dark dots on the hindwing margin are the spider's eyes, and the zig-zag pattern of the forewing – its legs. The reason for such protection is apparently protection from being eaten by salticids. These spiders are territorial and usually back away when encountering another spider. But considering the relatively small size of many jumping spiders, another hypothesis has been proposed: mimicking such fast and jerky spiders may make them look like unprofitable prey.

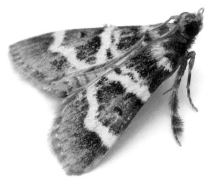

Yxygodes vieualis (Viette, 1960)

Acracona pratti (Kenrick, 1917)

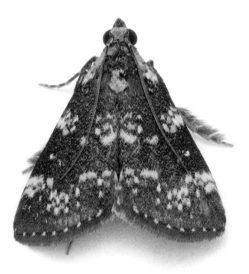

Yxygodes insignis (Mabille, 1900)

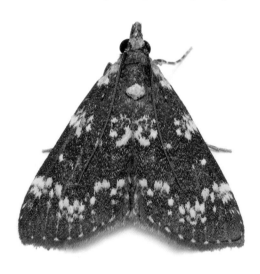

Yxygodes insignis (Mabille, 1900)

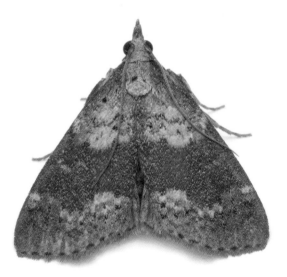

Yxygodes zonalis (Mabille, 1900)

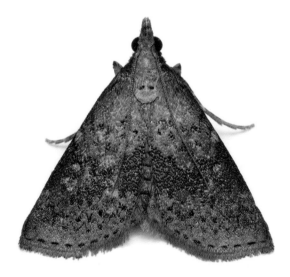

Yxygodes zonalis (Mabille, 1900)

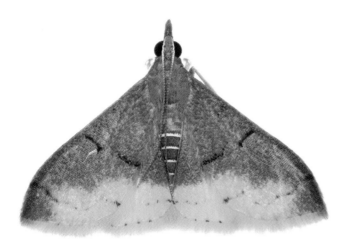

Clupeosoma sp. near *orientalalis* (Viette, 1954)

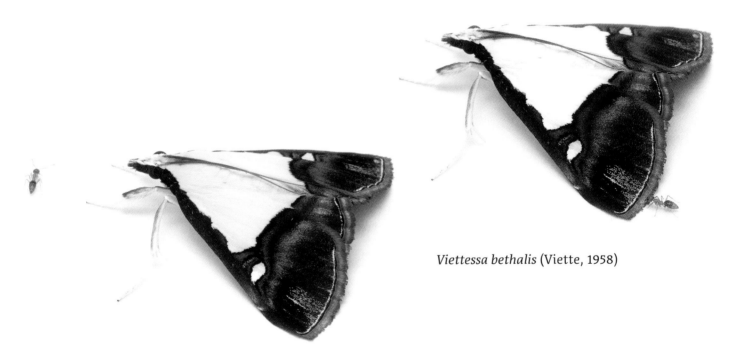

Viettessa bethalis (Viette, 1958)

Ant as a stowaway

As already mentioned, in Pyraloidea have evolved some of the most amazing life strategies in all Lepidoptera. Why should it not include interactions with other insects? In a few different species ants have been observed hanging around a moth, behaving a bit as if they were stowaways. It might be some completely unknown interaction, but perhaps the explanation is simpler and more brutal – ants may prey on weakened, dying moths. But nevertheless, in Pyraloidea there are other known kinds of interactions with ants. For instance, larvae of *Acracona pratti*, an adult of which is displayed on the previous page, develop inside the nests of *Crematogaster* ants and have apparently found a way to trick their hosts into leaving them alone.

113

Pyraloidea
Crambidae

Spilomelinae

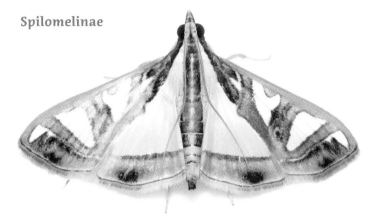

Glyphodes sp. Guenée, 1854

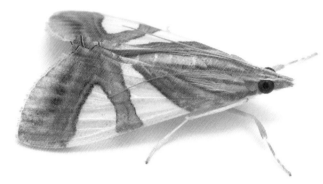

Agrioglypta toulgoetalis (Marion, 1954)

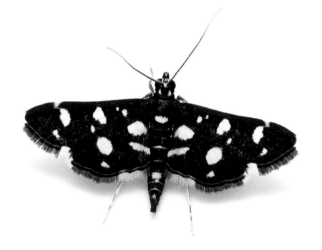

Bocchoris inspersalis (Zeller, 1852)

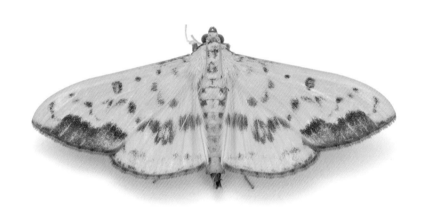

Botyodes andrinalis Viette, 1958

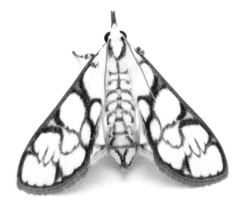

Cirrhochrista cygnalis Pagenstecher, 1907

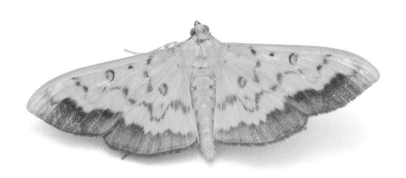

Botyodes asialis Guenée, 1854

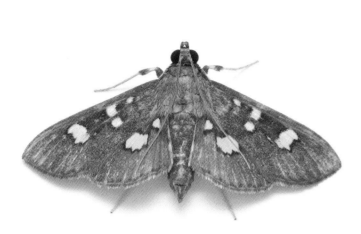

Coptobasoides pauliani (Marion, 1955)

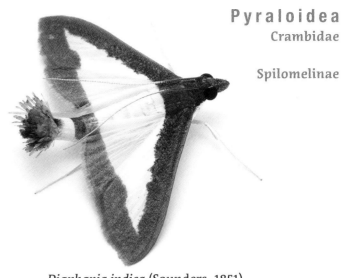

Diaphania indica (Saunders, 1851)

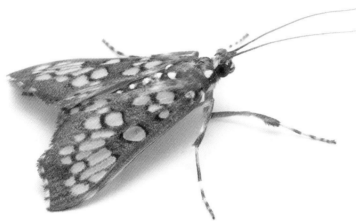

Euphyciodes albotessulalis (Mabille, 1900)

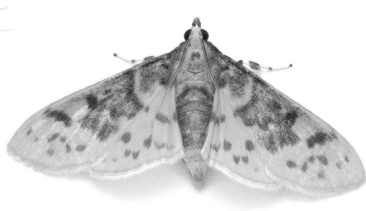

Ghesquierellana hirtusalis (Walker, 1859)

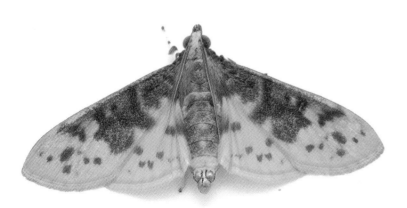

Ghesquierellana hirtusalis (Walker, 1859)

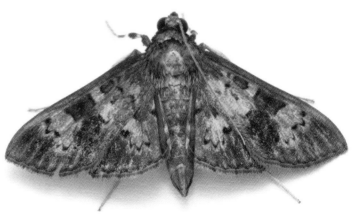

Ghesquierellana sp. Berger, 1955

115

Spilomelinae

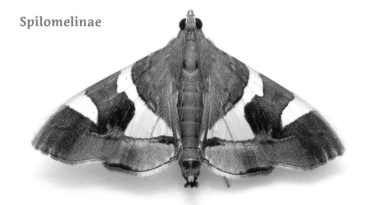

Glyphodes paramicalis Kenrick, 1917

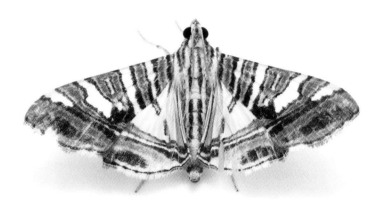

Glyphodes shafferorum Viette, 1987

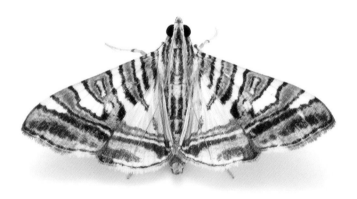

Glyphodes shafferorum Viette, 1987

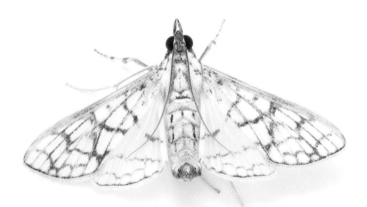

Sinomphisa jeannelalis (Marion & Viette, 1956)

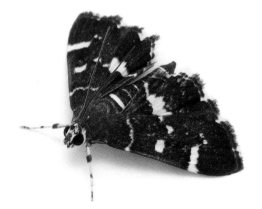

Hymenia perspectalis (Hübner, 1796)

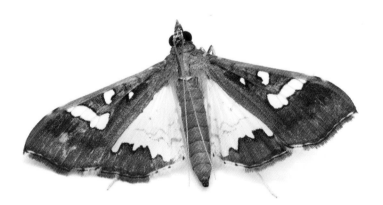

Maruca vitrata (Fabricius, 1787)

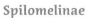

Pyraloidea
Crambidae

Spilomelinae

Megatarsodes baltealis (Mabille, 1881)

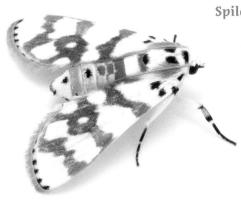

Obtusipalpis rubricostalis Marion, 1954

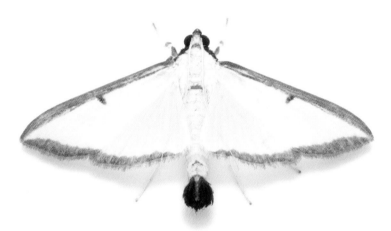

Palpita jacobsalis (Marion & Viette, 1956)

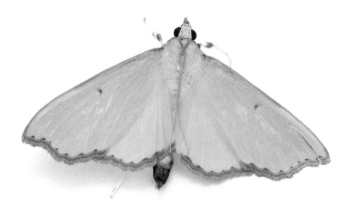

Parotis cf. *prasinophila* (Hampson, 1912)

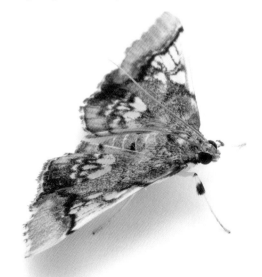

Pilocrocis sp. Lederer, 1863

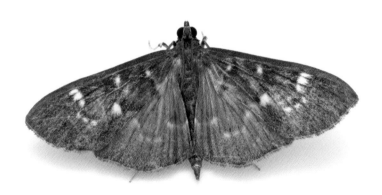

Pramadea ovialis (Walker, 1859)

117

Pyraloidea
Crambidae

Spilomelinae

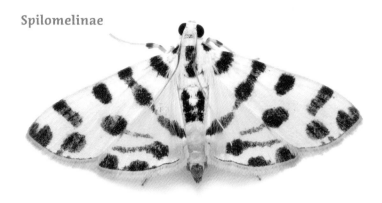

Pycnarmon sp. Lederer, 1863

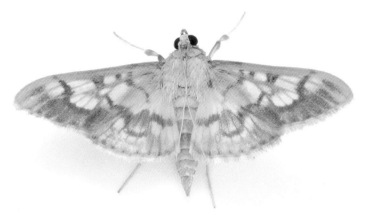

Syllepte lanatalis Viette, 1960

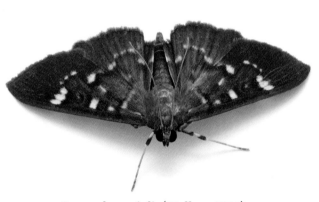

Pramadea ovialis (Walker, 1859)

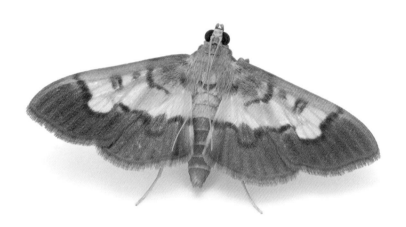

Syllepte lanatalis Viette, 1960

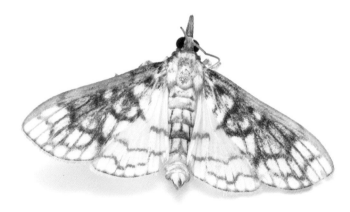

Sinomphisa jeannelalis (Marion & Viette, 1956)

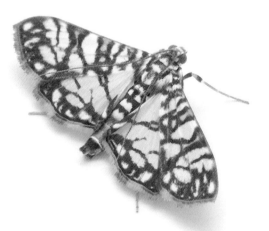

Synclera traducalis (Zeller, 1852)

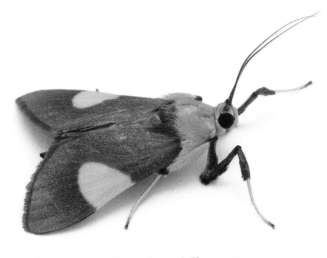

Ulopeza crocifrontalis Mabille, 1900
male

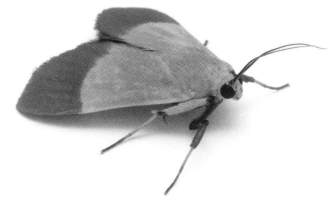

Ulopeza crocifrontalis Mabille, 1900
female

Sexual dimorphism – males and females are colored differently

Polymorphism, i.e., occurrence of different forms (so called morphs), is quite common in Lepidoptera. There are many different types of this phenomenon, and one of them is sexual dimorphism, meaning that the male and the female of a species look different. Usually these differences are subtle, as for example shape of the antennae, but sometimes very distinct, as in *Ulopeza crocifrontalis* displayed here: The male has subtriangular blotches on the forewings, whilst in the female they are almost entirely orange.

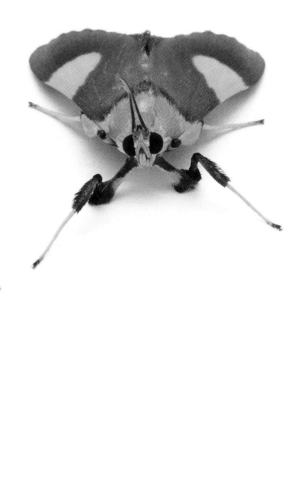

119

Pyraloidea
Crambidae

Spilomelinae

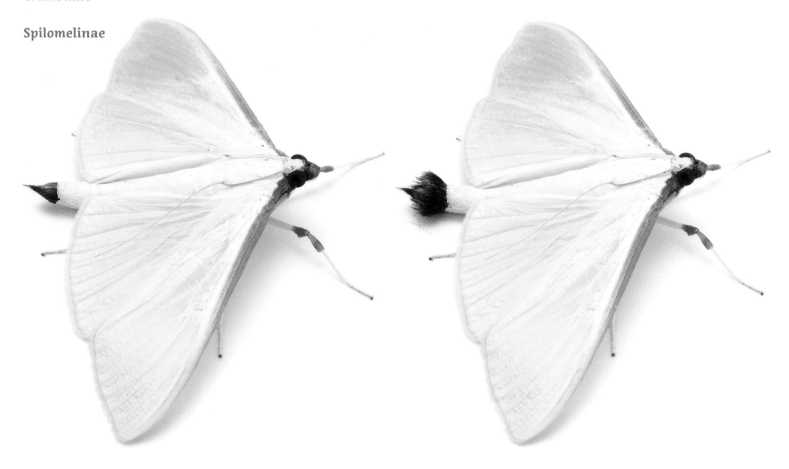

Parotis prasinalis (Saalmüller, 1880)

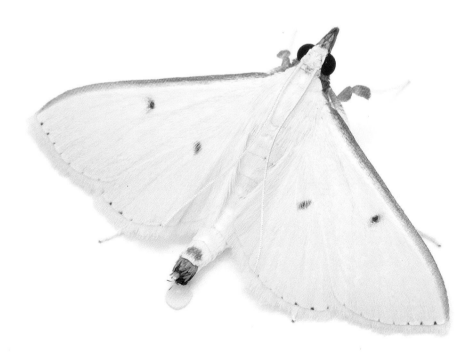

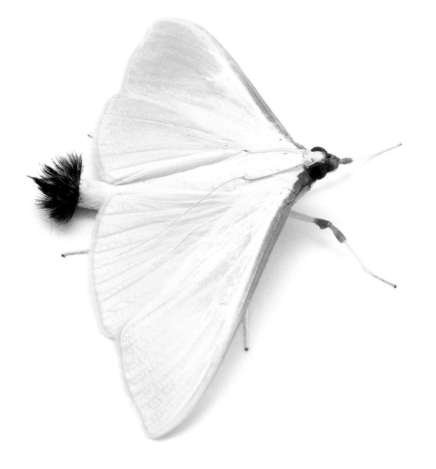

Pheromone scales at the end of the abdomen

How a male and female of a moth species are able to locate each other within a vast area is a wondrous thing. In fact, Lepidoptera leave almost everything to the sense of smell. Individuals of one sex emit special chemical substances, so-called pheromones, that diffuse in the air and transmit the signal of their presence to the individuals of the opposite sex (or even competitors of the same sex!), that detect it with their antennae. If these are males that emit pheromones, then they usually have on their bodies some special structures made up of scales, sometimes in the form of a brush or tuft. In the case of males of *Parotis prasinalis*, shown here (but also *Diaphania indica* on the page 111), it is a special tuft of pheromone scales at the end of the abdomen, which is normally folded, and unfolded when needed. The scent release might help the females to judge between rival males in the close stages of courtship.

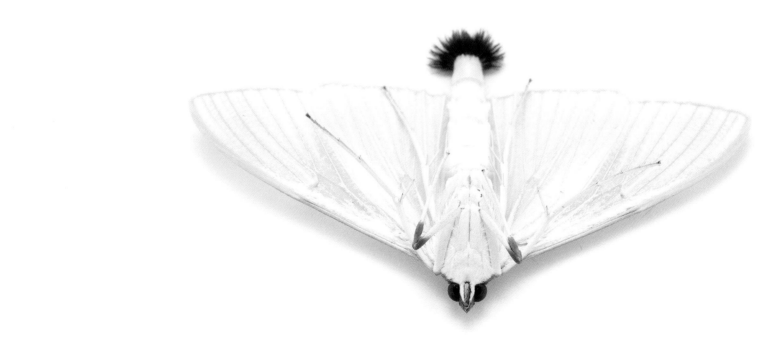

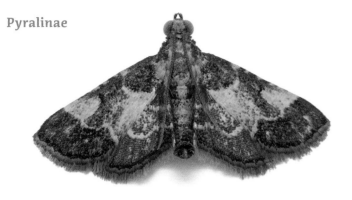

Zitha sp. near *sanguinalis* (Marion, 1954)

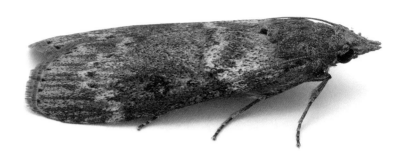

Lamoria clathrella (Ragonot, 1888)

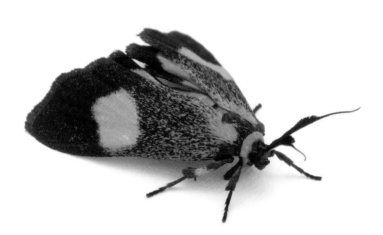

Lophocera vadonalis Marion & Viette, 1956

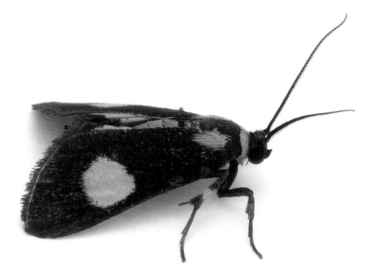

Lophocera flavipuncta Kenrick, 1917

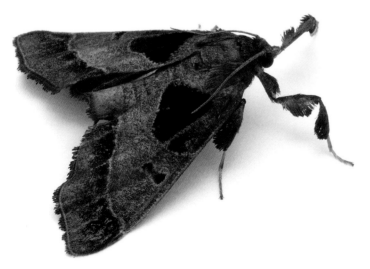

Sacada sp. Walker 1862

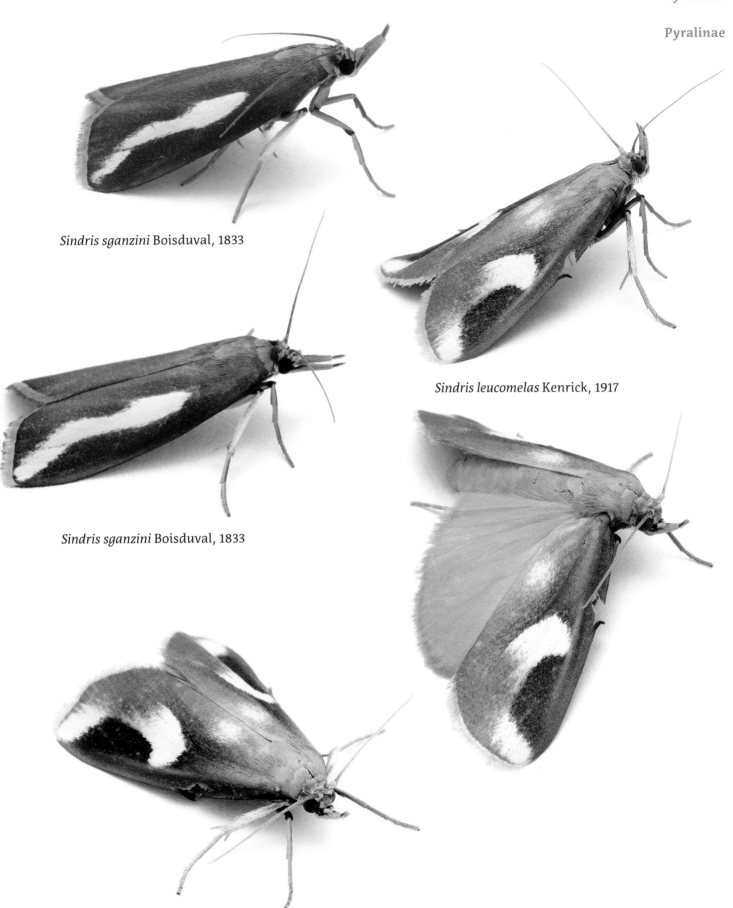

Sindris sganzini Boisduval, 1833

Sindris leucomelas Kenrick, 1917

Sindris sganzini Boisduval, 1833

Bombycoidea (Silk worm moths)

Text by David Lees

The superfamily Bombycoidea includes some of the largest and most spectacular as well as most popular moths. There are over 6,000 species worldwide and at least 92 in Madagascar. There are four families recognized for the fauna out of 10 worldwide. The Bombycidae have one native species in western Madagascar, *Ocinara malagasy*. The Eupterotidae have one unique species which is known from Antongil Bay forests, *Malagasanja palliatella* (Viette, 1954). In Madagascar the Saturniidae have 26 species, 22 of which are in the genus *Maltagorea* while 64 are Sphingidae species.

Many bombycoids have short lifespans as adult moths of about a week or less, since they have atrophied proboscises and all feeding occurs in the larval stage. The adults live just for dispersal and reproduction, their males usually sporting highly pectinate antennae to detect the female pheromones from afar; the fat females mate rapidly and race in their short lives to lay all their eggs, sometimes in batches. Many Sphingidae (hawkmoths), however, are important pollinators of flowers, often with significantly long tongues to probe elongated nectar tubes. Female hawkmoths are generally more selective in finding the right plant on which to oviposit, which they usually do singly.

Some bombycoid moths are culturally important in Madagascar. The introduced Silkworm *Bombyx mori* supplements some lasiocampid moths for the purpose of weaving silk to produce lambas (shrouds), particularly on the high plateaux. Pupae of some saturniid moths such as those of *Antherina suraka* are also sought after by Malagasy people for food, while cocoons of other species like *Bunaea aslauga* and *Ceranchia apollona* are stitched together to make beautiful artisan products in a highly successful cooperative SE-PALI formed of local farmers in Makira, who rear these silkmoths sustainably for much needed income on the international market. In Masoala, the adult of *Argema mittrei* has significance in village culture and beliefs; it is said that if one is found dead it can be placed on the end of a hoe, this presumably is a good sign for work on the ricefields!

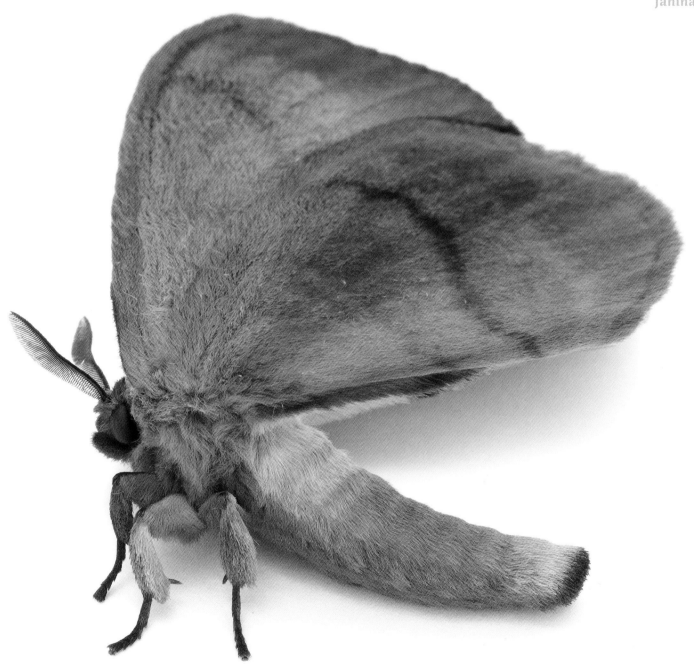

Malagasanja palliatella (Viette, 1954)

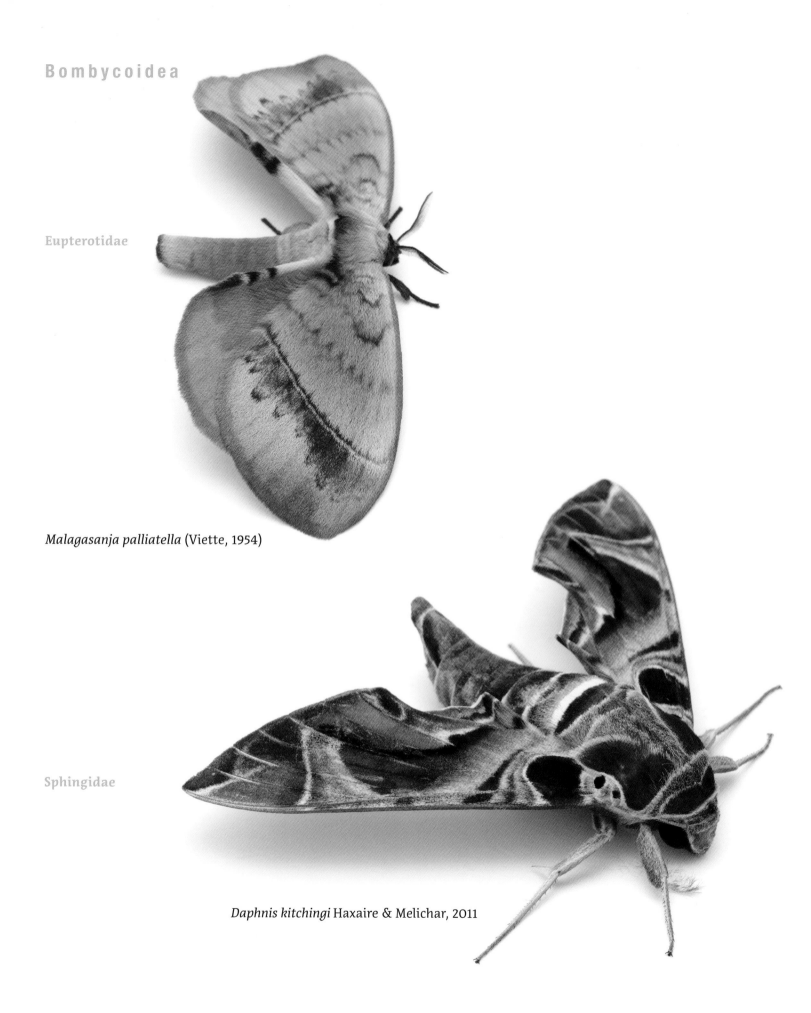

Bombycoidea

Eupterotidae

Malagasanja palliatella (Viette, 1954)

Sphingidae

Daphnis kitchingi Haxaire & Melichar, 2011

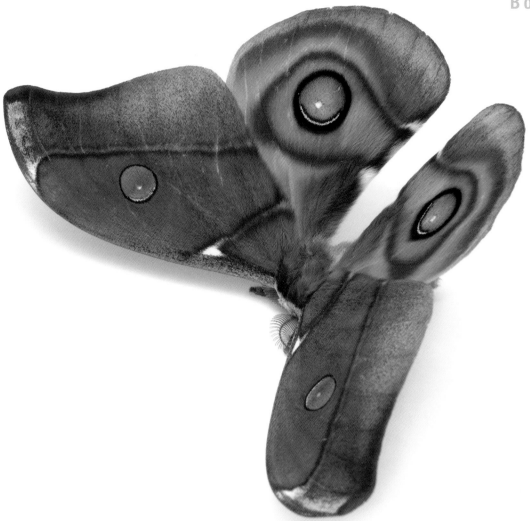

Antherina suraka (Boisduval, 1833)

Families of the superfamily Bombycoidea dealt with in this book

Worldwide there are around 3,350 known species of Bombycoidea. Most of the adult moths are powerfully built and have heavily scaled, often broad wings. Except for sphinx moths, they have feathered antennae which in the case of the males have strikingly long rami that look like a comb.

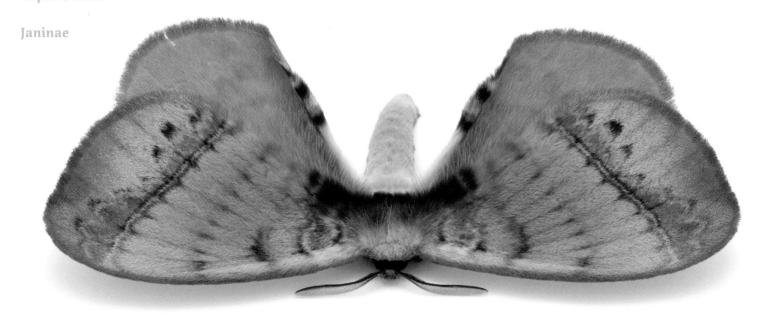

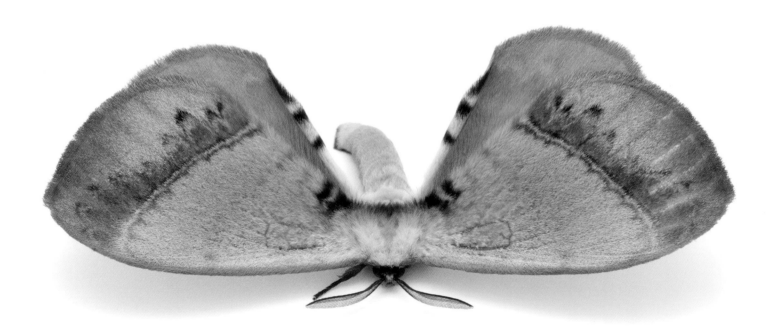

Malagasanja palliatella (Viette, 1954)

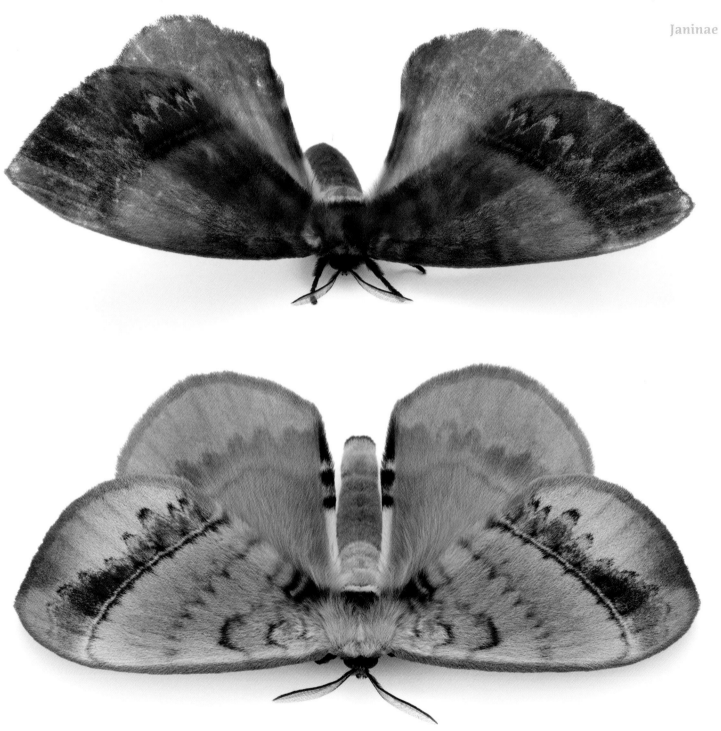

Malagasanja palliatella (Viette, 1954)

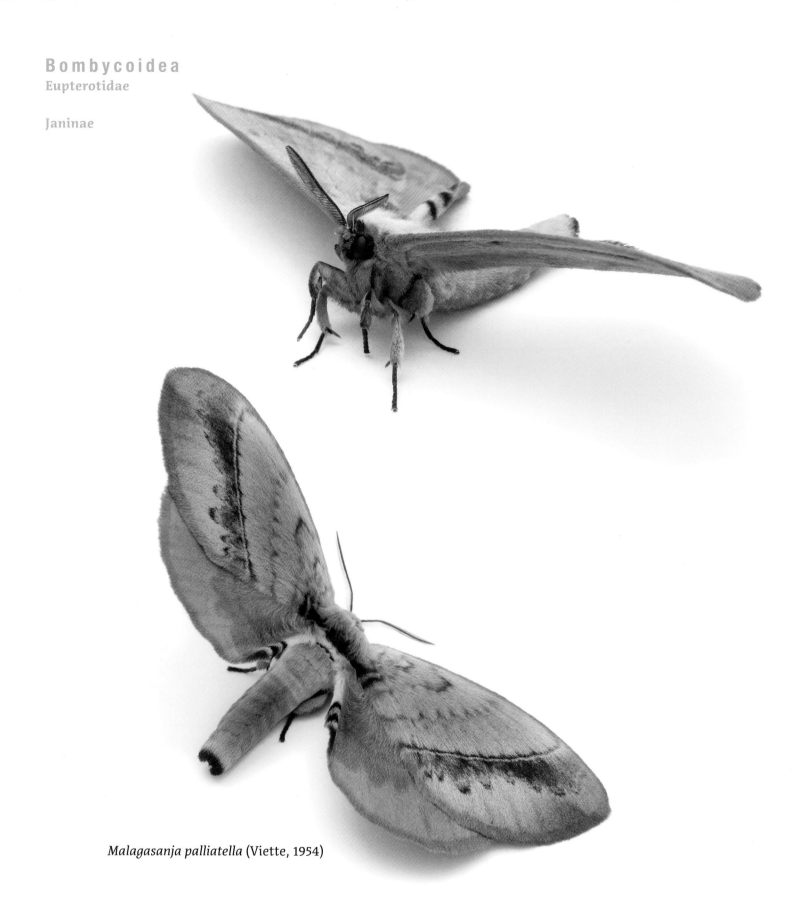

Malagasanja palliatella (Viette, 1954)

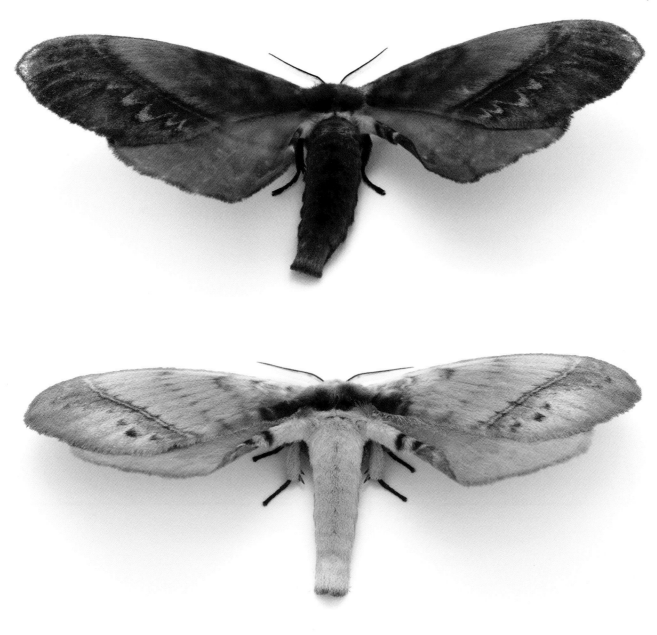

Malagasanja palliatella (Viette, 1954)

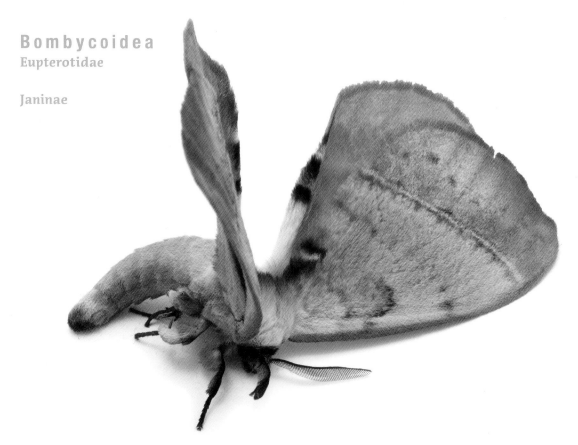

Response to disturbance

Malagasanja palliatella is the only known representative of 'Monkey Moth', Eupterotidae in Madagascar, better known in Africa and Australia. Individuals perform a broad range of behaviors in response to disturbance. The moths hold the wings together and play dead, but in doing so the legs are drawn up and the abdomen curved in a false stinging action. Occasionally an additional foul-smelling waste liquid (meconium) is excreted that in air dries quickly and turns dark brown. If the disturbance persists, the moth holds the wings like an umbrella over its thorax with head held up. Thus it resembles large dry leaves. Once the disturbance goes away, the wings are slowly folded back and the moth runs away unharmed. The life history is not reported.

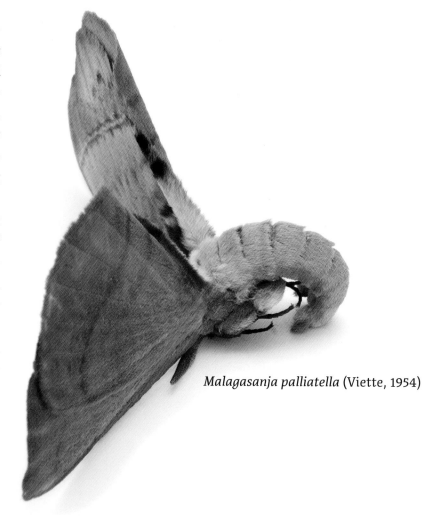

Malagasanja palliatella (Viette, 1954)

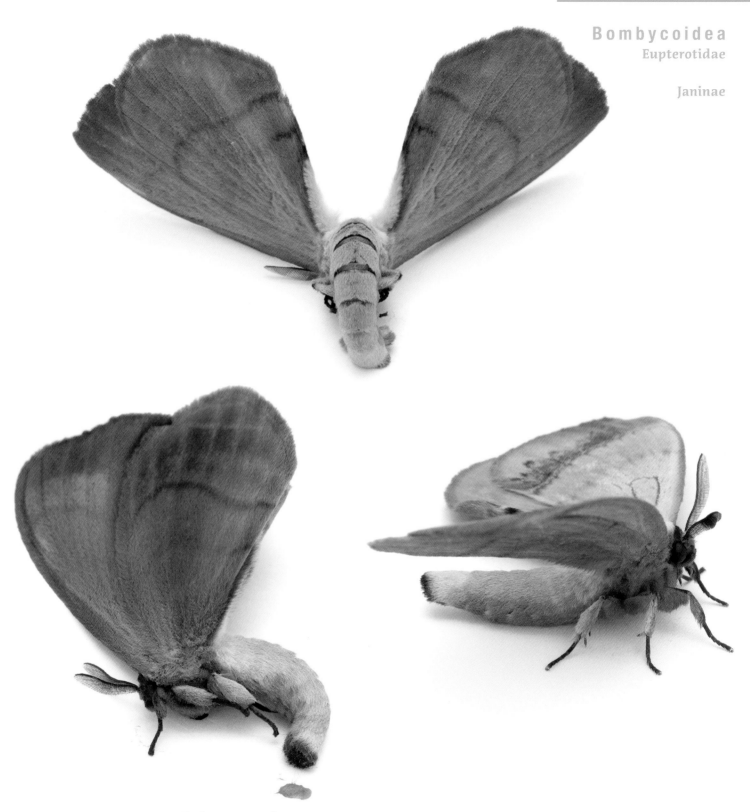

Bombycoidea
Eupterotidae

Janinae

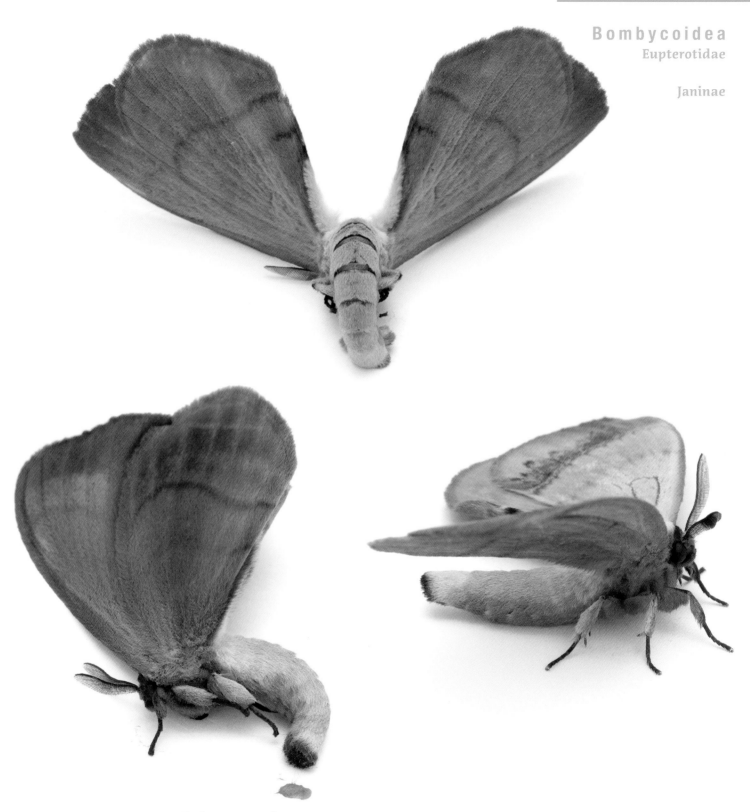

Malagasanja palliatella (Viette, 1954)

133

Saturniidae (Wild Silkmoths)

Text by Dr. Rodolphe Rougerie

More than 3.500 species worldwide, in Madagascar five genera with a total of 26 species, all are endemic

The fascinating diversity of Madagascan moths is rather discrete and largely unsuspected, but there are giants among them that do not go unnoticed. The Wild Silkmoths are massive insects that can exceed 30cm in wingspan and have fascinated generations of naturalists with their spectacular size and the diversity of their forms and patterns. They are distributed worldwide, with their diversity peaking in tropical regions of the globe, and their popularity made them one of the most studied and best-known groups of insects. Giant Atlas-, Hercules-, Emperor-, Moon- or Comet-moths are some of many popular names given worldwide to saturniid moths in relation to their shapes and patterns, but it is probably for the ability of their caterpillars to spin large and qualitative silk cocoons that they first bore importance to humans, with evidence of the use of their silk in Antiquity.

The large caterpillars of Wild Silkmoths are no less spectacular and diverse than the adults, and they are also consumed – sometimes even much prized – as food on several continents, especially in Africa where they represent a major source of proteins for the local populations of some regions. Besides their large size, saturniid moths often have patterns imitating eyespots on their hindwings; these, made of multiple concentric rings reminding us of those of the planet Saturn, are at the origin of the name taxonomists gave to the family. Hidden at rest and brusquely displayed when the moth is attacked, the eyespots offer protection to the moth against birds or lizards by suddenly surprising them. Big insects like saturniids are a feast for their predators; natural selection, during the course of their evolution, has been at the origin of a diversity of adaptive innovations, from moths with frenzied flight behavior, long-tailed hindwings or abdominal urticating scales, to caterpillars bearing

A tale of long tails

Of all moths in the world, the Madagascan Comet-moth is one of the most striking and has become a popular emblematic insect for the island. Males are only active at night, seeking females using their large feathery antennae as pheromone detectors. In forested areas of eastern Madagascar, it is not rare to observe this extraordinary moth near the public light of a village, fortuitously distracted from its path.

The absence of its fascinating long tails may disappoint the lucky observer, but it actually tells a fortunate tale of this moth escaping the deadly teeth of an insectivorous bat. Evolution, through millions of years of natural selection, has shaped these wings into the most elegant and smartest decoy against the sophisticated echolocation scanner of bats. Perceiving the twisted tips of the tails as distinct flying objects, bats are lured into attacking these non-vital parts instead of the coveted insect, thus offering it a chance to escape and survive.

Argema mittrei (Guérin-Méneville, 1847)

poisonous spines, exhibiting camouflage patterns or being venomous and aposematic (warning) in color. After metamorphosis and emergence from their pupa or cocoon, the adult saturniid moths only live for a few days, maybe a week, and their life is entirely devoted to reproduction. In fact, they do not even feed and their mouthparts are reduced, non-functional. In effect, for such large prey, this singular trait reduces the time of exposure to predation by their main natural enemies at night: bats. Once emerged, the female individuals remain motionless, emitting pheromones that are chemical clues traveling at random, carried in the air. At night, male saturniids become active for a very short period of time only, probably a couple of hours at most, using their characteristic large and feathery antennae to detect infinitesimal amounts of the female pheromones. Following that faint scent, they fly their way back to the source, where the molecules are more concentrated and where the female awaits patiently.

Research on the evolution of saturniid moths has revealed that the family likely diverged from its common ancestor with hawkmoths (family Sphingidae) about 50–60 million years ago, during the early Tertiary. The family is

represented on all continents and comprises more than 3,500 species world-wide, most of which occupy the Neotropical region. Remarkably, more than a third of these species were described by taxonomists within the past two decades, as the result of the combination of traditional morphological comparisons with molecular approaches using a small fragment of DNA, called "DNA barcode". As one of the best-documented groups of arthropods, saturniids represent unique insect models and are central to research programs investigating the spatial and temporal dynamics of their diversification, and the determinism of their responses to environmental changes.

In Madagascar, Wild Silkmoths are represented by five lineages, formally recognized as distinct genera in the Linnean classification of the family. Four of them (*Argema*, *Antherina*, *Bunaea* and *Ceranchia*) are represented by a single and unique species, whereas the fifth lineage, namely genus *Maltagorea*, is the only one that diversified significantly on the island, with 22 species known so far. All 26 Madagascan species of saturniids are endemic to the island, with their ranges only extending to Comoros in two of them, but none reaching the Mascarene Islands.

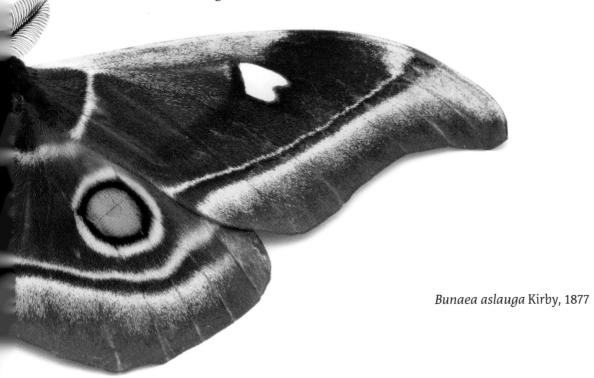

Bunaea aslauga Kirby, 1877

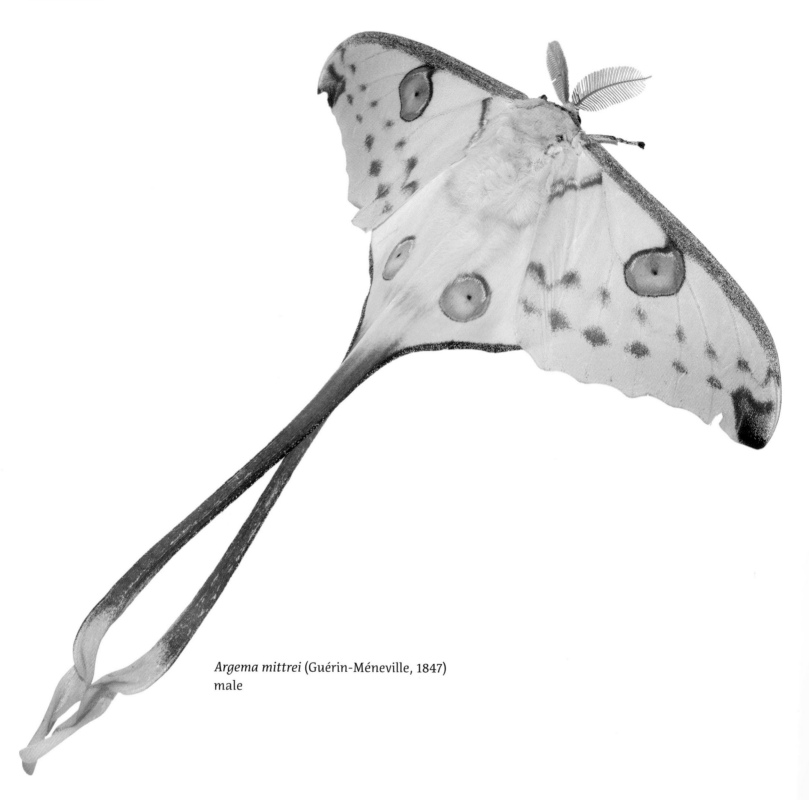

Argema mittrei (Guérin-Méneville, 1847)
male

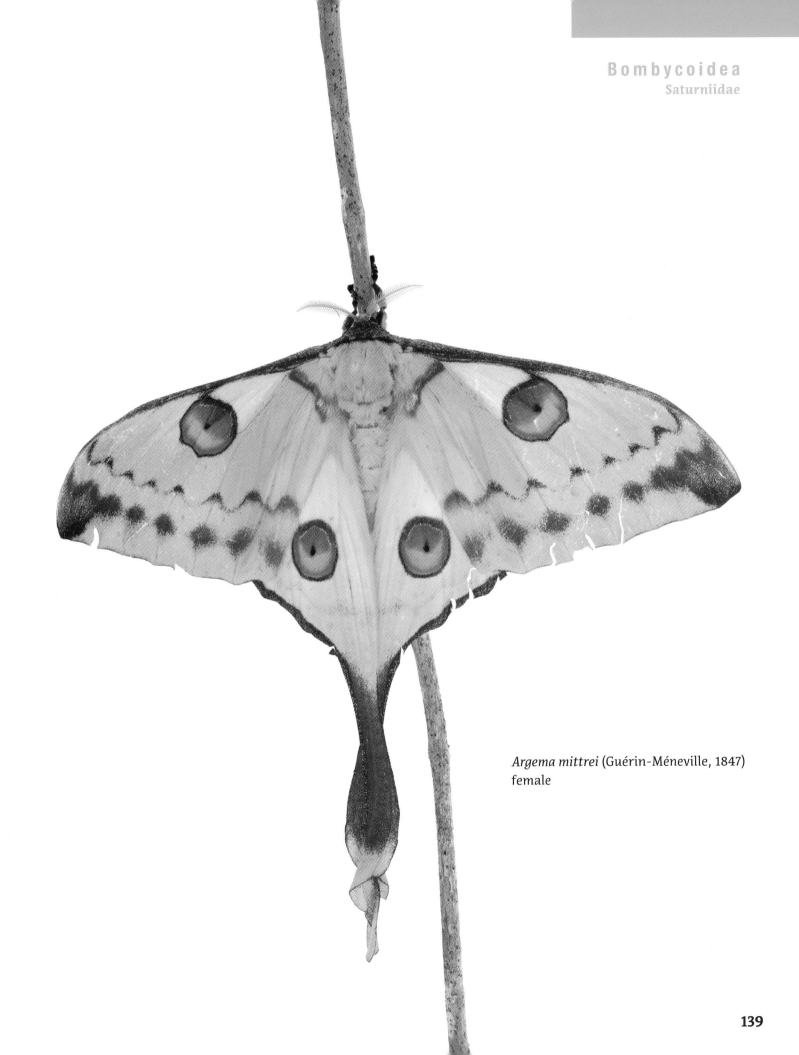

Argema mittrei (Guérin-Méneville, 1847)
female

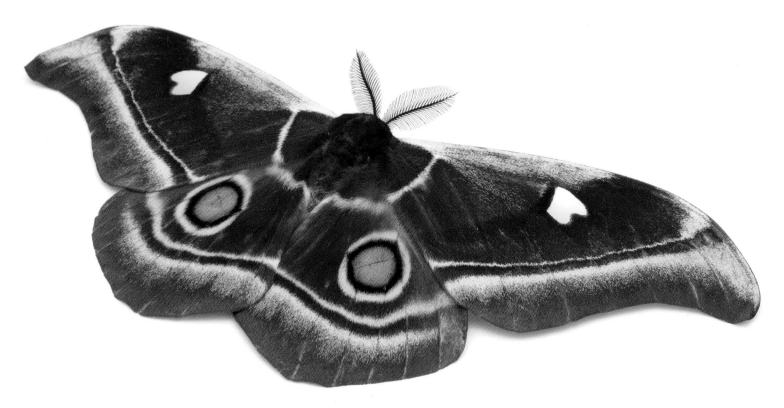

Bunaea aslauga Kirby, 1877
male

As large as a school ruler

Bunaea aslauga is a very impressive moth. With an almost 30 cm wingspan and a labored, flapping flight, it comes in to land at the light. At first one thinks of a bird or large bat. Pretty soon the moths settle in the surrounding vegetation and can be found, having evaded predators, in the morning. *Bunaea* features a scaleless transparent window in each wing, whose function is not quite clear but may resemble a hole eaten in a dead leaf.

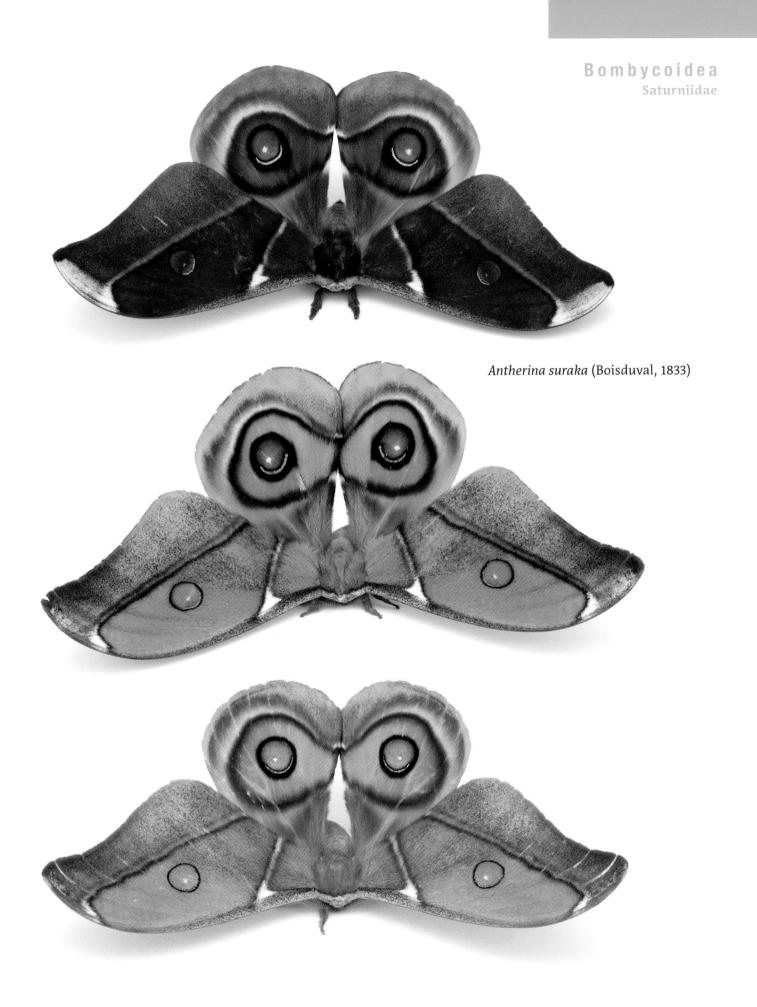

Antherina suraka (Boisduval, 1833)

141

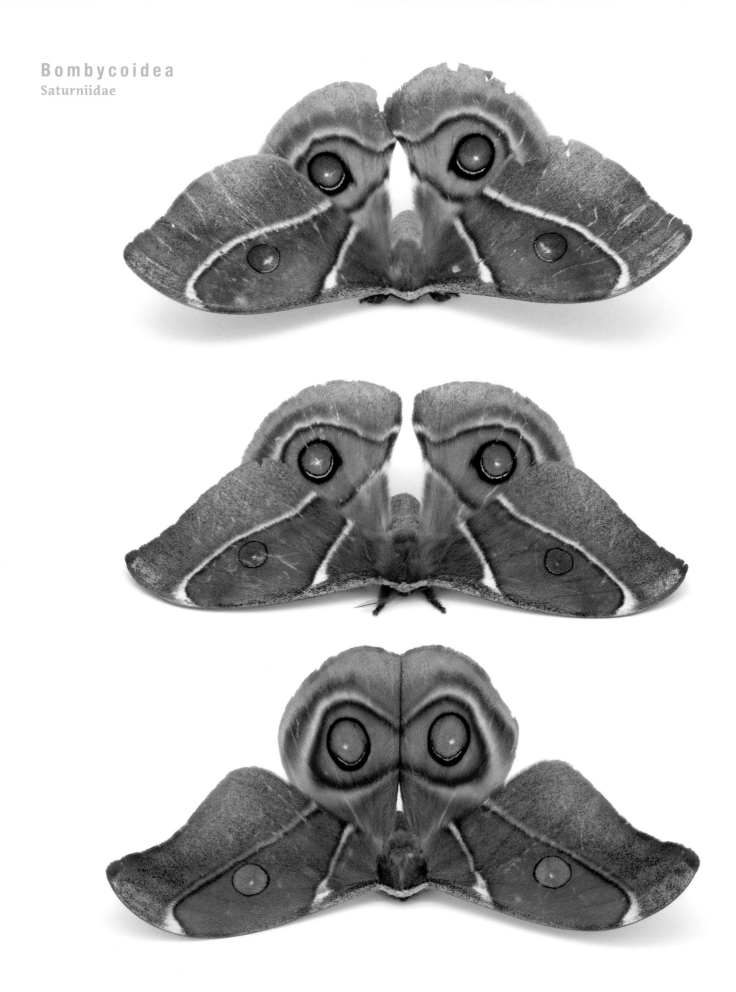

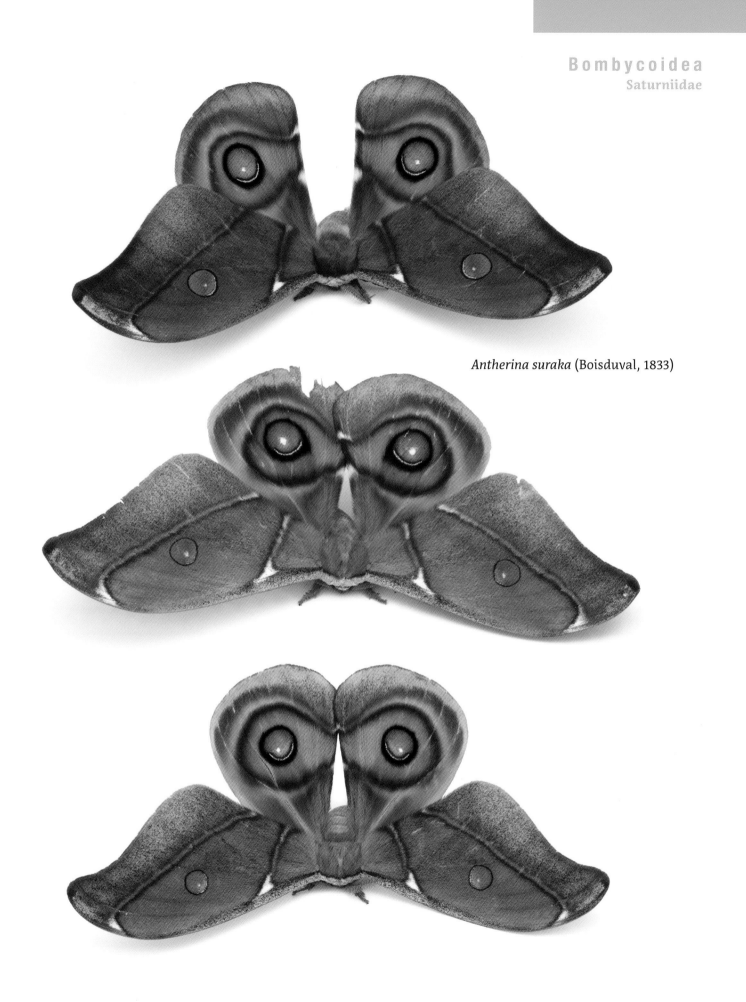

Antherina suraka (Boisduval, 1833)

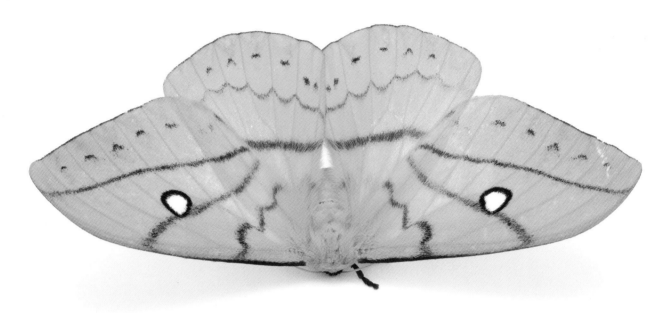

Maltagorea auricolor (Mabille, 1879)
female

Maltagorea auricolor (Mabille, 1879)
female

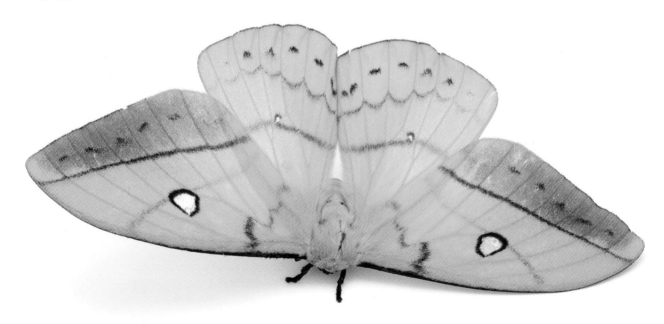

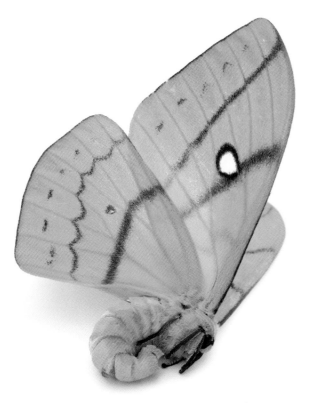

Maltagorea auricolor (Mabille, 1879)
female

Maltagorea auricolor (Mabille, 1879)
female

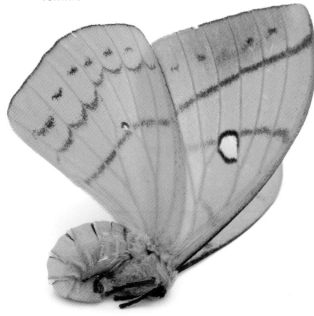

Hide and play dead …

Large moths like saturniids are particularly vulnerable to predators when they are active during the night, but also during the day when they rest motionless in the vegetation.

For species in the genus *Maltagorea*, it's all about not being seen and their wing patterns and colors make their detection by predators difficult among dead leaves. When discovered, individuals of *Maltagorea auricolor* have a very specific behavior: after releasing the support they were resting upon, they quickly curl their abdomen and tighten their legs against their body, effectively playing dead and using their wings to protect all the vital parts of their body.

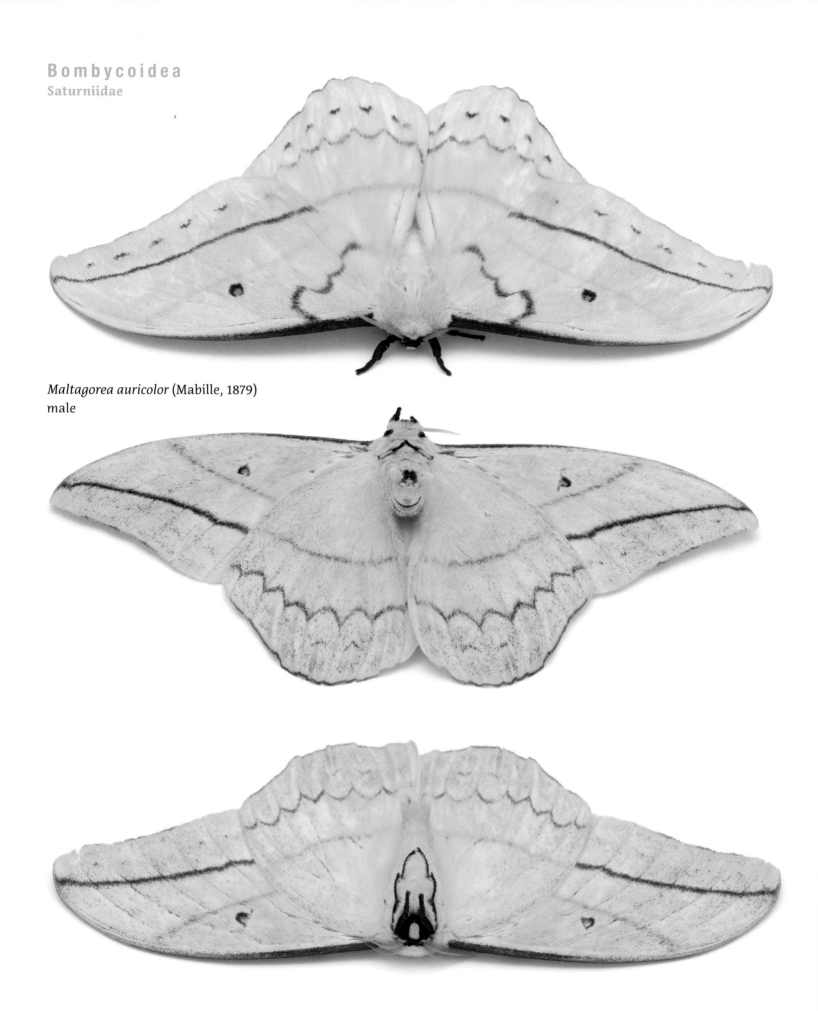

Maltagorea auricolor (Mabille, 1879)
male

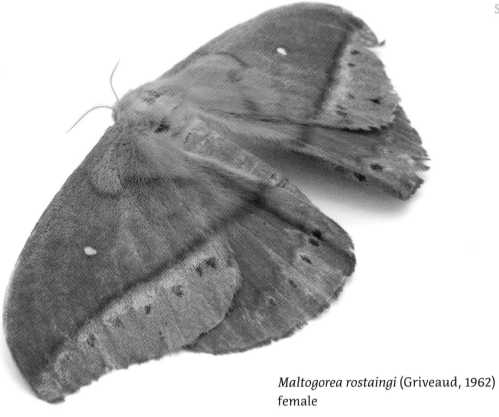

Maltogorea rostaingi (Griveaud, 1962)
female

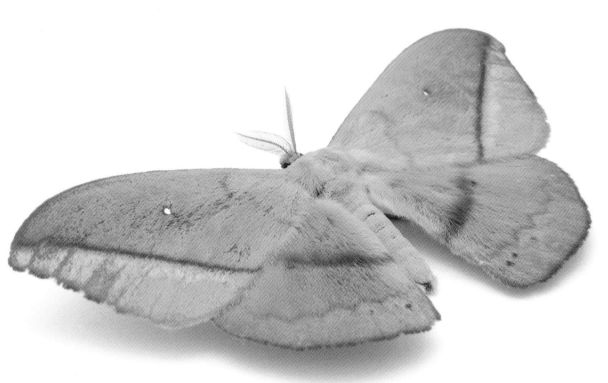

Maltogorea rostaingi (Griveaud, 1962)
male

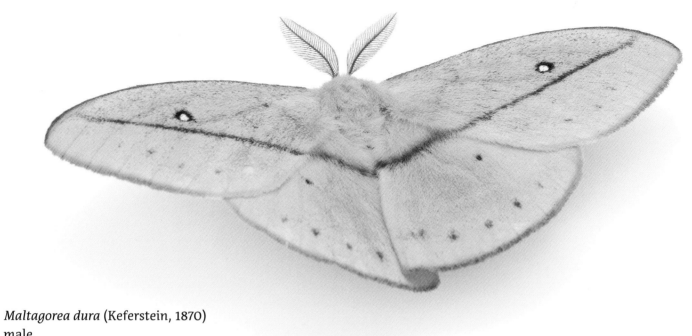

Maltagorea dura (Keferstein, 1870)
male

Maltagorea dura (Keferstein, 1870)
female

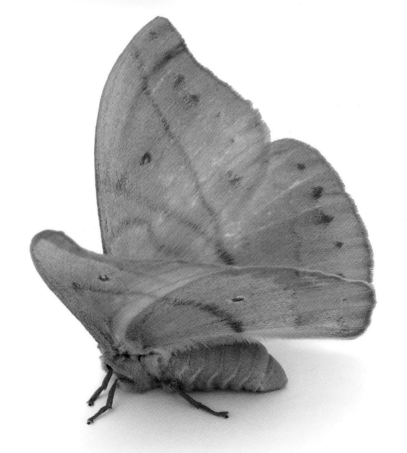

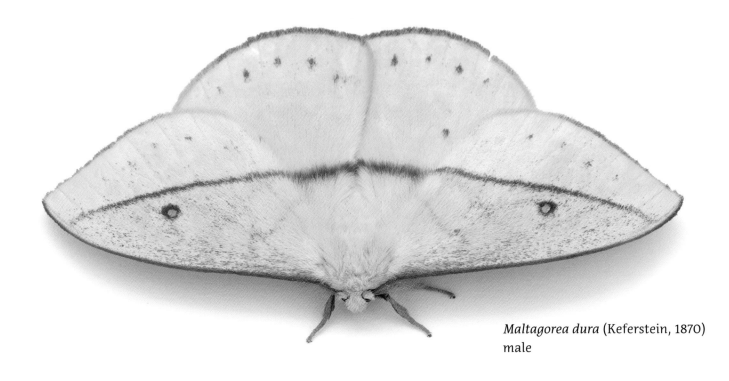

Maltagorea dura (Keferstein, 1870)
male

Maltagorea dura (Keferstein, 1870)
female

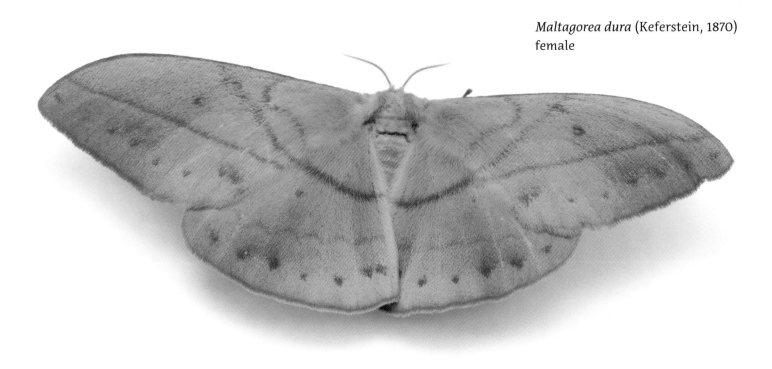

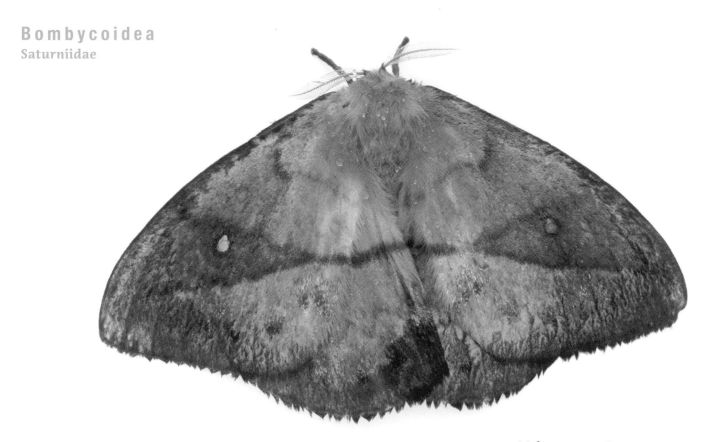

Maltagorea sp. Bouyer, 1993

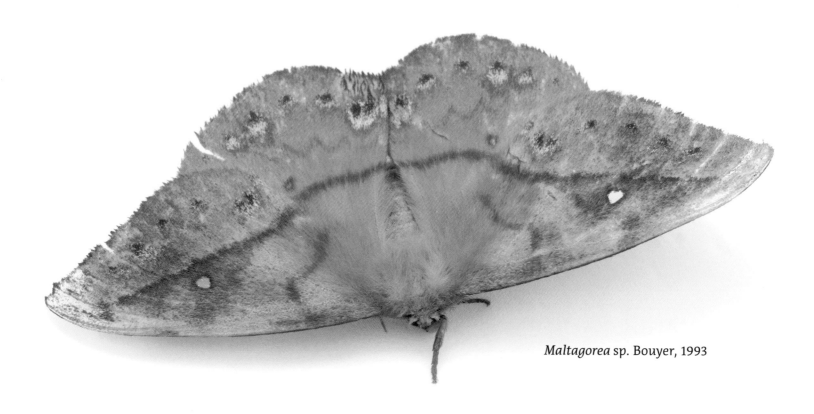

Maltagorea sp. Bouyer, 1993

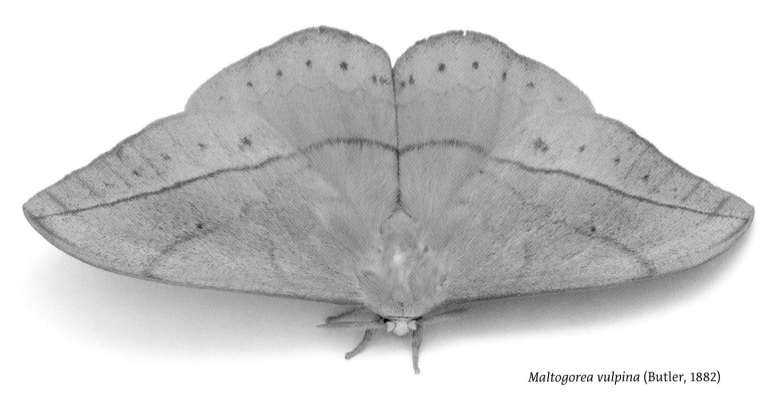

Maltogorea vulpina (Butler, 1882)

More species remain to be discovered

The genus *Maltagorea* is the only lineage of saturniid moths whose diversity exploded in Madagascar, with 22 distinct species recognized today. Of these, nine were discovered and described after the beginning of the 21st century, and it is expected that a few more species, from remote areas of Madagascar, remain to be unveiled and described as new for science by taxonomists. Standard methods now use a combination of morphological comparisons, with specimens in existing collections, and molecular analyses that build on the publicly available DNA sequences for these moths.

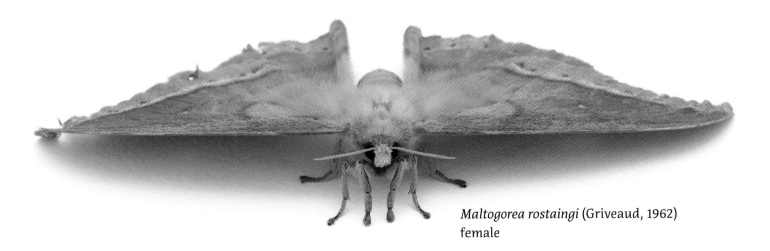

Maltogorea rostaingi (Griveaud, 1962)
female

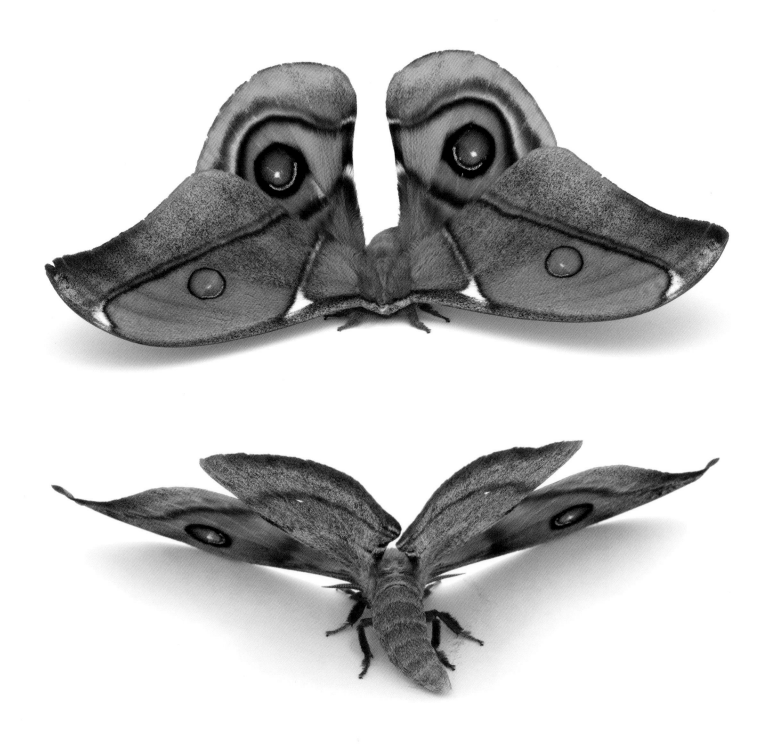

Antherina suraka (Boisduval, 1833)

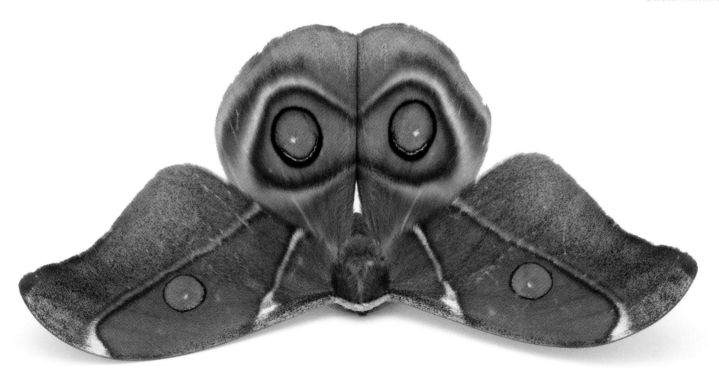

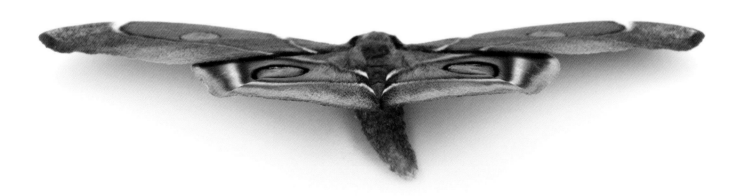

Antherina suraka (Boisduval, 1833)

153

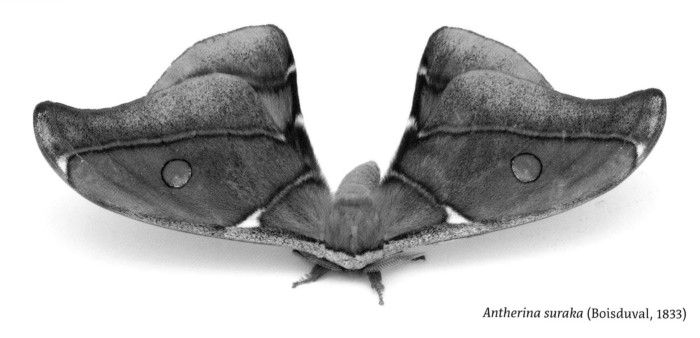

Antherina suraka (Boisduval, 1833)

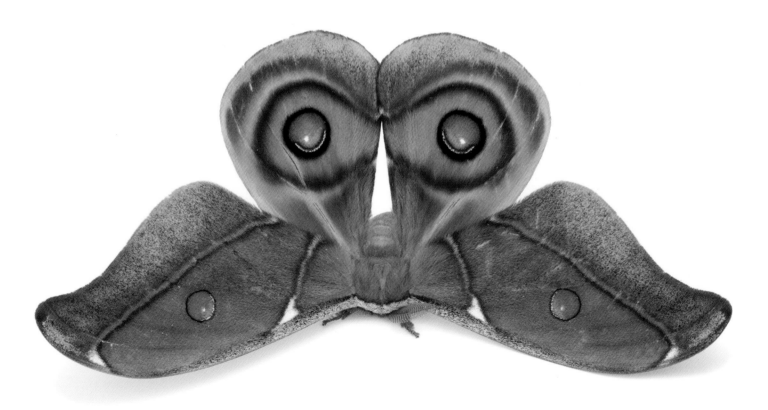

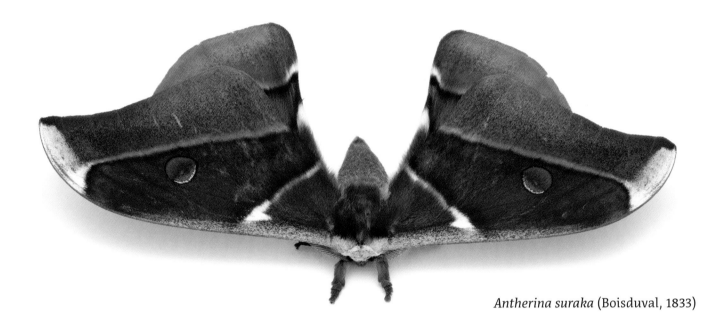

Antherina suraka (Boisduval, 1833)

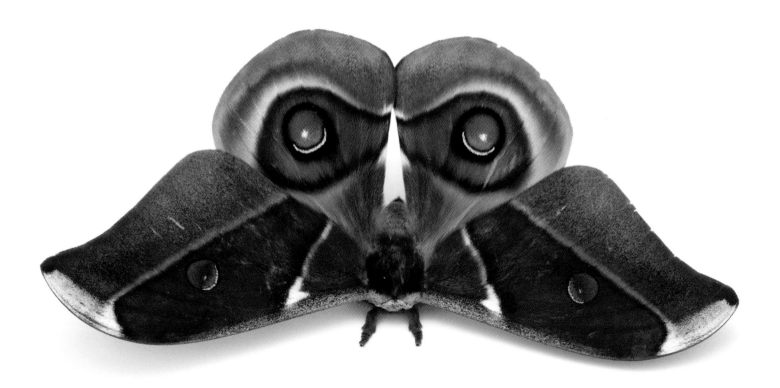

Rest position – defense

In rest position *Antherina* conceals the eyespots on the hindwings. After being disturbed all wings are raised slightly and spread so that the eyespots are visible. The displaying of these "false eyes" is intensified by a rhythmic sideways movement of the hindwings against each other inward toward the body.

155

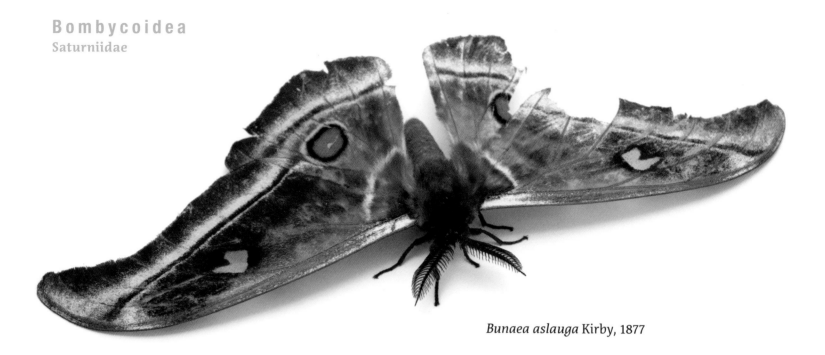

Bunaea aslauga Kirby, 1877

Life's (too) short

While the early stages of their development can span over several months, the life of adult saturniid moths is very short, rarely exceeding a week in nature. These large insects do not feed as adults and simply live upon the reserve accumulated during the larval stages. When flying erratically at night to find the chemical clues that will lead them to a female, the male saturniids often suffer severe damage to their wings, either from the vegetation they fly through, or from the teeth of their nocturnal predators such as bats ... Their chances of surviving the quest for a partner are thin.

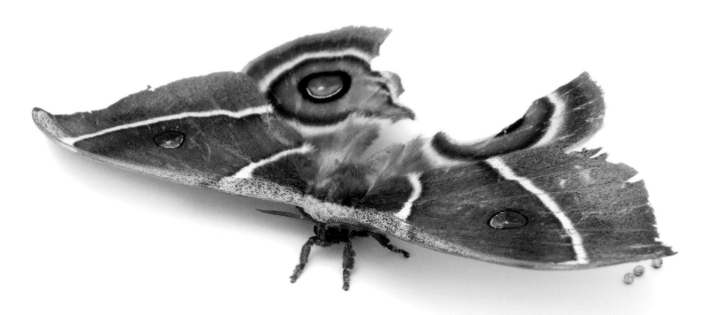

Antherina suraka (Boisduval, 1833)

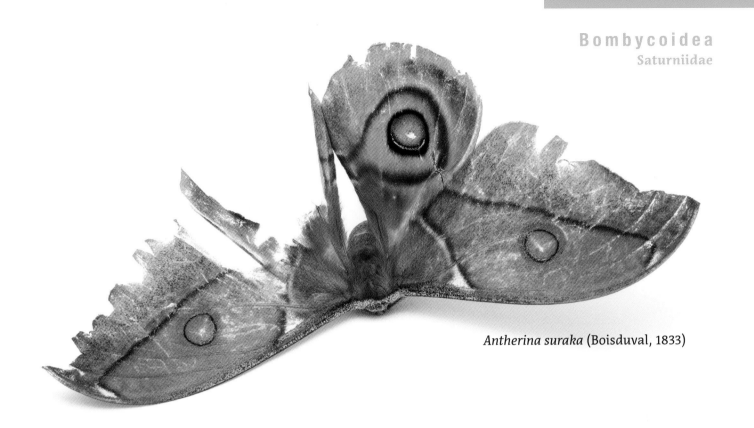

Antherina suraka (Boisduval, 1833)

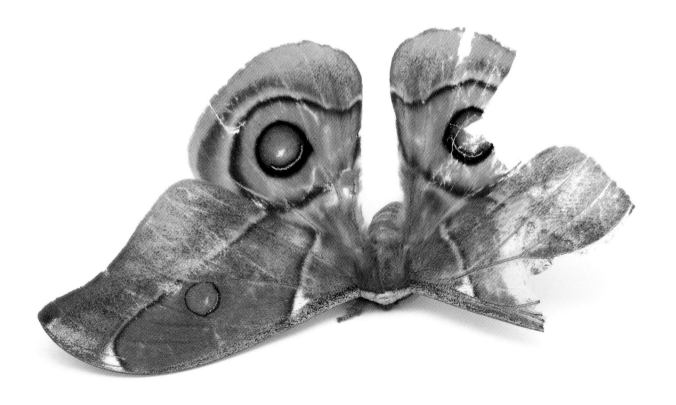

157

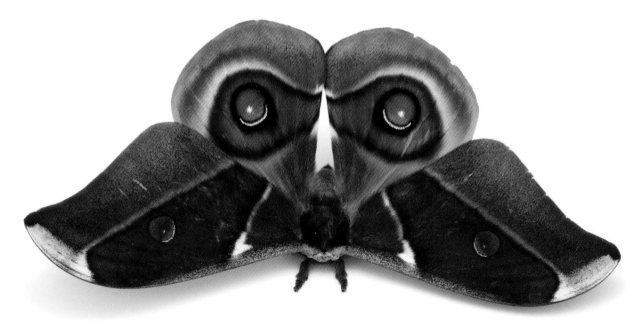

Don't bite off more than you can chew

Eyespots are a very common feature found on the hindwings of saturniid moths worldwide. In the Madagascan species *Antherina suraka*, these motifs are very realistic and mirror in both size and aspect the eyes of much larger animals such as lemurs. When attacked, by brusquely displaying their previously hidden hindwings, the moth surprises its predator with the unexpected stare of a much bigger, threatening animal, and thus triggers abortion of the attempt.

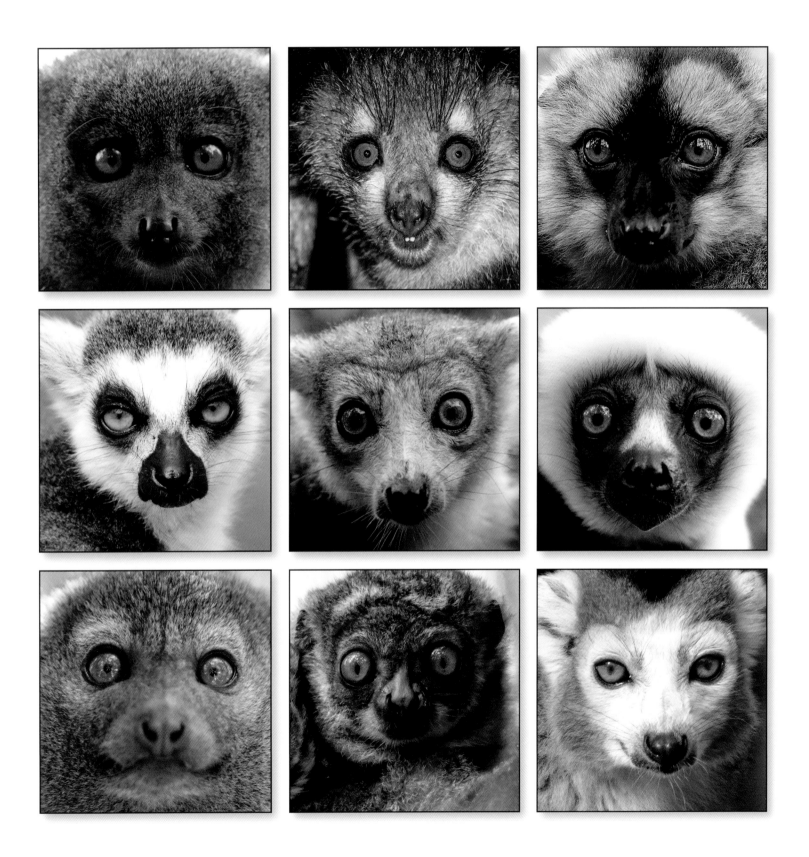

Sphingidae (hawkmoths)

Text by David Lees

The hawkmoths are among the most charismatic of all moths. Their name derives from a supposed Sphinx-like resting posture of some larvae. They boast at least 1,443 species worldwide. In Madagascar, there are at least 64 species, of which some half are endemic. The hawkmoths are large and robust moths, many with sleek, arched forewings with pointed apices, ideally for fast flight, and so some, like Acherontia atropos, are powerful migrants.

The subfamily Smerinthinae (e. g. *Gynoeryx meander* (Boisduval, 1875) do not feed as adults and have reduced proboscises, whereas those of the subfamily Macroglossinae often have quite long tongues, ideal for pollination of flowers with long nectar tubes, such as those of the coffee family Rubiaceae, or even orchids. The moth, indeed the insect, with the longest reported insect tongue is Wallace's Sphinx *Xanthopan praedicta*. Recently raised to species level, this is an iconic species of hawkmoth that was imagined by Darwin and Wallace to exist in Madagascar as the specialist pollinator of an endemic orchid with an approximately 30 cm long corolla, *Angraecium sesquipedale*, also known as Darwin's Star Orchid. Record holders of this moth have only recently been found in Madagascar possessing (in the male) a 28–28.5 cm long proboscis. This is exactly within the range (10–11 inches) imagined by Darwin in 1862. The moth was, however, only described in 1903 by Lord Walter Rothschild and Karl Jordan, although *Xanthopan morganii* (which has on average a shorter proboscis) was known to exist in Africa, and indeed Alfred Russel Wallace in 1877 included a figure of just such a moth flying to this plant in the Madagascar rainforest. Yet there was no actual observation of such a visit to *A. sesquipedale* until 2004.

Another moth with a long proboscis, which is also a member of the subfamily Sphinginae, is *Coelonia insularis* Basquin, 2021, only recently realized to be endemic to the island. A relative, *C. solani* (see p. 187) has a really long proboscis sometimes over 20 cm rivaling that of *Xanthopan praedicta* and even pollinates a different star orchid *Angraecum sororium*, among other flowers it visits. However, these orchids may be helplessly dependent on these species of moths for transfer of their pollen far and wide.

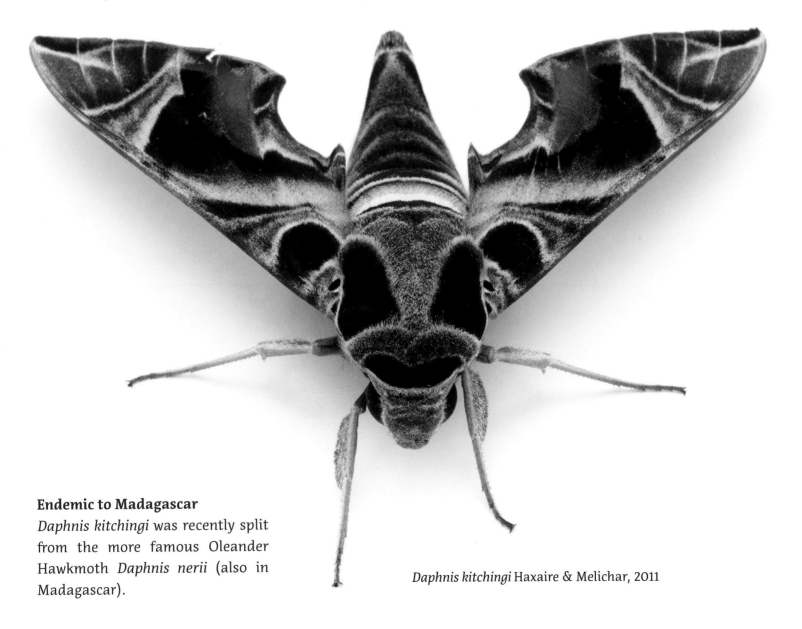

Endemic to Madagascar
Daphnis kitchingi was recently split from the more famous Oleander Hawkmoth *Daphnis nerii* (also in Madagascar).

Daphnis kitchingi Haxaire & Melichar, 2011

Wallace's Sphinx

Text by David Lees

Xanthopan praedicta, recently raised to species level, is an iconic species of sphingid moth that was imagined by Darwin and Wallace to exist in Madagascar as the specialist pollinator of an orchid with an approximately 30 cm long corolla, *Angraecium sesquipedale* Thouars, 1822.

Artist: Thomas W. Wood

Specimens of this moth have only recently been found in Madagascar possessing a very long proboscis. Darwin predicted, that this moth should have a 10–11 inches long proboscis, so it can use the nectar tube of *Angraecium* and pollinate this orchid. The moth was only described in 1903 by Rothschild and Jordan, although *Xanthopan morganii* (which has on average a shorter proboscis) was known to exist in Africa, as it was described (as a species of *Macrosila*) by Francis Walker in 1856.

Alfred Russel Wallace
whose name was adopted for the moth's common name, went as far as to say in 1867: *"That such a moth exists in Madagascar may be safely predicted, and naturalists who visit that island should search for it with as much confidence as astronomers searched for the planet Neptune, and they will be equally successful."*

Glowing tapetum
When moths are found at night, the tapetum often glows red. This effect vanishes during daylight.
Photo: David Lees

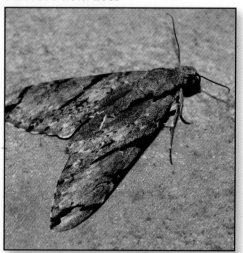

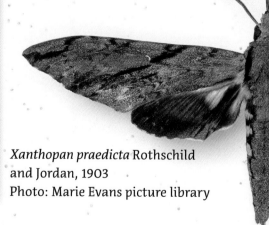

Xanthopan praedicta Rothschild and Jordan, 1903
Photo: Marie Evans picture library

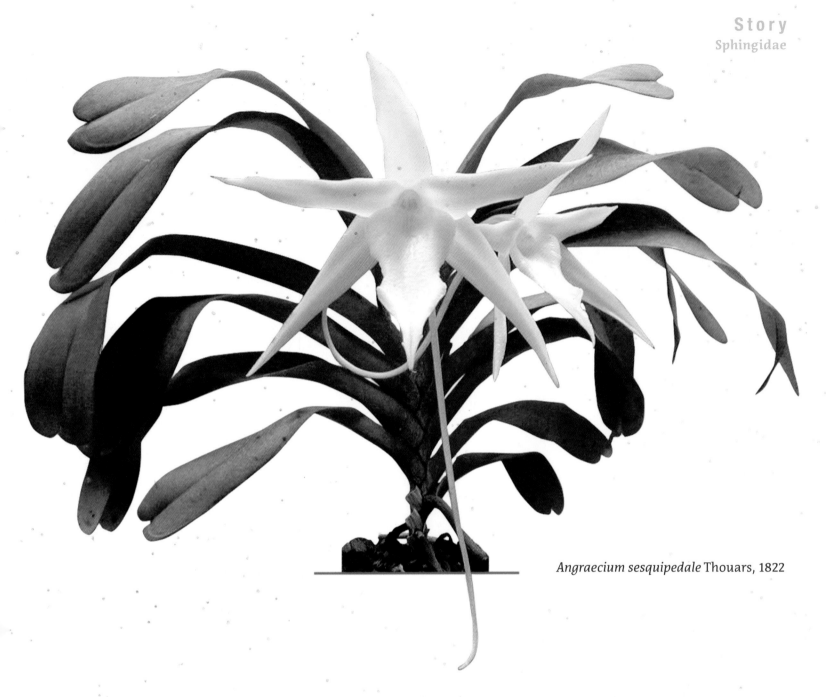

Angraecium sesquipedale Thouars, 1822

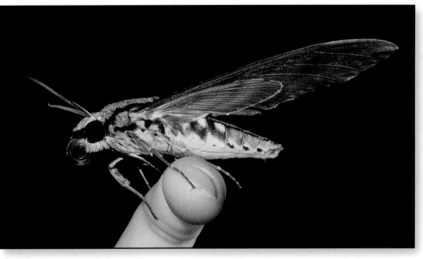

Camounflage

The upperside of the wings is gray with black streaks camouflaging the moth on tree trunks, while the underside is pinkish.

X. praedicta

With rolled-up proboscis ready to fly away. Note the pinkish coloration. Photo: Marcin Wiorek

Wallace's Sphinx

Text by David Lees

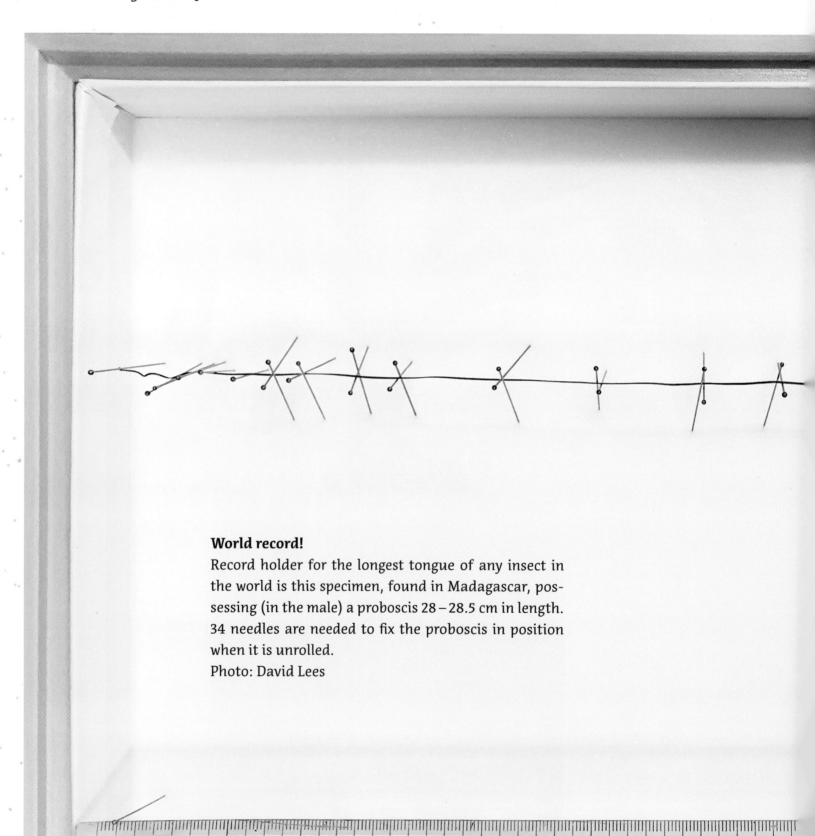

World record!
Record holder for the longest tongue of any insect in the world is this specimen, found in Madagascar, possessing (in the male) a proboscis 28 – 28.5 cm in length. 34 needles are needed to fix the proboscis in position when it is unrolled.
Photo: David Lees

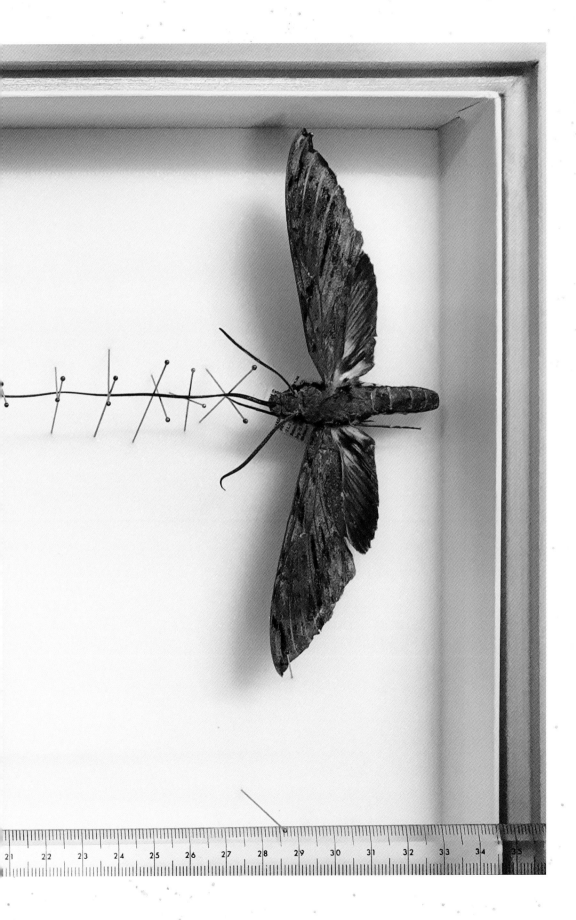

Charles Darwin
Bad luck! Darwin never saw this moth, he died 21 years before its description, not realizing that 19th century specimens had already existed from Madagascar.

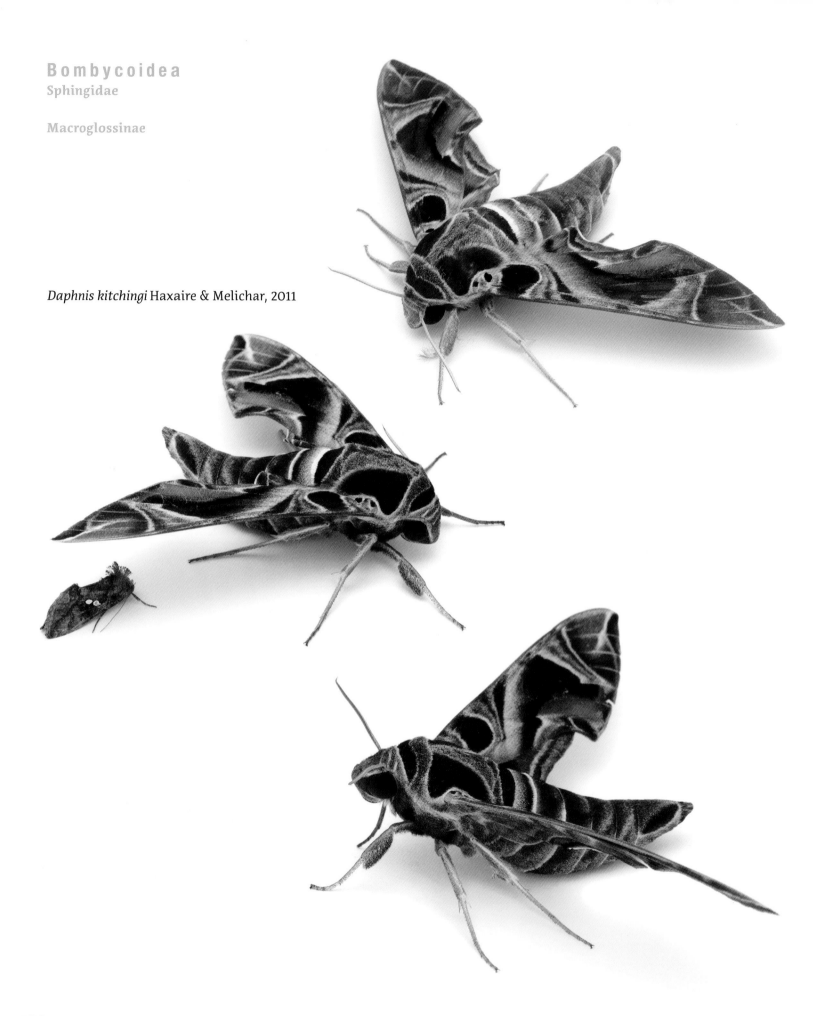

Bombycoidea
Sphingidae

Macroglossinae

Daphnis kitchingi Haxaire & Melichar, 2011

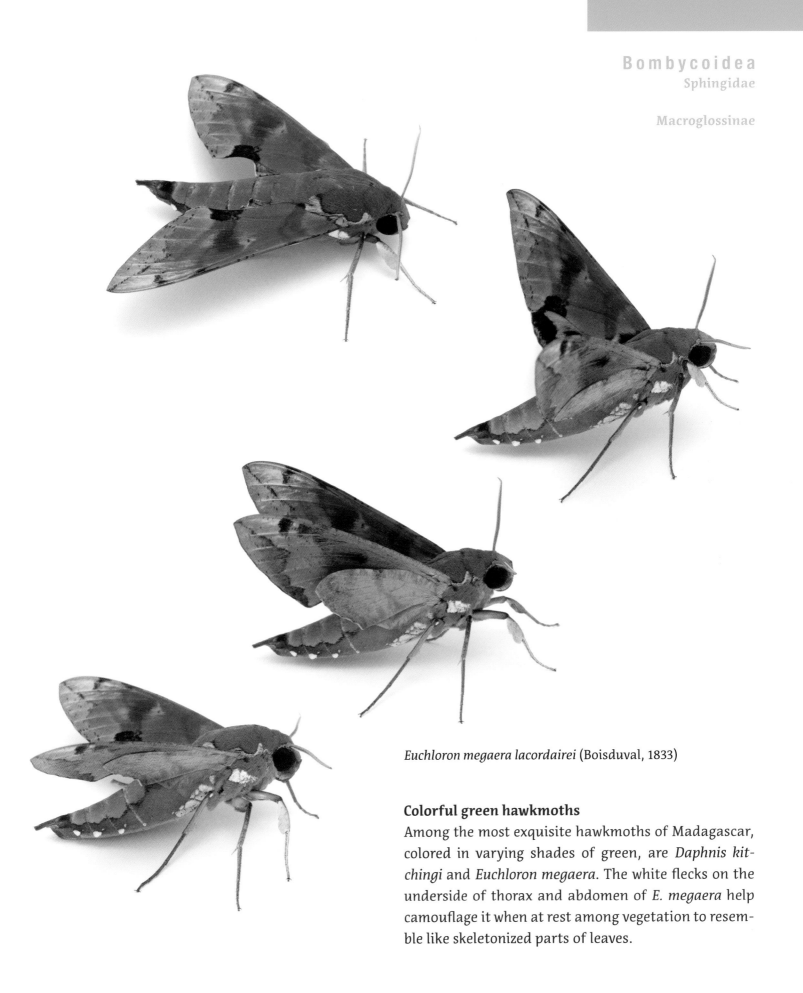

Euchloron megaera lacordairei (Boisduval, 1833)

Colorful green hawkmoths

Among the most exquisite hawkmoths of Madagascar, colored in varying shades of green, are *Daphnis kitchingi* and *Euchloron megaera*. The white flecks on the underside of thorax and abdomen of *E. megaera* help camouflage it when at rest among vegetation to resemble like skeletonized parts of leaves.

167

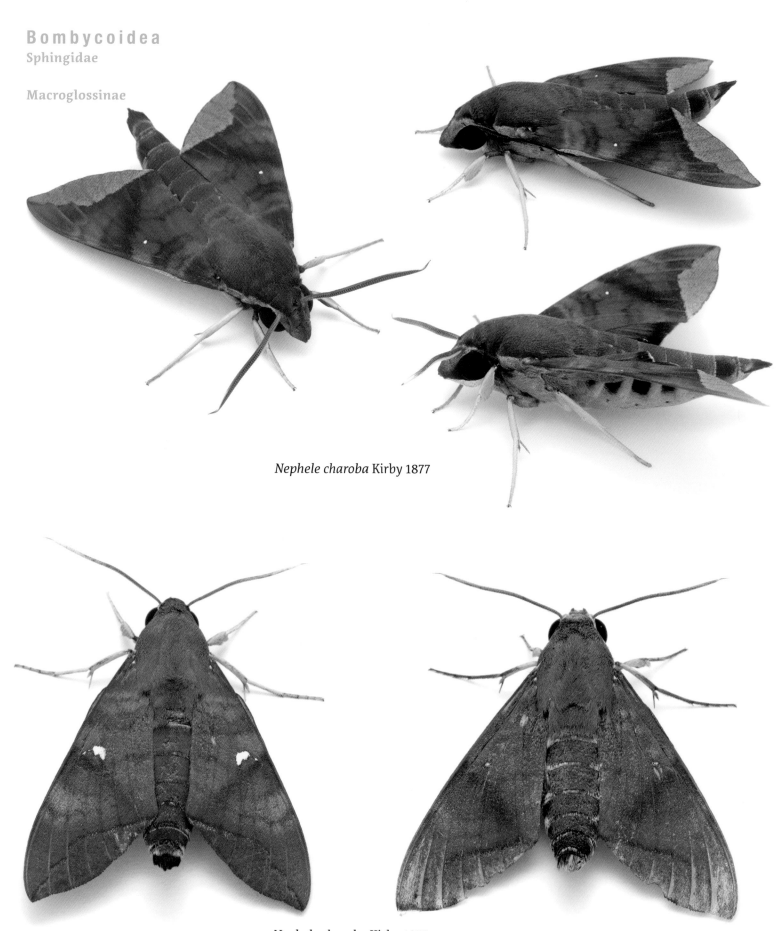

Nephele charoba Kirby 1877

Nephele charoba Kirby 1877

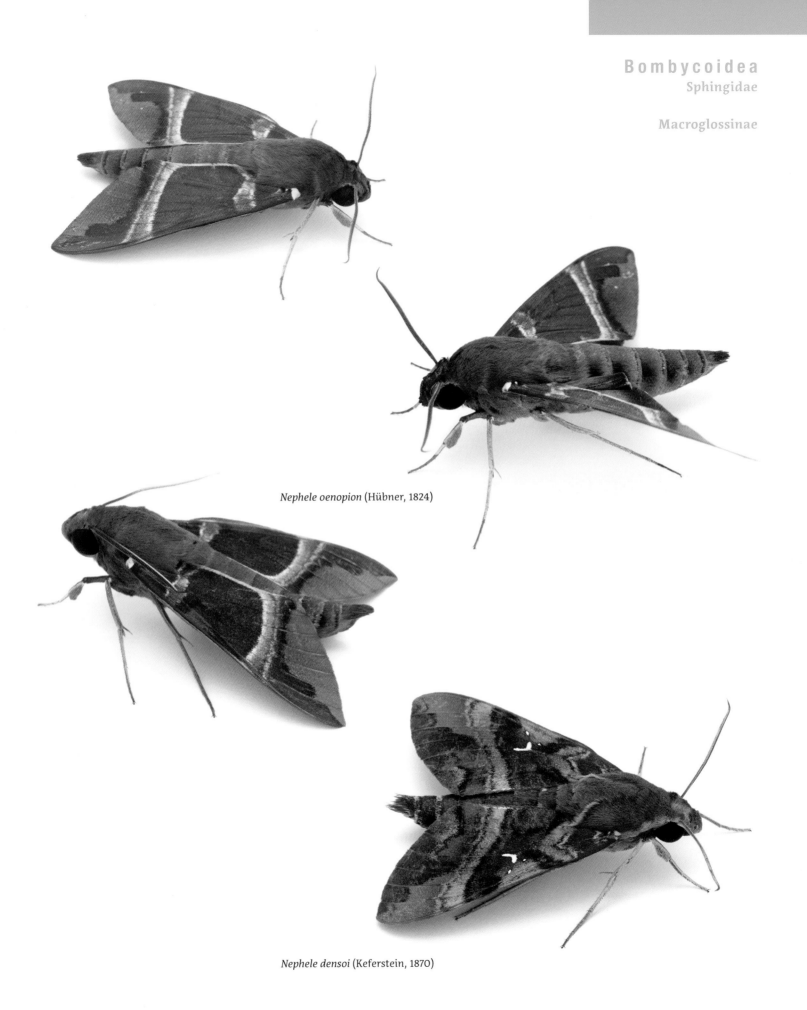

Nephele oenopion (Hübner, 1824)

Nephele densoi (Keferstein, 1870)

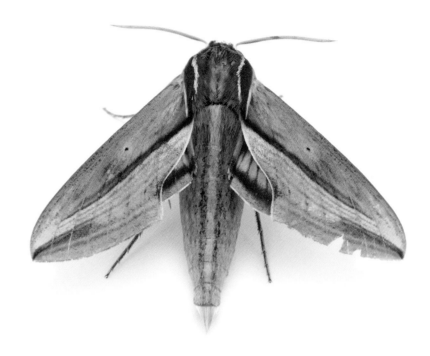

Hippotion aurora (Rothschild & Jordan, 1903)

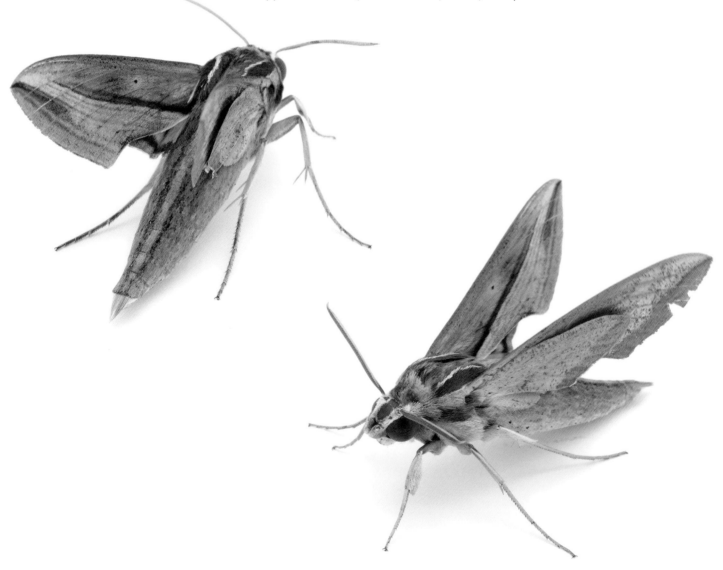

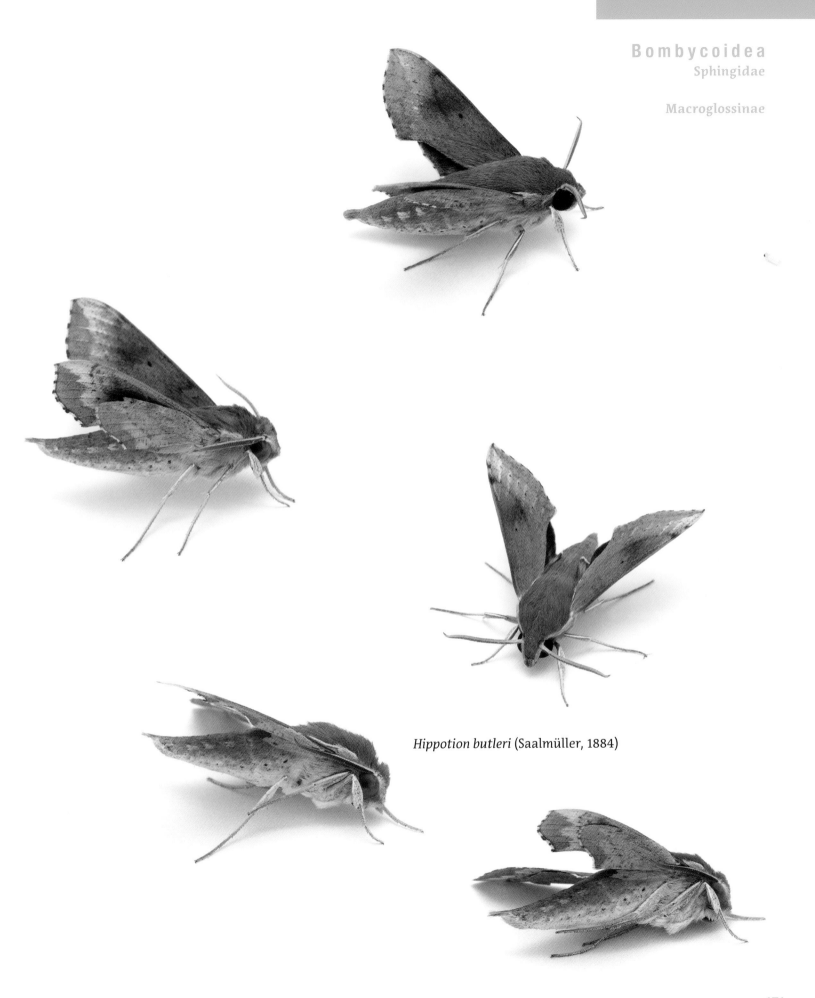

Hippotion butleri (Saalmüller, 1884)

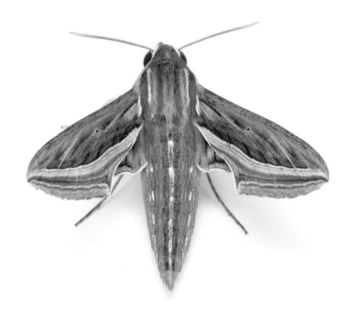

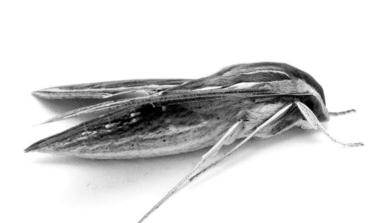

Hippotion celerio (Linnaeus, 1758)

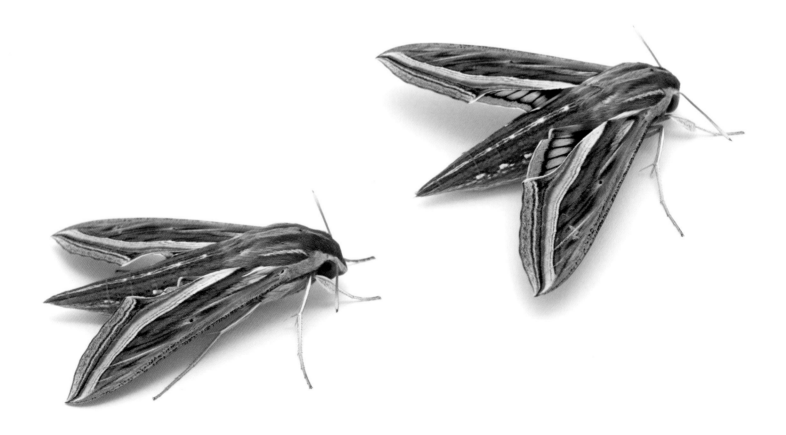

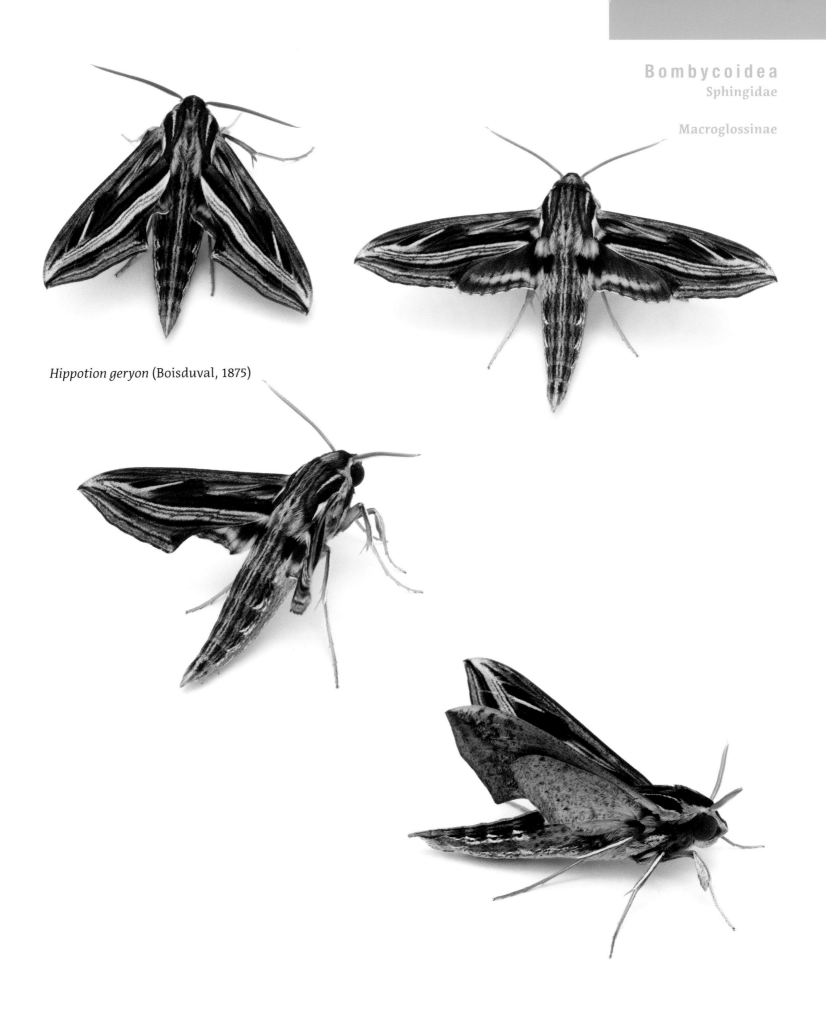

Hippotion geryon (Boisduval, 1875)

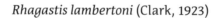

Rhagastis lambertoni (Clark, 1923)

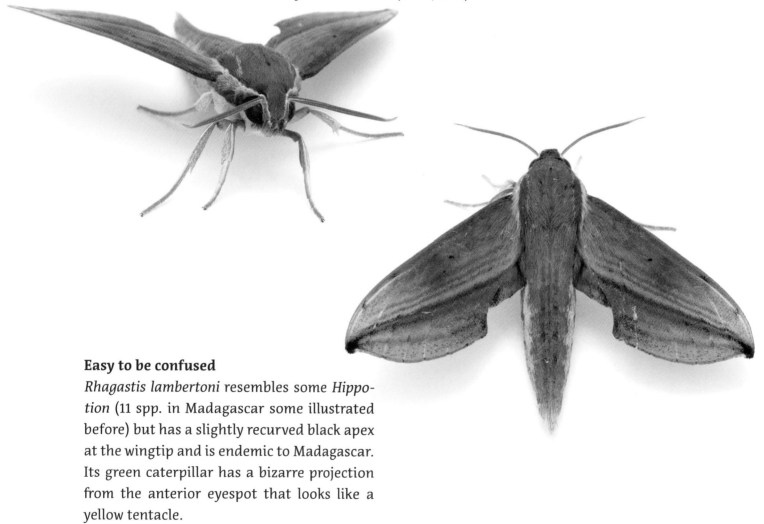

Easy to be confused
Rhagastis lambertoni resembles some *Hippotion* (11 spp. in Madagascar some illustrated before) but has a slightly recurved black apex at the wingtip and is endemic to Madagascar. Its green caterpillar has a bizarre projection from the anterior eyespot that looks like a yellow tentacle.

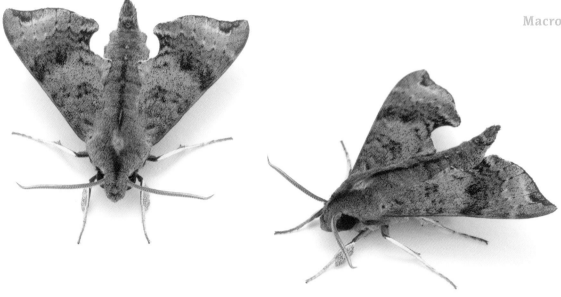

Temnora grandidieri (Butler, 1879)

Sphingonaepiopsis malgassica (Clark, 1929)

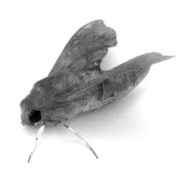

Dwarfs in hawkmoths

A genus with nine species of only medium size in Madagascar is *Temnora* (the commonest is *Temnora grandidieri* (Butler, 1879)). But *Sphingonaepiopsis malgassica* (Clark, 1929) is truly minute for a hawkmoth (about 2.5 cm wingspan) and it is an amazing sight to watch a small buzzing squadron of these tiny sphingids visiting flowers at dusk. The most famous hoverers in Madagascar are the species of the genera *Cephenodes* (great mimics of bees) and *Macroglossum* (closely resembling hummingbirds) when they fly to flowers by day, taking off at considerable speed.

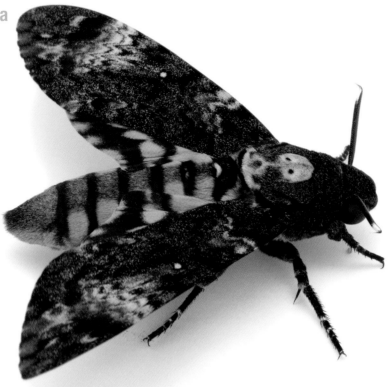

Acherontia atropos (Linnaeus, 1758)

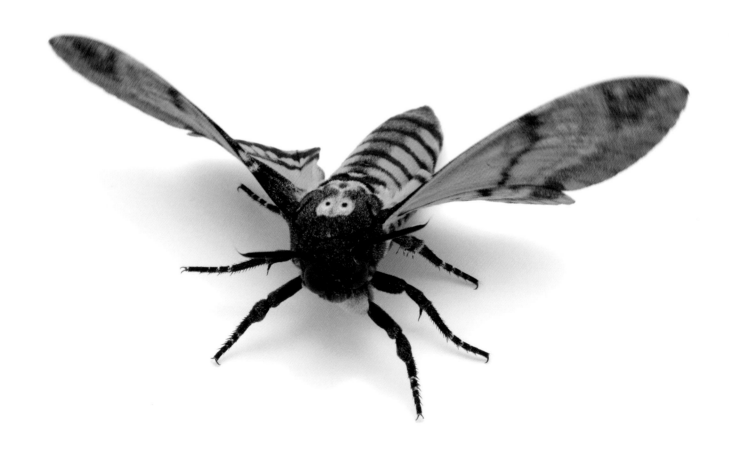

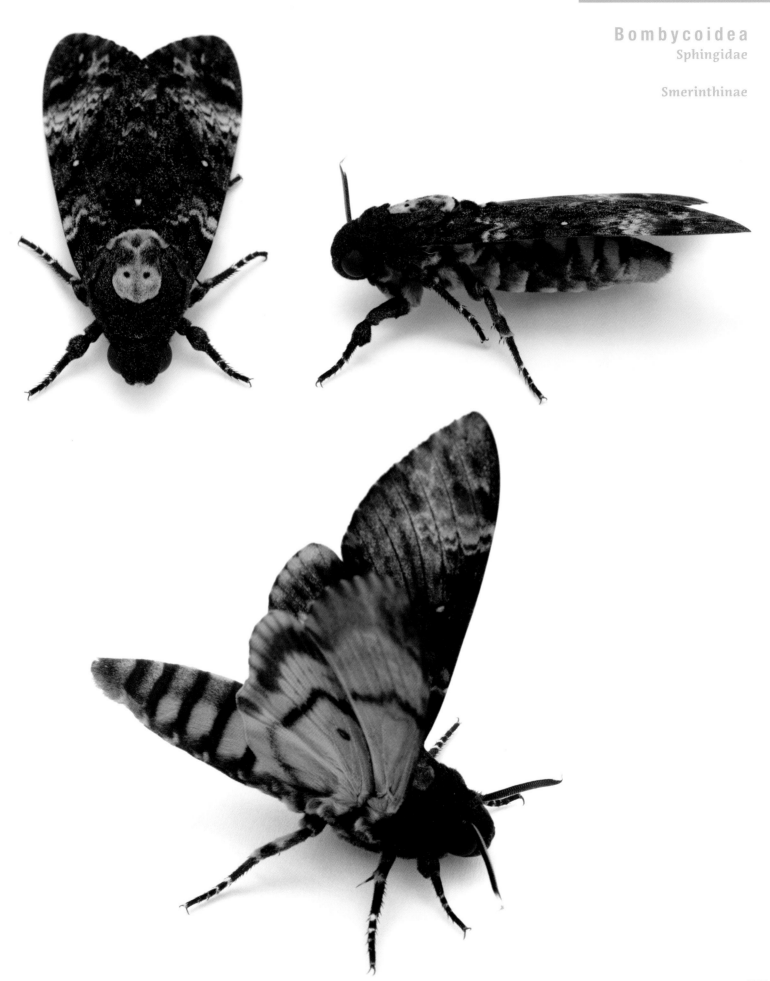

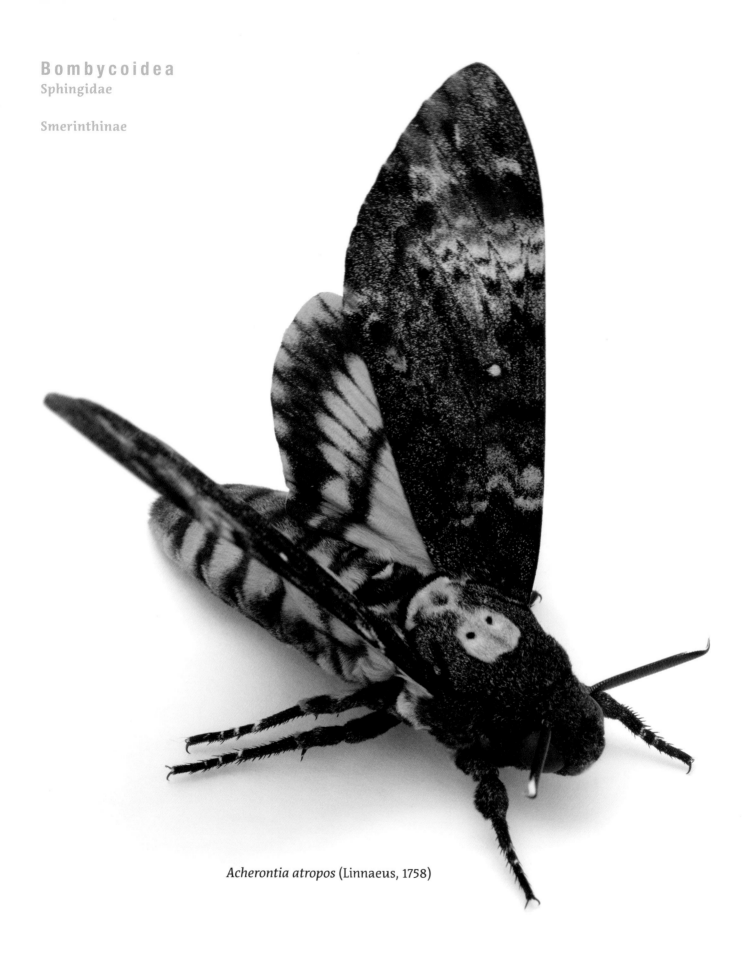

Acherontia atropos (Linnaeus, 1758)

Huge range – same looks

The genus *Acherontia* comprises three species (*A. lachesis*, *A. styx* and *A. atropos*). The distribution range of *A. atropos*, a species which migrates over long distances, is enormous and extends from the Afrotropic, including Madagascar, through Türkiye as far as northern Europe.

Madagascar, Makira,
03/21/2022 at 23:22

Germany, Markelfingen,
09/24/2020 at 22:23

Mimic of a queen bee

One of the more famous hawkmoths in the world is the Death's Head Hawkmoth *Acherontia atropos* (Linnaeus, 1758). It squeaks when disturbed and even sometimes in flight, and for food it plunders beehives at night, its short, sharp tongue being especially adapted for piercing honeycombs. This moth usually has a sinister reputation because of the skull-like markings on the thorax and strange behavior. They mimic attributes of queen bees such as the banded patterns of the body, the squeaking, and the use of pheromones to avoid being stung to death.

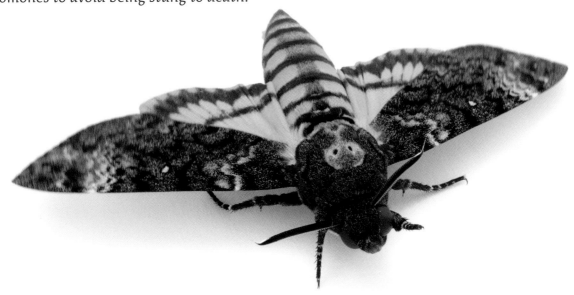

Batocnema coquerelii (Boisduval, [1875])

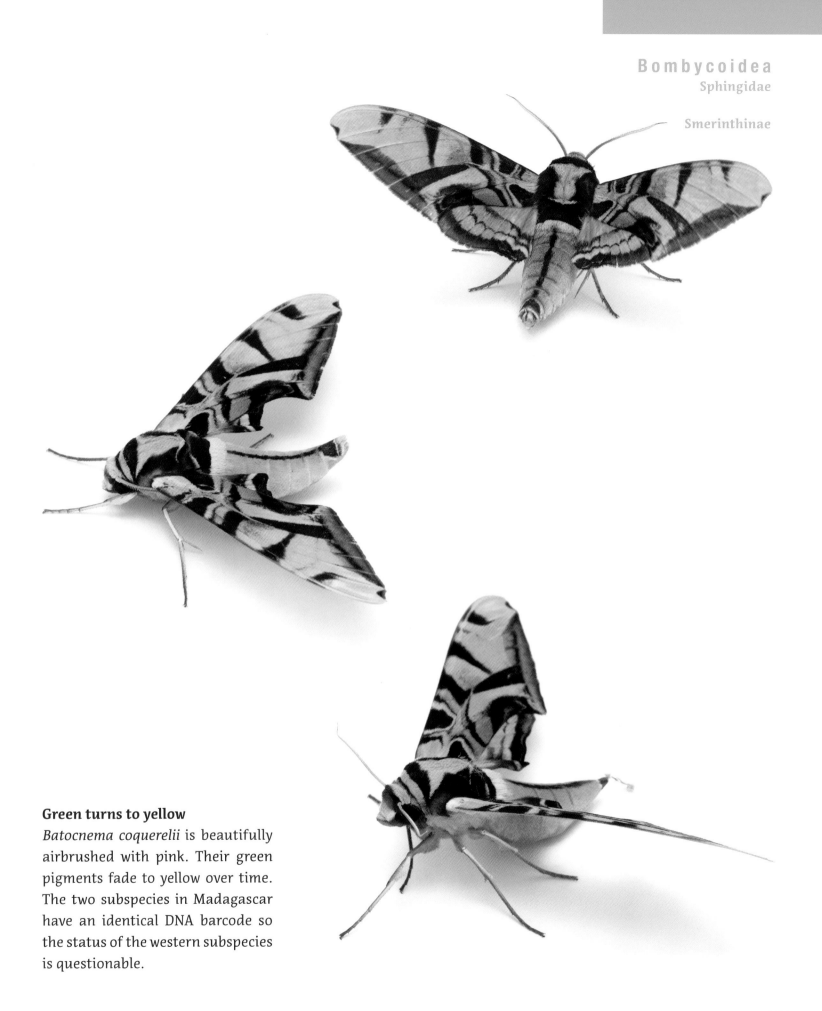

Green turns to yellow

Batocnema coquerelii is beautifully airbrushed with pink. Their green pigments fade to yellow over time. The two subspecies in Madagascar have an identical DNA barcode so the status of the western subspecies is questionable.

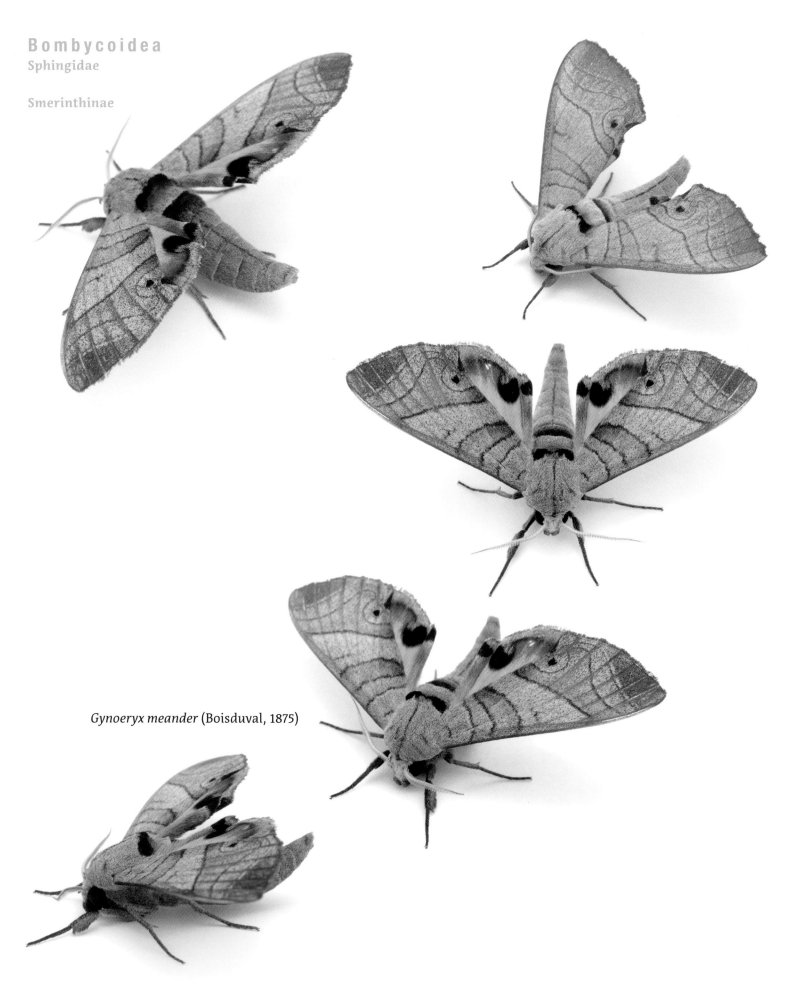

Gynoeryx meander (Boisduval, 1875)

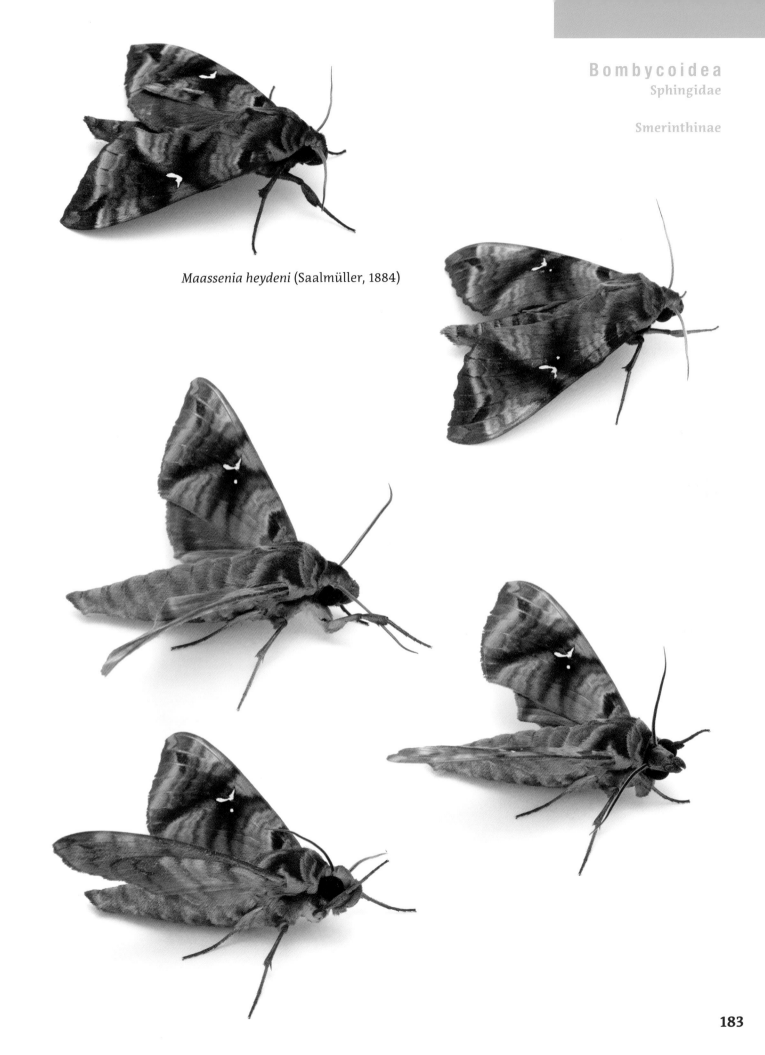

Maassenia heydeni (Saalmüller, 1884)

Sound-producing moth

Another hawkmoth and the one perhaps with the most unusual resting posture and behavior is *Pseudoclanis grandidieri* (Mabille, 1879). Although other hawkmoths make sounds, both sexes of this moth make a loud clattering noise when disturbed, as well as sometimes sticking their sharp leg spurs into the hand of the person who tries to pick one up. Although some sphingids such as *Xanthopan praedicta* and *Hippotion* spp. produce noises by scraping together the male genital valves, it is possible that the female of *P. grandidieri* does it from the mouth by pulsing air through its epipharynx, as does *A. atropos*. Note also the sharp tibial spurs that the moth is not reluctant to use for jabbing if it is disturbed.

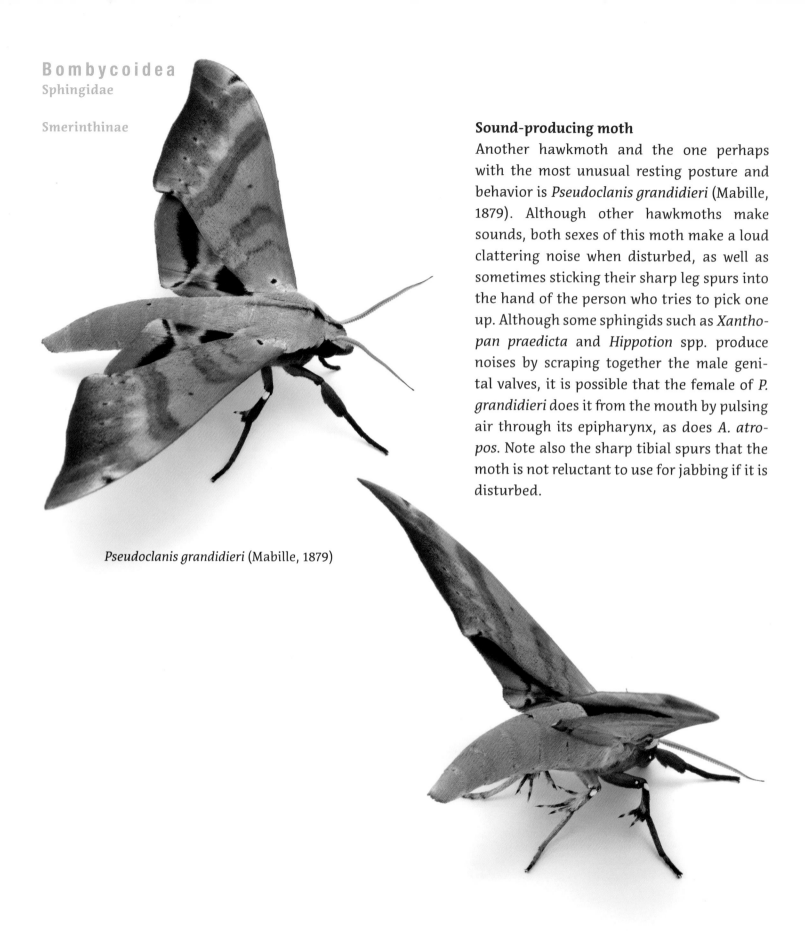

Pseudoclanis grandidieri (Mabille, 1879)

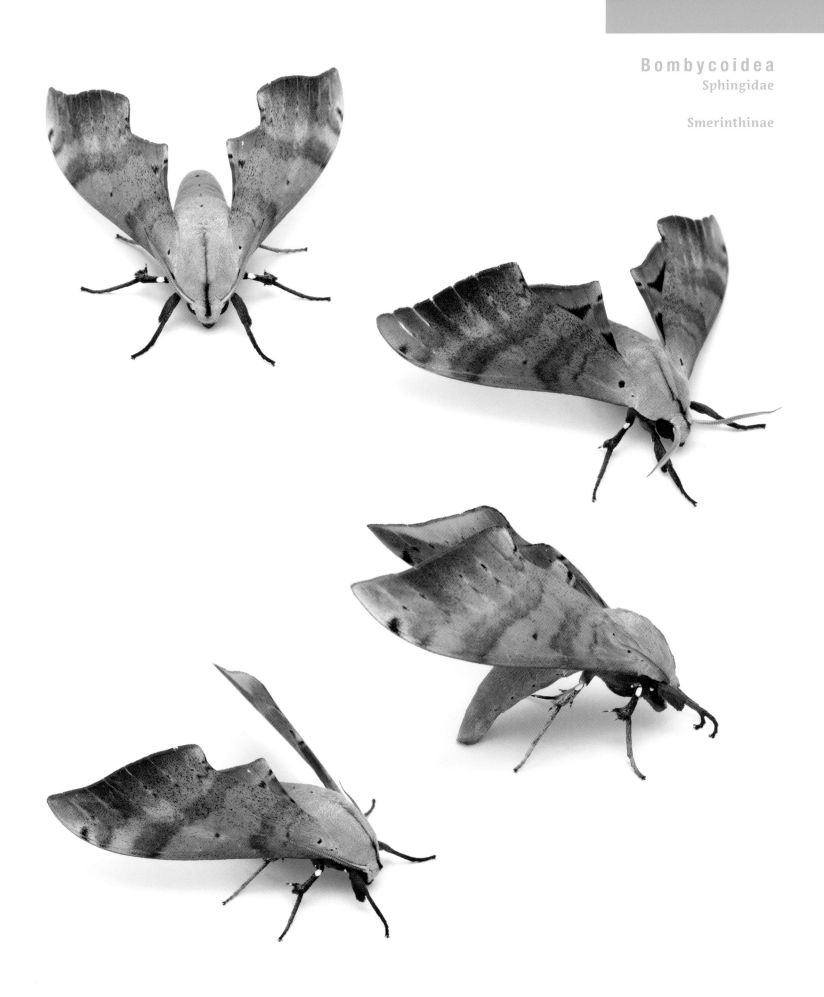

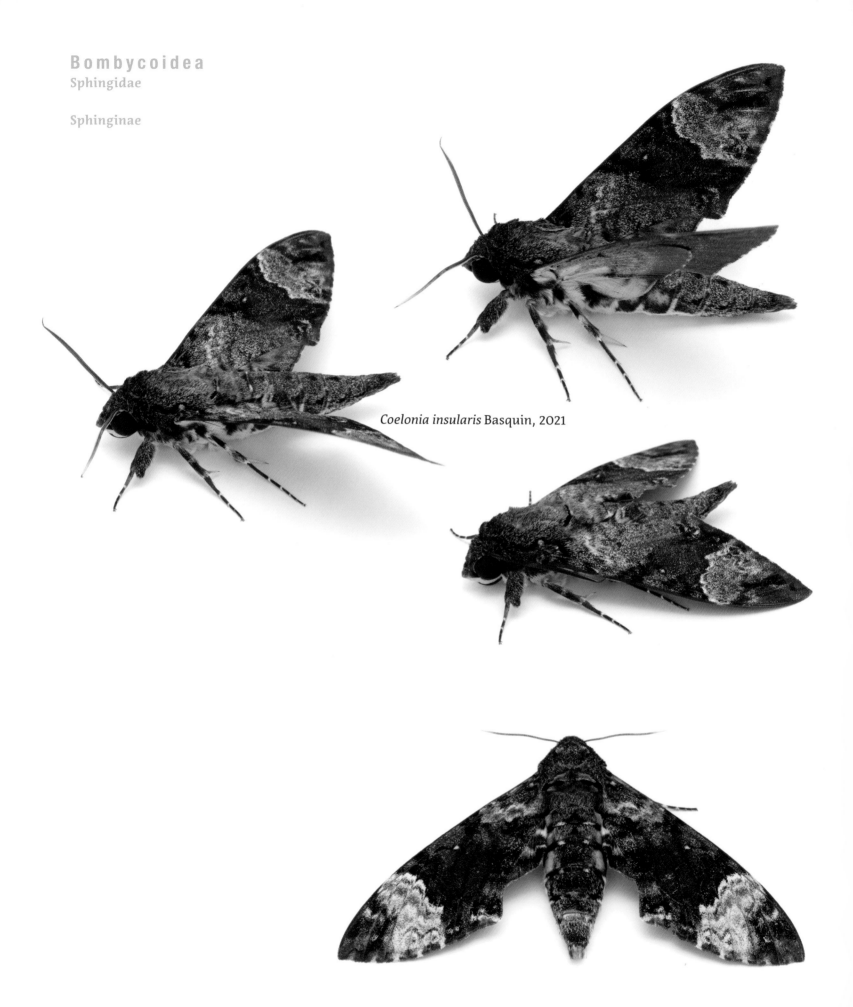

Coelonia insularis Basquin, 2021

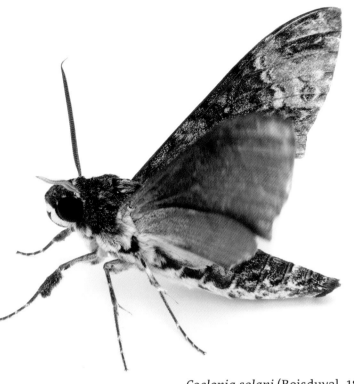

Symbiotic relationship with an orchid

Coelonia solani possesses a very long proboscis and pollinates the long-spurred orchid *Angraecum sororium*. Such a close evolutionary relationship can become a one-way journey without a happy end. Another member of the genus, *Angraecum longicalcar*, has a spur on average much longer than the proboscis of any known Madagascan moth species. This orchid is currently known only from a single, endangered population and, despite many efforts, scientists still have not detected any potential pollinator of this plant. Thus, hypothetically there could have been another species of long-proboscis hawkmoth that is now extinct ...

Coelonia solani (Boisduval, 1833)

187

Sphinginae *Coelonia insularis* Basquin, 2021

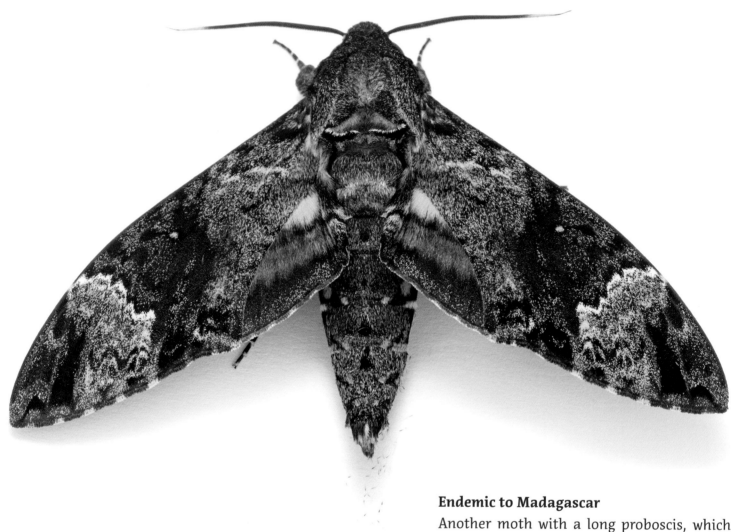

Endemic to Madagascar

Another moth with a long proboscis, which is also a member of the subfamily Sphinginae, is *Coelonia insularis* Basquin, 2021, only recently determined to be endemic to the island. On the left side, a color variation found in Makira, to the right, the same species found in Masoala.

Coelonia insularis Basquin, 2021

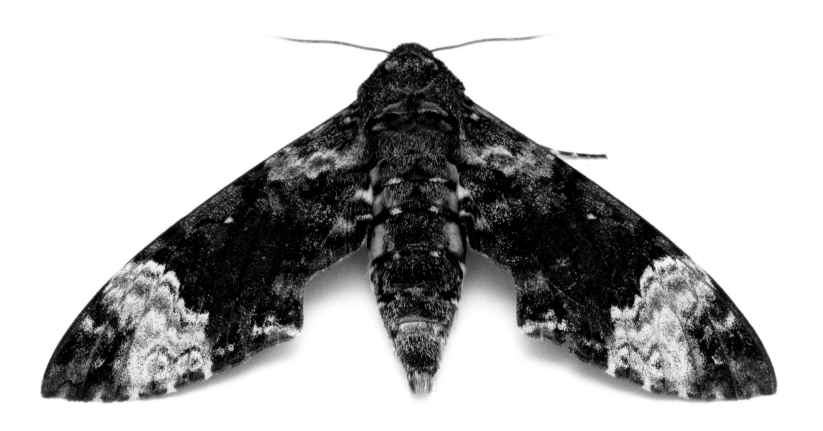

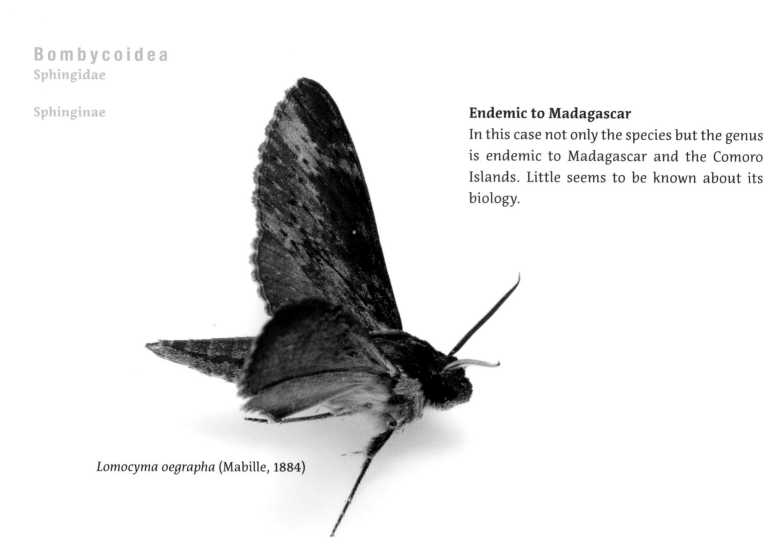

Endemic to Madagascar
In this case not only the species but the genus is endemic to Madagascar and the Comoro Islands. Little seems to be known about its biology.

Lomocyma oegrapha (Mabille, 1884)

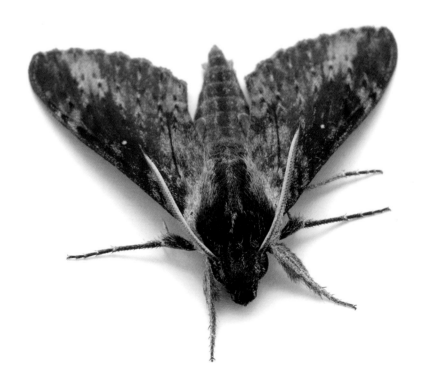

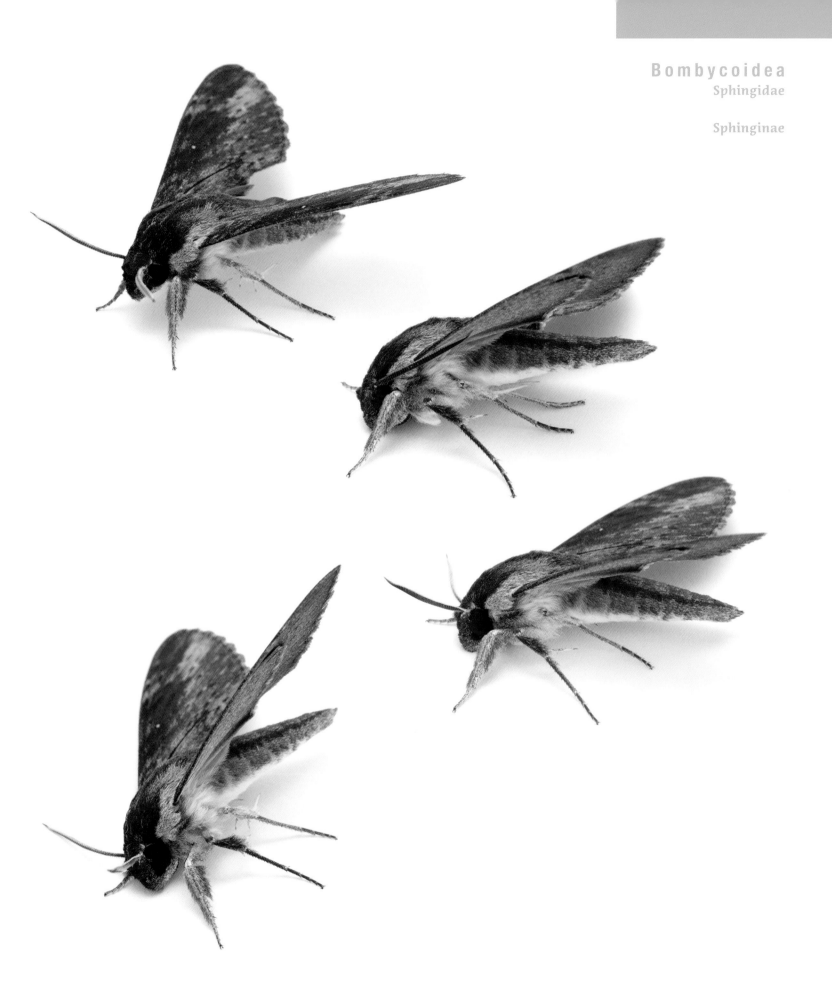

Lasiocampiodea (Lappet moths)

Text by Marcin Wiorek

The family Lasiocampidae, the only member of the superfamily Lasiocampoidea, is a relatively small group of around 1,950 species distributed worldwide. From Madagascar aroud 100 species have been recorded. To this family belong some quite big moths, and as you can see in the photos displayed in this chapter, they are very often colored uniformly, in brown or ochraceous, with only a poorly marked wing pattern. A specific character of these moths is the manner of folding their wings in the resting position. The forewings are oriented downwards, resembling somehow a roof over the abdomen, while the margins of the hindwings generally protrude horizontally from underneath, which serves to break up their outline.

The cocoons spun around themselves by the caterpillars of *Borocera* species before pupation are used in Madagascar to produce silk – as for those of some Saturniidae species. The silk created from *Borocera* is in Malagasy called landibe. This material is not as fine, smooth and shiny as the most commonly known silk made of the yarn of the mulberry-fed Silkworm *Bombyx mori* (in Malagasy: landikely). However, this fabric has a very important role in the traditional and still practiced beliefs of the Malagasy people. As already mentioned in the chapter about Erebidae, ancestor worship is the central part of their spirituality, and therefore funerals are very important celebrations. Landibe is used to produce traditional burial shrouds – burial in a shroud dyed red is a sign of the greatest respect. What is interesting is that the relatives open the tomb every few years, change the shroud for a new one, and dance with the cadaver. This celebration is very joyful and involves the entire community. However, the tradition of landibe manufacturing is slowly disappearing as it is more difficult than obtaining silk from the mulberry silkworm. Also, because *Borocera* moths are connected with

the tapia tree, *Uapaca bojeri*, which forms sparse woodlands on the Central Plateau of Madagascar, the cocoons are wild collected. Additionally, as also for *B. mori*, the pupae are a very important by-product, as they are traditionally eaten, served fried with rice and chicken, and are considered a true delicacy. That is also an important contrast with Africa, where silk moth caterpillars are preferred over pupae.

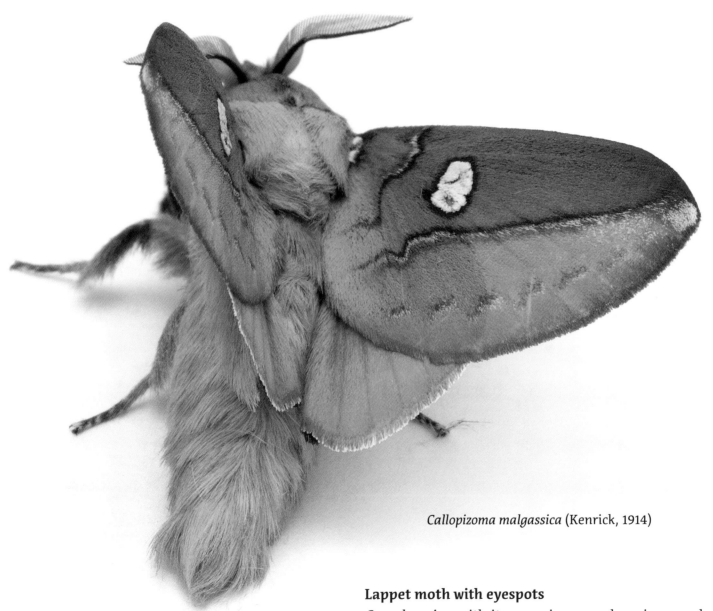

Callopizoma malgassica (Kenrick, 1914)

Lappet moth with eyespots
C. malgassica, with its conspicuous colors, is an ende-mic – it is found nowhere in the world but in Madagas-car. Eyespots are rather unusual with Lasiocampidae.

193

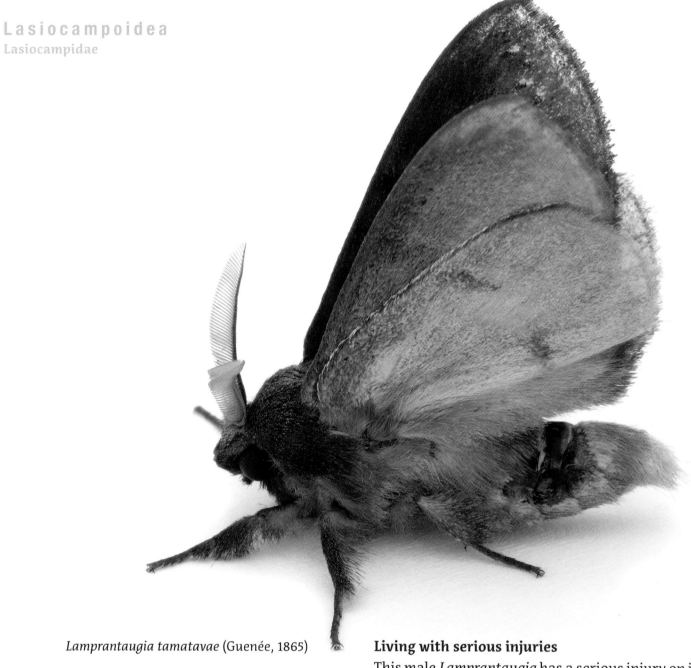

Lamprantaugia tamatavae (Guenée, 1865)

Living with serious injuries

This male *Lamprantaugia* has a serious injury on its abdomen which has healed at least enough for it to still be able to fly and reach the light trap in Makira. The cause of the injury is a matter for speculation: Perhaps it was an accident incurred on the not yet hardened chitinous outer shell when it was emerging from the pupa and cocoon. Or is it a wound from a bite? Birds, reptiles, bats, spiders, and praying mantises are some of the myriad moth predators.

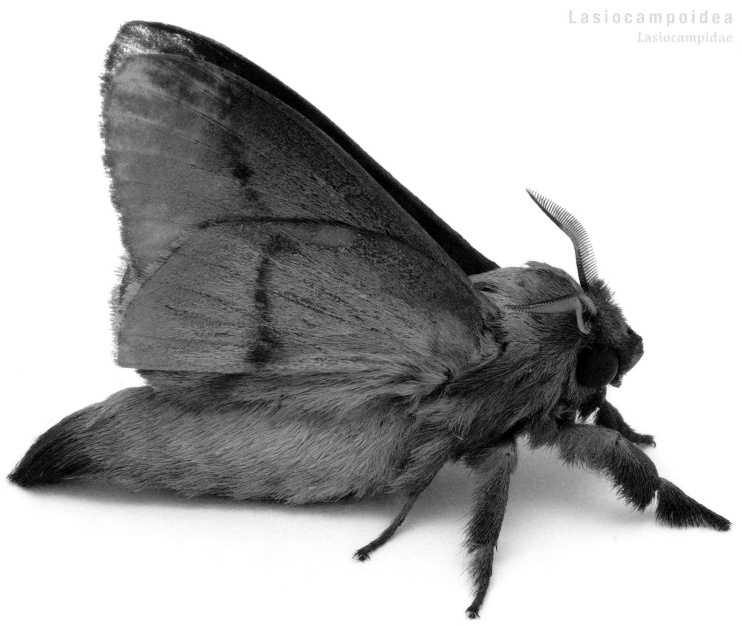

Borocera cajani Vinson, 1863

Food delicacy and silk production

Borocera (Lasiocampidae) caterpillars spin cocoons in which they pupate. In Madagascar the rare high-quality landibe silk is spun from the *Borocera* cocoons. In the highlands *B. cajani* has been used for centuries for this purpose, and on the coast, similarly, *B. madagascariensis*. The caterpillars feed on tapia trees *(Uapaca bojeri)*.

The deceased are wrapped in cloths that are woven from landibe silk and buried. Every 5–10 years they are then shrouded in new cloths – having been exhumed for this purpose – and subsequently interred with great ceremony. *B. cajani* is now endangered because of slash-and-burn practices in the *tapia* forests, among other circumstances. The *B. cajani* pupae are also considered a food delicacy; they are fried and eaten with chicken and rice.

195

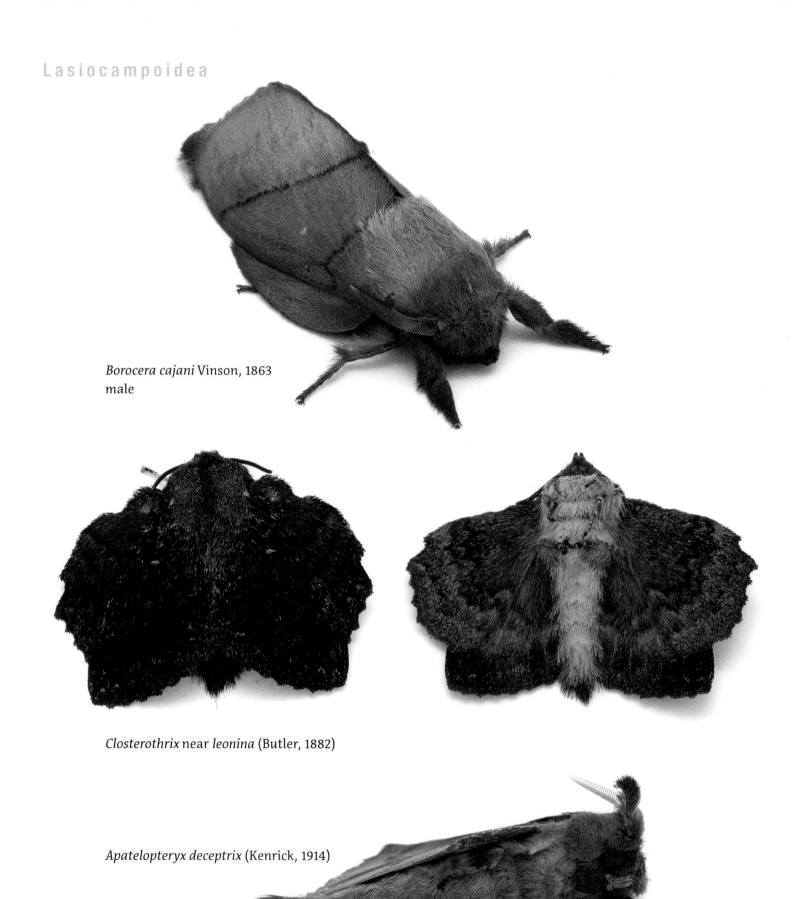

Borocera cajani Vinson, 1863
male

Closterothrix near *leonina* (Butler, 1882)

Apatelopteryx deceptrix (Kenrick, 1914)

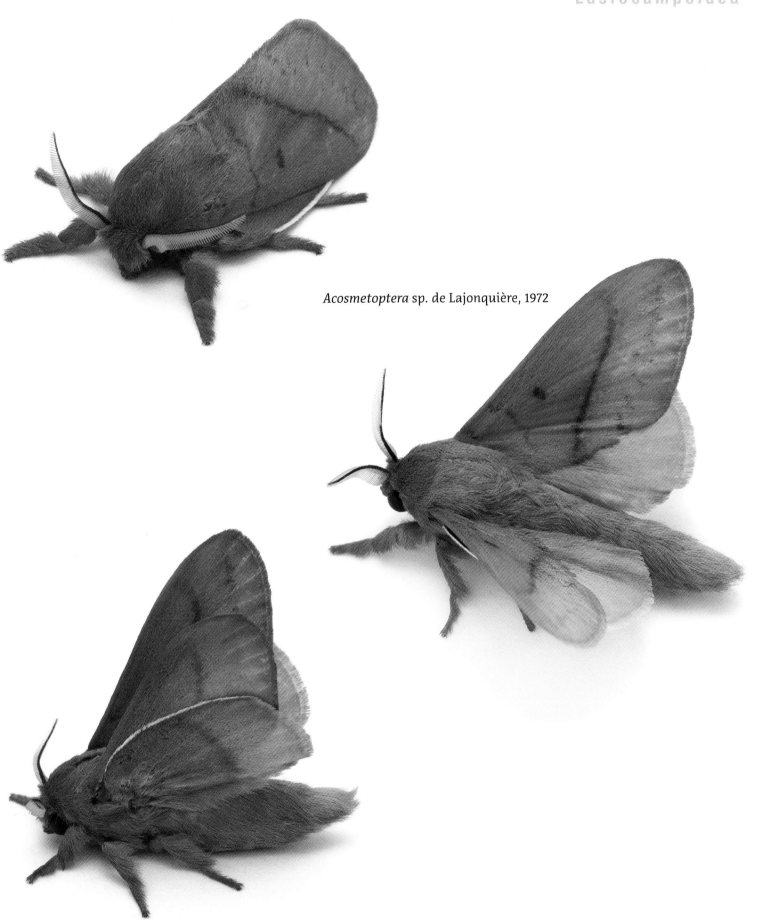

Acosmetoptera sp. de Lajonquière, 1972

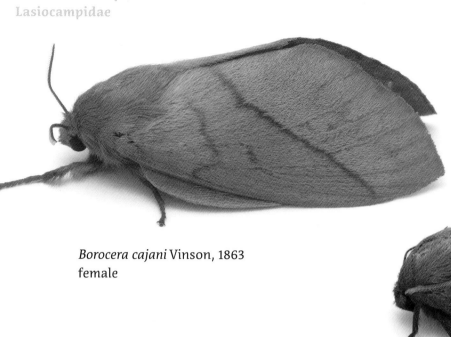

Borocera cajani Vinson, 1863
female

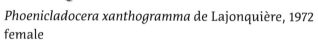

Phoenicladocera xanthogramma de Lajonquière, 1972
female

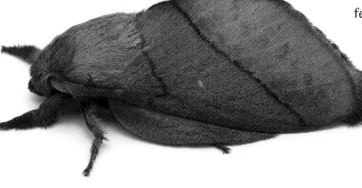

Borocera cajani Vinson, 1863
male

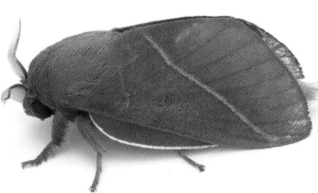

Phoenicladocera xanthogramma de Lajonquière, 1972
male

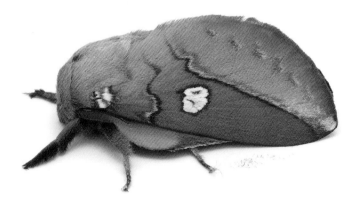

Callopizoma malgassica (Kenrick, 1914)

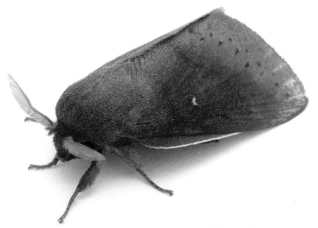

Lamprantaugia tamatavae (Guenée, 1865)

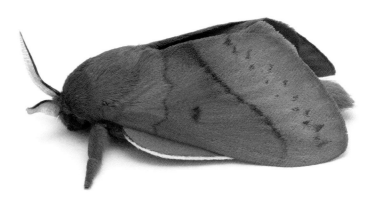

Acosmetoptera sp. de Lajonquière, 1972

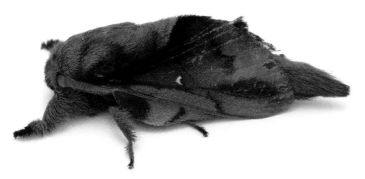

Apatelopteryx deceptrix (Kenrick, 1914)

Eupagopteryx affinis (Aurivillius, 1909)

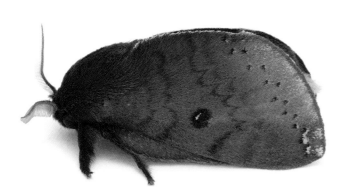

Europtera punctillata (Saalmüller, 1884)

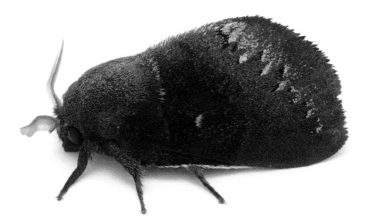

Acosmetoptera sogai (de Lajonquière, 1970)

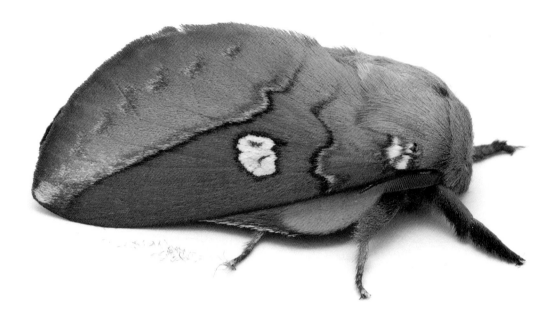

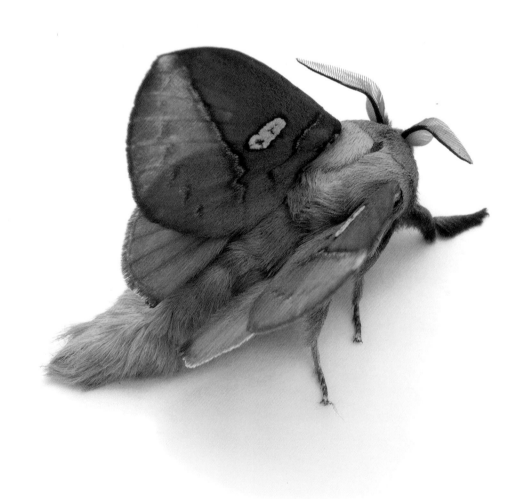

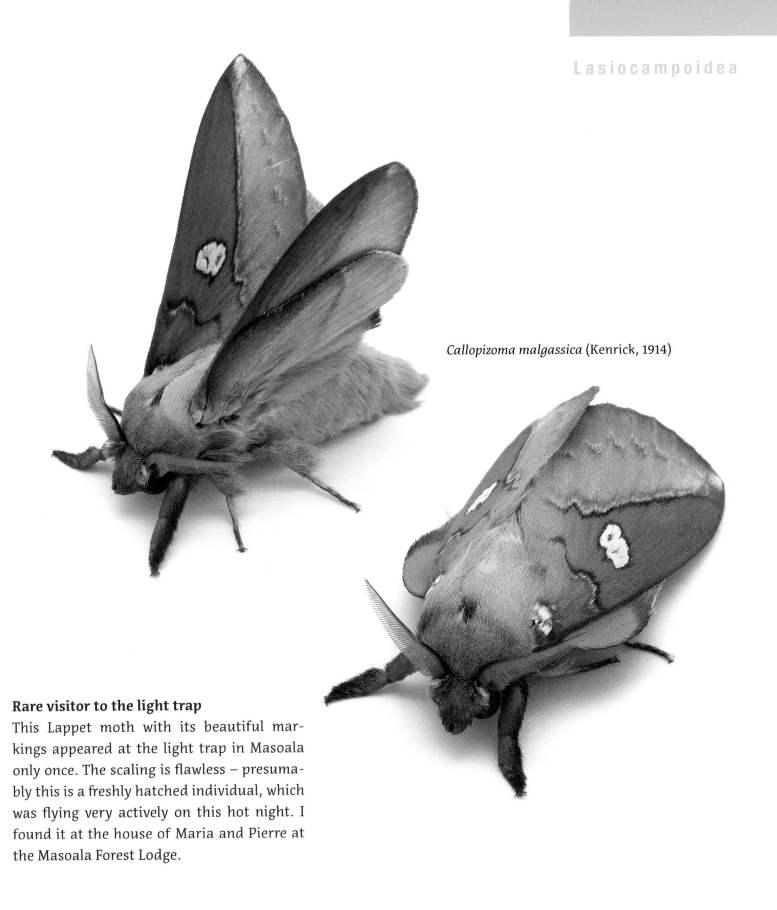

Callopizoma malgassica (Kenrick, 1914)

Rare visitor to the light trap
This Lappet moth with its beautiful markings appeared at the light trap in Masoala only once. The scaling is flawless – presumably this is a freshly hatched individual, which was flying very actively on this hot night. I found it at the house of Maria and Pierre at the Masoala Forest Lodge.

201

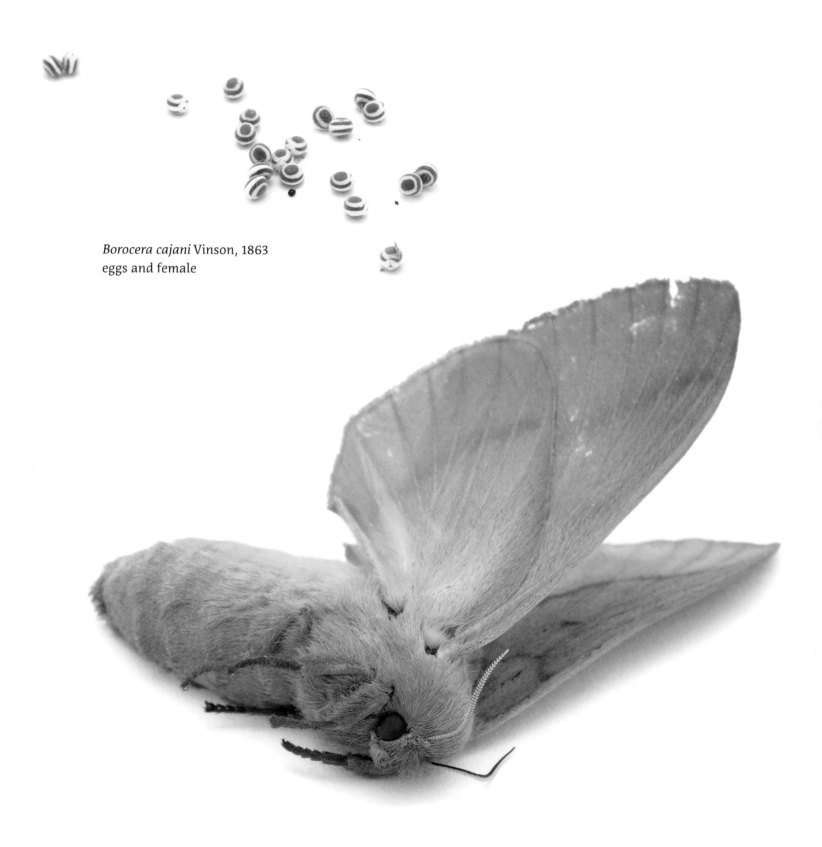

Borocera cajani Vinson, 1863
eggs and female

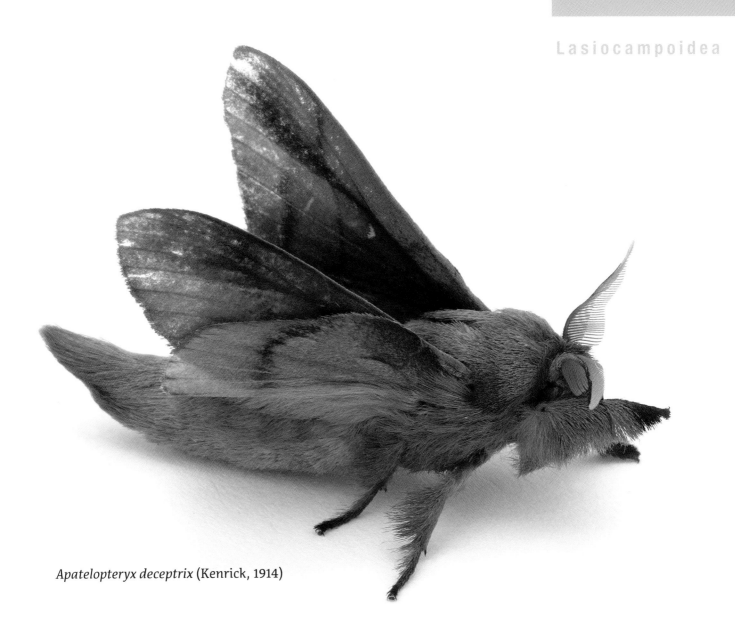

Apatelopteryx deceptrix (Kenrick, 1914)

Eye wipes

As you can see in the photo of *Apatelopteryx deceptrix* displayed here, moths also need to wipe clean their sensitive compound eyes. The forelegs of this moth seem to be perfectly designed for the purpose, with long, hairlike scales, wiping the eye like a fine brush. Interestingly enough, many moths also have on the forelegs another special device for cleaning the antennae. It is called the epiphysis (other examples on p. 63) and is located on the ventral side of the tibia in the form of a protrusion oriented in such a way that the antenna is cleaned when it is dragged through the gap between the surfaces of the epiphysis and leg.

Geometrid moths in Madagascar

Text by Dr. Axel Hausmann

History

The exploration of Madagascan geometrids started with the description of three species by Boisduval in 1833 *(Scopula minorata, Venusia distrigaria, Erastria madecassaria)*. Only 67 species were described from Madagascar before 1900. The first remarkable advance in the taxonomic research on the geometrids of Madagascar was made by Louis B. Prout (1864–1943), of the Natural History Museum in London who contributed the description of 130 valid species. However, next came the very important expeditions of French entomologists in the second half of the 20th century, especially those leading to the descriptions by Claude Herbulot (1908–2006; 253 valid species and subspecies!) and Pierre Viette (1921–2011; 171 species and subspecies).

Today the main source for studying the geometrid fauna are the original descriptions (most of them in smaller articles spread over many different journals) and the collections where the type specimens are deposited (NHMUK, London; MNHN, Paris; SNSB-ZSM-collection Herbulot, Munich).

Diversity

So far, 638 valid geometrid species are described from Madagascar, with an additional 21 subspecies of a nominotypical mainland species and with a few additional species which were described from mainland Africa but occur in the nominotypical subspecies also on Madagascar *(e.g. Thalassodes quadraria, Chiasmia normata, Zamarada calypso)*. When counting also the 17 additional subspecies described from Madagascar (several species split up into different subspecies in different regions of Madagascar), the number of valid taxa described from Madagascar is raised to 676 species and subspecies.

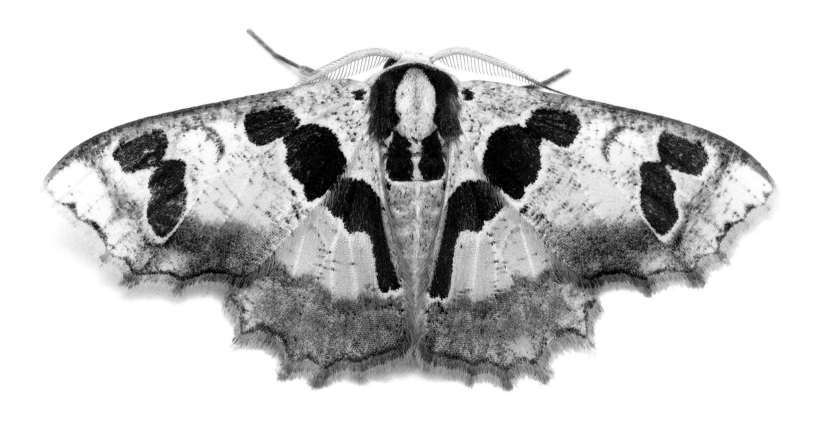

Archichlora trygodes Prout, 1922

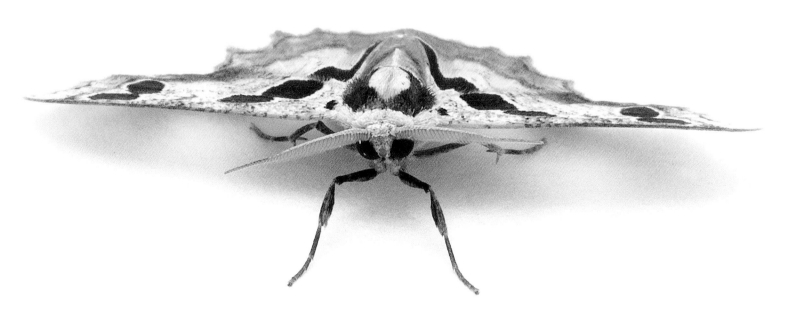

Knowledge gaps

So far, the global DNA barcoding initiative (iBOL) has provided DNA barcodes for 1,203 geometrid specimens from Madagascar, clustering to 413 BINs (barcode index numbers) which can be regarded as a proxy for species numbers. Only a few of these clusters are currently reliably identified to exact Linnean species names (260 names = 63%). Surely some of the remaining 153 clusters will yet be able to be attributed to described species after accurate study, which highlights the urgent need to study the geometrid fauna of Madagascar more in depth by assembling information on the type specimens. However, this pattern also seems to point to a remarkable potential of hidden and cryptic diversity. The amplitude of undescribed geometrid species in Madagascar can be estimated only very roughly and is suggested here to range from a minimum of 100 up to several hundreds.

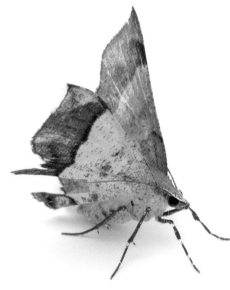

Erastria madecassaria
(Boisduval, 1833)

Evolution

Several geometrid genera are particularly species-rich in Madagascar suggesting recent radiations after colonization of one or just a few species from mainland Africa, e.g., in the genera *Archichlora* (32 species), *Chrysocraspeda* (54 species), *Drepanogynis* (35 species), *Epigelasma* (23 species), *Hylemera* (41 species), and *Psilocerea* (30 species). The genus *Idiodes* shows an interesting zoogeographical disjunction: 11 species are present in Madagascar, only three are known from continental Africa, and 14 are described from Australia and Pacific islands, while the genus is completely unknown from continental Asia. The genus *Blechroneromia* (15 species) is exclusively known from Madagascar and may either have evolved on Madagascar from another genus or represent the product of a radiation from a continental ancestor which has become extinct. The genus *Hypocoela* has 17 species in Madagascar and only four in continental Africa.

It will be highly interesting to reconstruct the evolutionary history of the related speciation scenarios. To achieve this, sound investigation of their phylogeny is necessary, involving integrated analysis (morphology, molecular data including nuclear genes and genomes, and host plants as well, if possible) and their potentially closest relatives on the African mainland.

Emblematic species

Most geometrid species in Madagascar show a camouflaged wing pattern and brown, ochreous, or greenish coloration, but a few are characterized by spectacular colors and wing patterns, e.g. *Rhodophthitus formosus* or *Hylemera euphrantica*.

Importance for humans

Three geometrid moths from Madagascar have been reported as regular or occasional pests, i.e., *Scopula minorata* (polyphagous on field crops, tobacco etc.), *Phaiogramma stipolepida* (on cotton) and *Thalassodes quadraria* (polyphagous on coffee, maize, mango, pepper, etc.).

All geometrid species play an important role in the balance of the ecosystems, as pollinators (also of crops, fruits and ornamental plants), in the food chain (e.g. as important prey for birds, bats etc.), and as decomposers and detritivores, e.g., in the case of the species of the genus *Idaea* with caterpillars regularly feeding on withering or dead leaves.

Archichlora catalai Herbulot, 1954

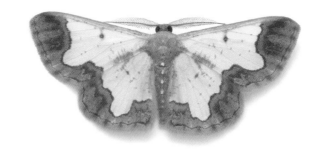

Zamarada oxybeles Fletcher, 1974

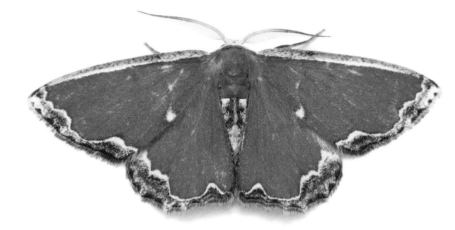

Archichlora cf. *engenes* Prout, 1922

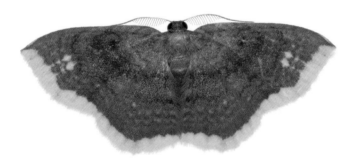

Eois cf. *grataria* (Walker, 1861)
[ab. mediofusca Prout]

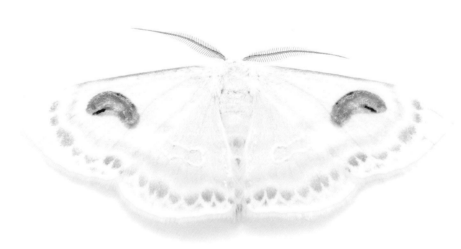

Problepsis meroearia Saalmüller, 1884

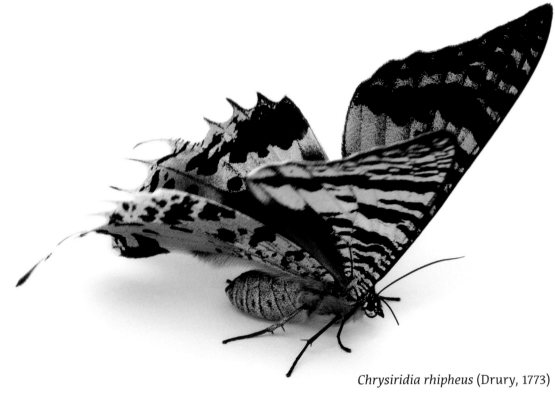

Chrysiridia rhipheus (Drury, 1773)

Epiplema cf. *anomala* Janse, 1932

Epiplema cf. *anomala* Janse, 1932

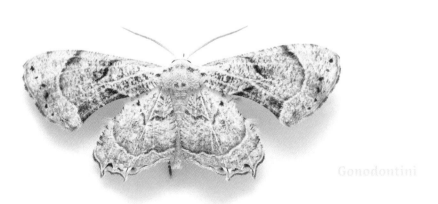

Xenimpia sp. Warren, 1895

**Subfamilies of the superfamily
Geometrioidea dealt with in this book.**

"Lolonandriana"

Text by David Lees & Armin Dett

A mistake 250 years ago

The British butterfly expert and goldsmith Dru Drury, well-known at the time for his passion for collecting and enthusiasm for butterflies and his outstanding books on exotic butterflies, received a particularly beautiful Lepidoptera from the ship captain William May of Hammersmith, who had perhaps just returned home from China. The beauty of the moth could even then not be surpassed and, according to the state of knowledge at the time, was new to science.

Despite the complete lack of tails on the specimen he had English illustrator Moses Harris paint, Drury was convinced that it must be a particularly beautiful and new species of swallowtail butterfly and named it *Papilio rhipheus* in 1773.

What Drury missed was that in order for the butterfly to look perfect as a collector's item – and perhaps make it more valuable – the head had been replaced with one from a true butterfly! Drury described it as bearing bulbous antennae, a key distinguishing feature from most moths.

It was not until 1816 that the German entomologist Jacob Hübner recognized Drury's error, i.e. that this represented a moth in the familuy Uraniidae, although he renamed it as *Chrysiridia rhiphearia*. But Drury's species name still stands today (as *Chrysiridia rhipheus* (Drury, 1773)). Even though Drury's actual type specimen appears to be missing, Harris' painting of the underside is at least an excellent match for an already famous uraniid moth from Madagascar and does not match *C. croesus* (Gerstaecker, 1871) from Tanzania, despite the missing tails and symmetrically painted pattern. Hübner's generic name *Chrysiridia* borrows from Greek and refers to the golden colors and rainbow-like spectrum of scales. Ripheus (which Drury spelled with an 'h') was a Trojan war hero who was killed fighting the Greeks.

In Malagasy, the butterfly is one of the few with a widespread vernacular name, known as "lolonandriana" and means the king of spirits (or butterflies). Translated, "lolo" also means the soul of a deceased that is resurrected person.

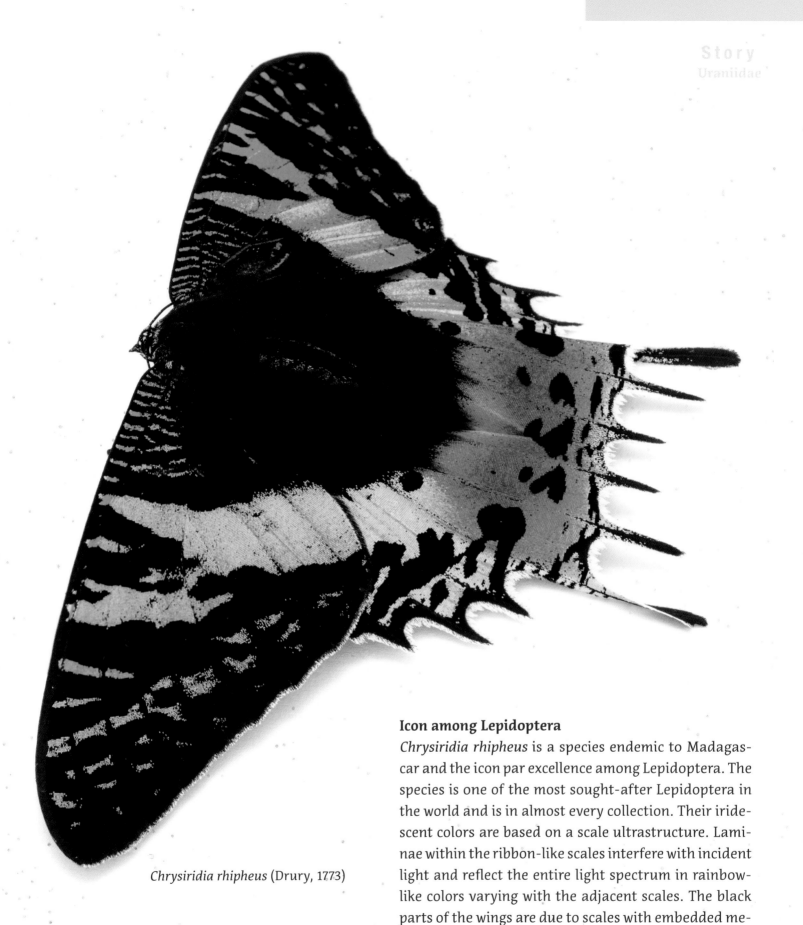

Chrysiridia rhipheus (Drury, 1773)

Icon among Lepidoptera

Chrysiridia rhipheus is a species endemic to Madagascar and the icon par excellence among Lepidoptera. The species is one of the most sought-after Lepidoptera in the world and is in almost every collection. Their iridescent colors are based on a scale ultrastructure. Laminae within the ribbon-like scales interfere with incident light and reflect the entire light spectrum in rainbow-like colors varying with the adjacent scales. The black parts of the wings are due to scales with embedded melanin, which absorb light and only partially reflect it.

Biology

Chrysiridia rhipheus has a fascinating developmental biology (Lees and Smith, 1991). As for three other genera of Uraniinae, the caterpillars feed exclusively on *Omphalea* trees, which belong to the Euphorbiaceae (spurge family). Leaves, blossoms and fruits of the tree are eaten. When feeding, the caterpillars ingest sugar-mimicking alkaloids, but they avoid the latex by cutting the veins before feeding. These toxins are passed on to the adult moth. The fact that the moths are poisonous is shown by their striking warning coloring (aposematism) and daytime activity. All of the species of *Omphalea* in Madagascar are fed on, even deciduous species in the West. This property can temporarily lead to the dwindling food sources of the caterpillars and, as a result, to strong population fluctuations of the moths. The caterpillars live on the host trees unmolested by ants, which actually protect and defend the plant from being eaten. The *Chrysiridia* caterpillar hangs off on threads at the risk of hymenopteran attacks. The shrubs themselves respond to herbiviory by producing even more toxins and becoming increasingly inedible.

The moths respond by migrating to regions where other *Omphalea* species grow. This means that although the moth ranges over most of the island except the south the localized occurrences of the hostplants ultimately control the reproduction of the moths. *Chrysiridia rhipheus* is diurnal except occasionally coming to lights during migration. By day it sits upside down on plants but at night the wings are held over the body – a curiosity among moths sometimes found in some Geometridae, and a much more typical feature of butterflies.

The eggs are laid singly or in clutches on the underside of the *Omphalea* leaves, or quite often off the hostplant completely (to escape parasitism). The eggs are yellowish and ribbed. After the larvae hatch, they disperse. Pupation occurs in a web on the ground. The flight activity during the day changes. When the sun is shining, the moths can be observed in large numbers visiting flowers. Suddenly, however, the moths seem to have disappeared from the face of the earth – only to fly again just as suddenly. The females like to oviposit during the afternoon and often in thundery weather.

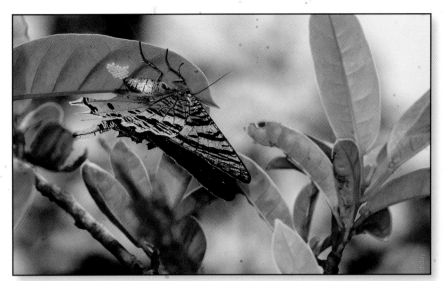

Oviposition

Chrysiridia rhipheus female oviposits on *Omphalea oppositifolia* (photo: Edi Day).
Below: A cluster of eggs and newly hatched first instar larvae.

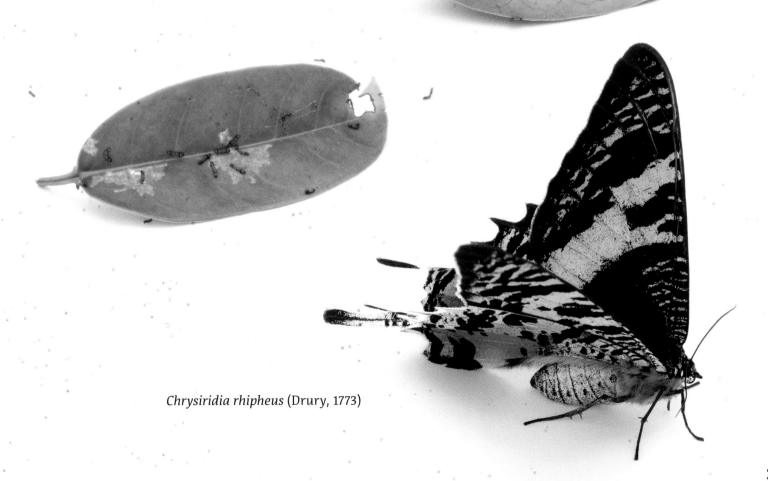

Chrysiridia rhipheus (Drury, 1773)

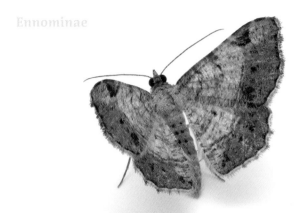

Chiasmia crassilembaria (Mabille, 1880)

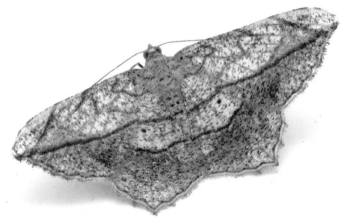

Chiasmia simplicilinea (Warren, 1905)

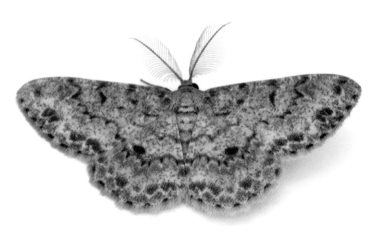

Hypomecis idiochroa (Prout L. B., 1925)

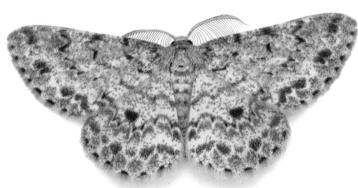

Hypomecis idiochroa (Prout L. B., 1925)

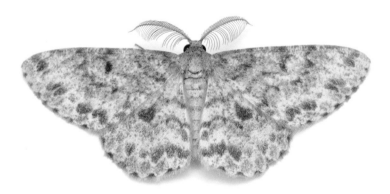

Hypomecis idiochroa (Prout L. B., 1925)

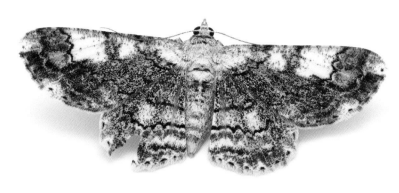

Cleora legrasi (Herbulot, 1955)

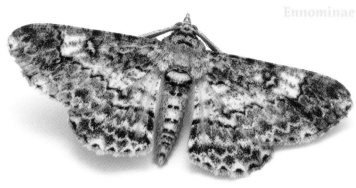

Cleora legrasi (Herbulot, 1955)

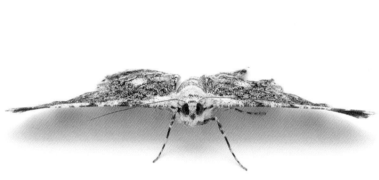

Cleora legrasi (Herbulot, 1955)

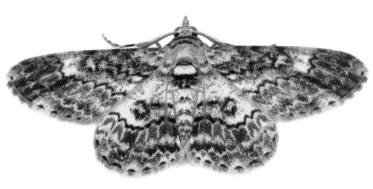

Cleora legrasi (Herbulot, 1955)

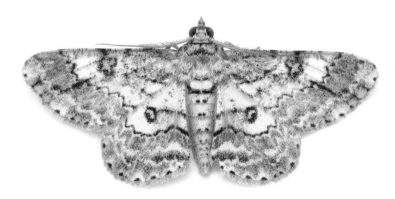

Cleora cf. *macracantha* (Herbulot, 1955)

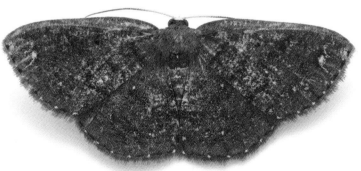

Cabera cf. *cadoreli* Herbulot, 2001

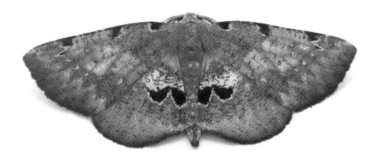

Drepanogynis alina Viette, 1980

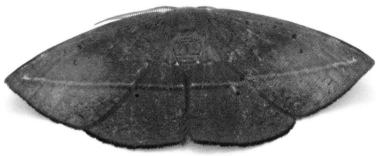

Drepanogynis alternans Herbulot, 1960

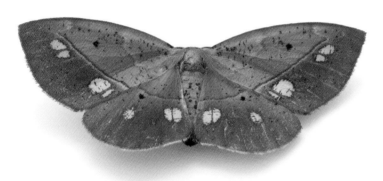

Drepanogynis near *hiaraka* (Viette, 1968)

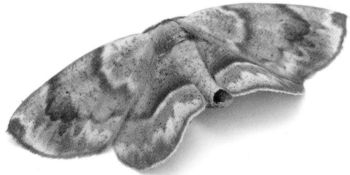

Drepanogynis purpurescens Herbulot, 1954

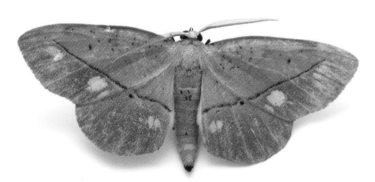

Drepanogynis near *hiaraka* (Viette, 1968)

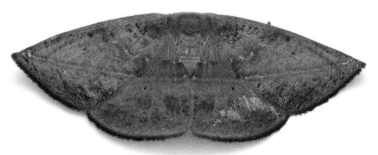

Drepanogynis sp. Boisduval & Guenée, 1857

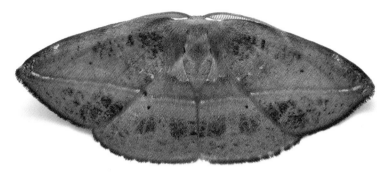

Drepanogynis sp. Boisduval & Guenée, 1857

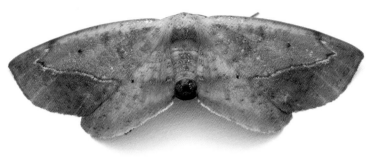

Drepanogynis sp. Boisduval & Guenée, 1857

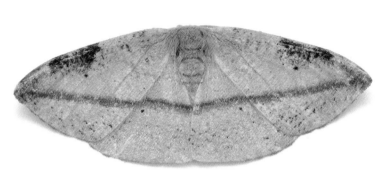

Drepanogynis sp. Boisduval & Guenée, 1857

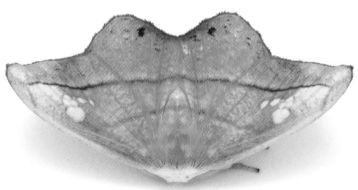

Drepanogynis sp. Boisduval & Guenée, 1857

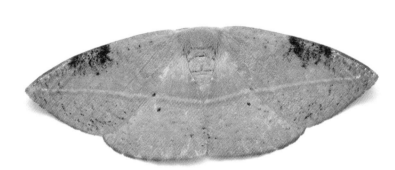

Drepanogynis sp. Boisduval & Guenée, 1857

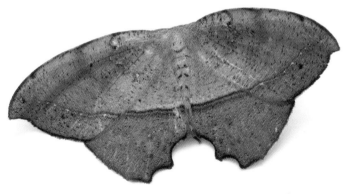

Epigynopteryx colligata (Saalmüller, 1891)

217

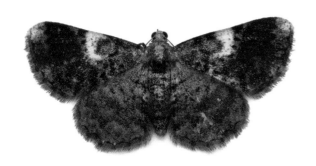

Ectropis sp. ['perineti Herbulot']

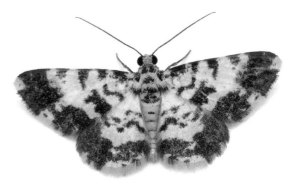

Ectropis sublutea (Butler, 1880)

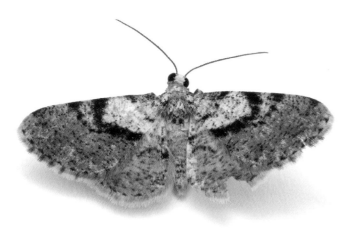

Ectropis basalis Herbulot, 1981

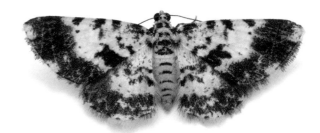

Ectropis sublutea (Butler, 1880)

Epigynopteryx glycera Prout L. B., 1934

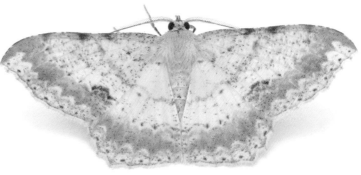

Luxiaria pratti Prout L. B., 1925

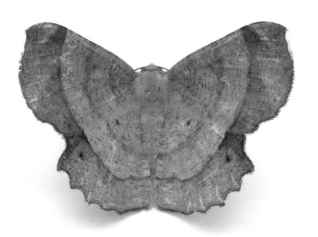

Erastria madecassaria (Boisduval, 1833)

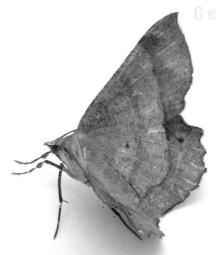

Erastria madecassaria (Boisduval, 1833)

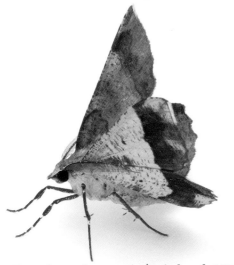

Erastria madecassaria (Boisduval, 1833)

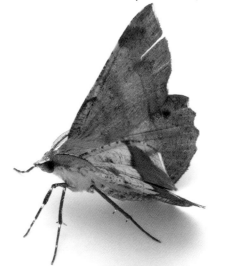

Erastria madecassaria (Boisduval, 1833)

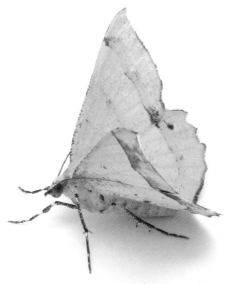

Erastria madecassaria (Boisduval, 1833)

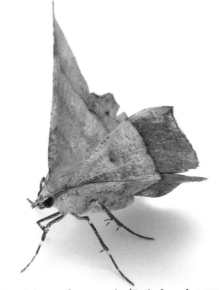

Erastria madecassaria (Boisduval, 1833)

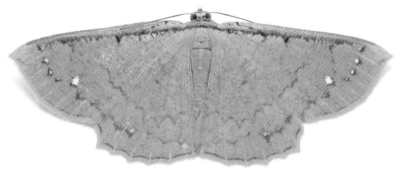

Melinoessa catenata (Saalmüller, 1891)

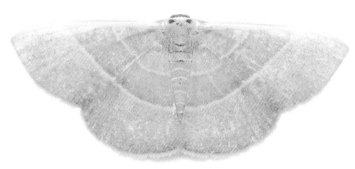

Ochroplutodes hova Herbulot, 1954

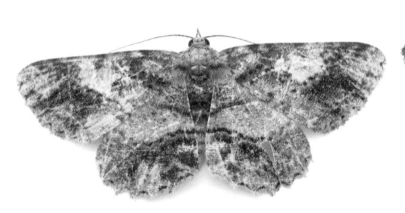

Racotis sp. Moore, 1887

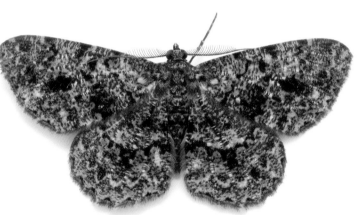

Racotis sp. Moore, 1887

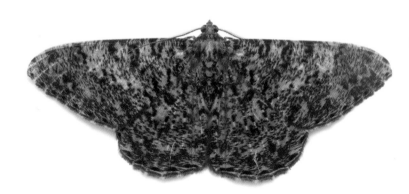

Racotis cf. *squalida* (Butler, 1878)

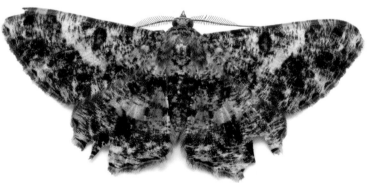

Racotis madagascariensis Chainey & Karisch, 2017

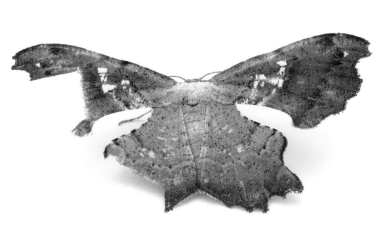

Xenimpia fletcheri (Herbulot, 1954)

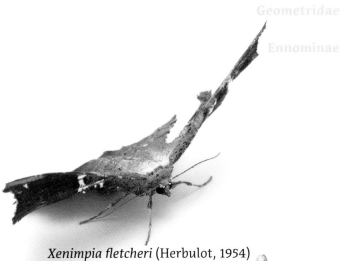

Xenimpia fletcheri (Herbulot, 1954)

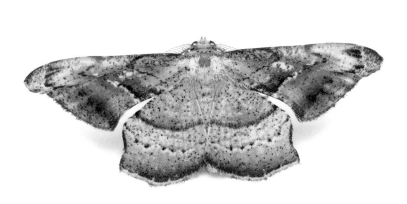

Xenimpia fletcheri (Herbulot, 1954)

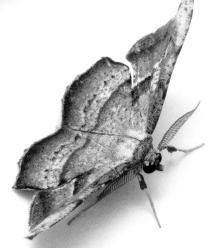

Xenimpia fletcheri (Herbulot, 1954)

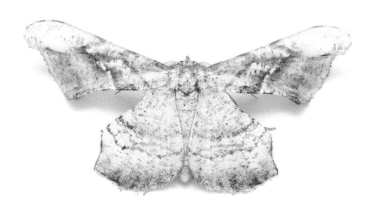

Xenimpia fletcheri (Herbulot, 1954)

221

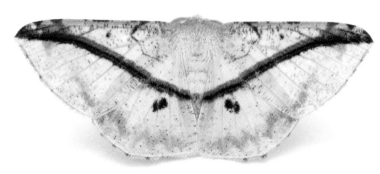

Psilocerea barychorda Prout L. B., 1932

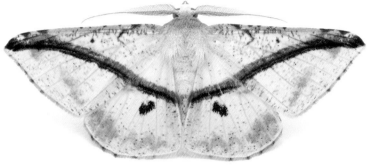

Psilocerea barychorda Prout L. B., 1932

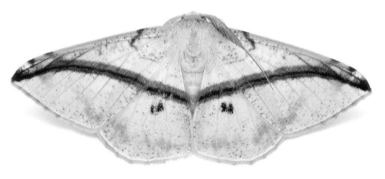

Psilocerea barychorda Prout L. B., 1932

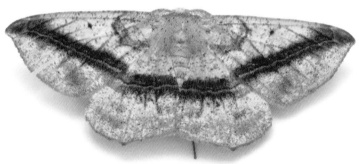

Psilocerea swinhoe Herbulot, 1859

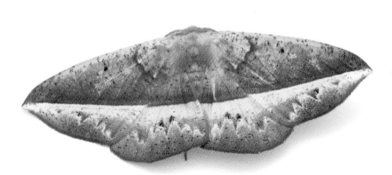

Psilocerea tigrinata Saalmüller, 1880

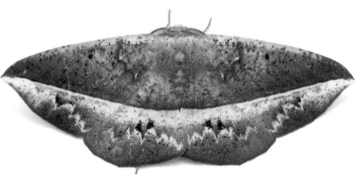

Psilocerea tigrinata Saalmüller, 1880

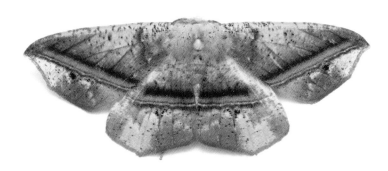

Psilocerea viettei Herbulot, 1954

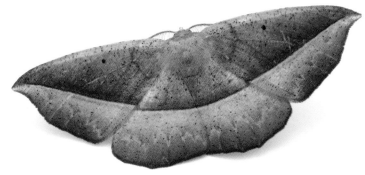

Psilocerea ferruginaria pallidizona Herbulot, 1959

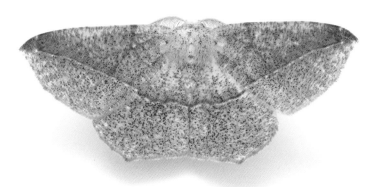

Psilocerea swinhoe Herbulot, 1859

Psilocerea monochroma Herbulot, 1959

Psilocerea tigrinata Saalmüller, 1880

Psilocerea sp. Saalmüller, 1880

223

Psilocerea sp. Saalmüller, 1880

Psilocerea toulgoeti Herbulot, 1859

Psilocerea jacobi Prout, 1932

Psilocerea vestitaria Swinhoe, 1904

Xenostega ochracea (Butler, 1879)

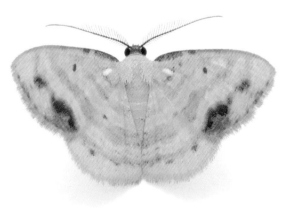

Xenostega ochracea (Butler, 1879)

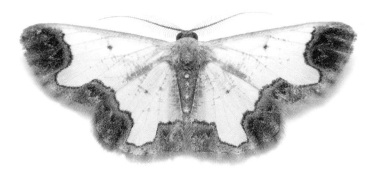

Zamarada oxybeles Fletcher, 1974

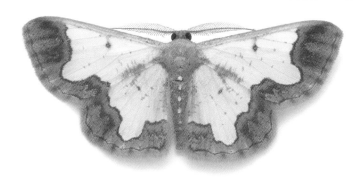

Zamarada oxybeles Fletcher, 1974

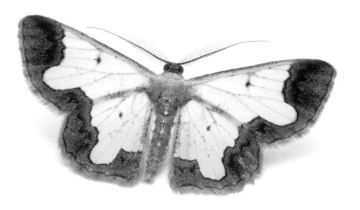

Zamarada sp. Moore, 1887

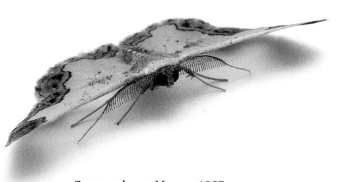

Zamarada sp. Moore, 1887

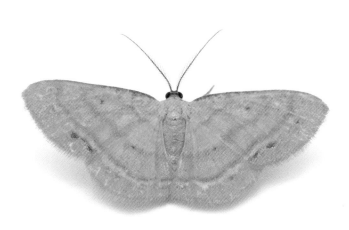

Xenostega sp. Warren, 1899

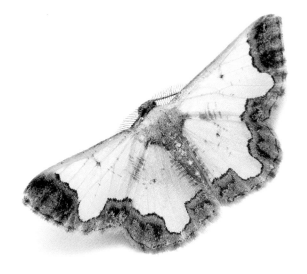

Zamarada sp. Moore, 1887

225

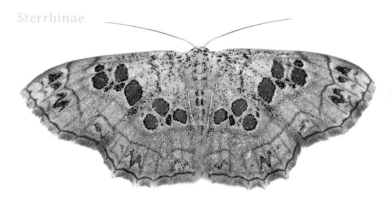

Antitrygodes dentilinea Warren, 1897

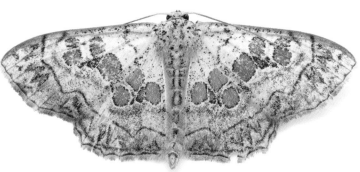

Antitrygodes dentilinea Warren, 1897

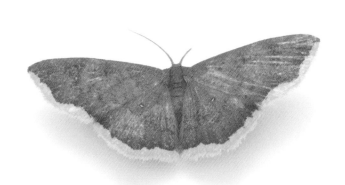

Chrysocraspeda cf. *erythraria* (Mabille, 1893)

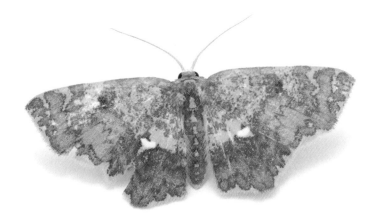

Chrysocraspeda tantale (Viette, 1970)

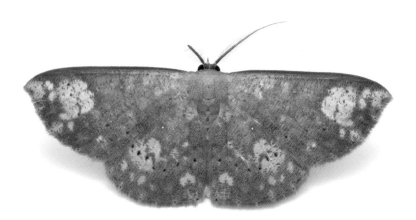

Cyclophora metamorpha (Prout, 1925)

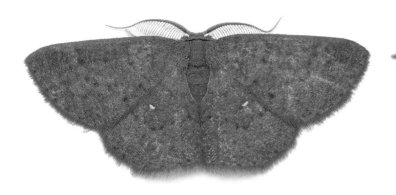

Chrysocraspeda sp. Swinhoe, 1893

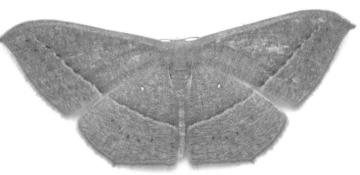

Traminda obversata atroviridata (Saalmüller, 1880)

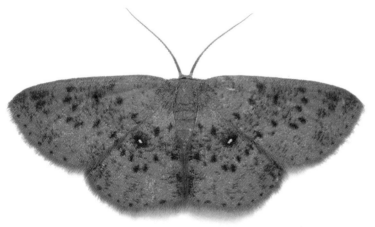

Chrysocraspeda cosymbia (Viette, 1984)

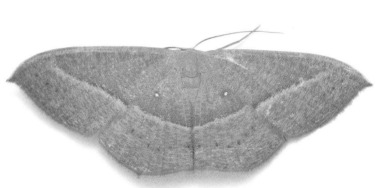

Traminda obversata atroviridata (Saalmüller, 1880)

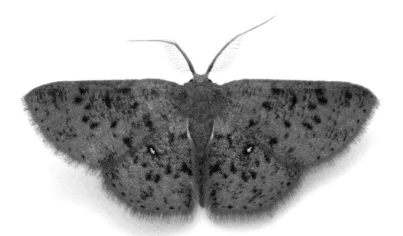

Chrysocraspeda cosymbia (Viette, 1984)

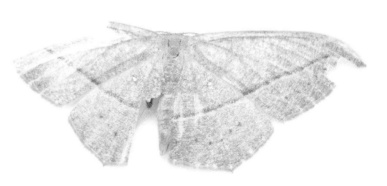

Traminda obversata atroviridata (Saalmüller, 1880)

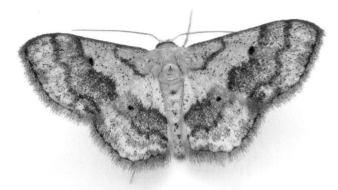

Metallaxis sp. Prout 1932

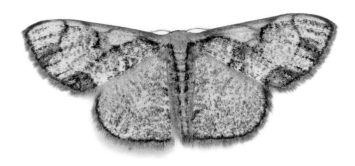

Metallaxis teledapa Prout, 1932

Problepsis meroearia Saalmüller, 1884

Problepsis meroearia Saalmüller, 1884

Scopula gibbivalvata Herbulot, 1972

Scopula internataria (Walker, 1861)

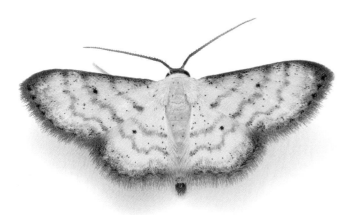

Scopula minuta (Warren, 1900)

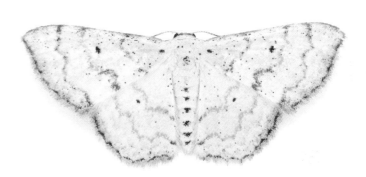

Scopula rubrosignaria rubrosignaria (Mabille, 1900)

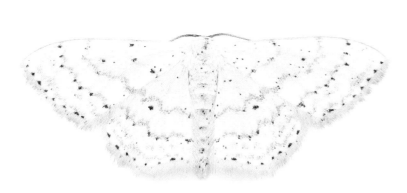

Scopula cf. *sparsipunctata* (Mabille, 1900)

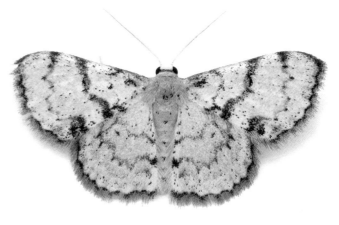

Scopula sp. Schrank, 1802

Geometrinae

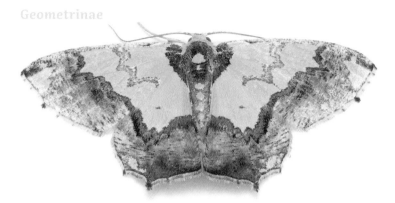

Agathia malgassa Herbulot, 1978

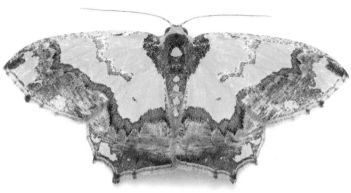

Agathia malgassa Herbulot, 1978

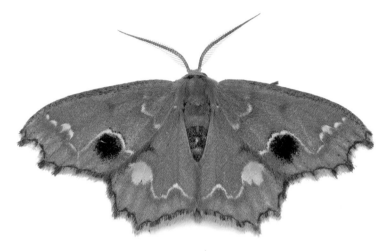

Archichlora catalai Herbulot, 1954

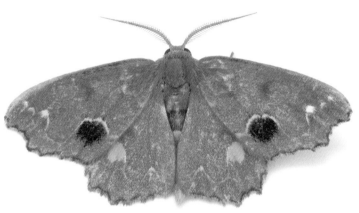

Archichlora catalai Herbulot, 1954

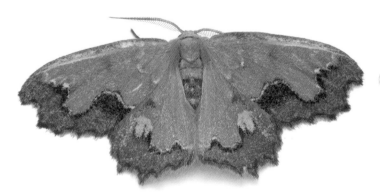

Archichlora Warren, 1898

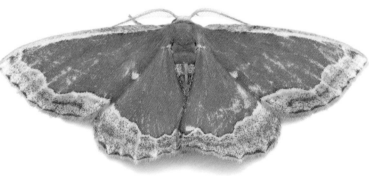

Archichlora cf. malgassa

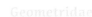

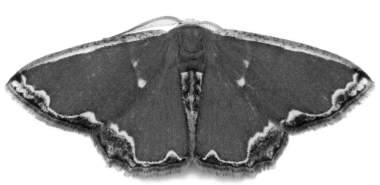

Archichlora cf. *engenes* Prout, 1922

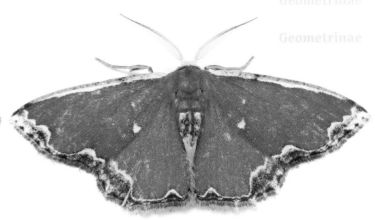

Archichlora cf. *engenes* Prout, 1922

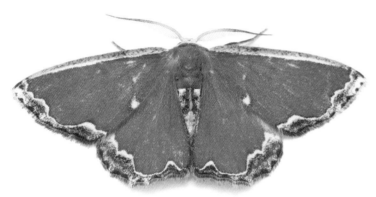

Archichlora cf. *engenes* Prout, 1922

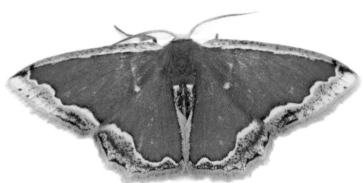

Archichlora cf. *chariessa* Prout, 1925

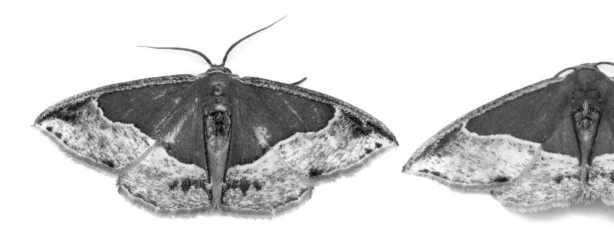

Archichlora cf. *nigricosta* Herbulot, 1960

Archichlora cf. *nigricosta* Herbulot, 1960

231

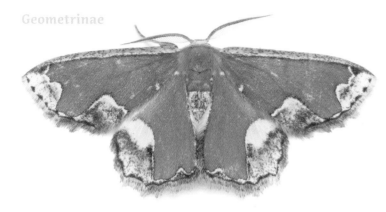

Archichlora hemistrigata (Mabille, 1900)

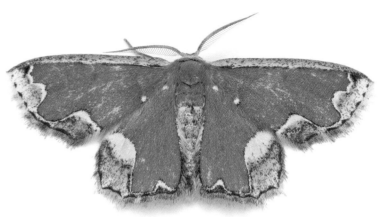

Archichlora hemistrigata (Mabille, 1900)

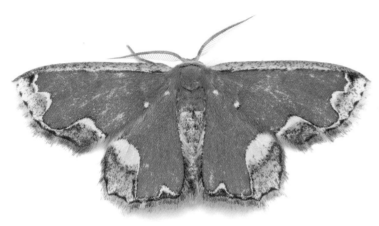

Archichlora hemistrigata (Mabille, 1900)

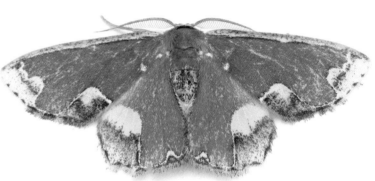

Archichlora hemistrigata (Mabille, 1900)

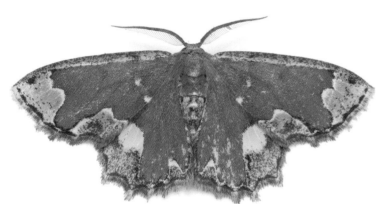

Archichlora hemistrigata (Mabille, 1900)

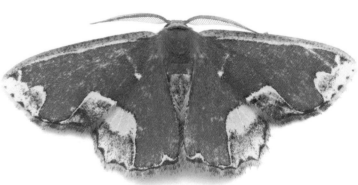

Archichlora hemistrigata (Mabille, 1900)

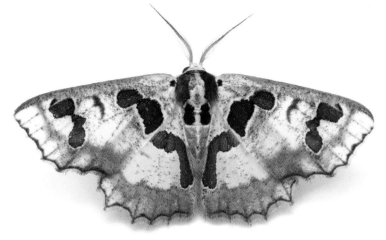

Archichlora trygodes Prout, 1922

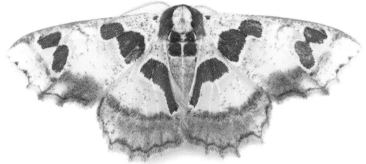

Archichlora trygodes Prout, 1922

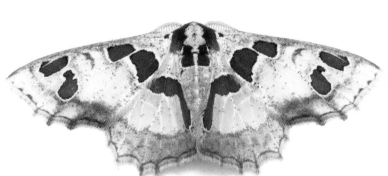

Archichlora trygodes Prout, 1922

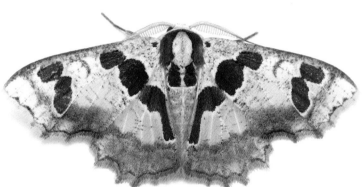

Archichlora trygodes Prout, 1922

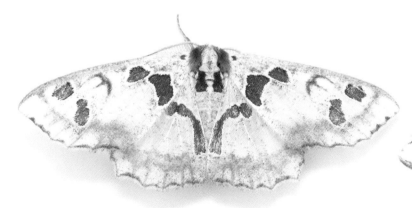

Archichlora trygodes Prout, 1922

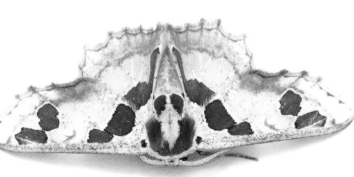

Archichlora trygodes Prout, 1922

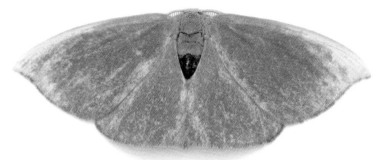

Archichlora cf. *stellicincta* (Herbulot, 1972)

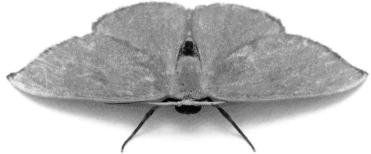

Archichlora cf. *stellicincta* (Herbulot, 1972)

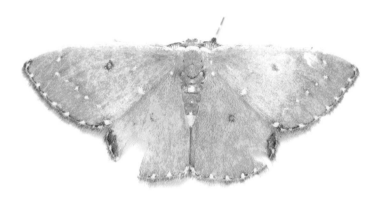

Comibaena punctaria (Swinhoe, 1904)

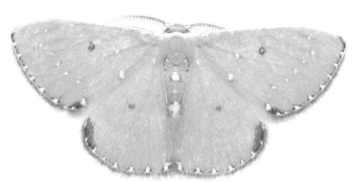

Comibaena punctaria (Swinhoe, 1904)

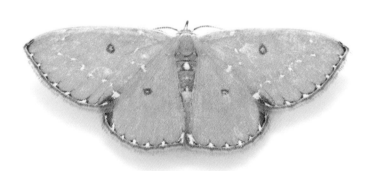

Comibaena punctaria (Swinhoe, 1904)

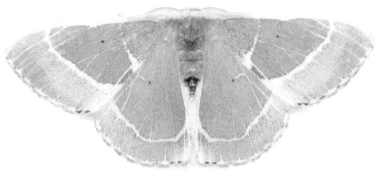

Comibaena leucochloraria (Mabille, 1880)

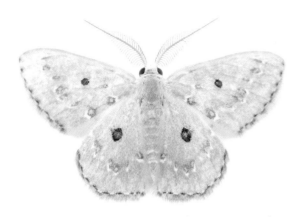

Comostolopsis rufocellata (Mabille, 1900)

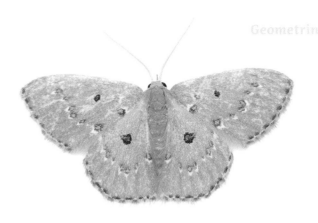

Comostolopsis rufocellata (Mabille, 1900)

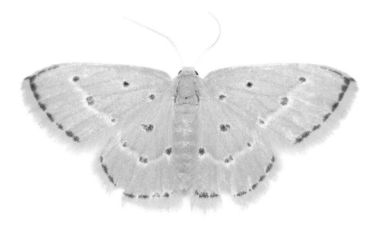

Comostolopsis stillata (Felder & Rogenhoffer, 1875)

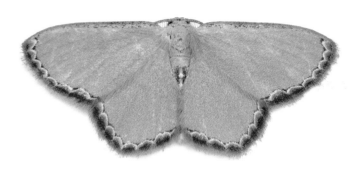

Heterorachis sp. Warren, 1898

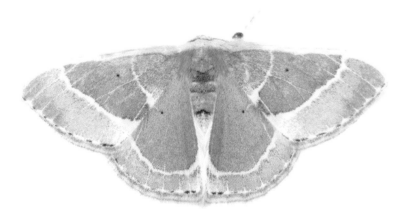

Comibaena leucochloraria (Mabille, 1880)

Geometridae

Geometrinae

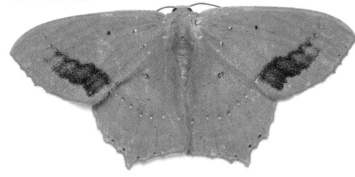 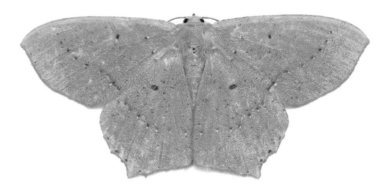

Dryochlora cinctuta (Saalmüller, 1891) *Dryochlora cinctuta* (Saalmüller, 1891)

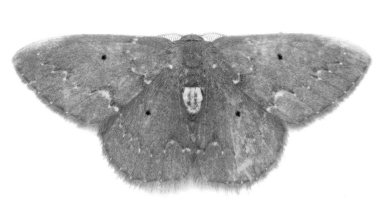 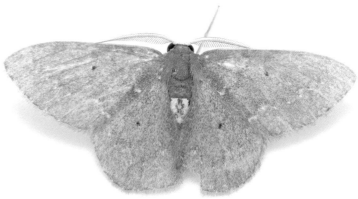

Heterorachis insueta Prout, 1922 *Heterorachis insueta* Prout, 1922

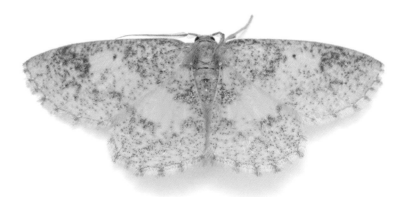

Blechroneromia herbuloti Viette, 1976

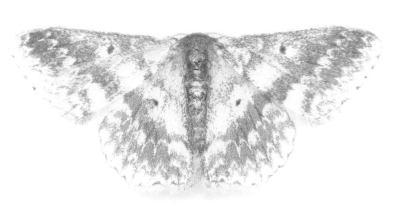

Epigelasma cf. *disjuncta* Herbulot, 1972

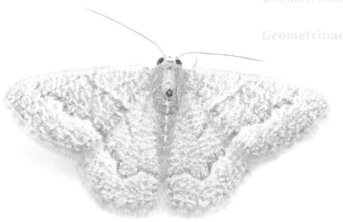

Phaiogramma stibolepida (Butler, 1879)

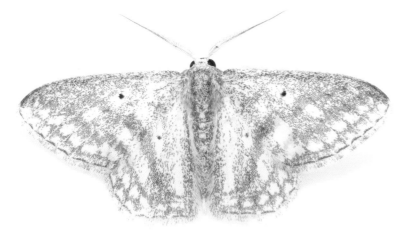

Epigelasma olsoufieffi Herbulot, 1972

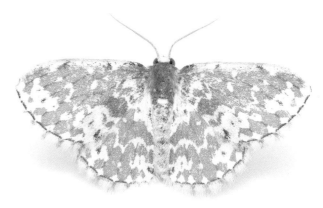

Rhodesia alboviridata (Saalmüller, 1880)

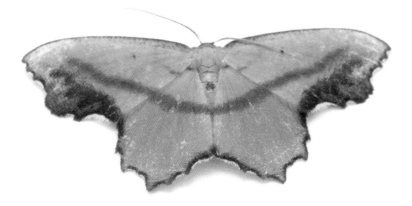

Blechroneromia malagasy Viette, 1976

237

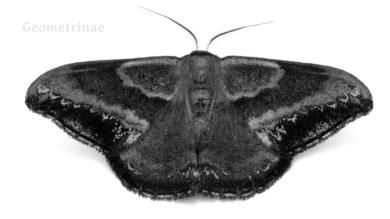

Hypocoela abstrusa Herbulot, 1956

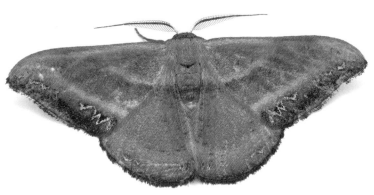

Hypocoela fasciata Herbulot, 1956

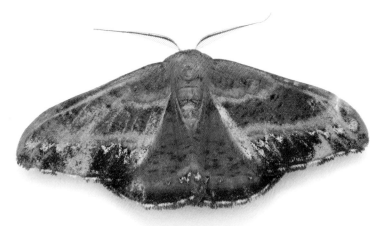

Hypocoela abstrusa Herbulot, 1956

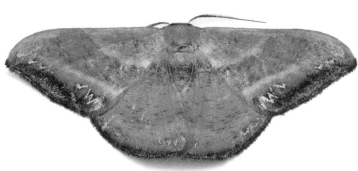

Hypocoela fasciata Herbulot, 1956

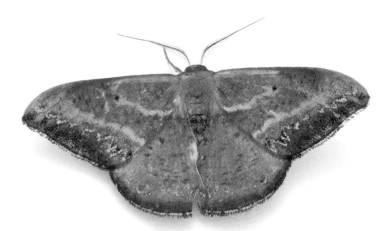

Hypocoela abstrusa Herbulot, 1956

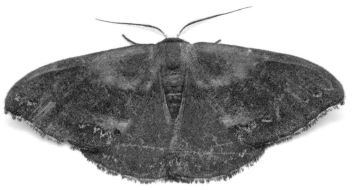

Hypocoela fasciata Herbulot, 1956

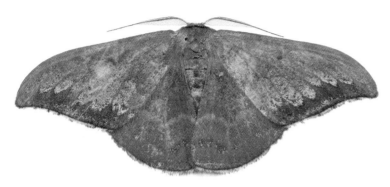

Hypocoela humidaria (Swinhoe, 1904)

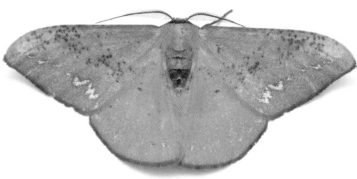

Hypocoela spodozona Prout L. B., 1925

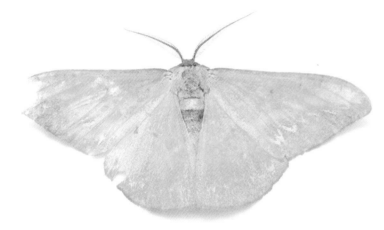

Hypocoela spodozona Prout L. B., 1925

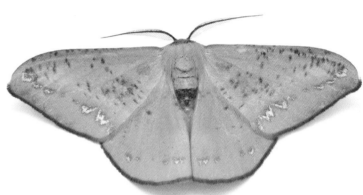

Hypocoela spodozona Prout L. B., 1925

Hypocoela spodozona Prout L. B., 1925

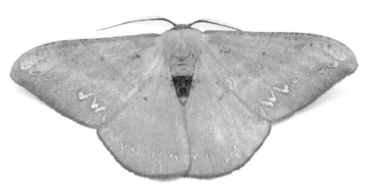

Hypocoela spodozona Prout L. B., 1925

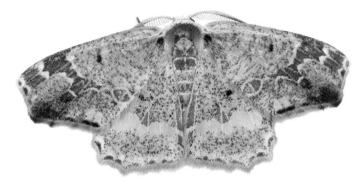

Leptocolpia superba Herbulot, 1965

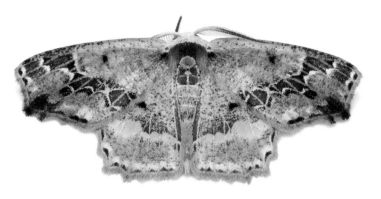

Leptocolpia superba Herbulot, 1965

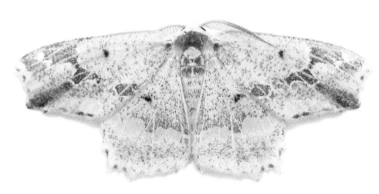

Leptocolpia superba Herbulot, 1965

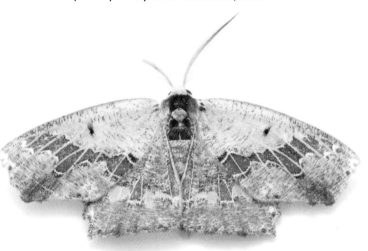

Leptocolpia superba Herbulot, 1965

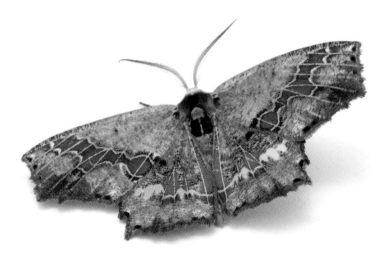

Leptocolpia superba Herbulot, 1965

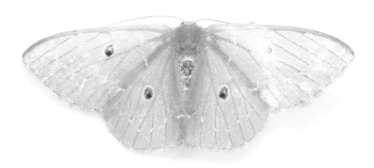

Lophostola cf. *cara cumatilis* Prout L. B., 1922

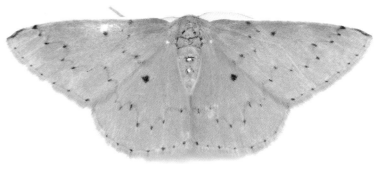

Lophorrhachia rubricorpus (Warren, 1898)

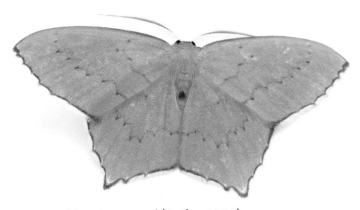

Maxates cowani (Butler, 1880)

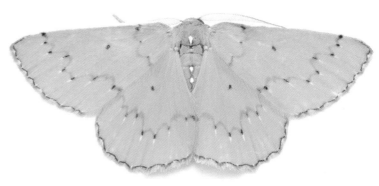

Lophorrhachia rubricorpus (Warren, 1898)

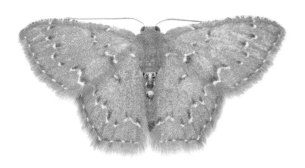

Metallochlora glacialis (Butler, 1880)

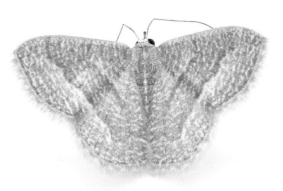

Phaiogramma stibolepida (Butler, 1879)

241

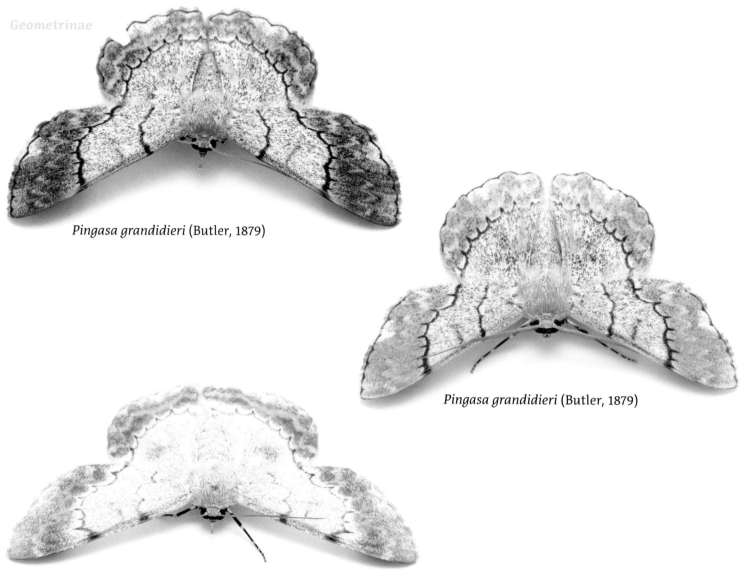

Pingasa grandidieri (Butler, 1879)

Pingasa grandidieri (Butler, 1879)

Pingasa herbuloti (Viette, 1971)

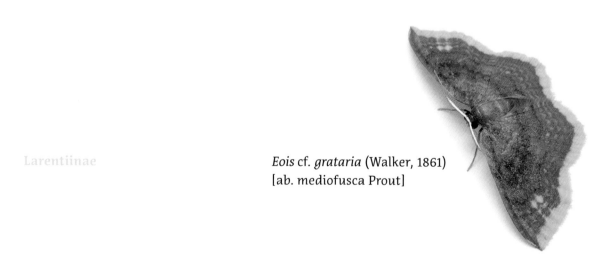

Eois cf. grataria (Walker, 1861)
[ab. mediofusca Prout]

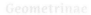
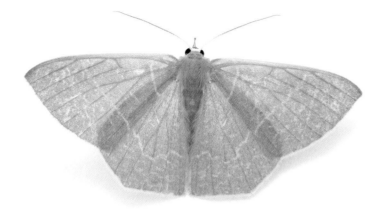

Thalassodes cf. *progressa* Prout, 1926

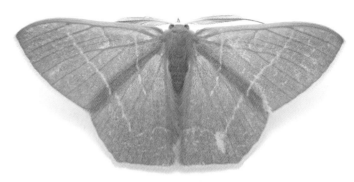

Thalassodes cf. *progressa* Prout, 1926

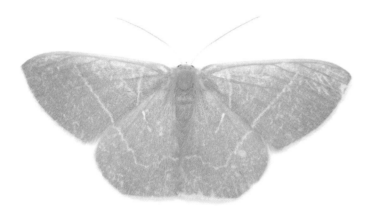

Thalassodes cf. *progressa* Prout, 1926

Thalassodes cf. *progressa* Prout, 1926

Victoria sp. Warren, 1897

243

Noctuoidea

Text by Marcin Wiorek

Noctuoidea are the most diverse and the largest superfamily within all Lepidoptera, comprising around 43,500 species, of which more than 2,000 have been reported from Madagascar. This group has definitely achieved evolutionary success, since despite its huge number of species it is also one of the youngest.

Among the families belonging to Noctuoidea, are Erebidae, Euteliidae, Nolidae, Notodontidae, and – obviously – Noctuidae, the family that gives the name to the entire superfamily. Representatives of each of these families are depicted below, giving a glimpse of the overwhelming diversity of Noctuoidea.

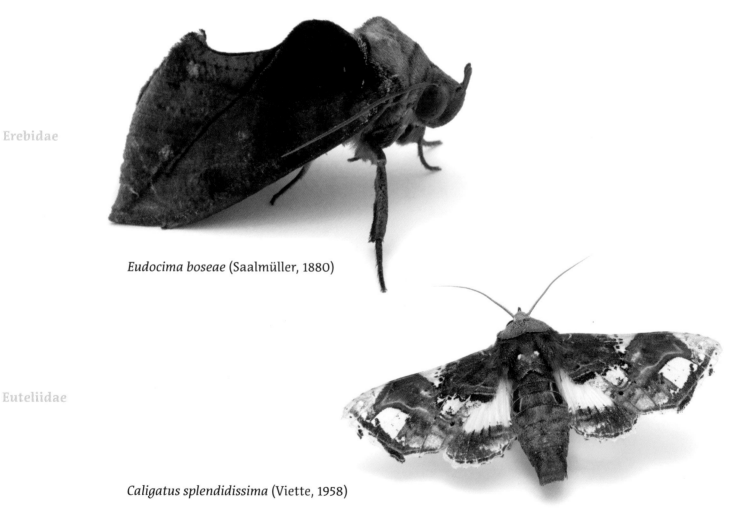

Erebidae

Eudocima boseae (Saalmüller, 1880)

Euteliidae

Caligatus splendidissima (Viette, 1958)

Families of the superfamily Noctuioidea dealt with in this book.

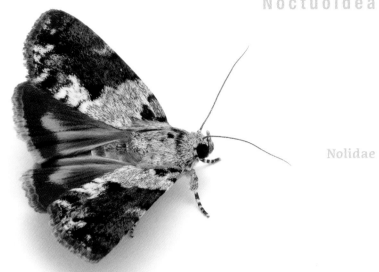

Blenina near *hyblaeoides* Kenrick, 1917

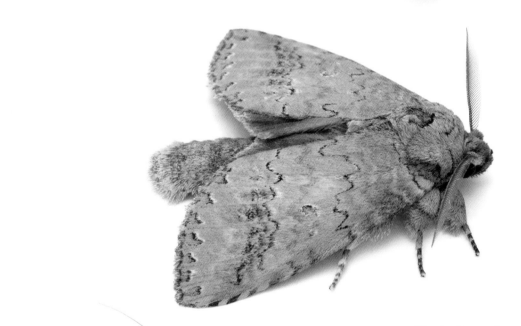

Vietteella madagascariensis (Draeseke, 1937)

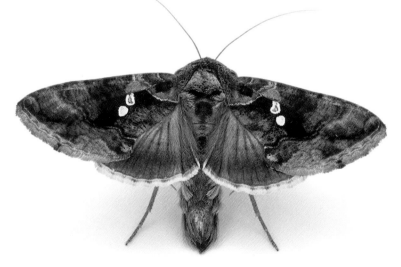

Chrysodeixis chalcites (Esper, 1798)

Madagascar's Tear Drinker

Text by Dr. Roland Hilgartner

The amazing and unique nature of Madagascar has long attracted the focus of researchers. Madagascar's long isolation from the African mainland has resulted in the evolution of a breathtaking array of flora and fauna. The vast majority of Madagascar's animal and plant species are endemic and can be found nowhere else in the world. The same is true for several unique biotic interactions that can be only observed on the island of Madagascar but not on the African mainland or elsewhere. In 2004 I was lucky to add one more peculiarity to Madagascar's bizarre parade of exceptional behaviors.

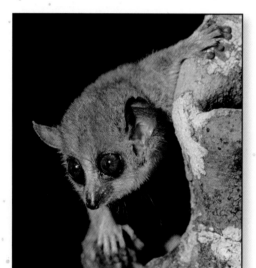

Madame Berthe's Mouse lemur

Roland Hilgartner did research on the smallest known species of lemur, Madame Berthe's Mouse lemur *(Microcebus berthae)* our smallest relative. It lives in the Kirindy Forest where at night it catches moths that visit baobab flowers to feed on nectar.

Photo: R. Hilgartner

During my nightly observations in the Kirindy Forest in western Madagascar I located a single Common Newtonia bird. The bird was sleeping on a branch in a bush at low height. On its neck sat the calpine moth *Hemiceratoides hieroglyphica*. A closer inspection revealed that the moth had its proboscis inserted beneath the lid of the closed eye of the bird. At this point it became clear to me that this was something very special never observed or documented before. While photographing this bizarre interaction the flash of my camera briefly disturbed the Common Newtonia. The bird moved its head and the proboscis of the moth lost contact with the bird's eye. However, the moth stayed on the bird's neck and after few seconds searched actively with its proboscis, inserting it beneath the lid of the closed eye. The moth stayed in this position for 35 minutes apparently drinking tears from the bird. During two years of research in Kirindy forest I observed this behavior only two more times. In one case the moth fed on tears of another bird species (Madagascar magpie-robin). The third observation was again with Common Newtonia as host species. These three observations were the world's first and only known observations of moths feeding on the tears of birds in Madagascar.

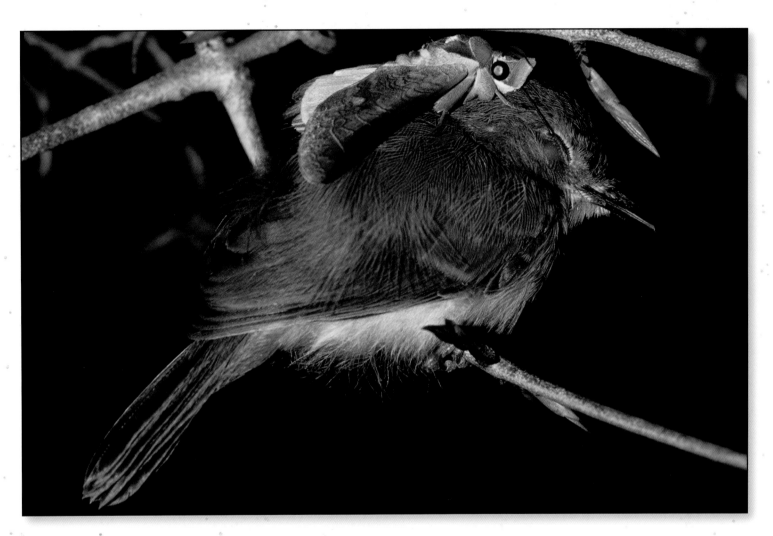

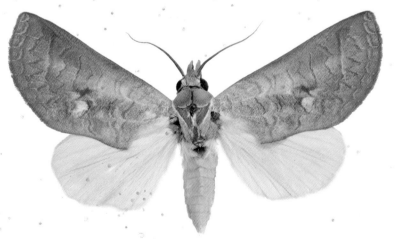

Hemiceratoides hierogyphica (Saalmüller, 1891)
Photo: Dr. R. Rougerie
Specimen of the Collection MNHN, Paris

Harpoon Moth
Hemiceratoides hieroglyphica sitting on the neck of a Common Newtonia *(Newtonia brunneicauda)*. The moth specializes in drinking the tears of sleeping birds. This remarkable behavior was discovered by Roland Hilgartner in the dry deciduous forest of western Madagascar in 2004.
Photo: Roland Hilgartner

Madagascar's Tear Drinker

Text by Dr. Roland Hilgartner

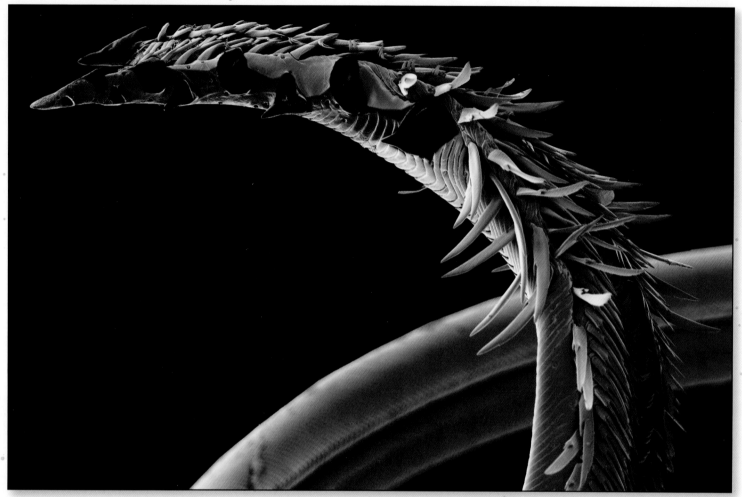

A lot of research questions about the tear-drinking behavior of *H. hieroglyphica* still remain unresolved. While the bird's eye was closed and the moth continued feeding, the host birds never showed signs of being disturbed. It would therefore be interesting to know whether the moths are able to introduce compounds such as antihistamines or narcotics to reduce irritation while the moth is feeding or to keep the bird asleep over such a long period of time. Another important question is the possible transmission of avian eye diseases. More observations are also needed to determine if the eastern rainforest species of the genus *Hemiceratoides* also exhibit tear-drinking behavior. To conclude: Madagascar remains a hotspot for naturalists to make new discoveries!

Harpoon-like proboscis

The harpoon-like proboscis is characteristic for *Hemiceratoides hieroglyphica*. To drink tears from sleeping birds it uses its specialized proboscis which it introduces underneath the bird's eyelid.
Photo: Harald W. Krenn
Coloration: Mamisolo R. Hilgartner

Tear-drinking moth

The overwhelming diversity of Noctuoidea - with over 2,000 species in Madagascar - also includes a huge diversity of life strategies. One of the most unusual has evolved in the Harpoon moth, *Hemiceratoides hieroglyphica*. All living organisms need micro- and macro-elements, and Lepidoptera are no exception. You may have observed butterflies and moths imbibing from mud puddles, or even from animal cadavers or feces – these are just some of the sources of these crucial elements. *Hemiceratoides hieroglyphica* is one of several species that have found a very interesting solution for this need – namely, drinking the salty tears of sleeping, completely unaware birds. This could well be an adaptation to the fact that many frogs and reptiles are predators while at the same time there are few large mammals to leave feces.

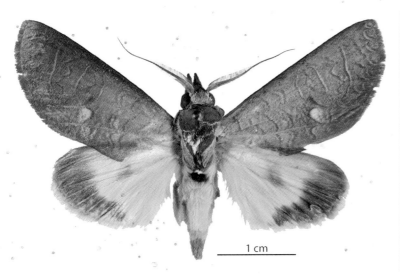

Hemiceratoides vadoni (Viette, 1976)
Photo: www.gbif.org
Specimen of the Collection MNHN, Paris

Genus *Hemiceratoides*

The genus *Hemiceratoides* comprises three species, and of these *H. hieroglyphica* has been substantiated in western Madagascar (Kirindy) and *H. vadoni* in the eastern part of the country (Masoala). The third species *H. sittaca* is found in Africa.

Notodontidae (Prominent moths)

Text by Dr. Alexander Schintlmeister

The Notodontidae or Prominent moths are one of the families in the Noctuoidea, the most species-rich super family of Lepidoptera (butterflies and moths) with about 60,000 currently recognized species. Nearly 5,000 of these belong to the Prominent moths and are found on every continent except Antarctica.

However, the actual number in Notodontidae is likely to be over 10,000 species because many of them await their discovery and description. Notodontid caterpillars eat a wide range of woody and herbaceous plants, and grasses (Poaceae) (Schintlmeister, 2008, Kroon, 1999). Caterpillars of some species are regarded as human food sources (Mabossy-Mobouna et al. 2022).

Family characteristics of Notodontidae are to be found specifically in the abdominal tympanal organ (an auditory structure), wing venation, male genitalia (well-developed socii), and larval morphology. Molecular phylogenetic research on Notodontidae began only recently. Initial results established Scranciidae, which formerly had been recognized as a subfamily within Notodontidae (Schintlmeister, 2008), as a distinct family (St. Laurent et al. 2023). Scranciidae are represented in Madagascar by three species but have not yet been found in Masoala.

In most cases the various subfamilies of Notodontidae are represented by only one species in Madagascar. But Thaumetopoeinae, Pygaerinae and Dicranurinae are rich in species in Madagascar. From the subfamily Thaumetopoeinae alone, 34 species have been described from Madagascar, with other Notodontidae in Madagascar currently numbering 73 species.

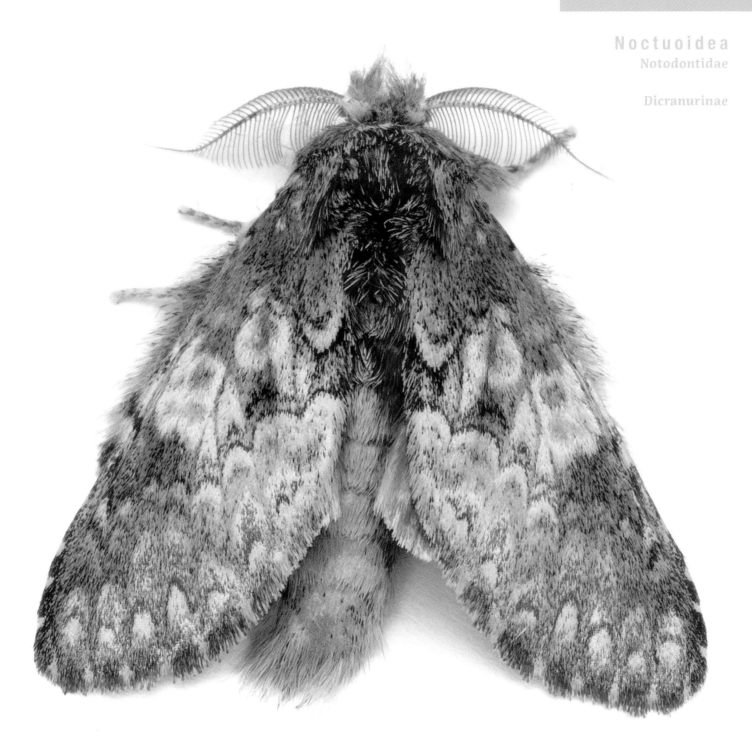

Desmeocraera robustior Kiriakoff, 1960

Color palette green

The antennae of male Dicranurinae are often bushy with naked tips. Many species appear green and are highly specialized ecologically. *Desmeocraera* is one of the largest genera among African Notodontidae with about 100 known species. But the author already is familiar with a further 47 new species that await description. Most *Desmeocraera* display green forewings. In Madagascar only three *Desmeocraera* occur: *robustior* (Kiriakoff, 1960), and two further similar species.

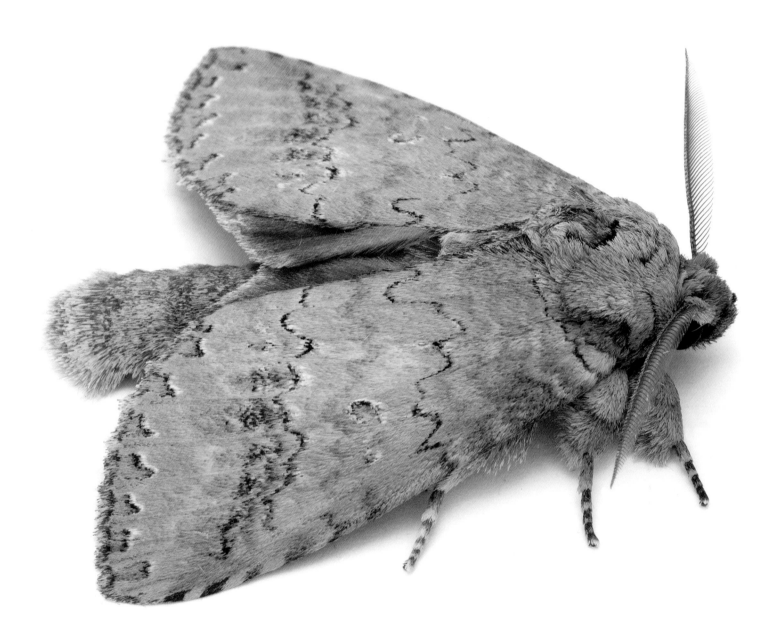

Vietteella madagascariensis (Draeseke, 1937)

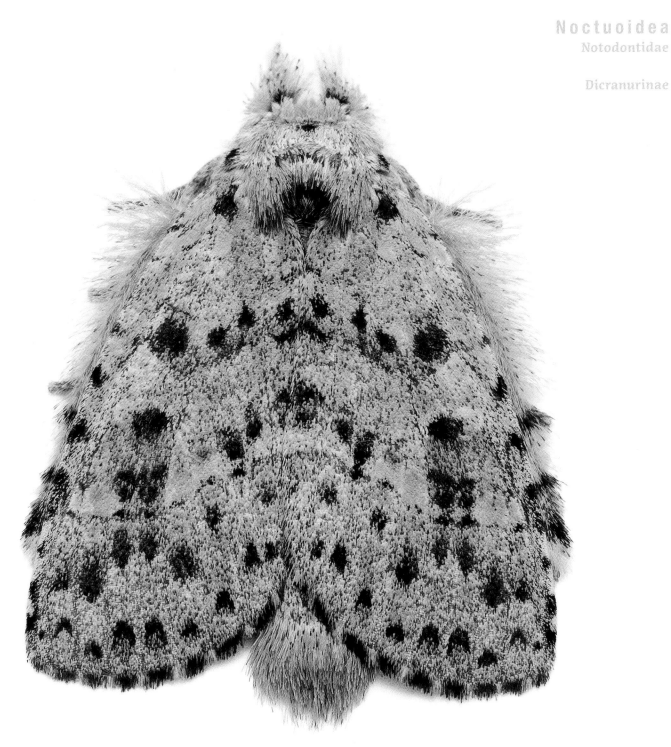

Lost male

This species is less well known. The lucky photographer was able to find the first male *Chlorocalliope dubiefae* (Viette, 1978) – the species was described from a female, which to date is the only known specimen in collections.

Chlorocalliope dubiefae (Viette, 1978)
February 23th/2019

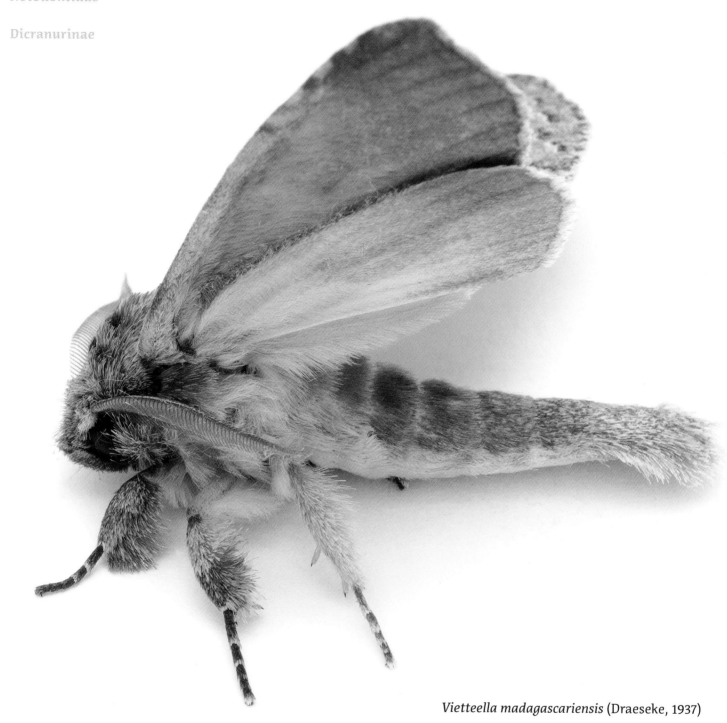

Vietteella madagascariensis (Draeseke, 1937)

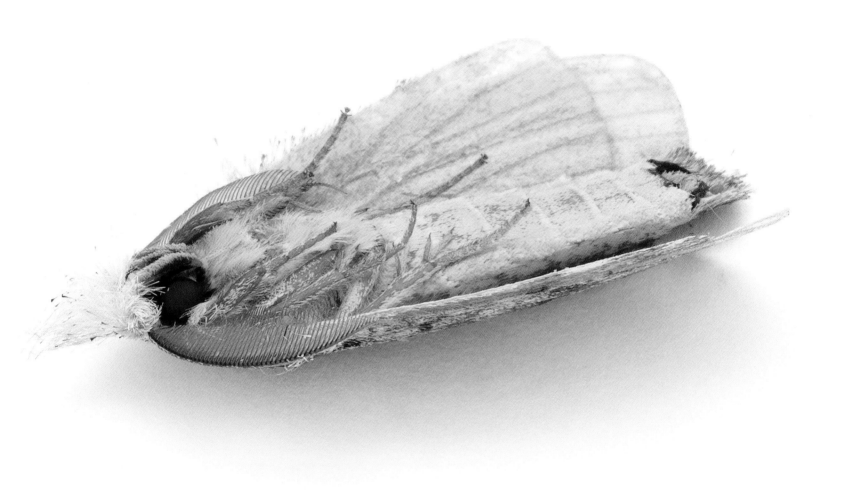

Stowaways

A glance at the underside of this moth reveals signs of life. On this male *Chlorocalliope dubiefae* two mites can be seen, in the area of the left antenna and on the abdomen. They are living on the moth. The leg scaling is in very large part missing and it can be surmised that the creature is already a few days old.

Chlorocalliope dubiefae (Viette, 1978)
February 23th/2019

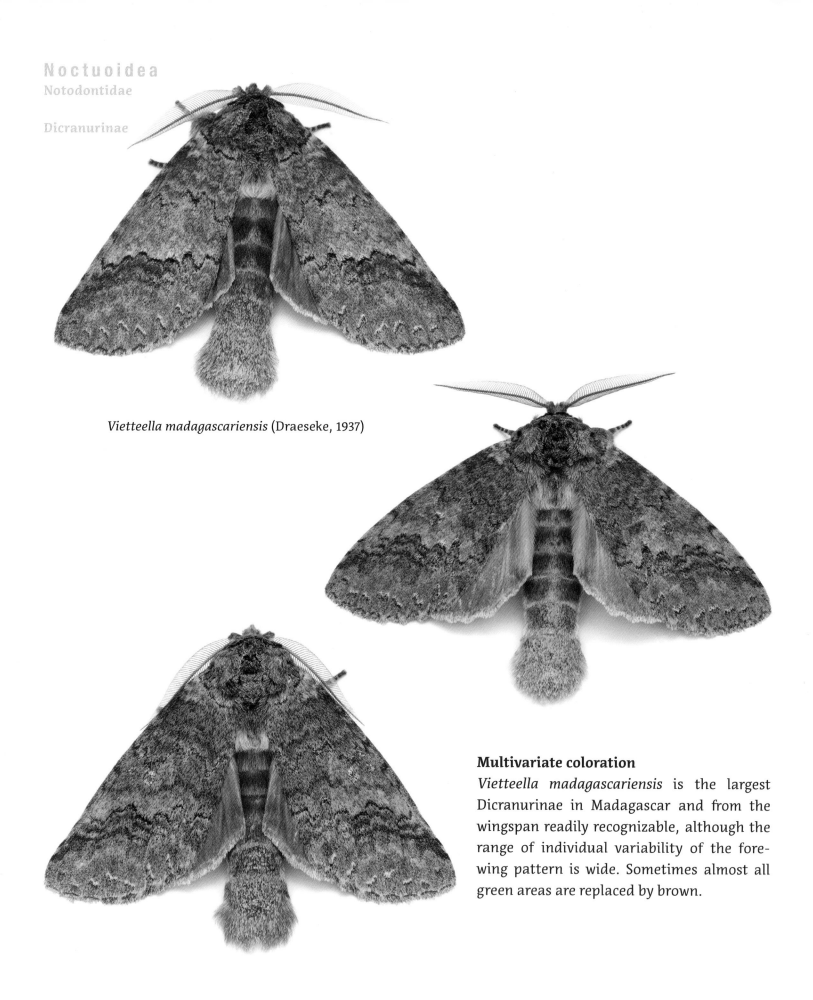

Vietteella madagascariensis (Draeseke, 1937)

Multivariate coloration

Vietteella madagascariensis is the largest Dicranurinae in Madagascar and from the wingspan readily recognizable, although the range of individual variability of the forewing pattern is wide. Sometimes almost all green areas are replaced by brown.

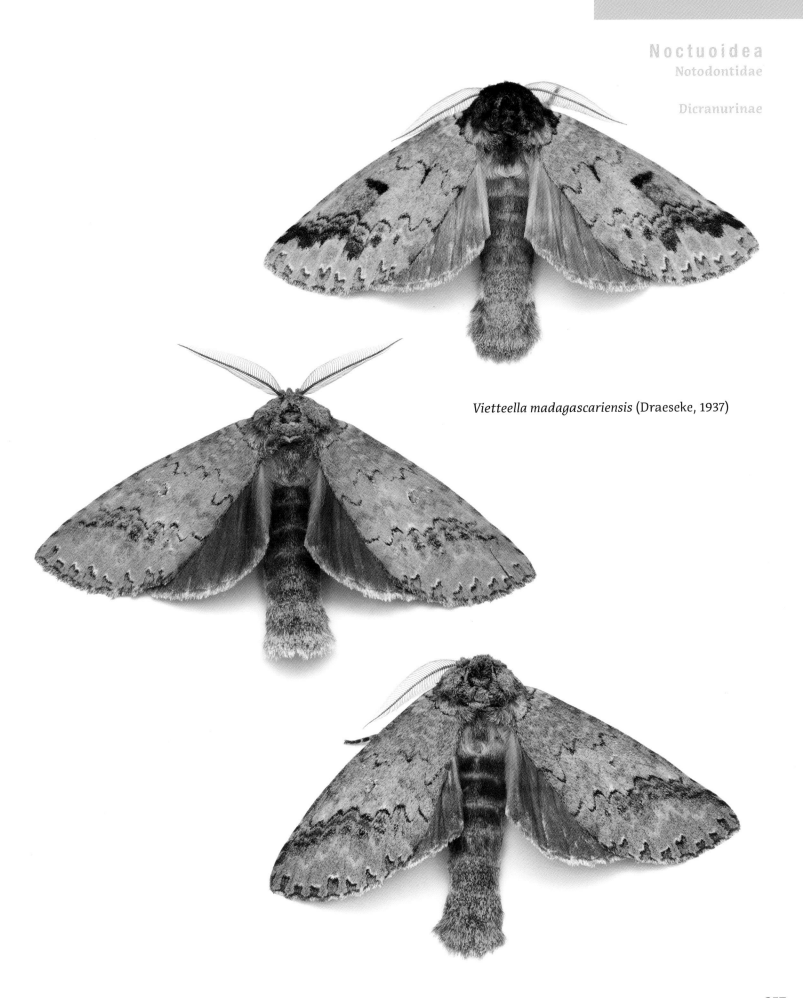

Vietteella madagascariensis (Draeseke, 1937)

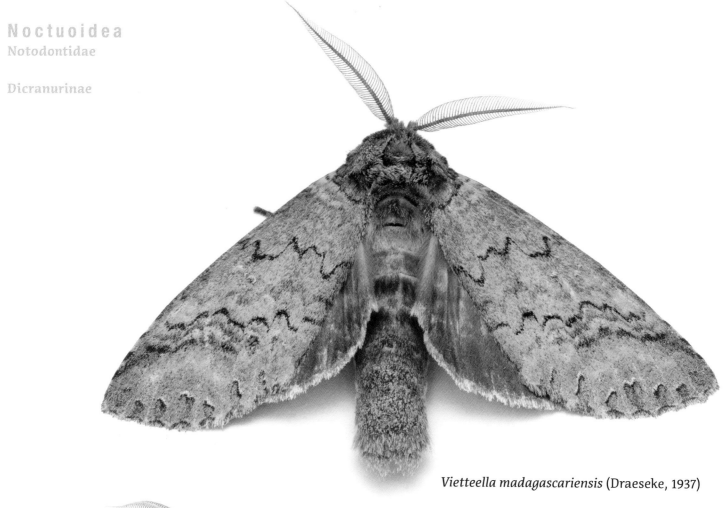

Vietteella madagascariensis (Draeseke, 1937)

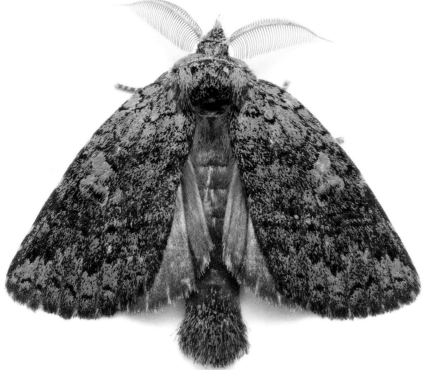

Pycnographa viridissima (Kiriakoff, 1958)

Elongated abdomen

This elegant species is unmistakable because of the intense dark-green forewings. The cryptic patterns hide the moth perfectly in the dense green rainforest. The bushy front legs are stretched forward when at rest, as in many Notodontidae. The abdomen is also longer than the folded forewings and only the protruding end is colored green like the forewings.

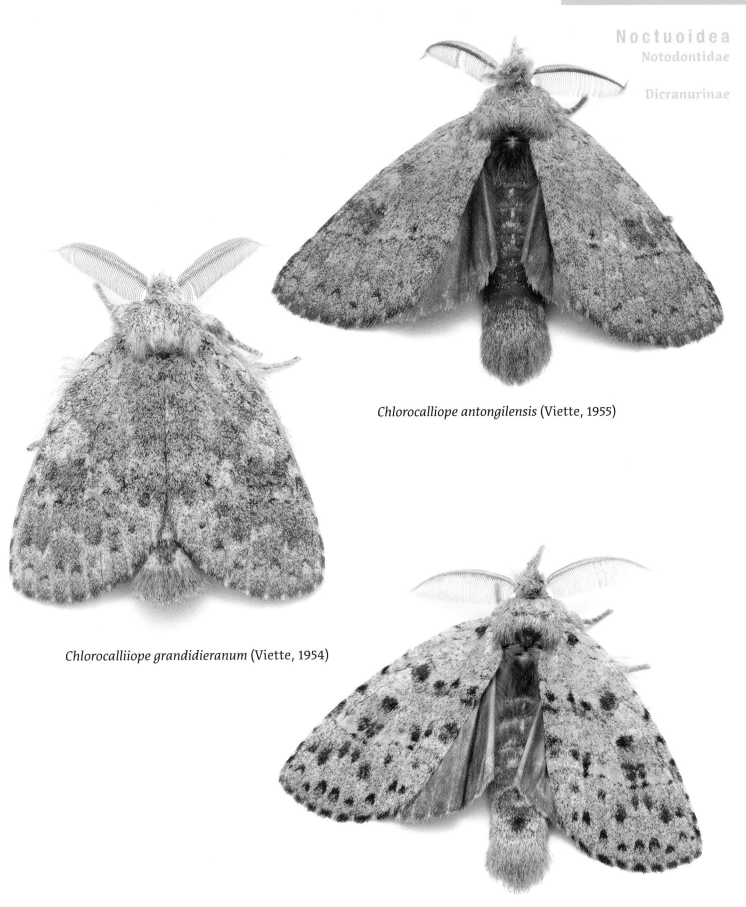

Chlorocalliope antongilensis (Viette, 1955)

Chlorocalliiope grandidieranum (Viette, 1954)

Chlorocalliope dubiefae (Viette, 1978)

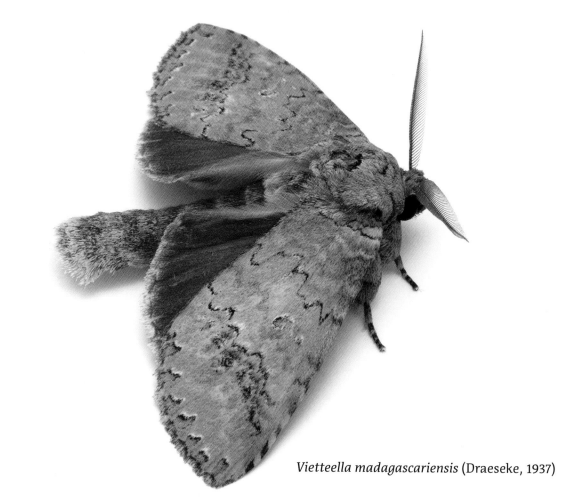

Vietteella madagascariensis (Draeseke, 1937)

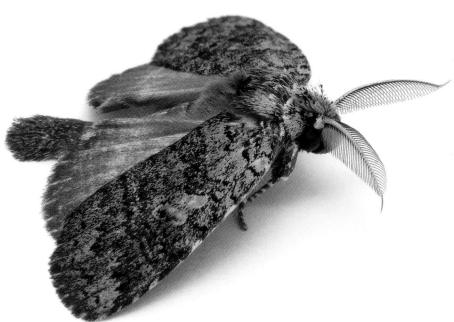

Pycnographa viridissima (Kiriakoff, 1958)

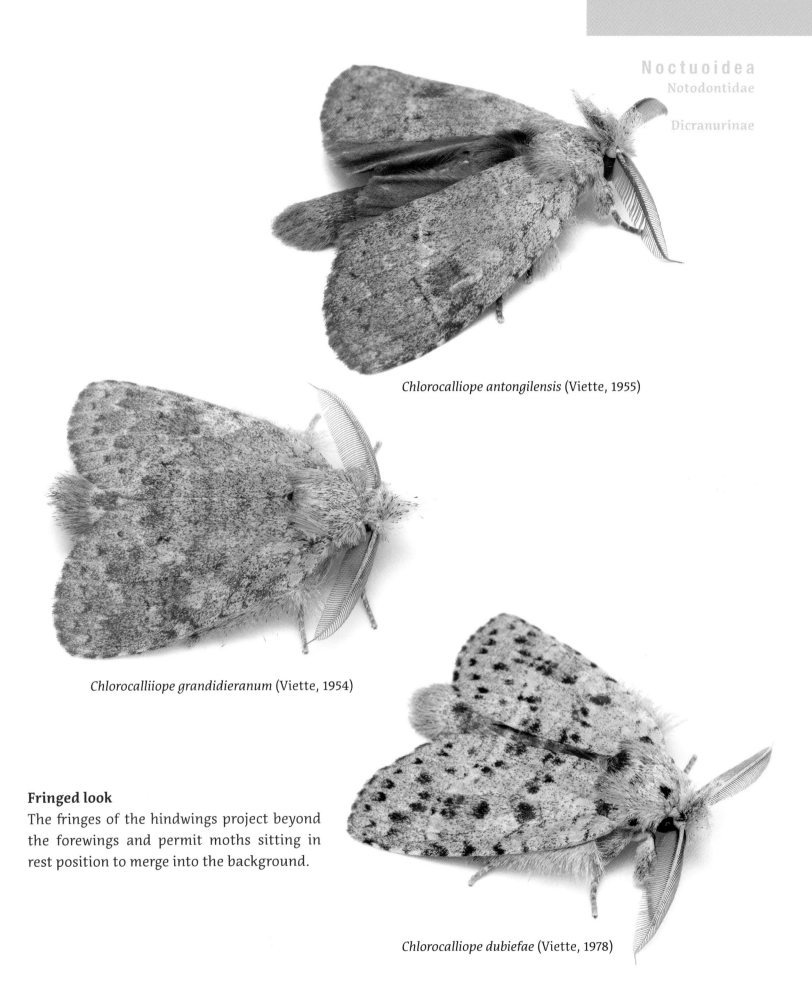

Chlorocalliope antongilensis (Viette, 1955)

Chlorocalliiope grandidieranum (Viette, 1954)

Fringed look
The fringes of the hindwings project beyond the forewings and permit moths sitting in rest position to merge into the background.

Chlorocalliope dubiefae (Viette, 1978)

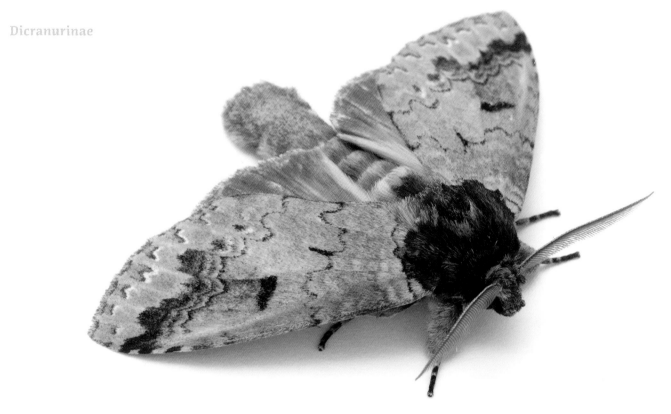

Vietteella madagascariensis (Draeseke, 1937)

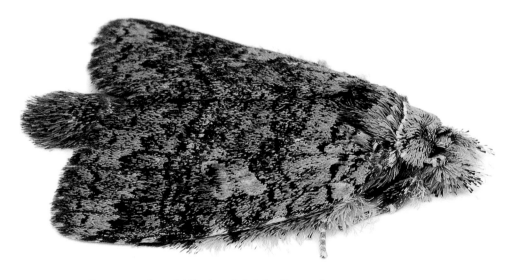

Pycnographa viridissima (Kiriakoff, 1958)

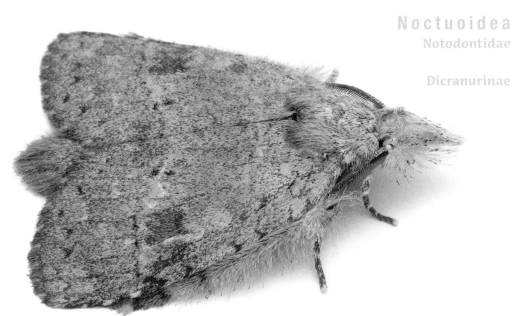

Chlorocalliope antongilensis (Viette, 1955)

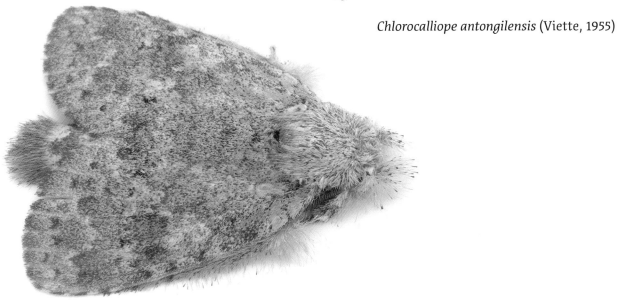

Chlorocalliope grandidieranum (Viette, 1954)

Perfect camouflage in resting position
When at rest, *Chlorocalliope* and *Pycnographa* press themselves down against the background. Moving from side to side, the abdomen positions itself centrally under the closed wings, with antennae and legs bent inwards and concealed under wings and body. Long scales on the upper thorax near the base of the antennae are folded forward and protect the eyes.

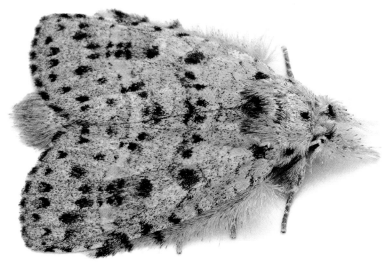

Chlorocalliope dubiefae (Viette, 1978)

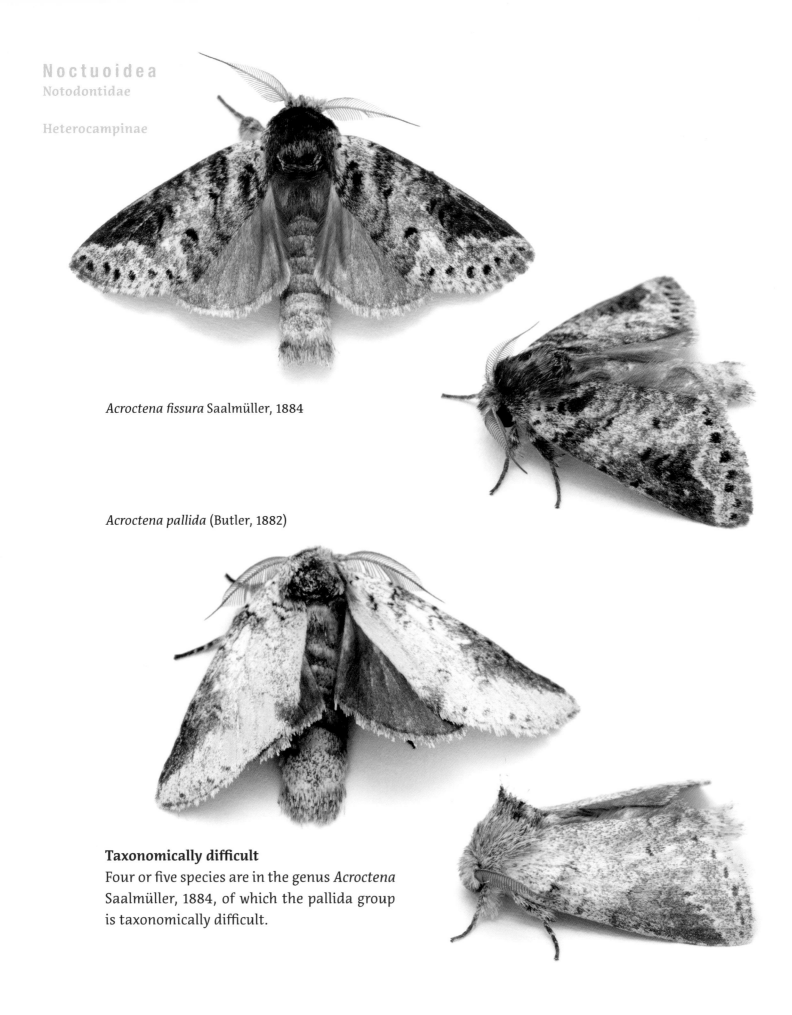

Acroctena fissura Saalmüller, 1884

Acroctena pallida (Butler, 1882)

Taxonomically difficult
Four or five species are in the genus *Acroctena*
Saalmüller, 1884, of which the pallida group
is taxonomically difficult.

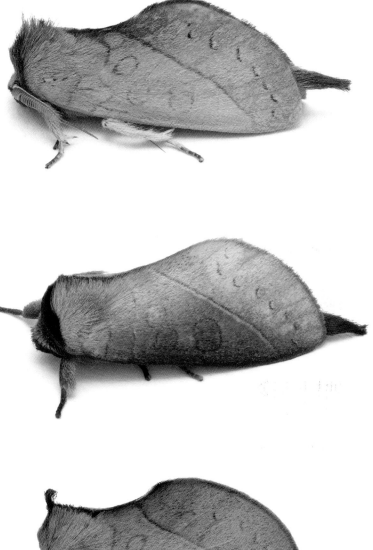

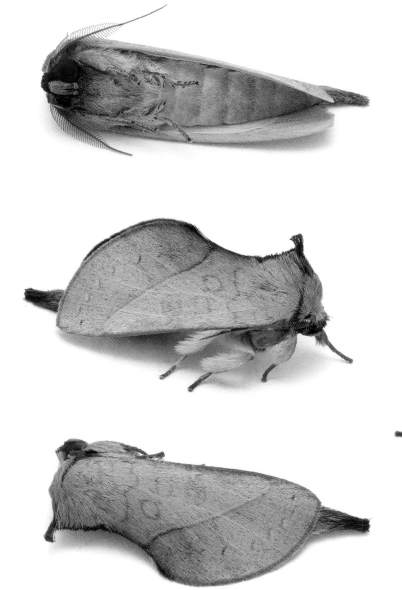

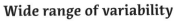

Wide range of variability

Ambina adults display a remarkably wide range of individual variability in forewing pattern. There are individuals with almost uniformly pale orange-brown forewings; other specimens display a blackish pattern, such as lines, spots, and three circles with a blackish border with various modifications. This led to the description of five more species between 1960 and 1969. But they belong, in fact, to one species and the different names are merely junior synonyms.

Ambina spissicornis (Mabille, 1899)

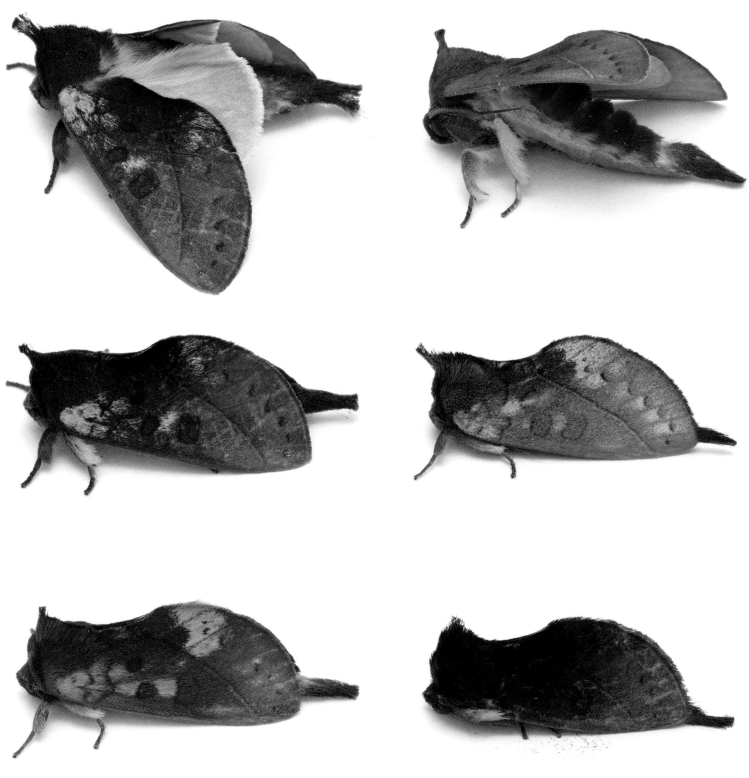

Ambina ochreopicta (Kenrick, 1917)

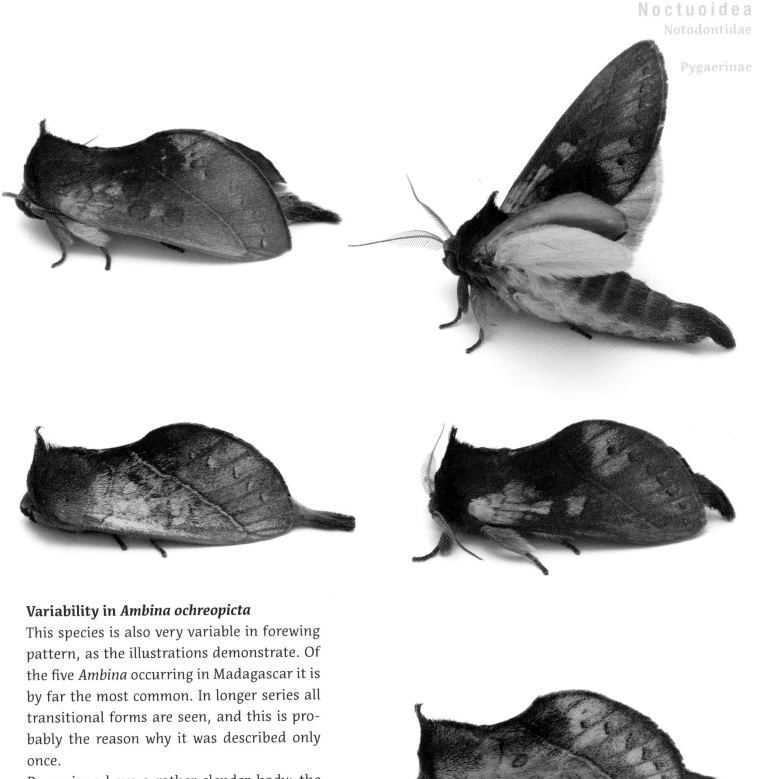

Variability in *Ambina ochreopicta*

This species is also very variable in forewing pattern, as the illustrations demonstrate. Of the five *Ambina* occurring in Madagascar it is by far the most common. In longer series all transitional forms are seen, and this is probably the reason why it was described only once.

Pygaerinae have a rather slender body; the thorax bears a dorsal tuft and in males the anal tuft of the abdomen is prominent – and bifid. In mainland Africa, the caterpillars are associated with willows and poplars (Salicaceae); caterpillars of Madagascan species and their host plants are hitherto unknown.

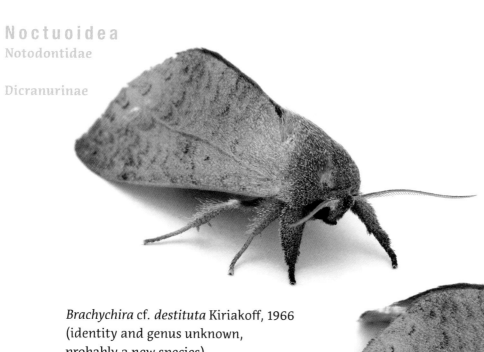

Brachychira cf. *destituta* Kiriakoff, 1966
(identity and genus unknown,
probably a new species)

Clostera albidilinea (Gaede, 1928)
Eutronotus albidilinea

Worldwide range
Clostera is distributed worldwide in many,
mostly smaller, species and Madagascar
hosts no fewer than 16 species, 2 of which are
illustrated here.

Clostera pratti (Kenrick, 1917)

Not assigned

The contrasting white discal streak on the forewings makes this small species unmistakable. Its assignment to a subfamily, however, remains uncertain.

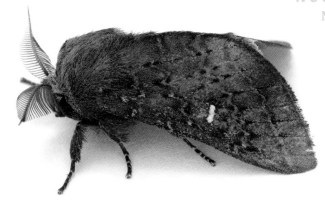

Romaleostaura insularis Kiriakoff 1960

Numerous species of Phalerinae

Phalerinae are numerous in Africa, with about 100 species in 12 genera, but only four species occur in Madagascar. Caterpillars of many Phalerinae are associated in Africa with grasses (Poaceae), but in Europe or Asia their host plants are various trees and shrubs, while grass is not taken. The host plants of *Elaphrodes* are, however, unknown. In mainland Africa a further four *Elaphrodes* species are known.

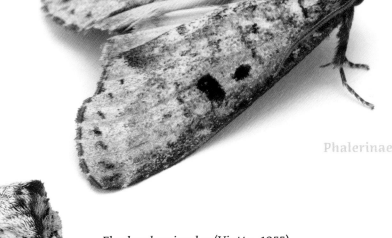

Phalerinae

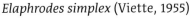

Elaphrodes simplex (Viette, 1955)

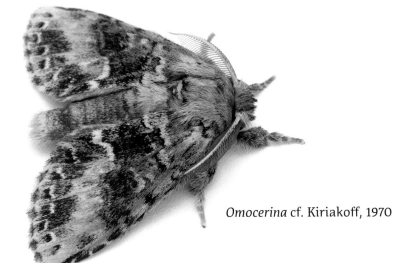

Dicranurinae

Omocerina cf. Kiriakoff, 1970

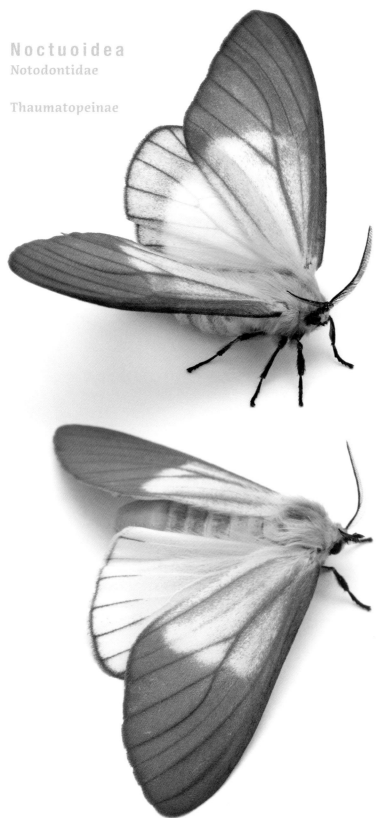

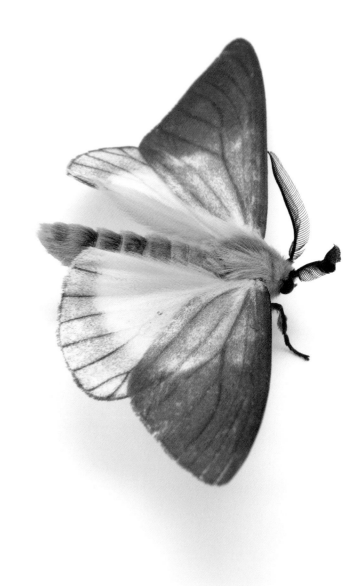

Hypsoides radama (Coquerel, 1855)

Species-rich genera

Thaumetopoeinae or Processionary moths – seen by some authors as their own distinct family – are, in Madagascar, moths with large wing areas and wings that are often whitish and blackish. The name Processionary moths is derived from the habit of the gregarious caterpillars of walking in "processions", i.e., each caterpillar's head touches the hindquarters of the preceding one. From Madagascar, 34 species in three genera have been described and all of them are endemic.

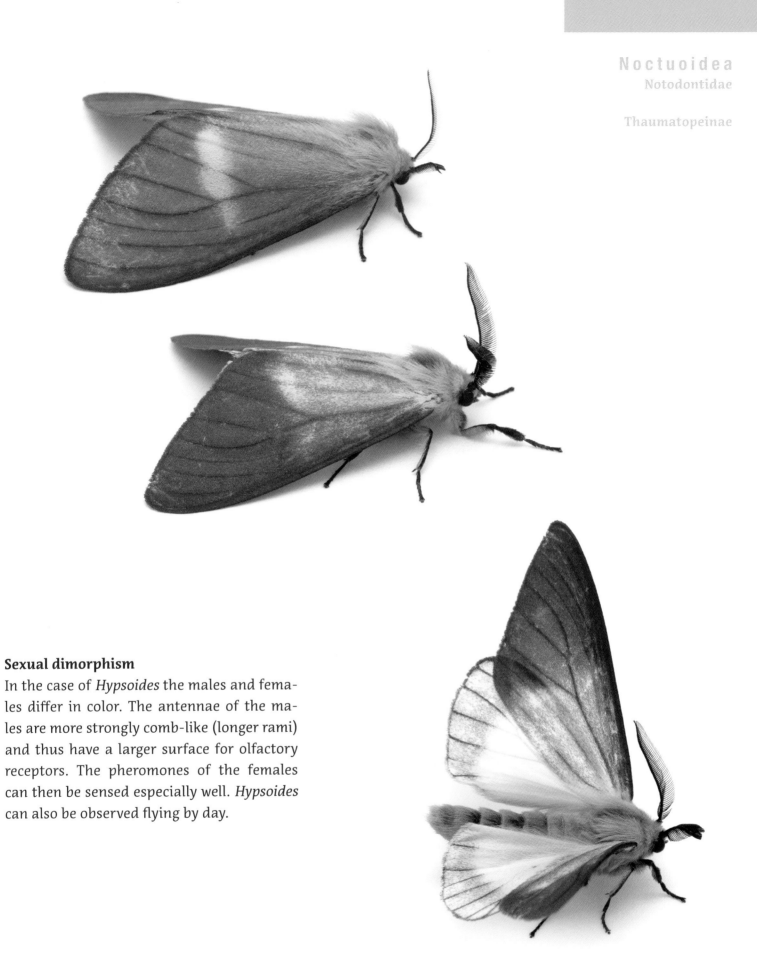

Sexual dimorphism

In the case of *Hypsoides* the males and females differ in color. The antennae of the males are more strongly comb-like (longer rami) and thus have a larger surface for olfactory receptors. The pheromones of the females can then be sensed especially well. *Hypsoides* can also be observed flying by day.

Erebidae

Text by Marcin Wiorek

The family Erebidae is evolutionarily a very young yet highly diverse group and its classification is still quite a riddle for scientists. Right now, to this family are assigned around 25,000 species distributed worldwide, and it includes some of the moths with both the largest and the smallest wingspans on earth.

In Madagascar there are around 1,250 known species of erebids. Among the numerous subfamilies belonging to Erebidae, there are for example tiger moths (subfamily Arctiinae), piercing moths (subfamily Calpinae), underwings (subfamily Erebinae) and tussock moths (subfamily Lymantriinae).

An interesting detail is that the entire family Erebidae derives its name from the genus *Erebus* – such a genus in systematics is called the typical genus, being the "namebearer" of the entire group. The only species of this genus occurring in Madagascar is *Erebus walkeri*.

Subfamilies of Erebidae:
- Aganainae
- Anobinae
- Arctiinae
- Boletobiinae
- Calpinae
- Erebinae
- Eulepidotinae
- Herminiinae
- Hypeninae
- Hypenodinae
- Hypocalinae
- Lymantriinae
- Pangraptinae
- Rivulinae
- Scolecocampinae
- Scoliopteryginae
- Tinoliinae
- Toxocampinae

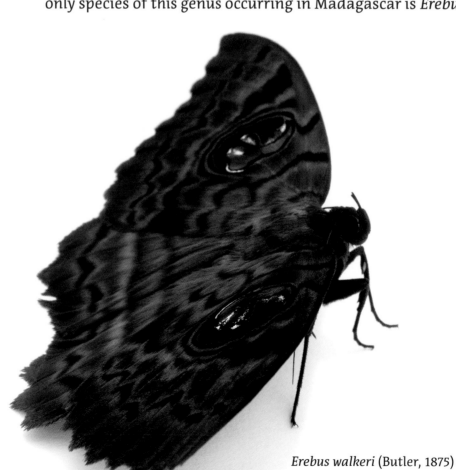

Erebus walkeri (Butler, 1875)

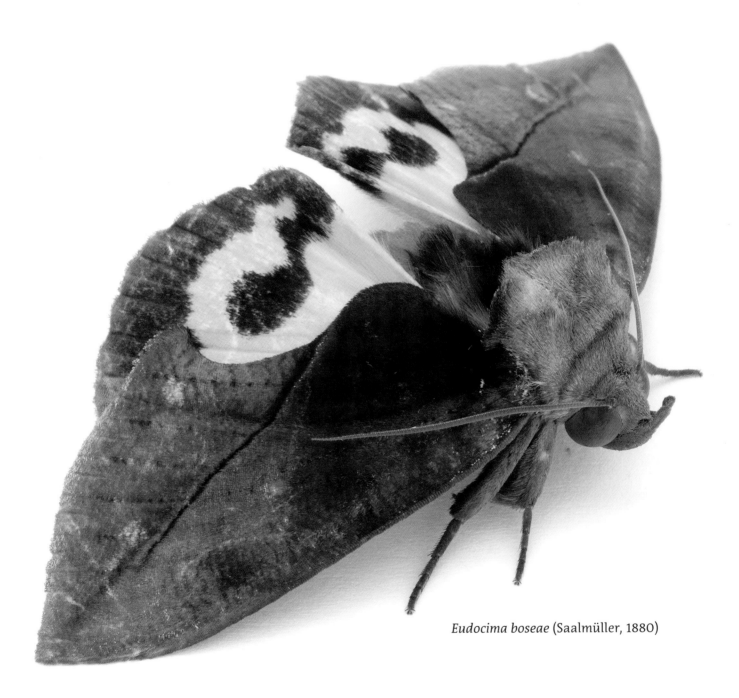

Eudocima boseae (Saalmüller, 1880)

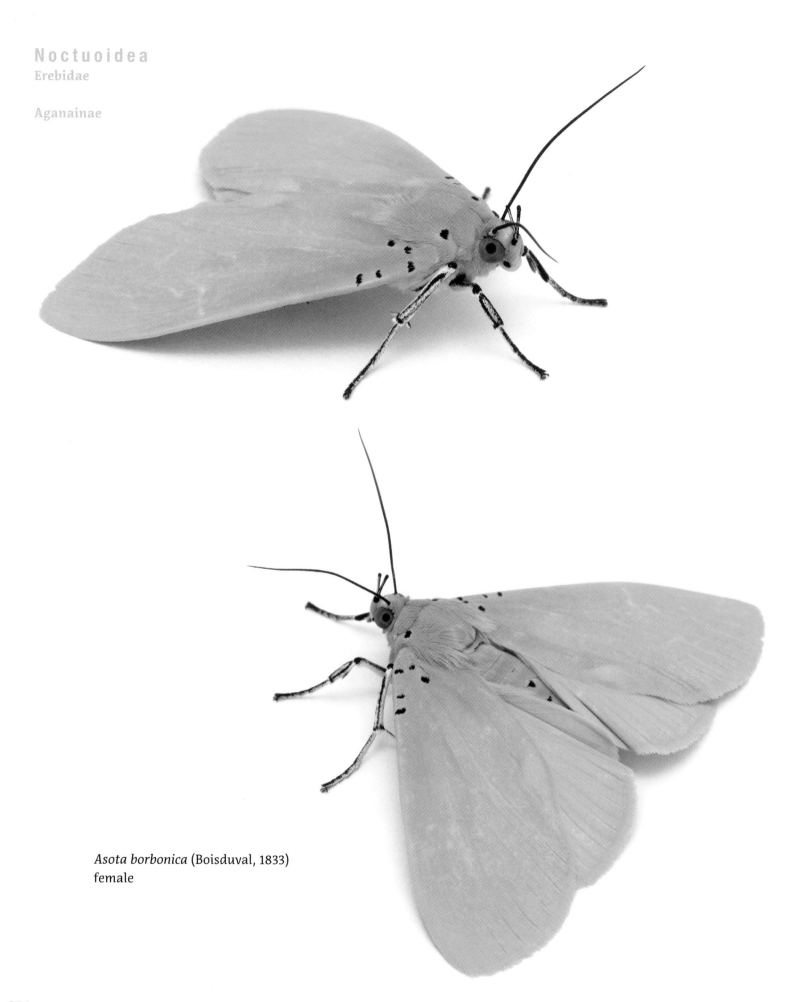

Asota borbonica (Boisduval, 1833)
female

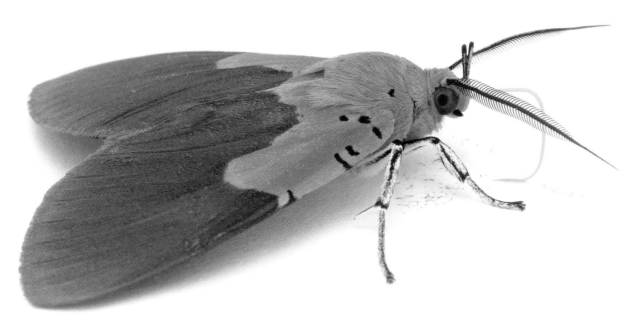

Flexible proboscis with a brush-like tip

Butterflies and moths ingest liquid food – whether this be nectar from flowers or sap from trees. Any other sources of liquids are used, including also dung, sugary or salty juices from fruits, sweat, or many other kinds, even the tears of birds. In order to do this, they sop up the liquids with the tip of their flexible proboscis. The proboscis itself is a supple, maneuverable double tube whose tip is shaped like an artist's paintbrush – thus the large surface area of the proboscis tip produces a capillary effect that enables the nutrient solution to be sucked up. Here, *Asota borbonica* is ingesting a sugar solution. By moving the head and the proboscis the solution is soaked up. At the same time, the antennae are repeatedly raised or extended forward, while keeping the same posture. After taking the food the proboscis is rolled up and placed between the palpi in resting position.

Asota borbonica (Boisduval, 1833)
male

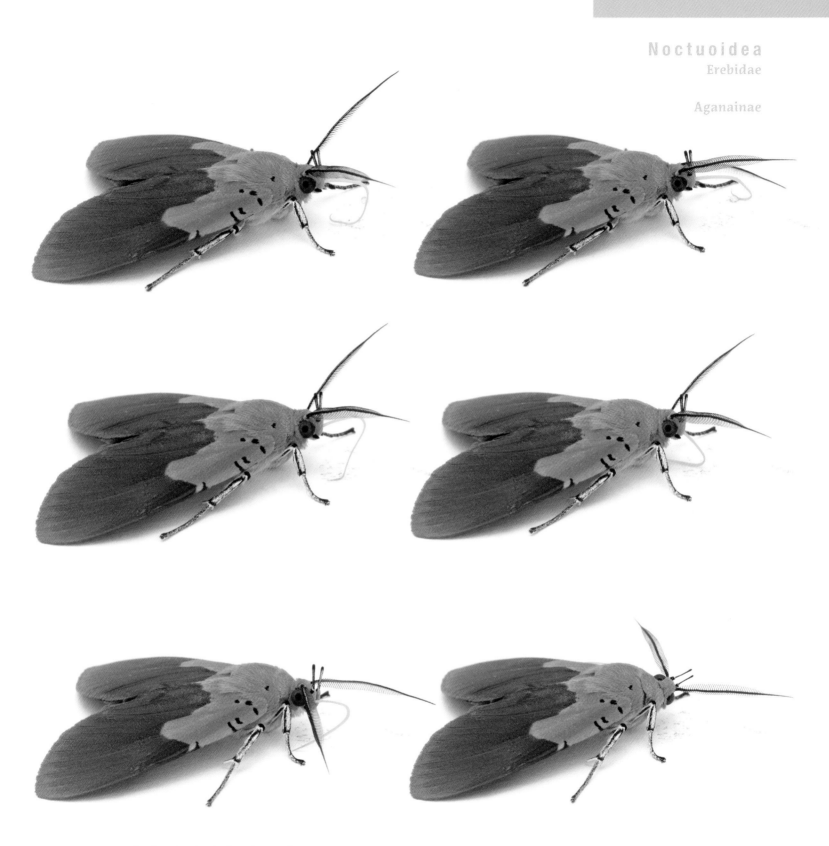

Asota borbonica (Boisduval, 1833)
male

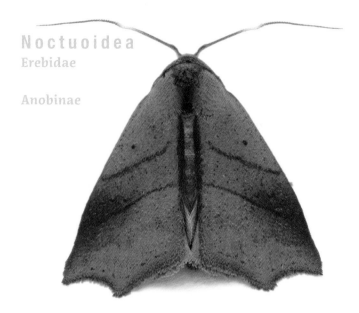

Acripia megalesia Viette, 1965

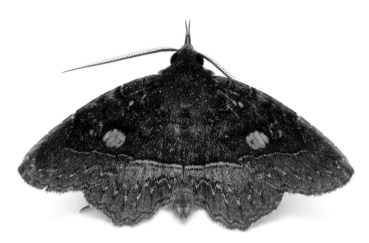

Aburina dufayi Viette, 1979

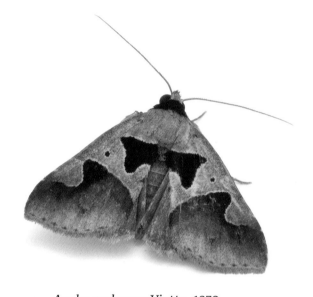

Anoba malagasy Viette, 1970

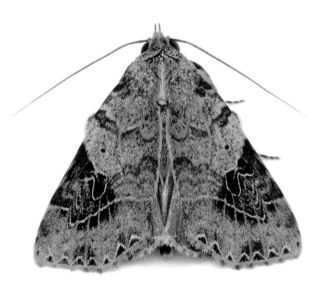

Plecoptera lacinia (Saalmüller, 1880)

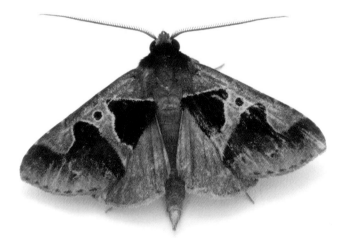

Anoba malagasy Viette, 1970

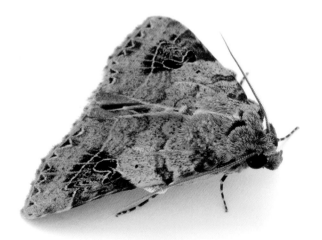

Plecoptera lacinia (Saalmüller, 1880)

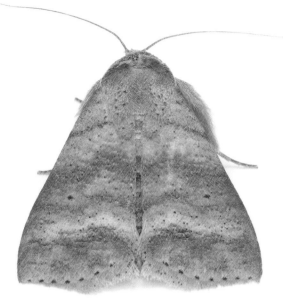

Mafana lajonquierei Viette, 1979

Mafana lemairei Viette, 1979

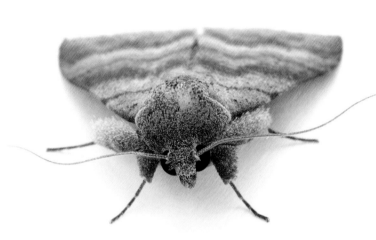

Mafana lajonquierei Viette, 1979

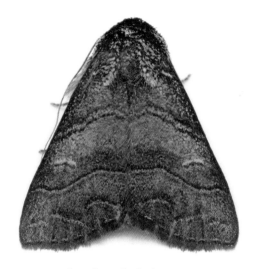

Mafana lemairei Viette, 1979

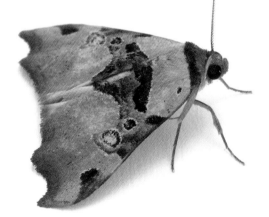

Marcipa noel Viette, 1966

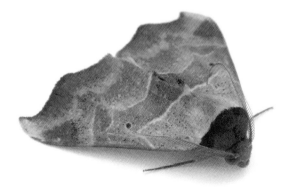

Marcipa callaxantha (Kenrick, 1917)

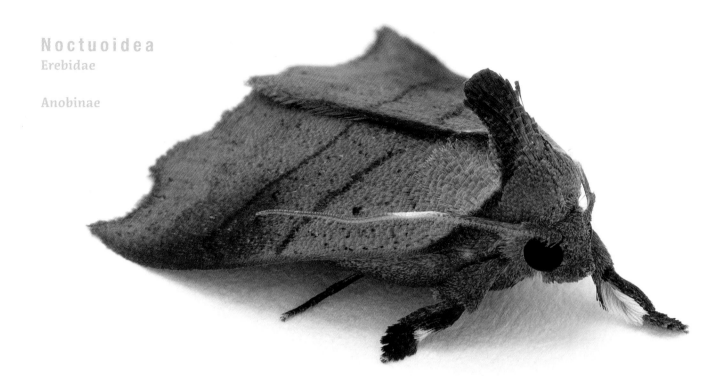

Acripia megalesia Viette, 1965

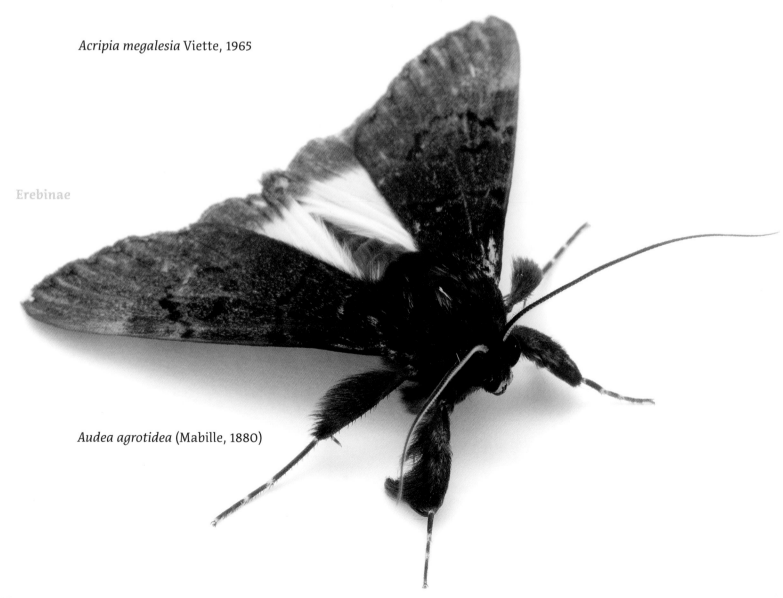

Audea agrotidea (Mabille, 1880)

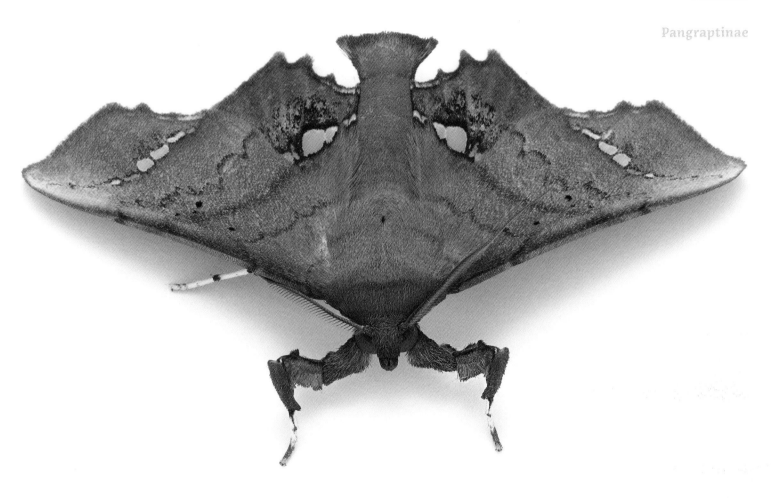

Episparis vitrea (Saalmüller, 1891)

Scaly legs

Legs, as for the entire moth body, are covered with scales. In some erebids this vestiture is very varied, forming different kinds of tufts or brushes, as in *Acripia megalesia* and *Audea agrotidea* shown here. The exact functions of these scales is unknown, but considering the cryptic coloration of these moths, it may simply help them to blend more efficiently into the background in the resting position. Additionally, the beak-like tuft on the thorax of *A. megalesia* is perhaps part of such camouflage making the moth look like a piece of broken twig. In the similar way, projecting front legs of *Episparis vitrea* displayed here fit well with the general appearance of this moth, resembling a withered and already perforated leaf.

Arctiinae (Tiger moths)

Text Marcin Wiorek

Arctiinae is a large subfamily of Erebidae moths, comprising some 11,000 species inhabiting mostly the tropics. Their scientific name derives from the Greek word arktos meaning "bear", which refers to the caterpillars of these moths, which are often densely hairy and called woolly bears. Adult arctiines, due to their very characteristic appearance, are commonly named tiger moths, wasp moths, lichen moths, footmen and polka-dot moths.

In Madagascar there are only about 370 known arctiine species, but that number comprises some of the most interesting groups of moths endemic to the island. A treasure trove of the Madagascan arctiines is the group of around 100 species of polka-dot moths of the tribe Syntomini – one of them, representing the genus *Tenuinaclia*, can be seen at the bottom of pages 296 – 297. The unique thing about these moths is that all of them derive from a single ancestor, and in a relatively short time (in the evolutionary timescale) diversified into a hundred species.

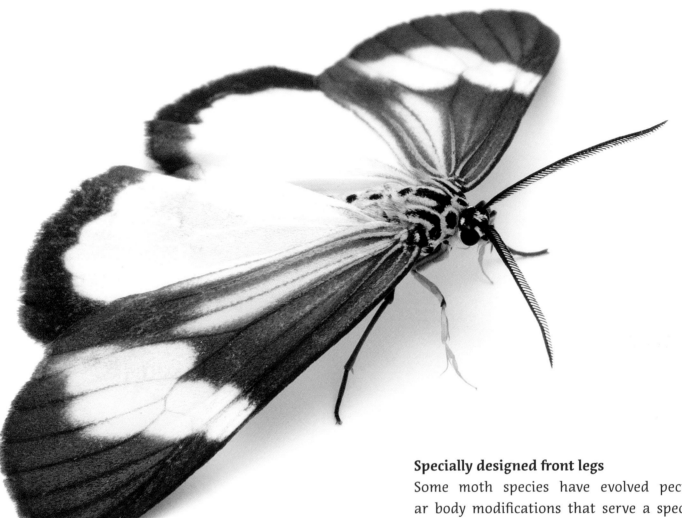

Chiromachla insulare (Boisduval, 1833)

Specially designed front legs

Some moth species have evolved peculiar body modifications that serve a specific purpose. For example a pair of legs may no longer be used for walking, but have a completely new function. In the case of genus *Chiromachla* the male forelegs are reduced and have a modified shape, different in each species of the genus! In *Chiromachla insulare* displayed here, the front legs are orange, have a club-like contraction and are provided with a row of very long, hair-like setae. It is believed that these structures have a sexual function, but their exact role still remains unknown.

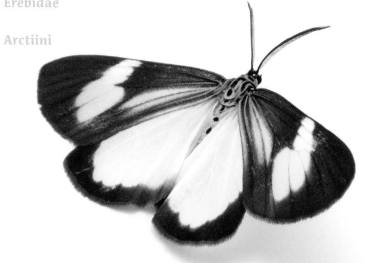

Chiromachla insulare (Boisduval, 1833)

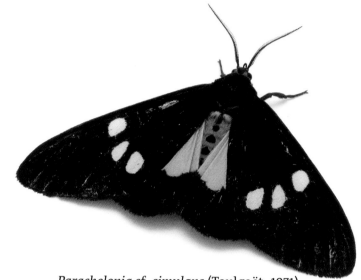

Parachelonia cf. *simulans* (Toulgoët, 1971)

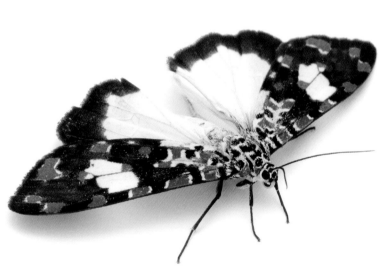

Utetheisa elata (Fabricius, 1798)

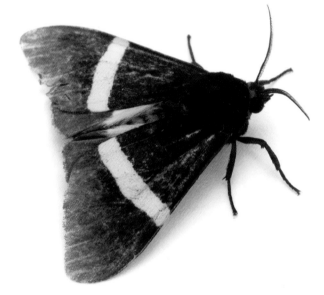

Fodinoidea rectifascia Collenette, 1930

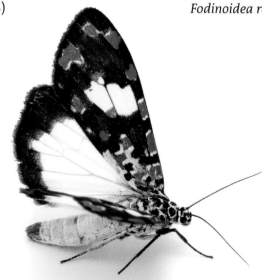

Madagascarctia cellularis (Toulgoët, 1954)

Detoulgoetia virginalis (Butler, 1878)

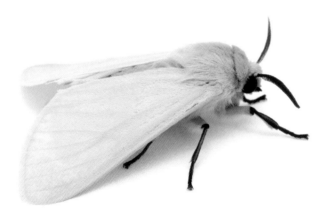

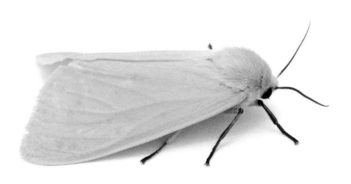

Madagascarctia madagascariensis (Butler, 1882)

Madagascarctia madagascariensis (Butler, 1882)

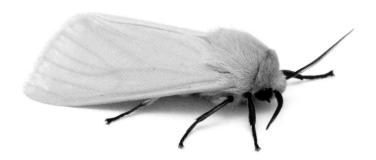

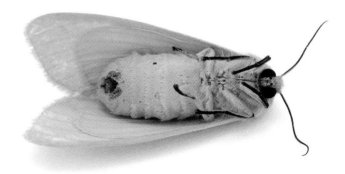

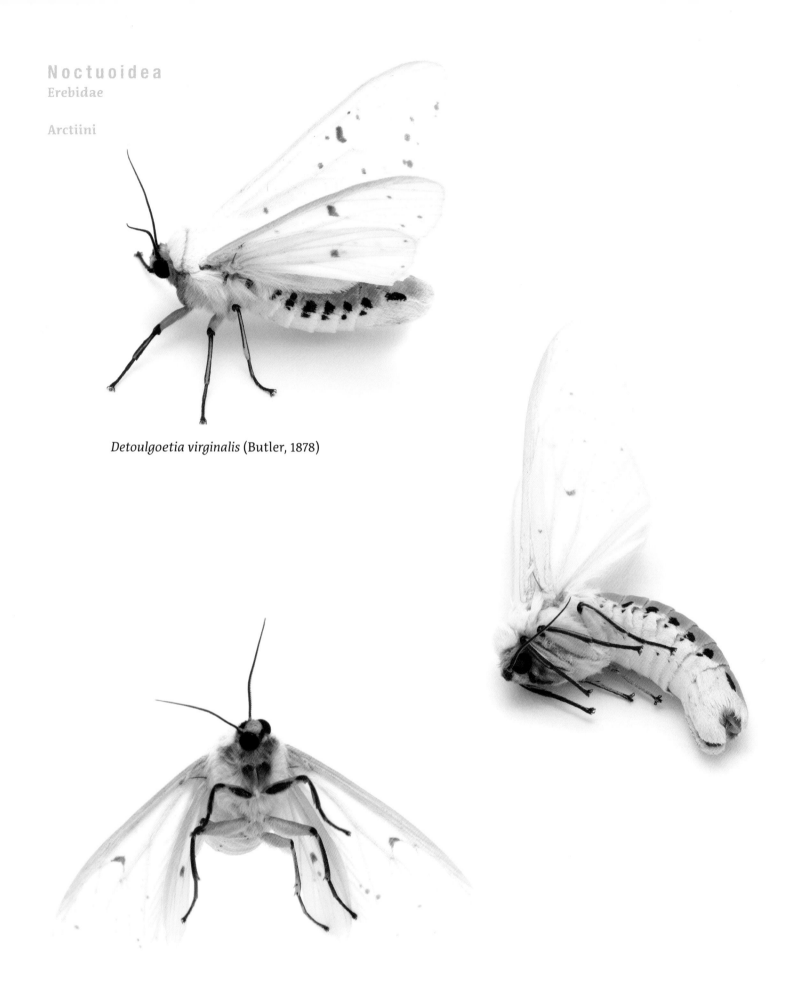

Detoulgoetia virginalis (Butler, 1878)

Aposematism – warning coloration on abdomen

Tiger moths owe their name to the bright and vivid coloration, which often does indeed include tiger-orange, as in *Detoulgoetia virginalis* shown here. Such patterns and colors in nature are a universal sign that their owner is dangerous, unpalatable or even poisonous. In the case of arctiines it is actually a true warning as bodies of many species contain secondary compounds obtained from plants. These substances are completely harmless to the moths, but unpalatable or toxic to a potential predator. Thus, if any predator were to ignore the visual signals, it is then immediately taught through the sense of taste to avoid this kind of prey.

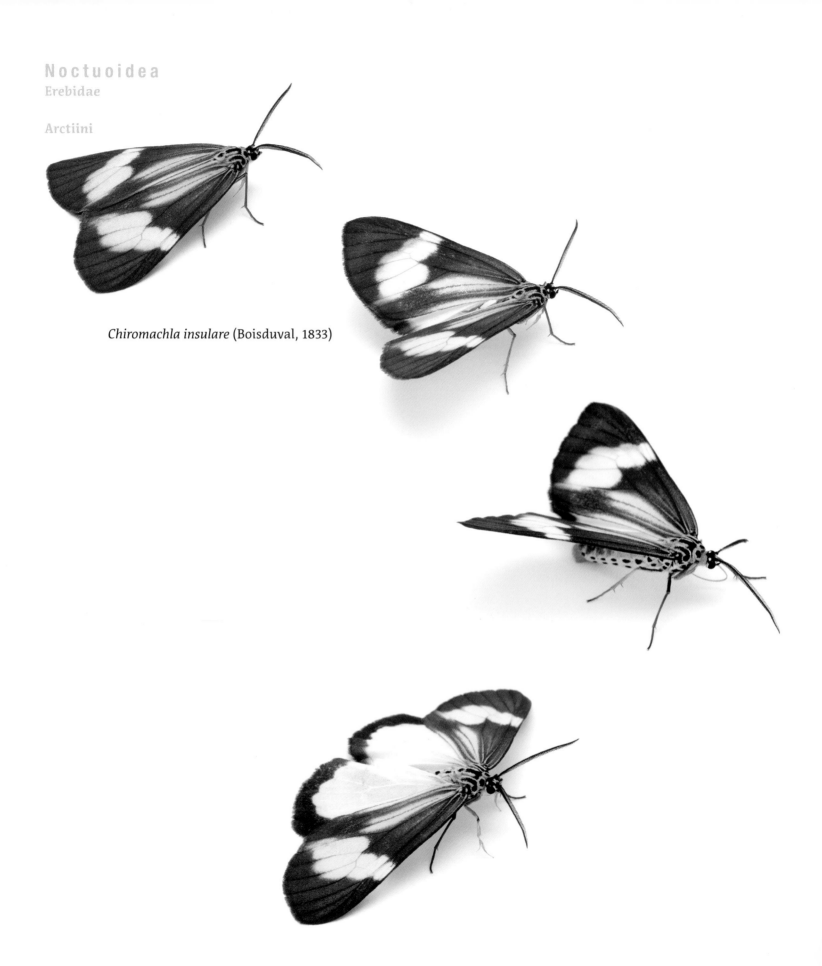

Noctuoidea
Erebidae

Arctiini

Chiromachla insulare (Boisduval, 1833)

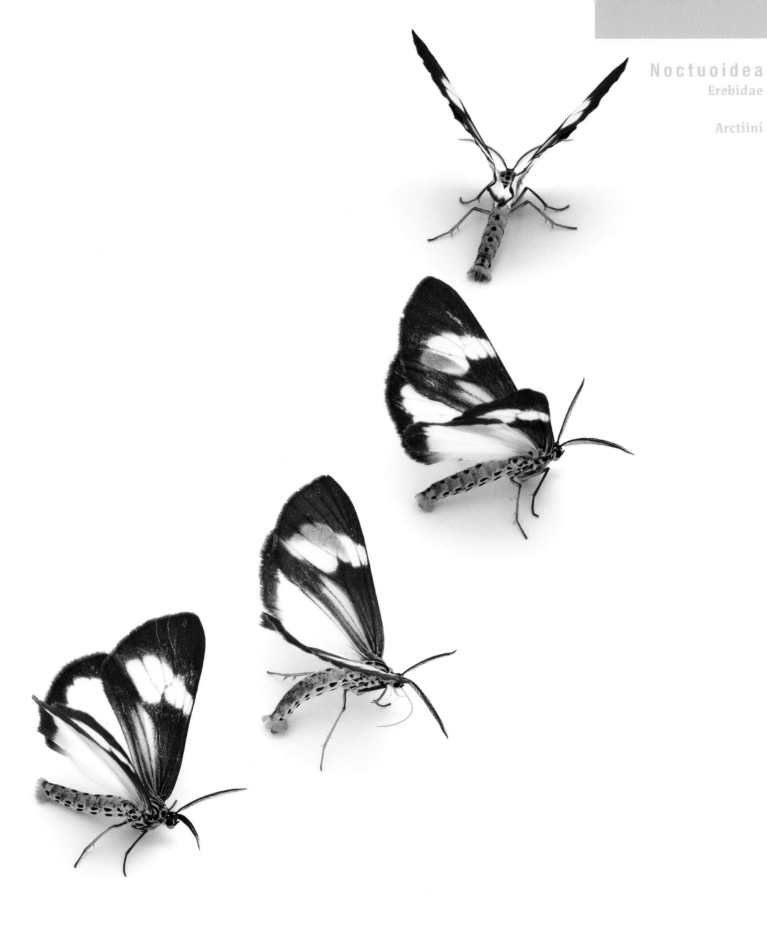

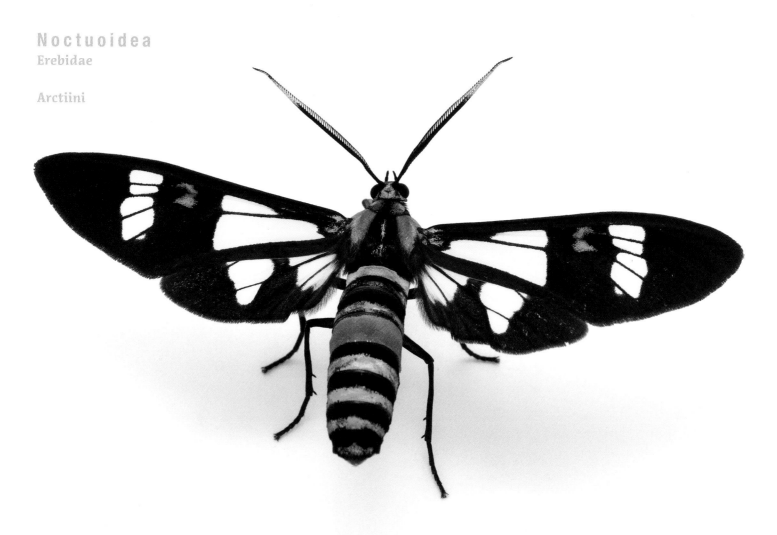

Euchromia folletii (Guérin-Méneville, 1832)

Mimicry – wasp or moth?
There are around 50 species of *Euchromia* wasp moths, inhabiting the tropics of the Old World. *Euchromia folletii* shown here is one of the two species occurring in Madagascar. The common character of all moths from this genus is their wasp-like appearance. With their striped abdomens and large blotches on elongate and narrowed wings, they more resemble big hornets than moths. An interesting thing is the metallic-blue gloss of their body, being the effect of structural coloration. It means that this color is not the result of pigmentation of scales, but their nanostructure. Thus, this phenomenon in *Euchromia* follows the same principles as in the widely known neotropical butterflies of the genus *Morpho* – the scales themselves are brownish but their surface refracts light in such a way that only the blue part of the spectrum is reflected.

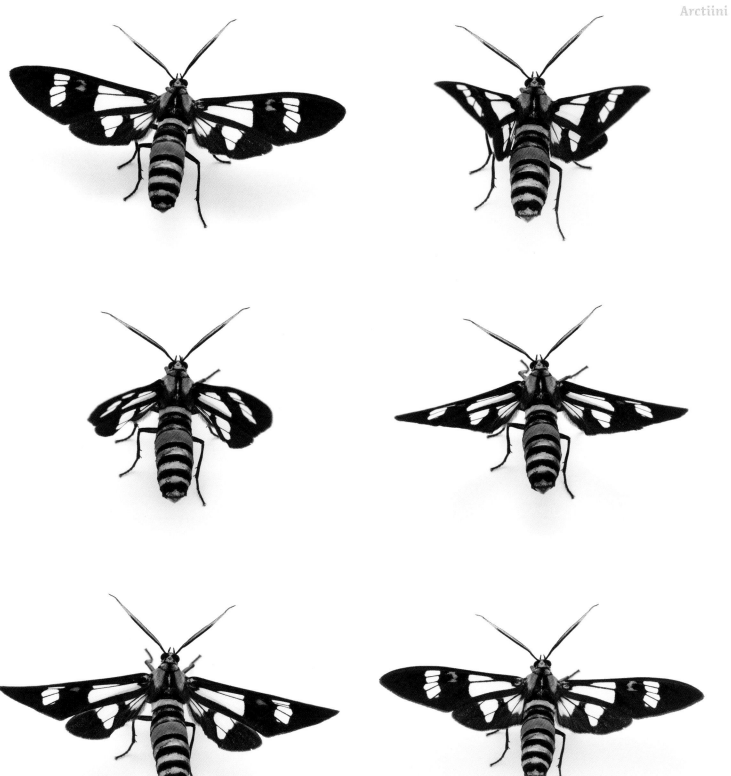

291

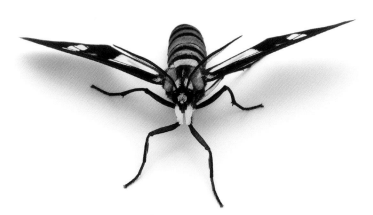

Euchromia folletii (Guérin-Méneville, 1832)

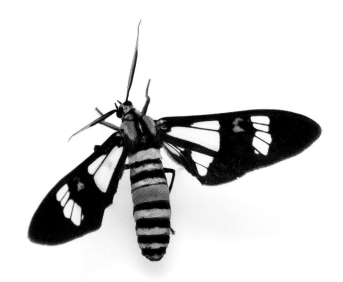

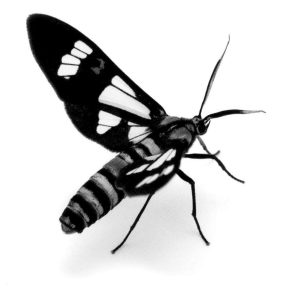

Busy behavior – show that you might be armed and dangerous

But it is not only the body shape and coloration that produce the wasp-like effect. *Euchromia* moths also behave like wasps, folding their wings in a specific, sharply angled position and being active by day, flying slowly and ponderously in the sunlight. Moreover, the appearance is not the only weapon they possess. As already mentioned, some arctiines accumulate unpalatable or toxic substances in their bodies. This phenomenon is called pharmacophagy, which means taking substances that are not nutrients. *Euchromia* moths do it as adults, imbibing exudation or nectar of some plants containing so-called pyrrolizidine alkaloids. The purpose of this behavior seems to be simply enhancement of the aposematic signals. If any predator, not discouraged by the moth's appearance, dares to try to eat it, it then detects an unpleasant taste. It has already been proven experimentally that animals that encountered these moths for the first time avoided eating them after only a few attempts.

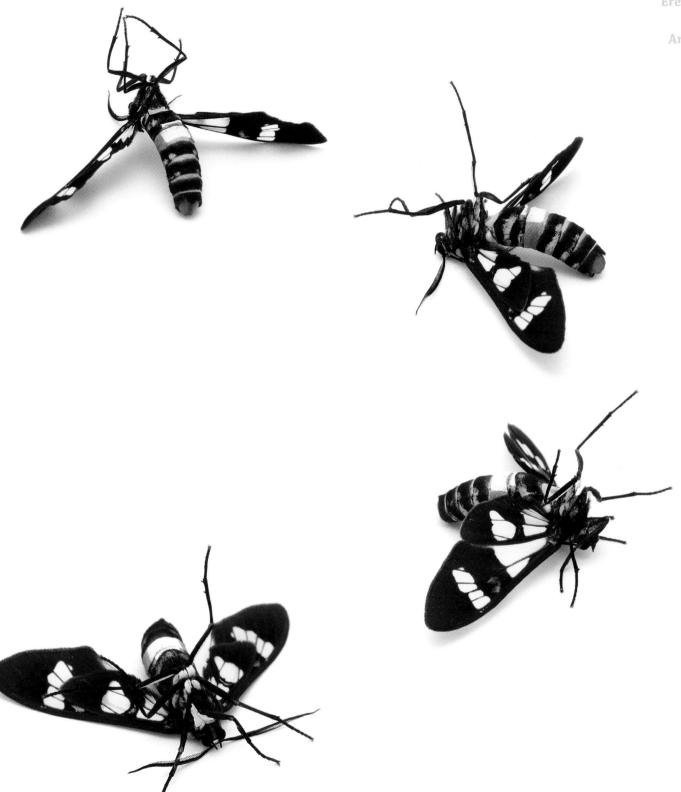

293

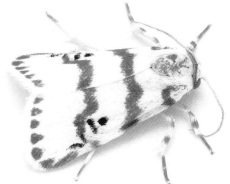

Cyana amatura (Walker, 1863)

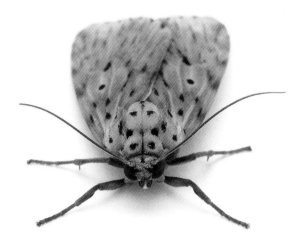

Phryganopteryx triangularis Toulgoët, 1958

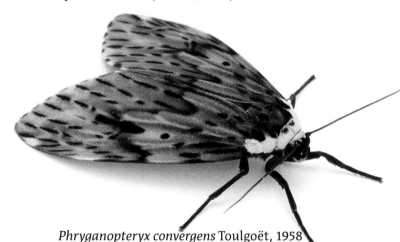

Phryganopteryx convergens Toulgoët, 1958

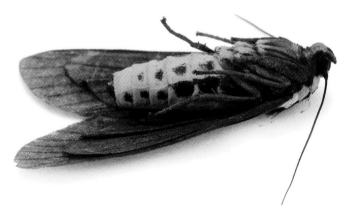

Phryganopteryx convergens Toulgoët, 1958

Pollinators

You may have seen busy bees, bumblebees and butterflies bustling around flowers, collecting nectar and pollen. It is no exaggeration to state that this activity keeps our planet – and us – alive, since the majority of fruits and vegetables we eat are pollinated by insects. But this is not only a diurnal service – there is also a night shift, as many moths are very efficient pollinators. In the picture displayed above of *Phryganopteryx triangularis*, a tiger moth species occurring only in Madagascar, you can see some yellow, egg-like granules on its labial palps. These are so-called pollinaria of some orchid species. Orchids have a very peculiar trait of distributing "packed" pollen, whereby the pollinators collect entire pollinaria – not just separate pollen grains, as in the case of other flowering plants – and move them to the stigma of another plant. Thus, the presence of pollinaria on that moth's head can be an indirect proof that it is the pollinator of a particular orchid species.

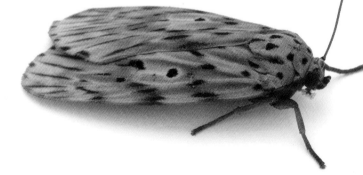

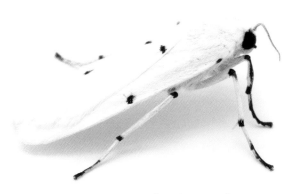

Eilema argentea (Butler, 1878)

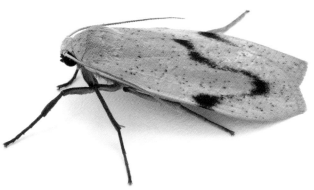

Eilema hybrida Toulgoët, 1957

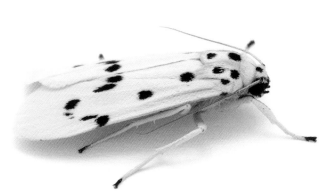

Eilema kingdoni (Butler, 1877)

Eilema sp. near *laurenconi* Toulgoët, 1976

Eilema pallidicosta (Mabille, 1900)

Eilema recticosta Toulgoët, 1956

Siccia nigropunctana (Saalmüller, 1880)

295

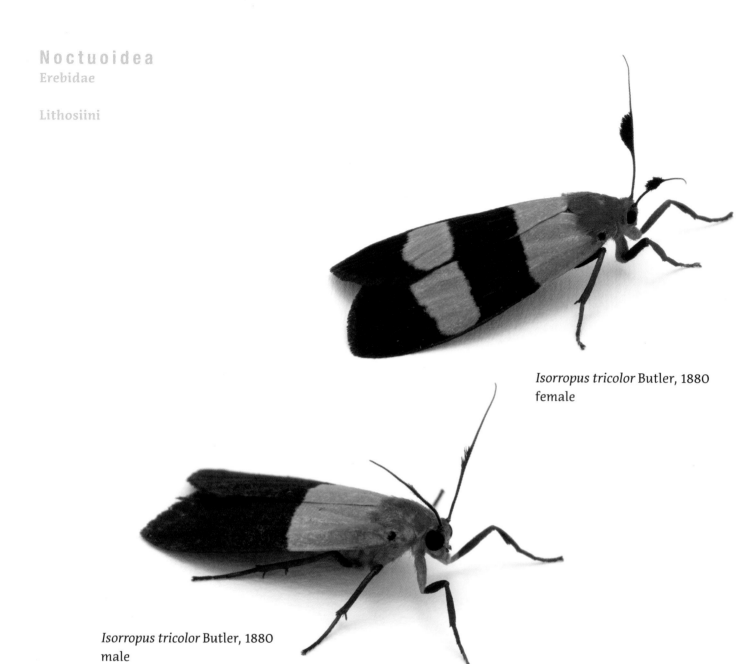

Isorropus tricolor Butler, 1880
female

Isorropus tricolor Butler, 1880
male

Tenuinaclia andapa Griveaud, 1964

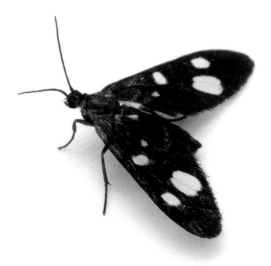

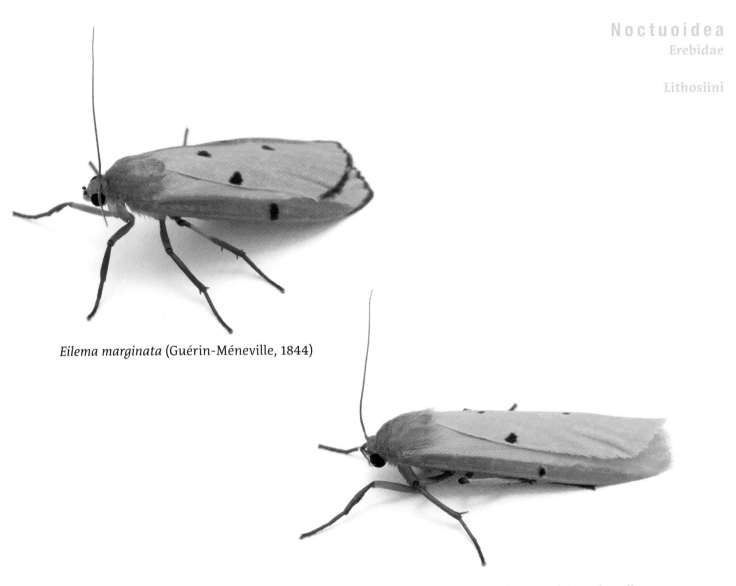

Eilema marginata (Guérin-Méneville, 1844)

Eilema marginata Guérin-Méneville, 1844

Tenuinaclia andapa Griveaud, 1964

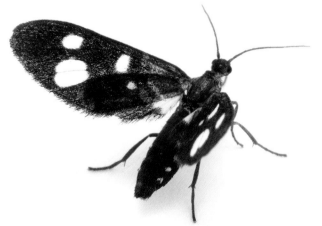

Adaptive radiation in polka-dot moths

The Malagasy polka-dot moths are an example of adaptive radiation in Lepidoptera. All of their nearly 100 valid described species derived from a single ancestor in a relatively short evolutionary timescale.

Acremma axerina (Viette, 1988)

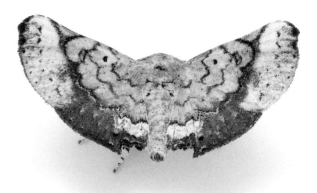

Acremma thyridoides (Kenrick, 1917)

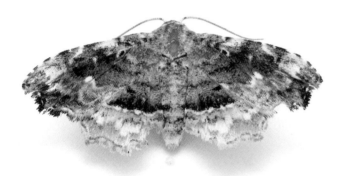

Acremma neona (Viette, 1962)

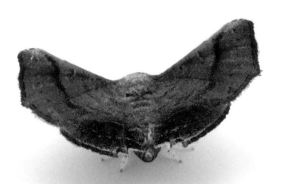

Acremma cf. *thyridoides* (Kenrick, 1917)

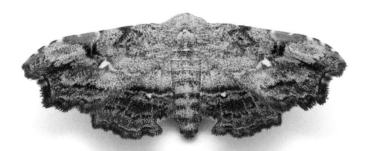

Acremma sp. near *ingens* (Viette, 1968)

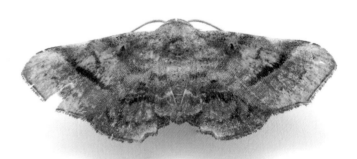

Acremma sp. Berio, 1959

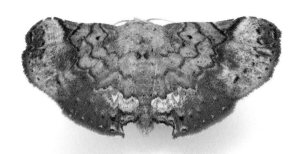

Acremma sp. near *thyridoides* (Kenrick, 1917)

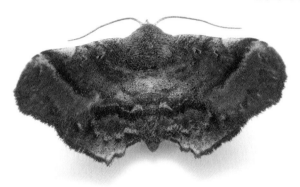

Acremma sp. Berio, 1959

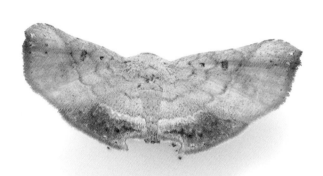

Acremma thyridoides (Kenrick, 1917)

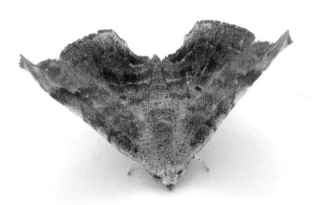

Acremma sp. Berio, 1959

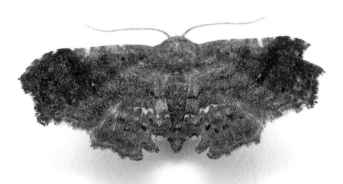

Acremma sp. Berio, 1959

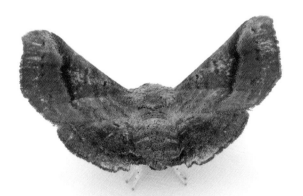

Acremma sp. Berio, 1959

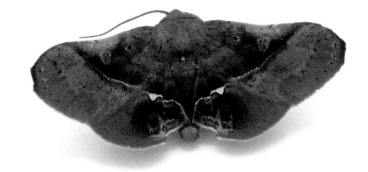

Andrianam poinimerina Viette, 1954

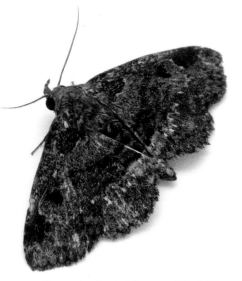

Argyrolopha trisignata (Mabille, 1900)

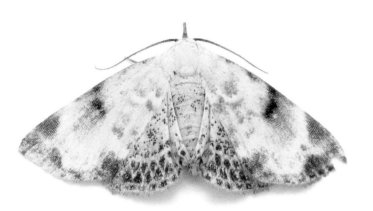

Bertula sandrangato (Viette, 1962)

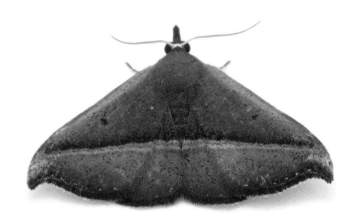

Corgatha zotica (Viette, 1956)

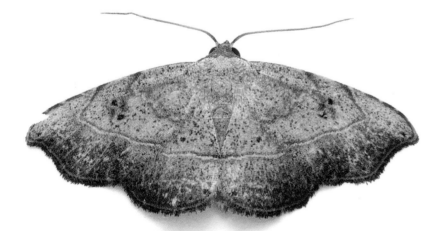

Cautatha cf. *coenogramma* (Mabille, 1900)

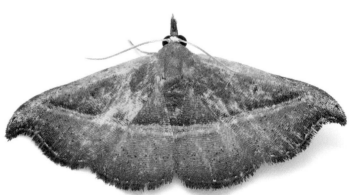

Corgatha falcigera (Berio, 1959)

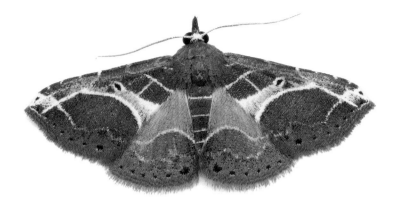

Corgatha fissilinea (Hampson, 1910)

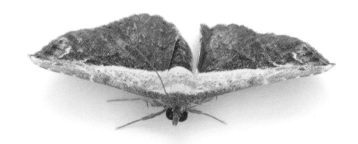

Corgatha latifera (Walker, 1869)

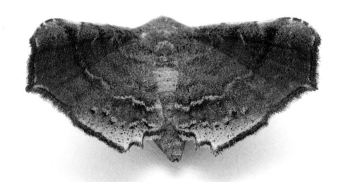

Corgatha sp. Walker, 1859
(*Acremma* sp. near *funebris* (Viette, 1962))

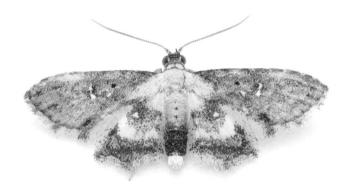

Hypobleta sp. Turner, 1908

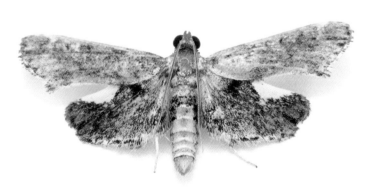

not assigned

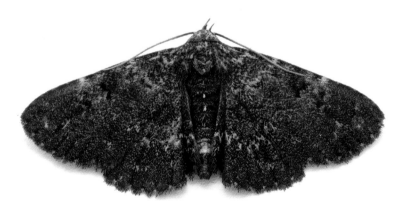

Boletobiinae sp. Guenée, [1858]

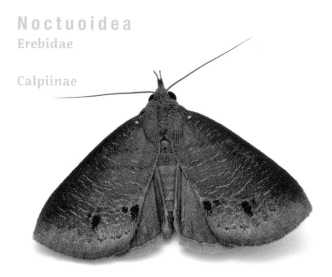

Avitta cf. *lineosa* (Saalmüller, 1891)

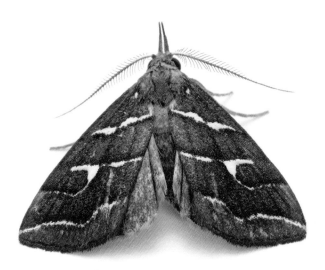

Coelophoris sogai Viette, 1965

Claterna sp. near *berioi* Viette, 1954

Claterna ochreoplaga Viette, 1966

Claterna sparsipuncta Viette, 1966

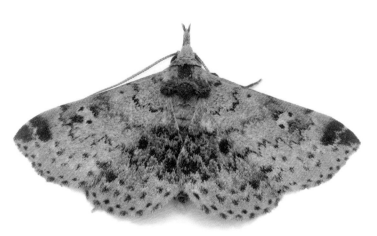

Claterna sp. Walker, 1858

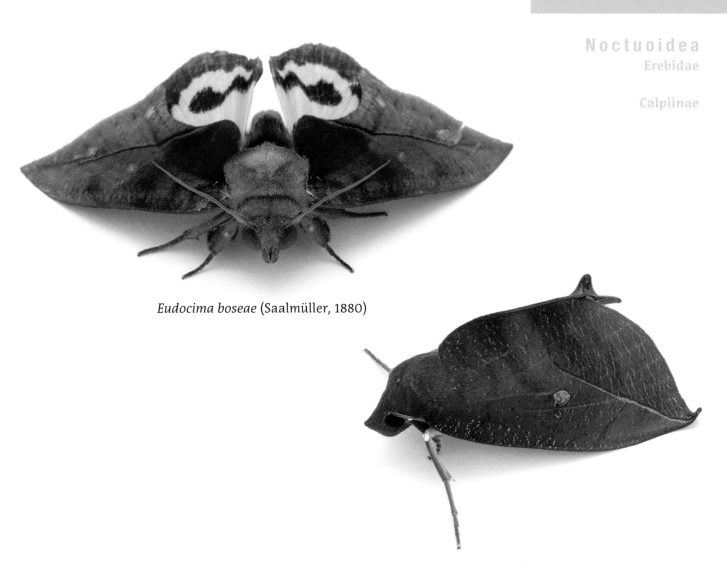

Eudocima boseae (Saalmüller, 1880)

Eudocima phalonia (Linnaeus, 1763)

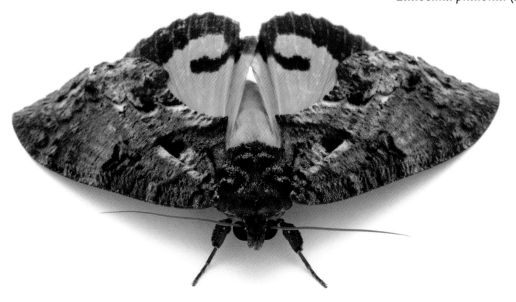

Eudocima imperator (Guérin-Méneville, 1832)

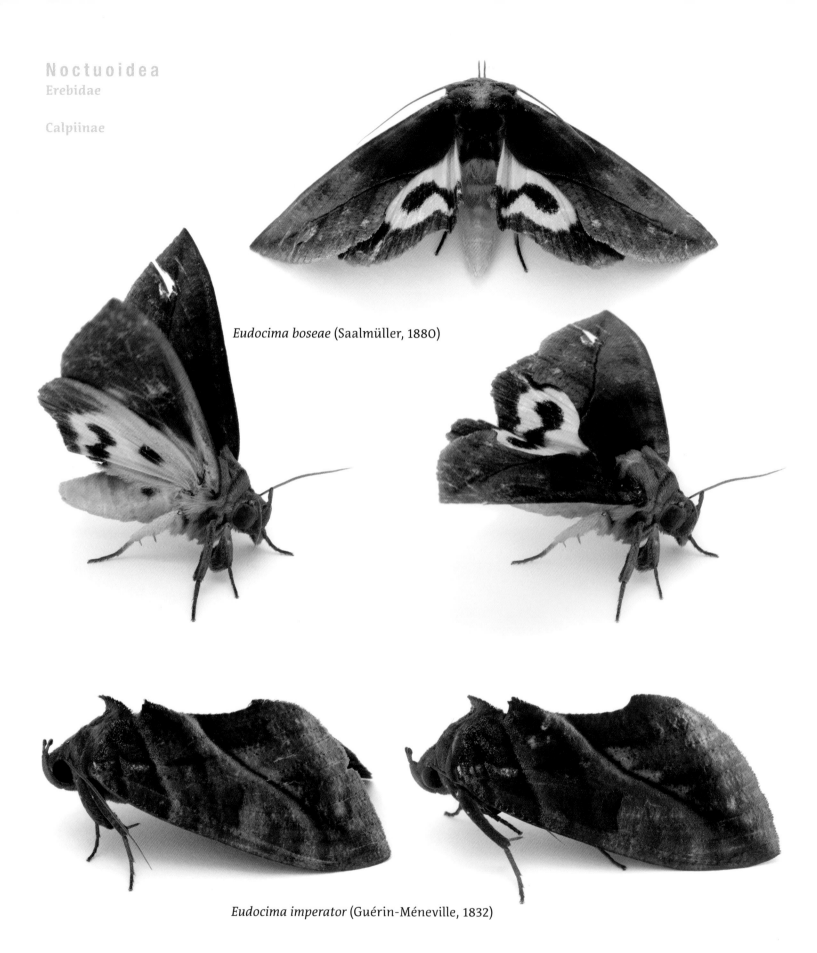

Eudocima boseae (Saalmüller, 1880)

Eudocima imperator (Guérin-Méneville, 1832)

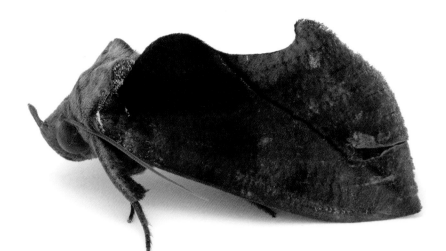

Eudocima boseae (Saalmüller, 1880)

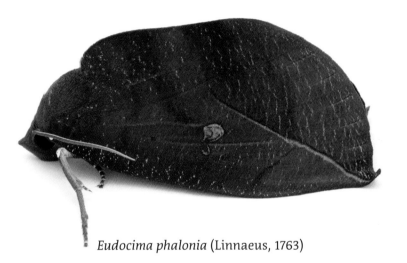

Eudocima phalonia (Linnaeus, 1763)

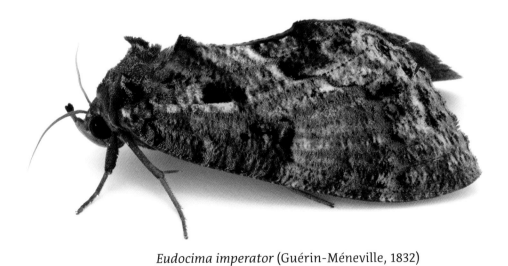

Eudocima imperator (Guérin-Méneville, 1832)

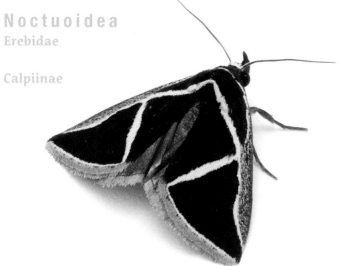

Fodina decussis (Saalmüller, 1891)

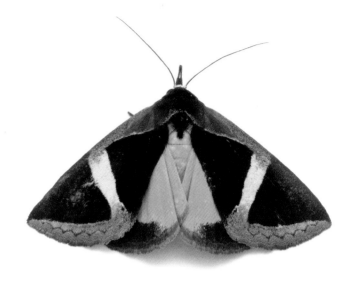

Fodina hayesi Viette, 1981

Fodina insignis (Butler, 1880)

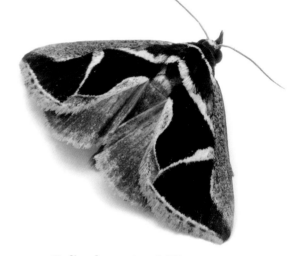

Fodina laurentensis Viette, 1966

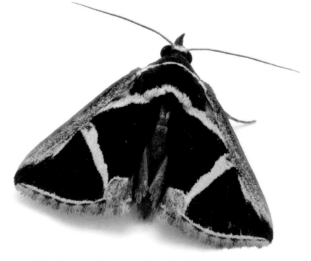

Fodina madagascariensis Viette, 1966

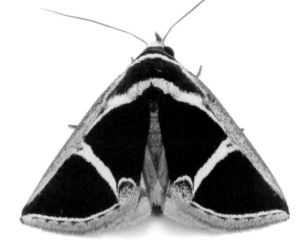

Fodina vieui Viette, 1966

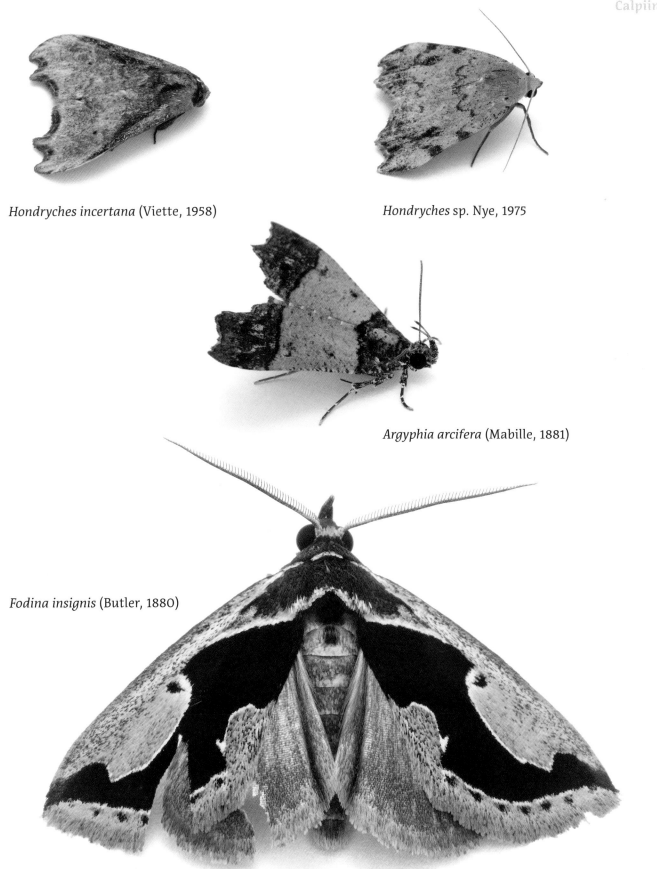

Hondryches incertana (Viette, 1958)

Hondryches sp. Nye, 1975

Argyphia arcifera (Mabille, 1881)

Fodina insignis (Butler, 1880)

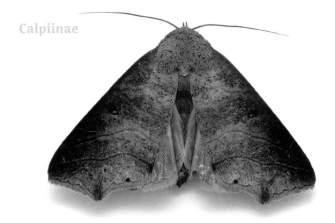

Maronis rivosa Saalmüller, 1891

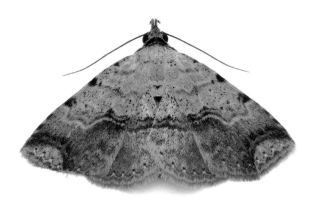

Maxera nova Viette, 1956

Mecodinops anceps (Mabille, 1879)

Maxera nova Viette, 1956

Paralephana angulata (Viette, 1966)

Mepantadrea reuteri (Saalmüller, 1881)

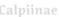
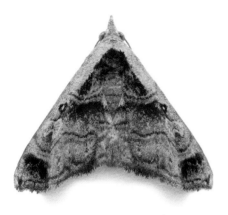

Polypogon descarpentriesi (Viette, 1954)

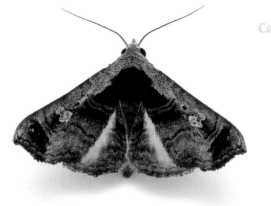

Nyctennomos descarpentriesi (Viette, 1954)

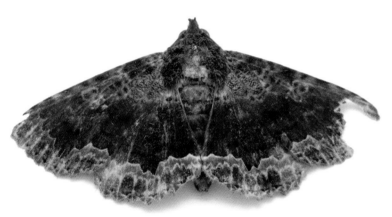

Calligraphidia tessellata (Kenrick, 1917)

Prominea porrecta (Saalmüller, 1880)

Singara sp. Walker, 1865

Zethes near *humilis* Mabille, 1899

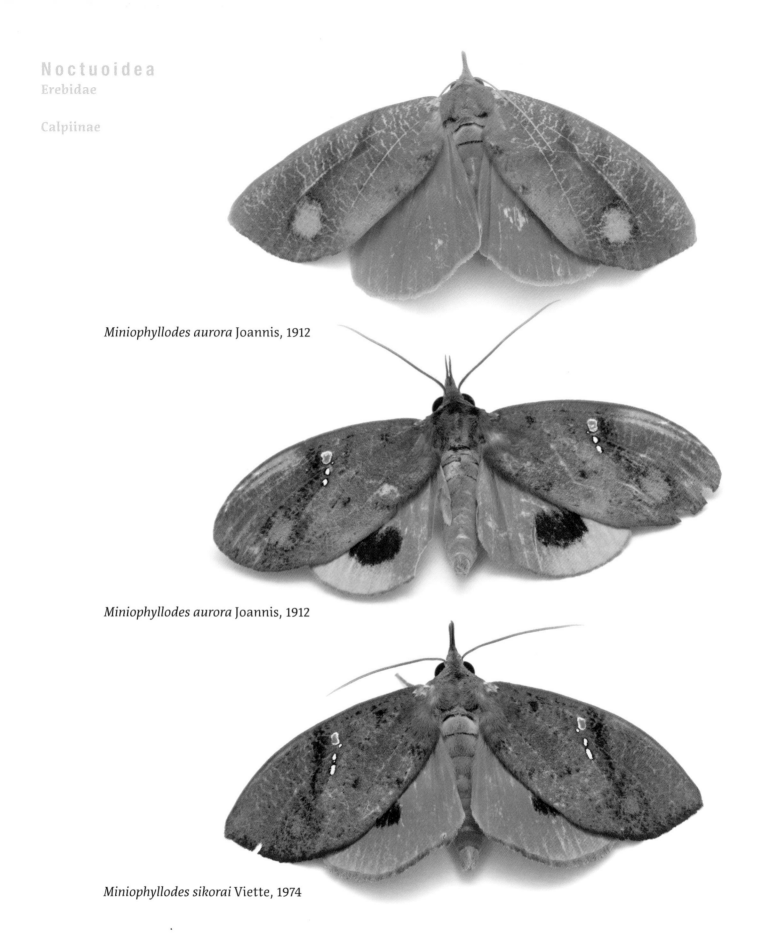

Miniophyllodes aurora Joannis, 1912

Miniophyllodes aurora Joannis, 1912

Miniophyllodes sikorai Viette, 1974

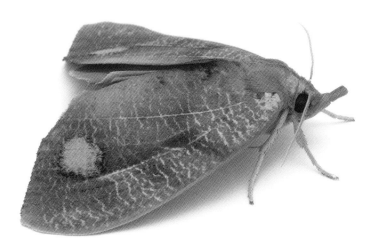

Miniophyllodes aurora Joannis, 1912

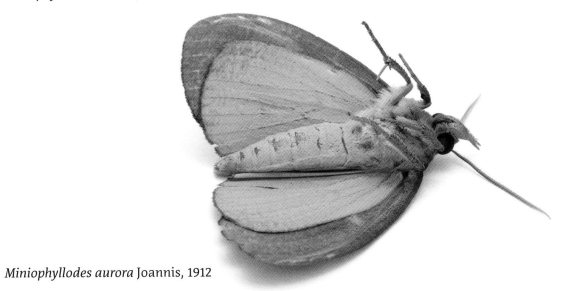

Miniophyllodes aurora Joannis, 1912

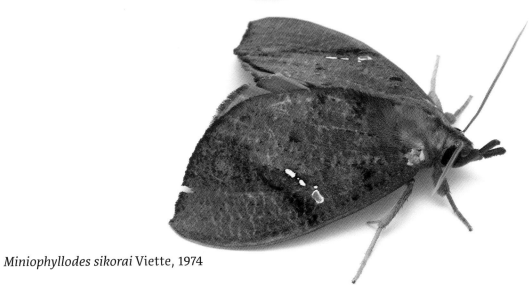

Miniophyllodes sikorai Viette, 1974

Herminiinae

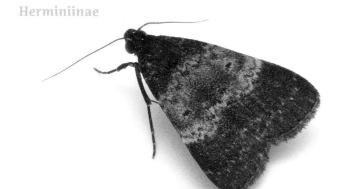

Hydrillodes cf. *uliginosalis* Guenée, 1854

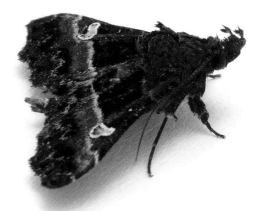

Heteromala rougeoti Viette, 1979

Hypeninae

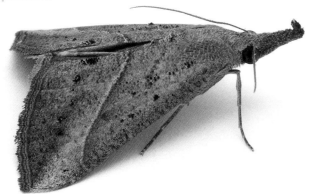

Hypena simplicalis Zeller, 1852

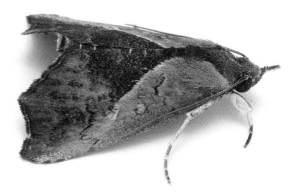

Zekelita sp. Walker, 1863

Hypocalinae

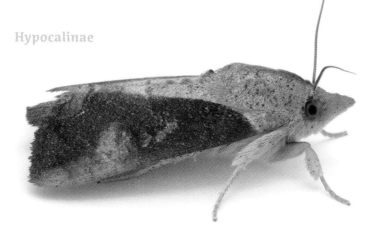

Hypocala sp. Guenée, 1852

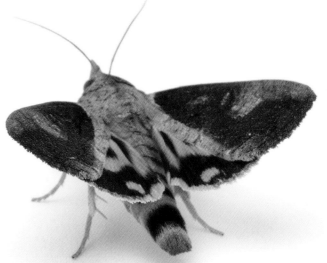

Hypocala sp. Guenée, 1852

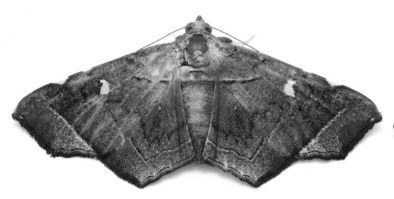

Episparis malagasy Viette, 1966

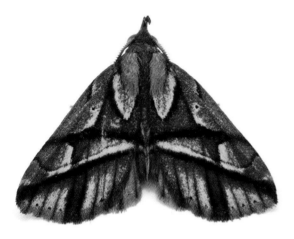

Pangrapta fauvealis Viette, 1965

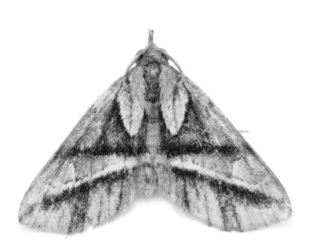

Pangrapta fauvealis Viette, 1965

Episparis vitrea (Saalmüller, 1891)

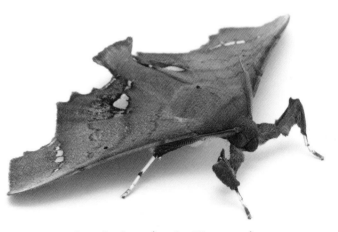

Episparis vitrea (Saalmüller, 1891)

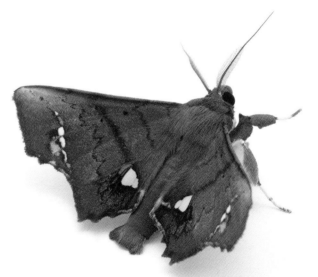

Episparis vitrea (Saalmüller, 1891)

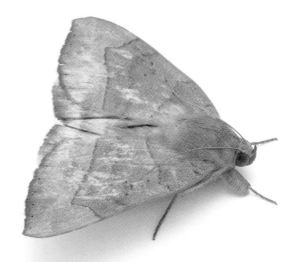

Achaea catella Guenée, 1852

Achaea cf. *faber* Holland, 1894

Achaea cuprizonea (Hampson, 1913)

Achaea oedipodina Mabille, 1879

Hypopyra capensis Herrich-Schäffer, 1854

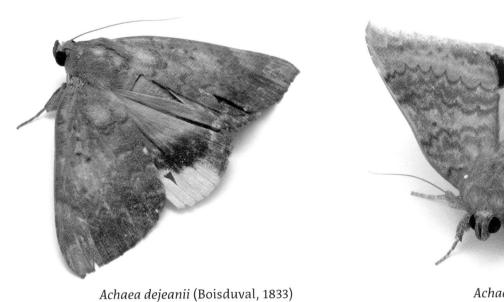

Achaea dejeanii (Boisduval, 1833)

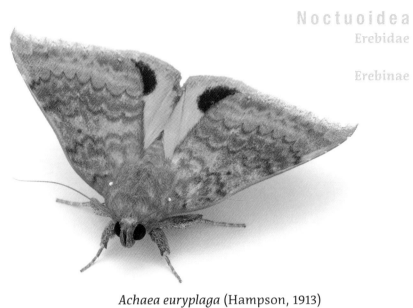

Achaea euryplaga (Hampson, 1913)

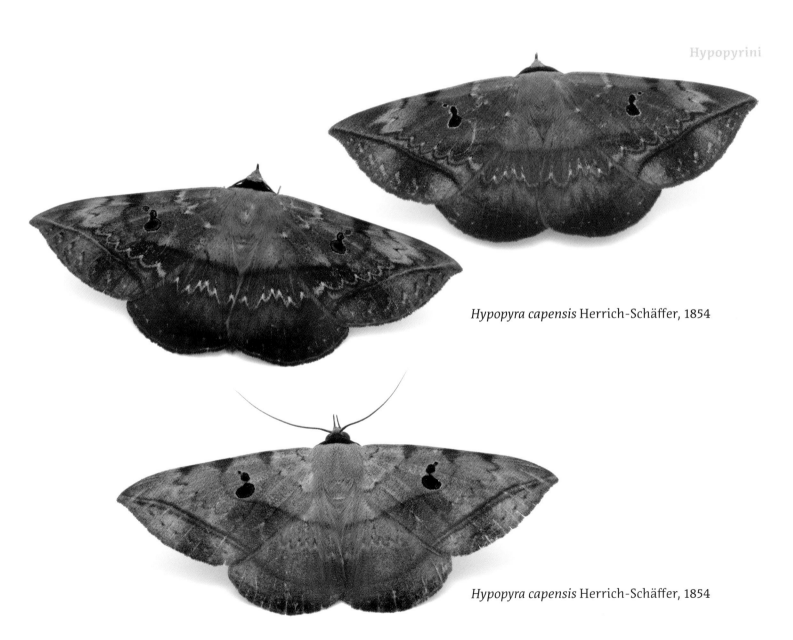

Hypopyra capensis Herrich-Schäffer, 1854

Hypopyra capensis Herrich-Schäffer, 1854

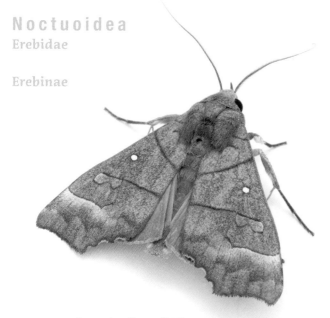

Anomis alluaudi Viette, 1965

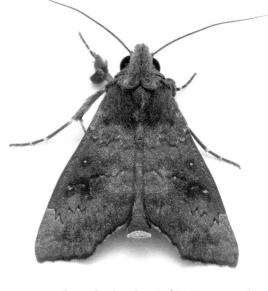

Anomis simulatrix (Walker, 1865)

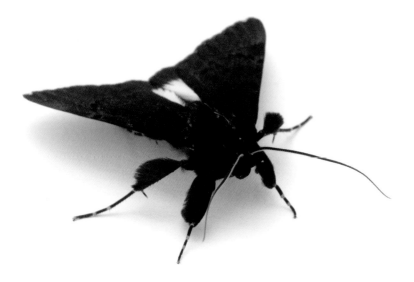

Audea agrotidea (Mabille, 1880)

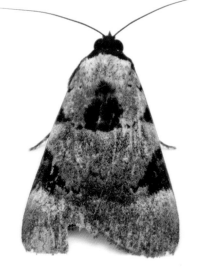

Audea agrotidea (Mabille, 1880)

Spirits of the ancestors

Culturally important is that the Malagasy word for moth or butterfly, "lolo", also means "ghost" or "soul". Actually, there must be something universal in that association of the human soul with an ephemeral lepidopteran, as it is known in the European culture too – the Greek word "psyche" also means both "soul" and "butterfly". The Malagasy people call some large and dark-colored erebid moths, especially *Erebus walkeri* and *Cyligramma* species displayed here, as "lolopaty", which can be translated as "spirit of the dead". It corresponds with the ancestor worship that occupies the central place in the traditional spirituality of the Malagasy people. They believe that their beloved ones who have passed away return to this world as large moths like *Cyligramma disturbans*, shimmering in the darkness with the wing pattern filigreed with gold. It probably comes from the behavior of these moths, quite often flying into houses lured by light. Additionally, by day they hide in shadowy places, e.g. among the stones used for the tombs and thus can be observed flying out of the grave.

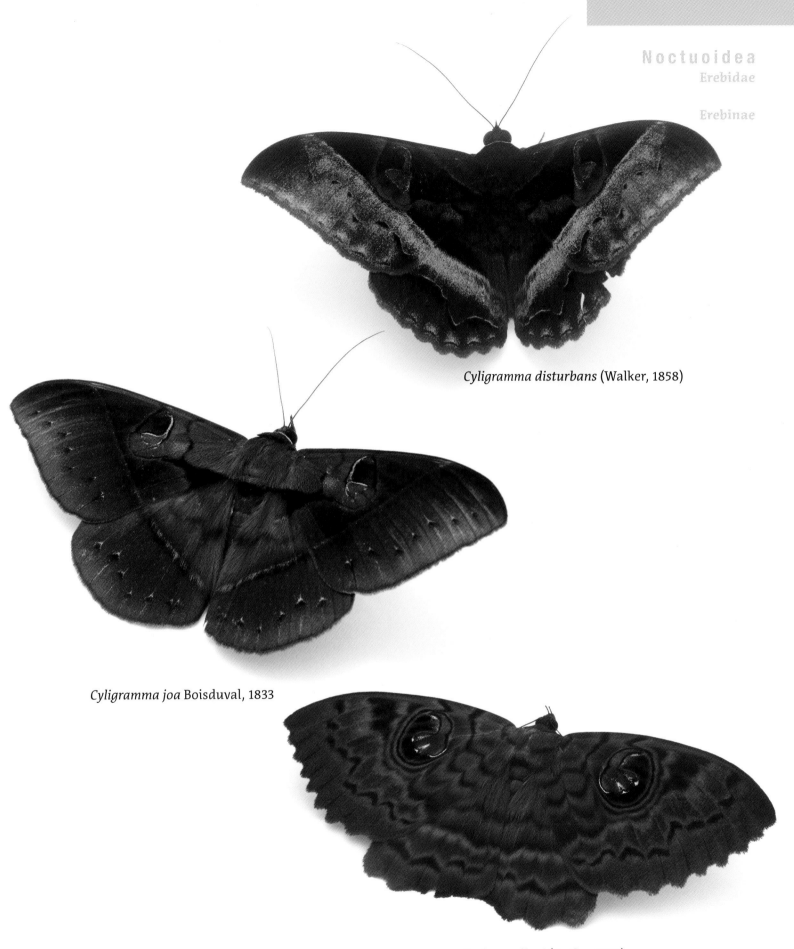

Cyligramma disturbans (Walker, 1858)

Cyligramma joa Boisduval, 1833

Erebus walkeri (Butler, 1875)

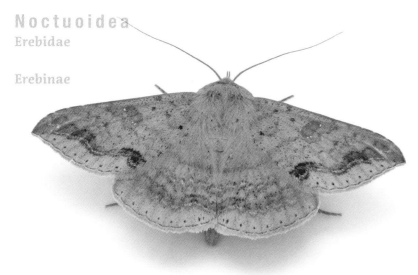

Ericeia inangulata (Guenée, 1852)

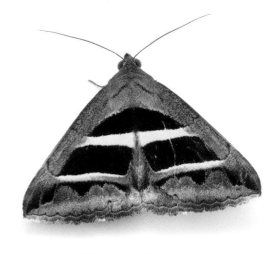

Grammodes bifasciata (Petagna, 1787)

Hyperlopha rectefasciata (Kenrick, 1917)

Hypopyra leucochiton (Mabille, 1884)

Hypopyra guttata Wallengren, 1856

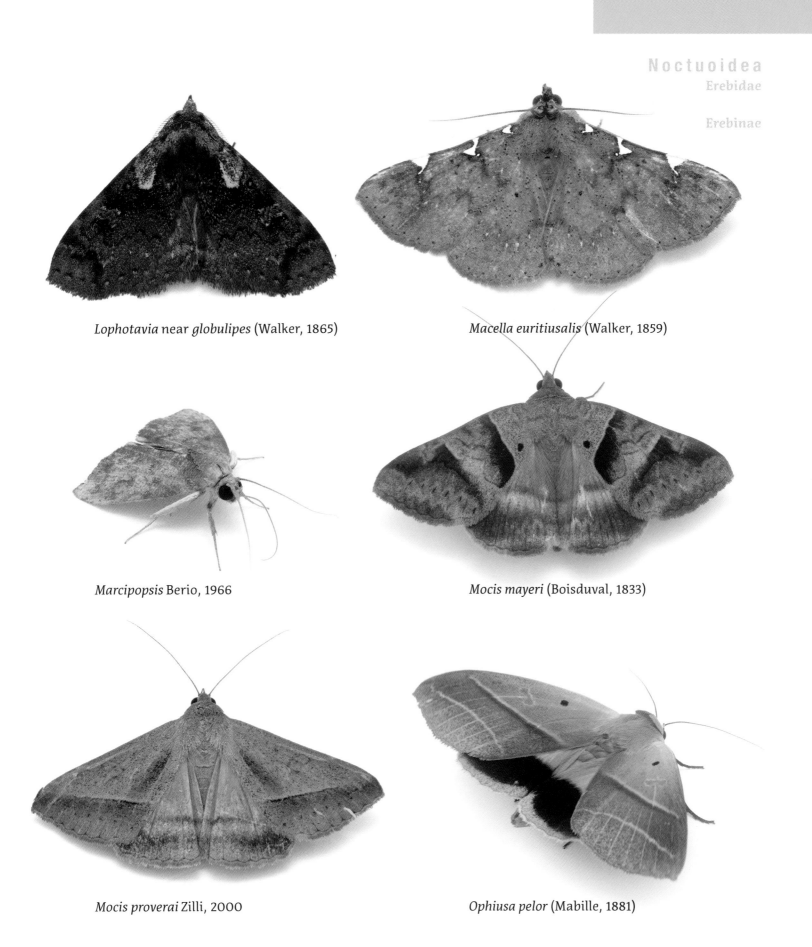

Lophotavia near *globulipes* (Walker, 1865)

Macella euritiusalis (Walker, 1859)

Marcipopsis Berio, 1966

Mocis mayeri (Boisduval, 1833)

Mocis proverai Zilli, 2000

Ophiusa pelor (Mabille, 1881)

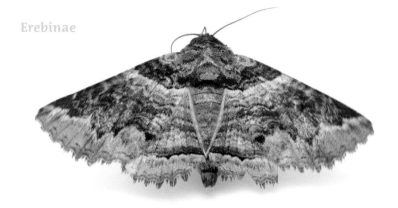

Pericyma Herrich-Schäffer, 1851

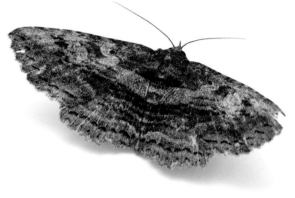

Pericyma near *viettei* (Berio, 1955)

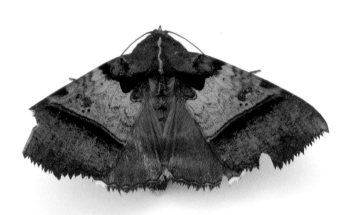

Serrodes trispila (Mabille, 1890)

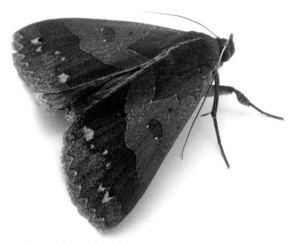

Stenopis mabillei Viette, 1974

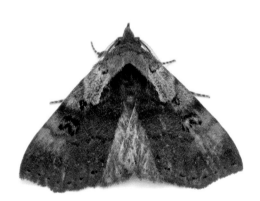

Thausgea sp. Viette, 1966

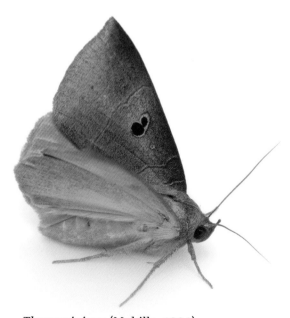

Thyas minians (Mabille, 1884)

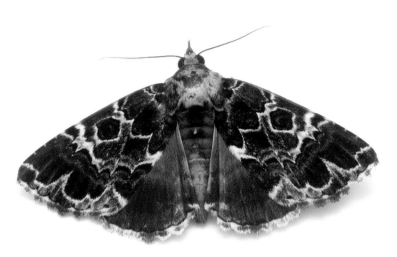

Tolna complicata (Butler, 1880)

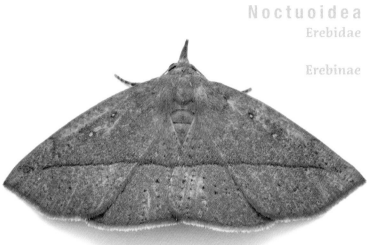

Ugia radama Viette, 1966

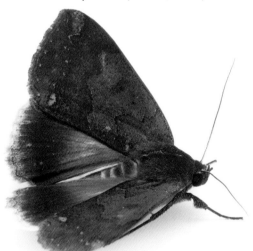

Stenopis cf. *reducta* Mabille, 1880

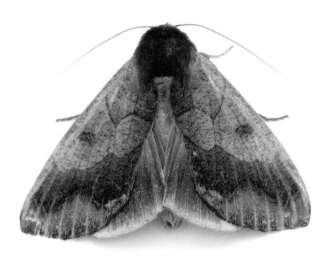

Stenopis sp. Mabille, 1880

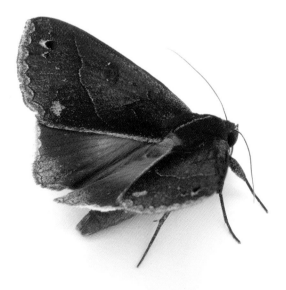

Stenopis mabillei Viette, 1974

Mocis proverai Zilli, 2000

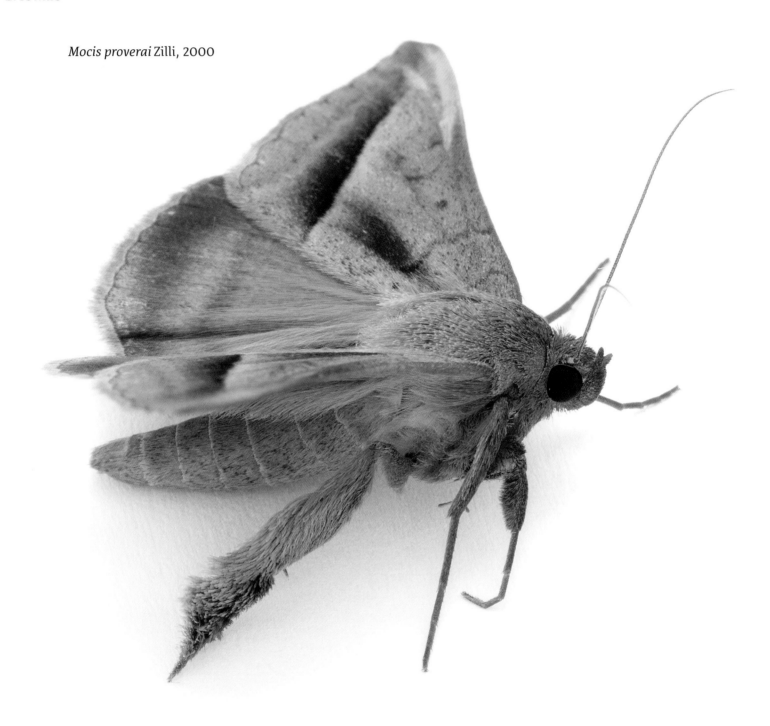

Stenopis mabillei Viette, 1974

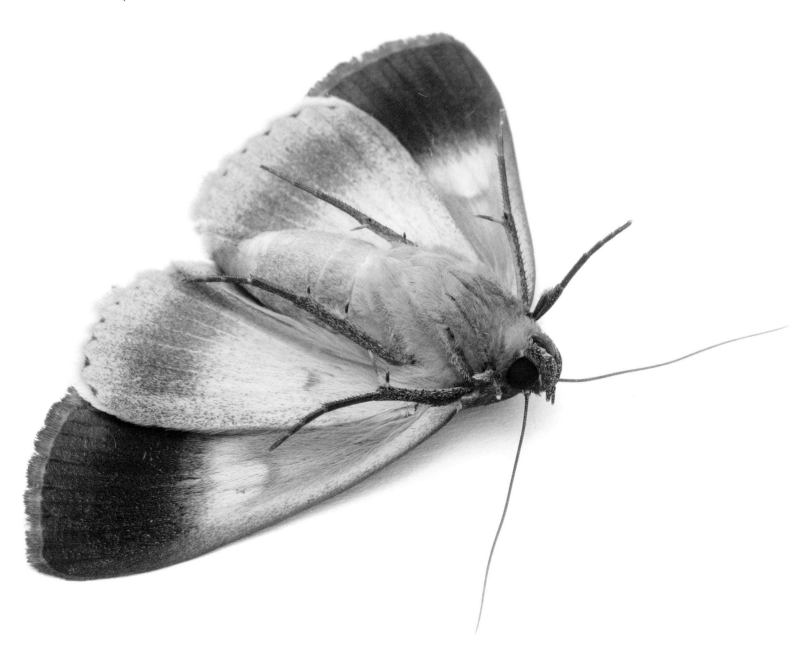

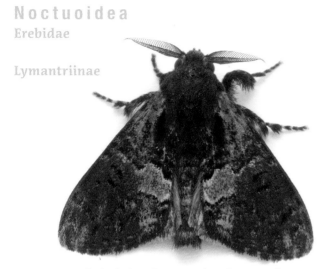

Abakabaka phasiana (Butler, 1882)

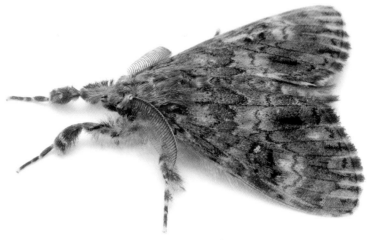

Rahona cf. *albilunula* (Collenette, 1936)

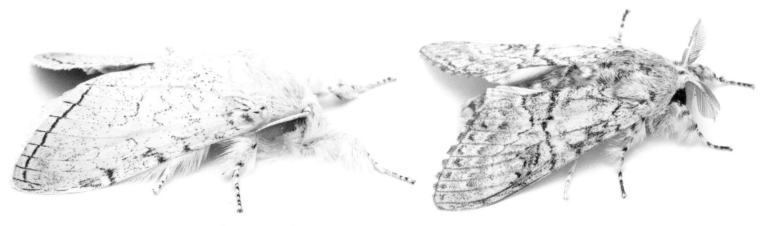

Eudasychira ampliata (Butler, 1878)

Eudasychira diaereta (Collenette, 1959)

Euproctis ochrea (Butler, 1878)

Mpanjaka pyrsonota (Collenette, 1939)

Jabaina ithystropha (Collenette, 1939)

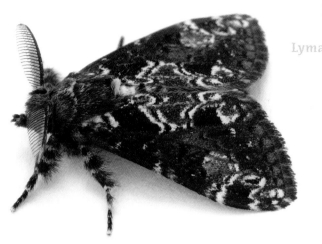

Jabaina sp. Griveaud, 1976

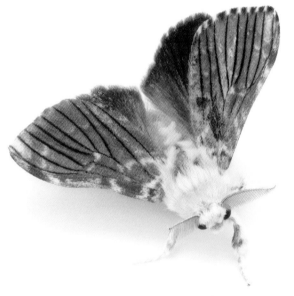

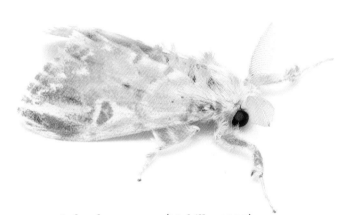

Labordea marmor (Mabille, 1880)

Labordea cf. *hedilacea* (Collenette, 1936)

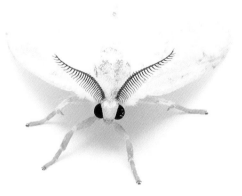

Collenettema sp. Griveaud, 1977

Collenettema sp. Griveaud, 1977

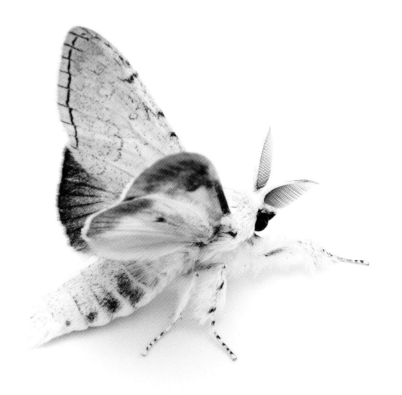

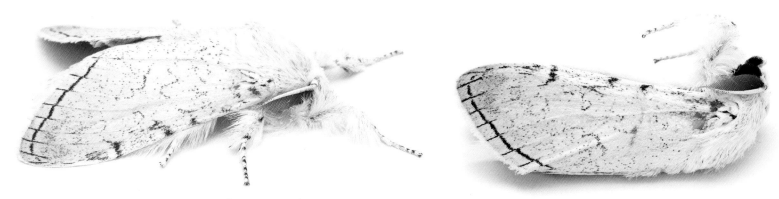

Eudasychira ampliata (Butler, 1878)

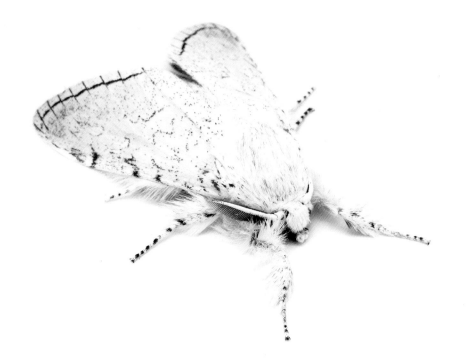

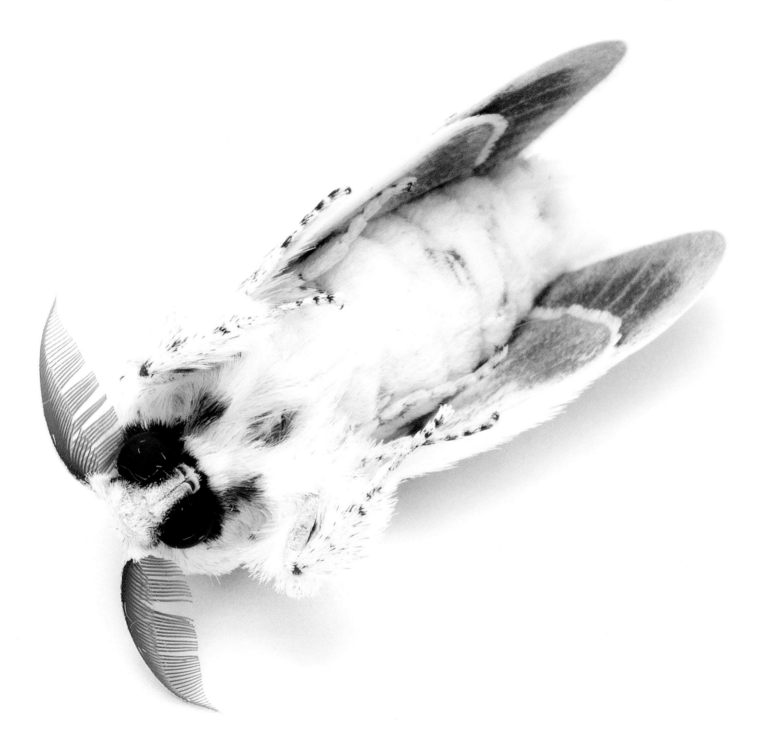

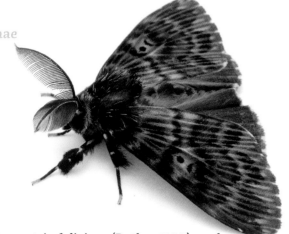

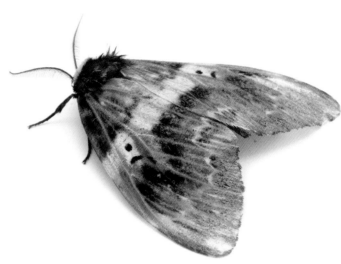

Lymantria fuliginea (Butler, 1880), male

Lymantria fuliginea (Butler, 1880), female

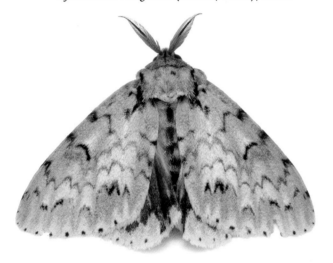

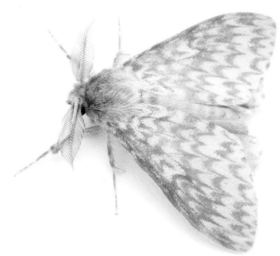

Lymantria joannisi (Le Cerf, 1921)

Lymantria malgassica (Kenrick, 1914)

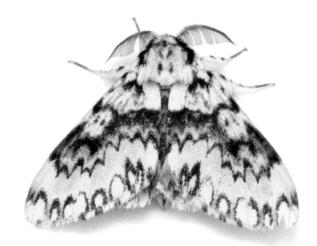

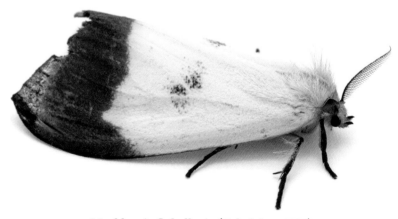

Lymantria rosea Butler, 1879

Marblepsis flabellaria (Fabricius, 1787)

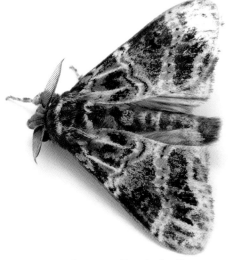

Mpanjaka junctifascia (Collenette, 1936)

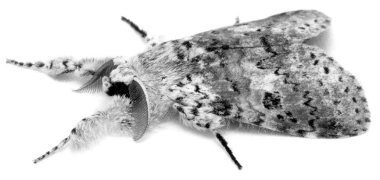

Eudasychira aurantiaca (Kenrick, 1914)

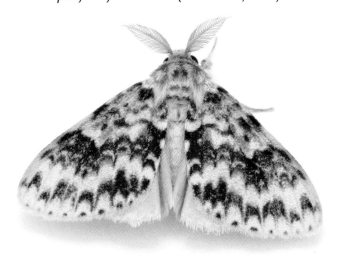

Lymantria polycyma Collenette, 1936

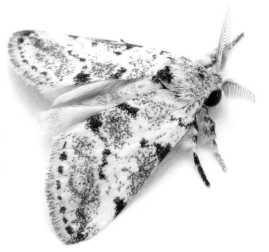

Noliproctis sp. Hering, 1926

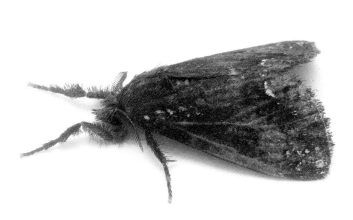

Zavana cf. *acroleuca* (Hering, 1926)

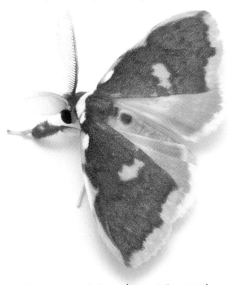

Stenaroa miniata (Kenrick, 1914)

329

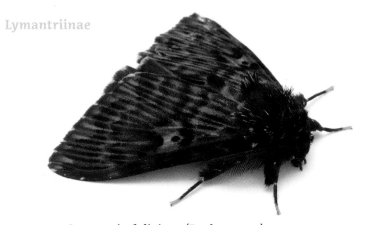

Lymantria fuliginea (Butler, 1880)

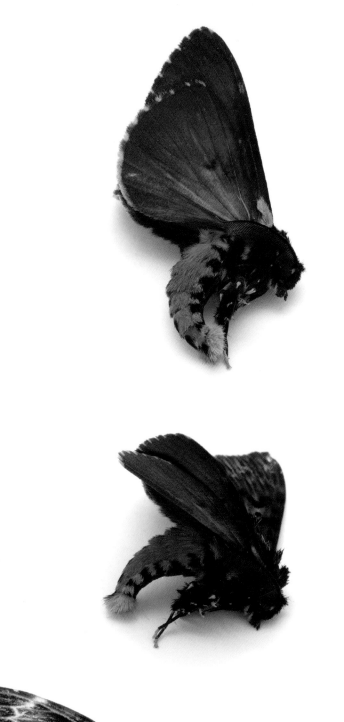

Catalog of protective behaviors: delay, distract, flee, play dead, defend

Moths have evolved a stunning diversity of defense strategies against predators. One of them is cryptic coloration, displayed by many species of Lymantriinae which resemble just a piece of bark covered with moss and lichen, as for example *Abakabaka phasiana*, *Jabaina ithystropha* or *Mpanjaka* species.

Just look at the individual of *Lymantria fuliginea* shown here. When sitting in its resting position, it has cryptic, dark-brown coloration and can remain undetected, e.g. on a tree trunk. However, once noticed and disturbed, it can unfold the wings displaying the vivid red, aposematically colored abdomen, curled, moreover, in a pseudostinging display. Any potential predator most probably will be startled by this surprise long enough to give the moth time to escape or be avoided completely. Lymantriinae also have a noise-producing organ, called the Goodger organ, which protects against bats when flying at night by advertising their likely unpalatability.

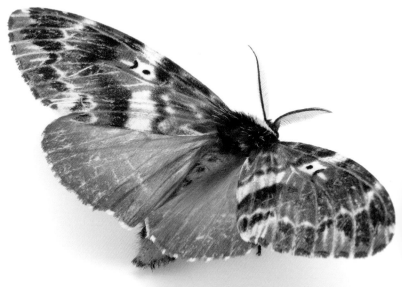

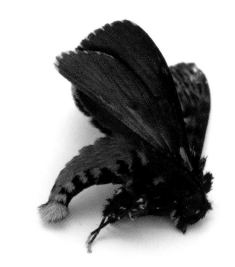

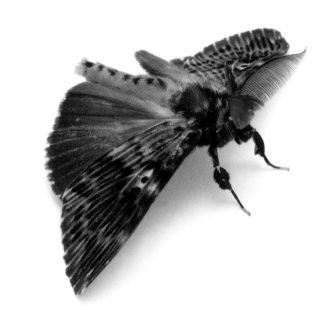

Remote sensing

The displayed male of *Lymantria fuliginea*, as with males of many lymantriines, shows remarkable antennae. Their many feathered branches provide a maximal array for detection of just a few molecules of a distant female's calling pheromone; the female (left) by contrast has antennae with much less prominent side branches.

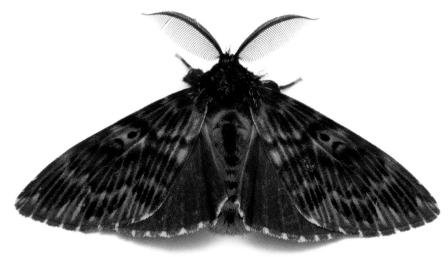

Lymantria fuliginea (Butler, 1880)

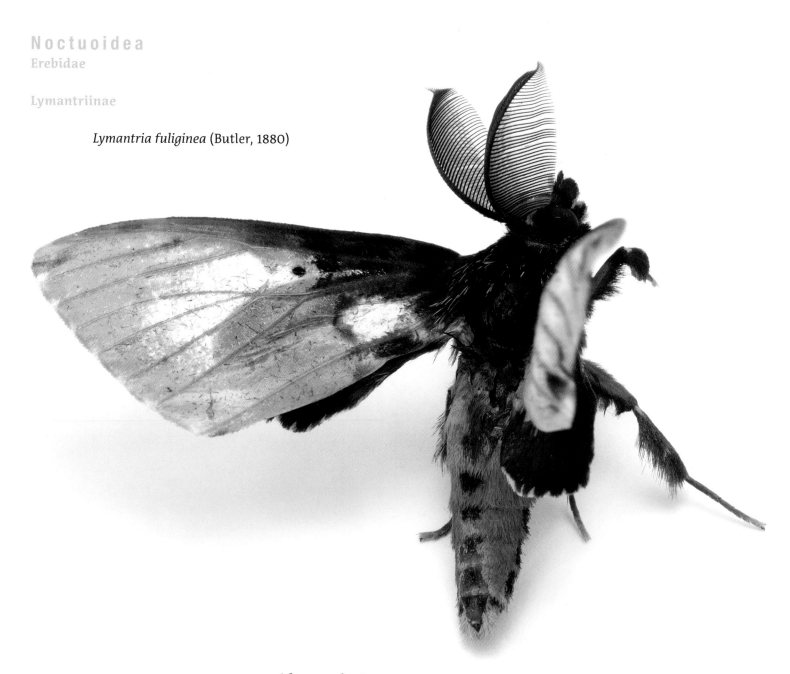

After a rainstorm

The scales covering the wings of Lepidoptera are hydrophobic, which me-
ans that are not wettened by water. Thus, interestingly enough and maybe
a bit counterintuitively, many moths fly in the rain not caring about the
circumstances at all. Moreover, in tropics, including Madagascar, the met-
hod of collecting moths by attracting them to light is very often the most
successful in rainy weather. Moths fly most intensely in a downpour, when
bats' sonar is less efficient as it bounces off raindrops. However, being
completely soaked in heavy rain can wash the scales away, as in the case
displayed here. Now we can see the venation, the "scaffolding" of the wing.
An interesting detail is that many groups of insects, including moths, have
their own, characteristic branching scheme of the veins, that when classi-
fied can be used to distinguish them from other families.

Lymantria fuliginea (Butler, 1880)

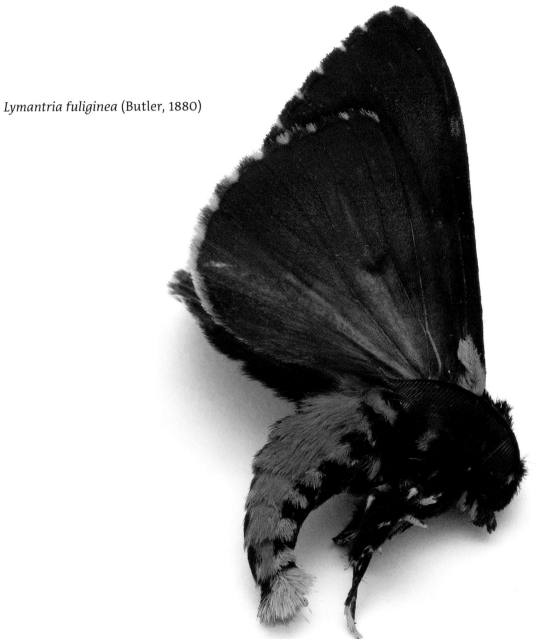

Playing dead

Another possible strategy to discourage pre-dators is thanatosis, known also as apparent death, or "playing possum". This phenome-non is quite widespread among animals, and is quite simply posing as a dead individual. In the case of a moth it means folding the wings upwards over the abdomen and folding the legs inwards. This strategy is based on the fact that those predators which are not sca-vengers generally avoid potential prey that are already dead, that may no longer be juicy or may contain toxic microorganisms.

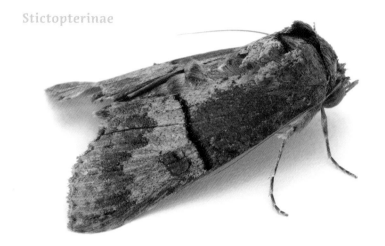

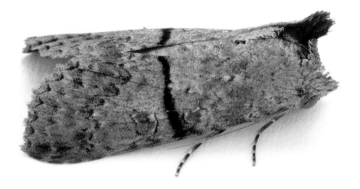

Stictoptera cf. *semipartita* Saalmüller, 1880

Stictoptera cf. *semipartita* Saalmüller, 1880

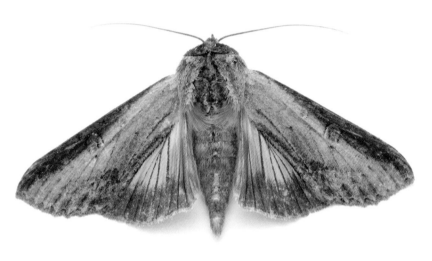

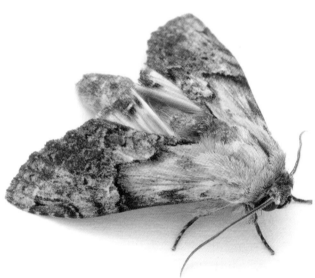

Stictoptera antemarginata Saalmüller, 1880

Stictoptera sp. Guenée, 1852

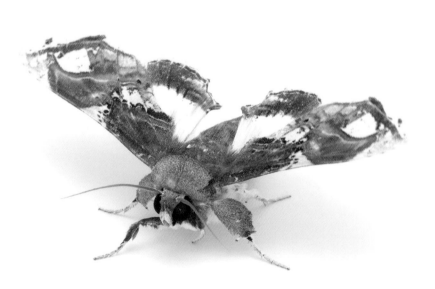

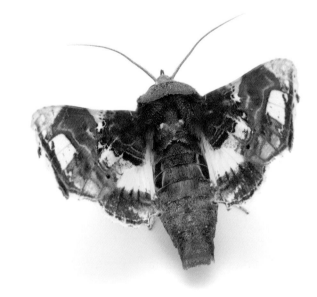

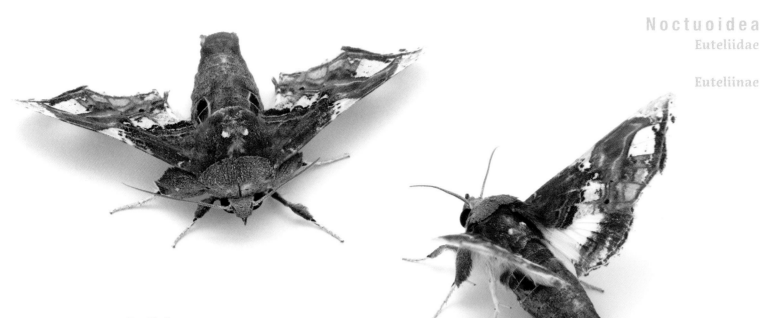

Rare guest at the light

The specific epithet of the scientific name of the species of *Caligatus* displayed here, *splendissima*, (Euteliidae), literally means "the most splendid" – and indeed, the colorful pattern of its wings is magnificent. This moth is, however, a very rare guest at the light, and this brings up the question of why moths are attracted to light. The phenomenon of moths being lured to "the flame" has been observed even long before the invention of artificial light sources. Such potentially suicidal behavior has baffled humans since antiquity, yet this seemingly basic phenomenon is still not fully understood. One of the earliest hypotheses, reformulated recently, is that moths navigate by positioning their body at a right angle to the light source. This works perfectly well with remote light sources like the Moon but fails with lightbulbs, which are too close. A moth trying to keep the position relative to the light beams needs to turn all the time, and the effect is that it starts to fly in spiral as it approaches the light source. There are several other leading theories, including that moths get disoriented by interpreting the light as the sky, to which they would normally keep their bodies back-upwards in flight. The matter is not fully resolved.

Caligatus splendidissima (Viette, 1958)

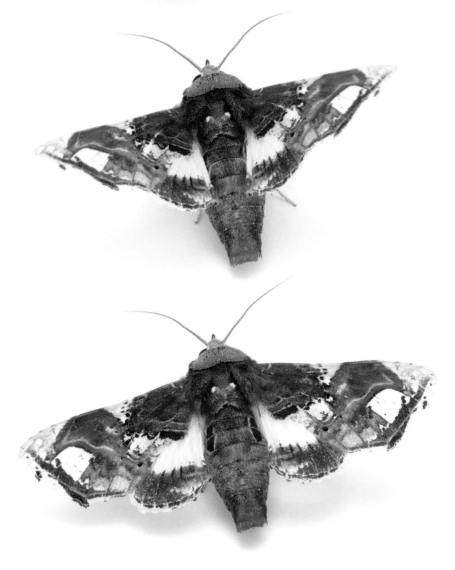

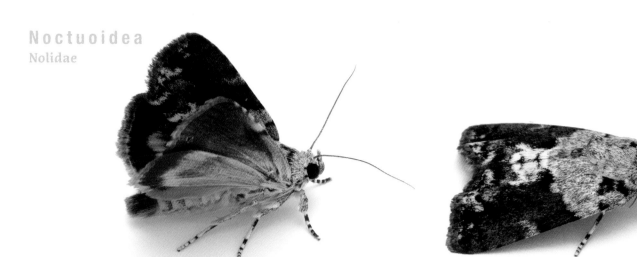

Blenina near *hyblaeoides* Kenrick, 1917

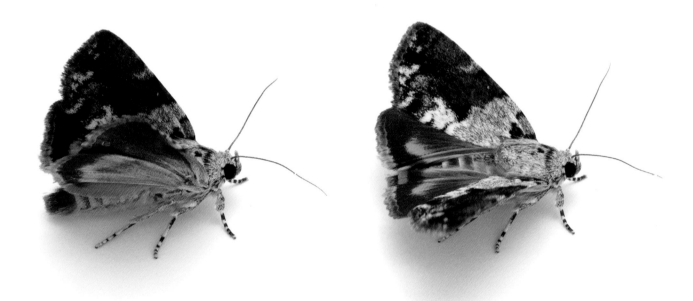

Sex-specific frenulum

Many groups of insects provided with two pairs of wings have different mechanisms to join them into one functional flying surface. In the majority of moths such as Noctuoidea the linking mechanism is made up of a thread-like protrusion of the hindwing, called a frenulum, that interlocks with a hook-like structure of the fore-wing, called a retinaculum. In males, the retinaculum takes the form of an actual cuticular hook, and in females this structure is missing, and its place is taken by a tuft of special scales. Also, the frenulum is a sex-specific character, in males consisting of single, thick filament, whilst in females there are a few thinner ones. Thus, now you can easily tell that the individual of *Blenina* species (Nolidae) shown in the photo is a female, as it has a dichotomous frenulum, interlocked with a tuft of scales directed upwards. In a male the retinaculum would be located a bit closer to the wing margin, and directed downwards.

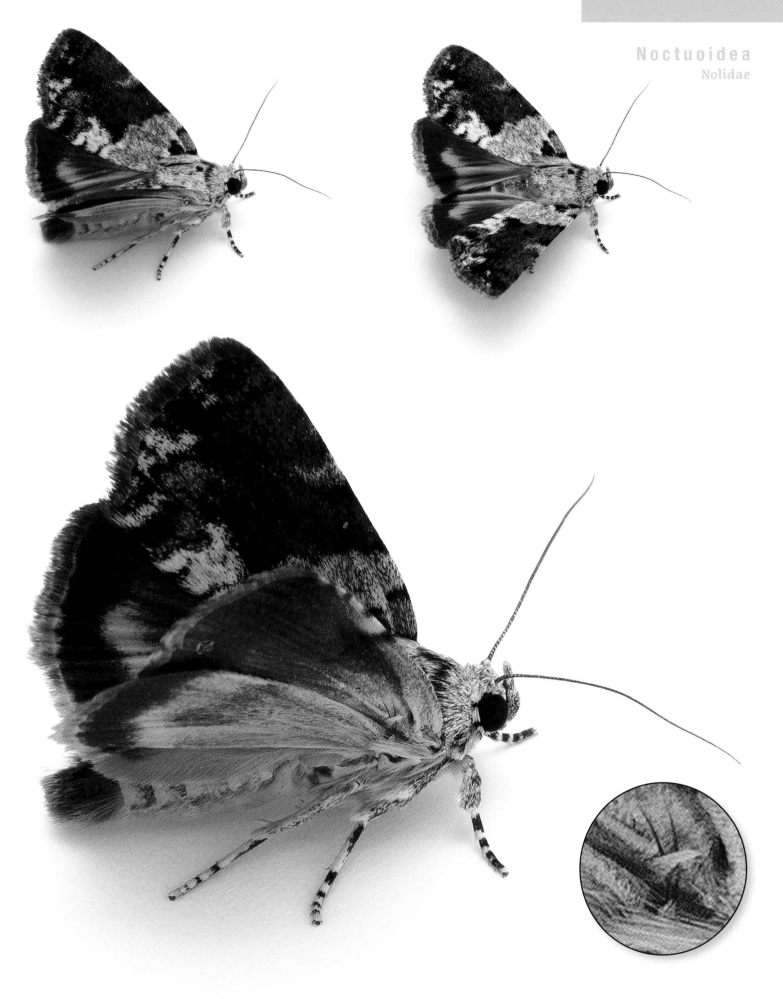

Noctuidae (Owlet moths)

Text by Marcin Wiorek

Noctuids, known also as owlets, are usually cryptically colored, with grays and browns dominant. The characteristic feature of this group with 11,750 species worldwide is the forewing pattern that includes two spots, which have different forms but are obscure in some species: the round, basal one, called the orbicular stigma, and the other one, kidney-shaped, called the reniform stigma. Additionally, some noctuoids have elongate scales on the thorax and head directed downwards, so that in effect they resemble sticks or dead wood, as with the *Stictoptera* species (Euteliidae) or the noctuids *Lyncestis* species or *Campydelta stolifera*.

However, some noctuids can be quite vividly colored, like the pinkish *Acontia viettei*. This species is named in honor of the late Pierre Viette, a renowned French lepidopterist, who throughout his entire life made great contributions to the knowledge of the moths of Madagascar, not just to Noctuidae; in all he contributed almost 1,200 currently recognized species and subspecies, or just less than a quarter of the known fauna!

Some noctuids, which can also be found in the rainforest, are serious agricultural pests, as for example the nearly-cosmopolitan genus *Spodoptera*. One of its members, *Spodoptera mauritia*, is shown on the following pages. However, its specific epithet refers to Mauritius, a small island located almost 1,000 km east from Madagascar, from which it was originally described, but the species has a very wide range extending from Africa to Hawaii. Larvae of this moth feed on many plants, including rice, *Oryza sativa*, which is the staple diet of the Malagasy. Thus, its outbreaks in rice paddies can cause serious damage, exacerbating the already difficult food situation on the island.

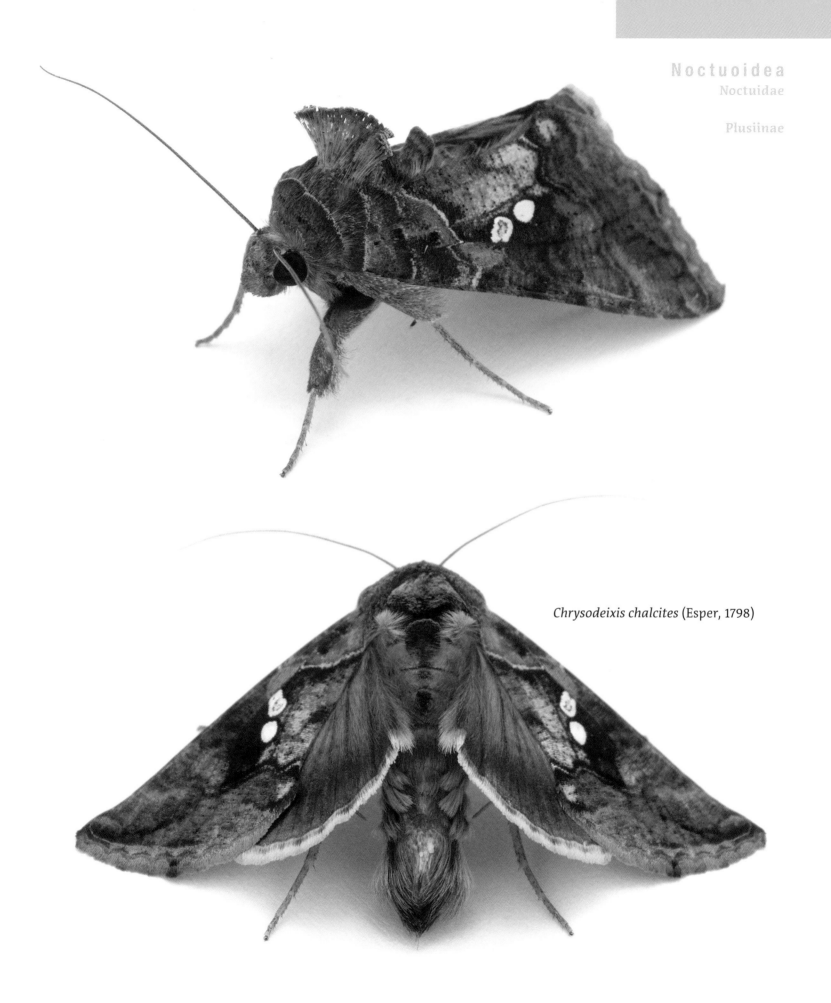

Chrysodeixis chalcites (Esper, 1798)

Nolidae

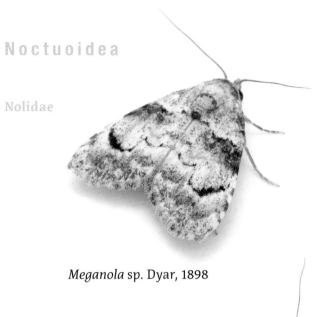

Meganola sp. Dyar, 1898

Chloephorinae

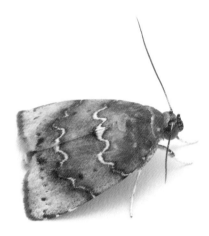

Earias biplaga Walker, 1866

Microzada sp. Hampson, 1912

Xyleninae

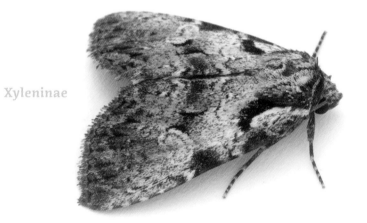

Kenrickodes rubidata (Kenrick, 1917)

Westermanniinae

Plusiocalpe sericina (Mabille, 1900)

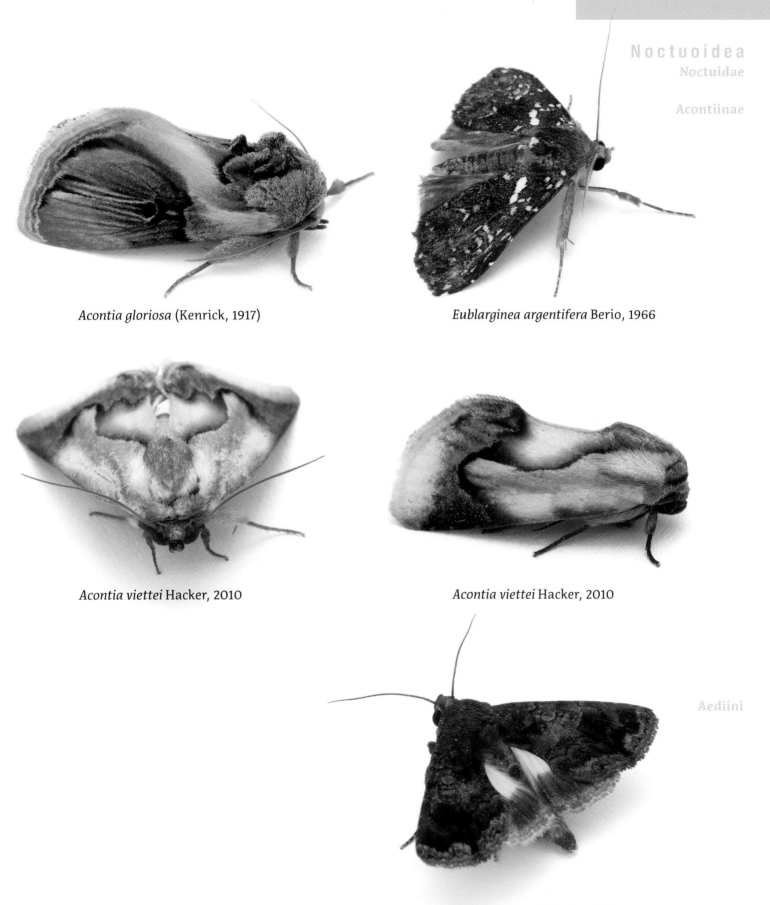

Acontia gloriosa (Kenrick, 1917)

Eublarginea argentifera Berio, 1966

Acontia viettei Hacker, 2010

Acontia viettei Hacker, 2010

Melanephia vola Viette, 1971

Amphipyrinae

Lyncestis grandidieri Viette, 1968 *Lyncestis grandidieri* Viette, 1968

Bagisarinae

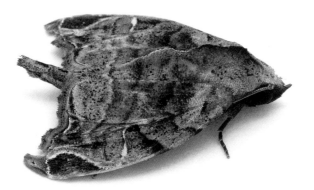 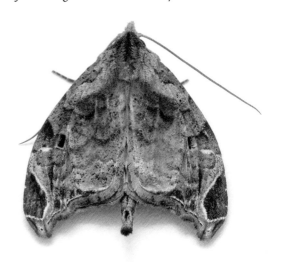

Androlymnia malgassica Viette, 1965 *Androlymnia malgassica* Viette, 1965

Plusiinae

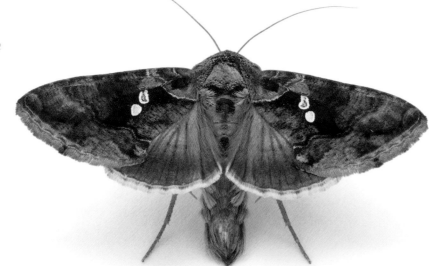

Chrysodeixis chalcites (Esper, 1798)

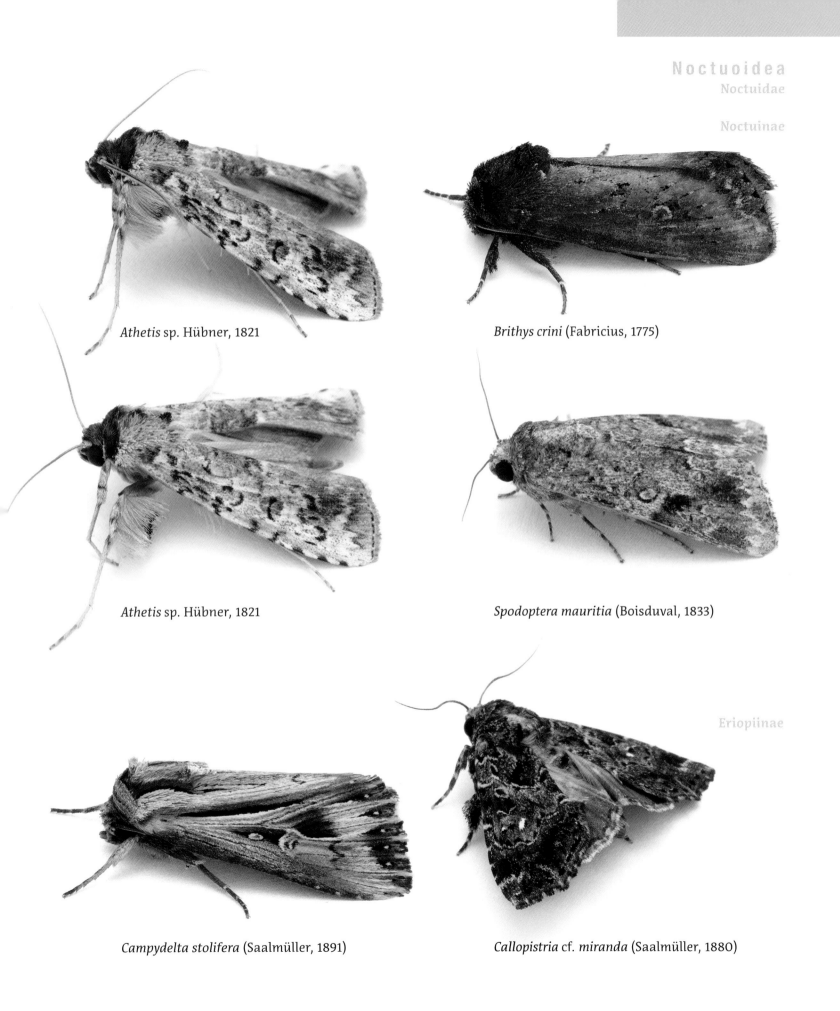

Athetis sp. Hübner, 1821

Brithys crini (Fabricius, 1775)

Athetis sp. Hübner, 1821

Spodoptera mauritia (Boisduval, 1833)

Campydelta stolifera (Saalmüller, 1891)

Callopistria cf. *miranda* (Saalmüller, 1880)

Mantodea (Mantises) – Alien Predators

Text by Moritz Grubenmann

Praying mantises are omnipresent in Masoala and particularly in Makira where these bizarre insects are encountered on every woodland walk. They inhabit all niches of the rainforest – from moss-laden tree trunks right up to treetops fully exposed to the sun. Adult praying mantises are able to fly and do so regularly. At night they can also be attracted by the use of a UV light trap. Their abundance of forms and their beauty make for exciting viewing when studying their biology and taxonomy.

Worldwide there are some 2,300 species of praying mantises and there are about 80 species living in Madagascar in all biotopes and climate zones. These adaptable animals can be found in the east coast rainforest, the deciduous dry forest in the west and north of the island, and also in the thorn forests of the south.

Cockroaches, termites and mantises are closely related and together comprise the Dicyoptera superorder (Leach 1818). The origins of Dictyoptera go back 300 million years. From these came cockroaches some 275 million years ago and termites became separated from these in turn 150 million years ago. The first mantises may have populated the earth some 200 million years ago.

With their prickly forelimbs raised as if to pray, praying mantises are fascinatingly weird creatures. The Latin name of the European praying mantis, *Mantis religiosa*, comes from the Greek word «mantikos» for soothsayer or prophet. And with the raptorial forelegs raised high and folded in front of the body as if in prayer, this posture looks truly spiritual-religious. The main distribution range of the European mantis is in the countries bordering on the Mediterranean; north of the Alps it lives in «heat islands» along the Rhine and occurs in various selective places in Germany. In Switzerland praying mantises are regularly found in the southern cantons of Wallis and Tessin, where herbaceous meadows with bushes are the preferred habitat. Praying mantises hunt spiders and insects of all kinds by seizing them with their raptorial legs, which strike with lightning quickness. After mating, the male may sometimes be eaten – ultimately then, he serves as a foundation for the evolution of

his progeny. Even people without much interest in nature find this occasionally occurring sexual cannibalism fascinating.

Females lay a mass of eggs (ootheca), a frothy case that quickly hardens in the air like foam insulation and insulates the eggs and larvae inside very effectively from heat, cold and rain. Eggs and larvae develop in the ootheca protected against all environmental influences. The hatchlings prey on insects from the very first day and are left to fend for themselves and roam around.

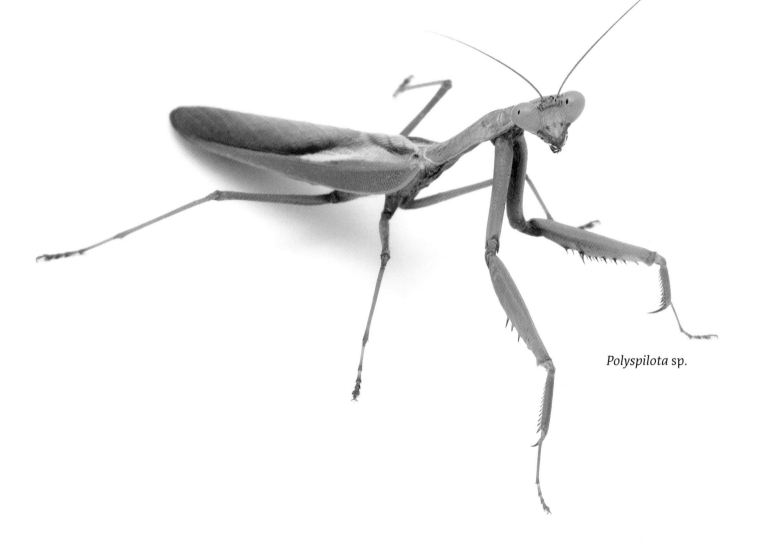

Polyspilota sp.

This species is missing one leg on the left side of the body. This does not in any way alter the fact that it is a dangerous predator. In all mantises the two forelegs of the usually six legs are remodeled into raptorial legs and can be used both for predation and walking.

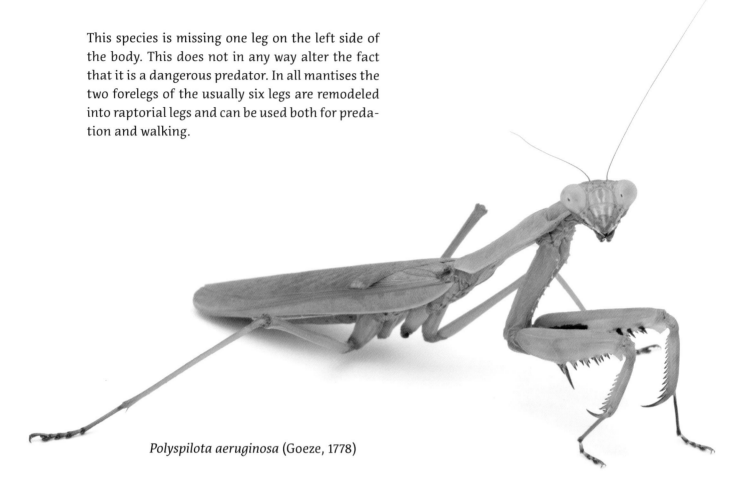

Polyspilota aeruginosa (Goeze, 1778)

The generalist: *Polyspilota aeruginosa* (Madagascar marbled Mantis)
The Madagascar marbled Mantis is to Madagascar what *Mantis religiosa* is to Europe: It is the commonest praying mantis in Madagascar. *Polyspilota aeruginosa* is a synanthrope whose habitat also includes hotel gardens and garden areas in villages and towns. At night they can be seen where they perch on lamps and you can watch as they prey on flying insects that approach and settle. *Polyspilota aeruginosa* has an enormous distribution range that extends from the east African mainland of Ethiopia through Kenya to as far as Tanzania. Further east it is native in the African countries of the Indian Ocean from Madagascar, the Comoros, Mauritius, and as far as the Seychelles, where it is found on most of the islands.

In the highlands it occurs up to 2,000 m elevation in grasslands. It can also be found in the eastern rainforests and in the dry forests of the west and the south.

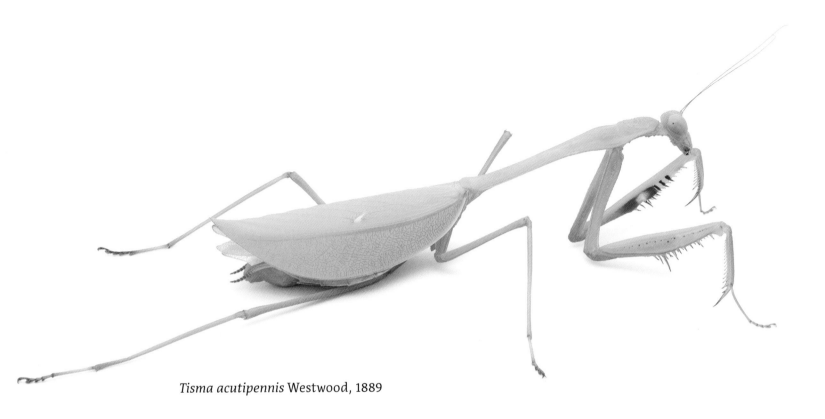

Tisma acutipennis Westwood, 1889

The generalist: *Tisma acutipennis*

A praying mantis that lives among the leaves in bushes and trees. The genus *Tisma* contains six large species with intensely green colors and a filigree outer wing tegmina pattern, which brings to mind the venation of a leaf. The genus was revised by Roger Roy in 2005.

Differentiation based on morphological features is possible thanks to the distinctive coloration and marking on the inner sides of the femur. The oothecae of individual species, which may contain 60–80 eggs or larvae, were also published.

Liturgusella malagassa Saussure & Zehntner, 1895

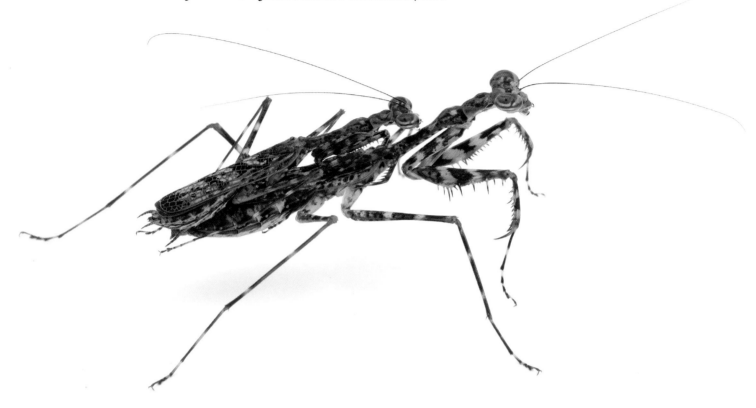

Mating of *Liturgusella*

Liturgusella malagassa is a bark mantis that is found in the rainforests of the east coast from the shores of the Indian Ocean up to an elevation of 1,400 m elevation, on the trunks of various tree species whose bark is overgrown with moss and lichens. The larvae of this mantis species are not outwardly distinguishable from those of the neotropical mantises (genus *Liturgusa*).

The molecular data gave the first indication that these allegedly identical species on the different continents have not evolved from a single species, but instead are related to the other praying mantis species on the same continent. The same evolutionary pressure – on different continents – led to this convergent development. This species shows how the environment, through evolutionary adaptation to habitat, created the same external phenotype. Phenotypes linked to habitat type in this way are termed eco-morphs. Thus, all mantises that live on tree bark have flat bodies and long legs and show brown-green, seemingly militaristic markings.

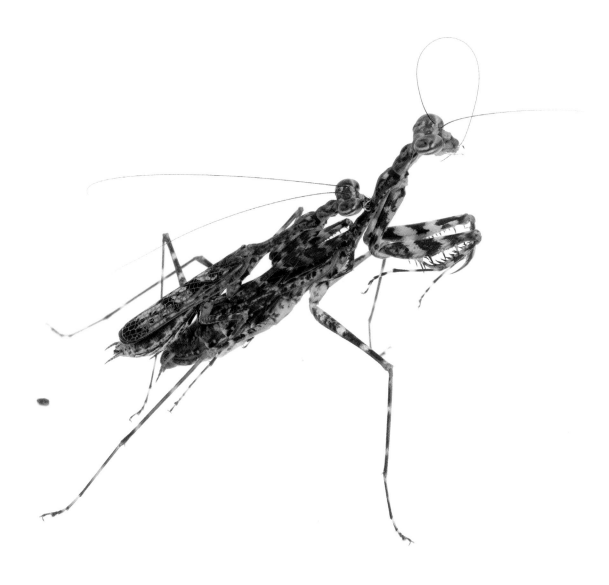

If this camouflage coloration fails and the *Liturgella* can be approached as it sits on the tree, it quickly runs around the tree trunk to the side facing away from the intruder. The adults can fly and are then no longer to be found down low on the tree trunks. Presumably they will mate higher up in the trees where they will then deposit their oothecae.

In the illustration above, the smaller male sits on top of the female and bites her in the chest. The female cleans her feelers by pulling each feeler, one by one, through her jaws. This situation seems almost laid-back but it is highly dangerous for the male: he can sometimes be eaten!

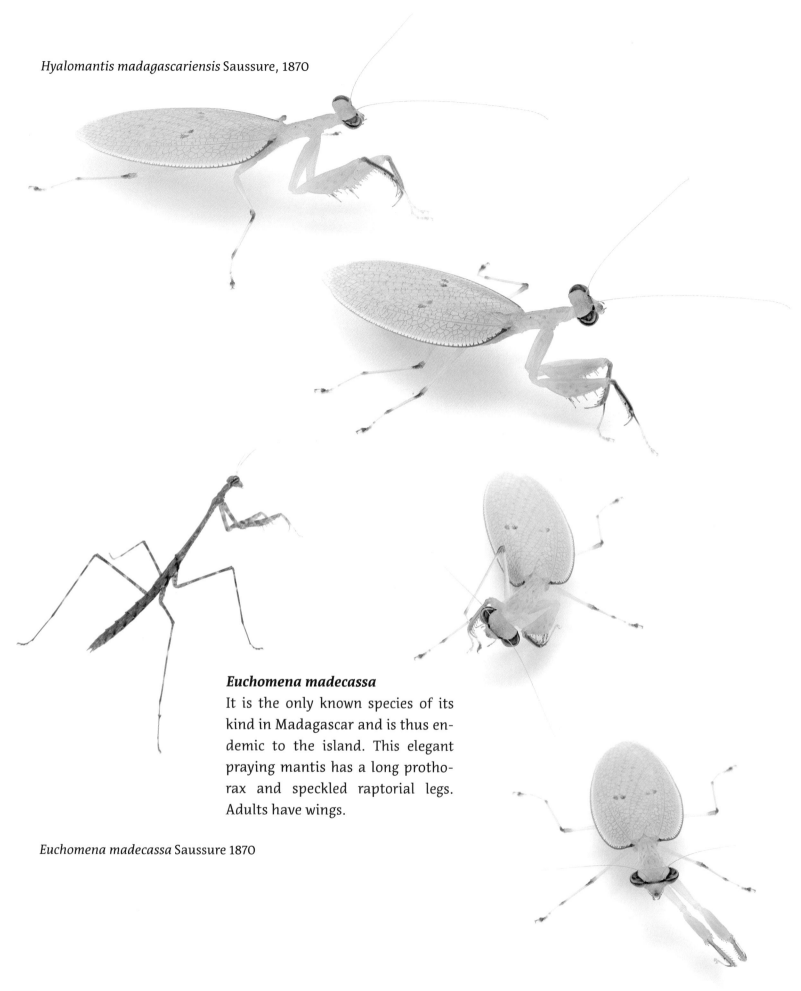

Hyalomantis madagascariensis Saussure, 1870

Euchomena madecassa

It is the only known species of its kind in Madagascar and is thus endemic to the island. This elegant praying mantis has a long prothorax and speckled raptorial legs. Adults have wings.

Euchomena madecassa Saussure 1870

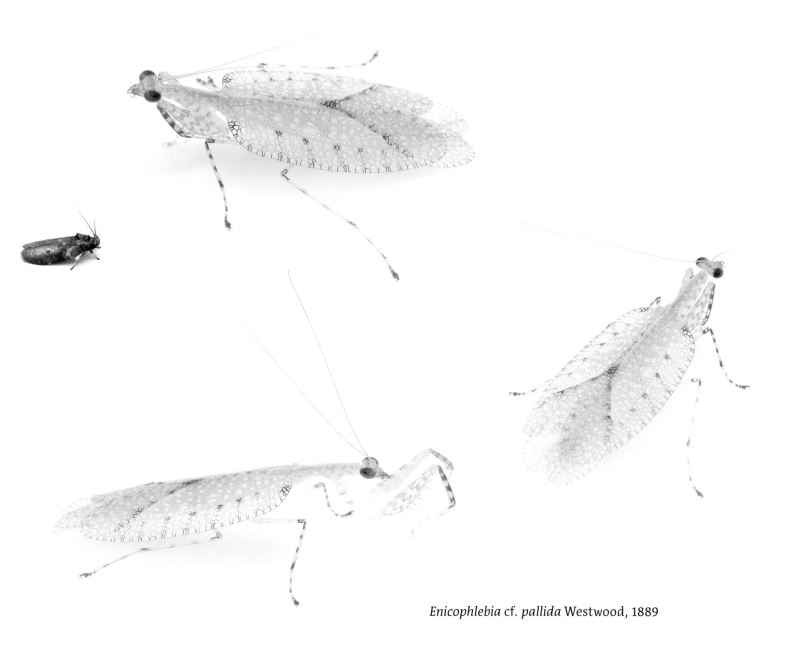

Enicophlebia cf. *pallida* Westwood, 1889

Nilomantini: Smart predators in the treetops

Praying mantises, which live in the tops of the 20–25 meter-tall trees of the primeval forest, are quite capable fliers and are very agile. In the subfamily Hapalomantinae they are grouped together in the Nilomantini tribe and all of them can be identified by their well-formed wings and colors, which match the leaves of the virgin forest. These praying mantises are small and dainty measuring up to 35 mm in length but they are seldom seen except at a light trap.

To date, little is known about their biology. Much research still remains to be done and to be published about the 14 species in the five genera endemic to Madagascar (*Cornucollis, Enicophlebia, Hyalomantis, Ilomantis* and *Platycalymma*).

Amphibians and reptiles of Makira

Text by Frank Glaw, J.M. Rafanoharana, H. Raherinjatovo,
A. Rakotoarison & M. H. R. Maheritafika

Madagascar currently harbors more than 400 species of amphibians and more than 450 species of reptiles. However, many more species have been discovered and are still awaiting their scientific analysis and description. No other country in Africa has such an enormous herpetological diversity and almost all of these species are naturally endemic to this island country and occur nowhere else in the world.

Most amphibian and reptile species inhabit the remaining rainforests of eastern Madagascar, and the comparatively large reserves of Makira and Masoala are therefore of enormous relevance for the conservation of this extraordinary diversity.

The herpetofauna of the Parc Naturel de Makira, known for short as Makira, is still poorly explored. Raselimanana et al. (2018) recorded 68 species of amphibians and 60 species of reptiles from this reserve. Most of these species were recorded during three expeditions:

In November / December 1996 a herpetological survey team (F. Andreone and J. E. Randiranirina) studied several rainforests in northeastern Madagascar (Andreone et al. 2000). Their southernmost localities (in the Tsararano massif) are today included in the northern parts of the Makira park, which was officially created in 2012. These studies revealed several new species including the chameleons *Calumma vatosoa* and *Calumma vencesi*, described by Andreone et al. (2001).

In June 2009 another team (M. Vences, D. R. Vieites, J. Patton, R.-D. Randrianiaina, F. M. Ratsoavina and E. Rajeriarison) surveyed the amphibians and reptiles of forest remnants at the western border of Makira at an elevation of about 1,000 m, which also resulted in numerous interesting discoveries (e. g., the splendid snake species *Liophidium pattoni*, see Vieites et al. 2010).

In April 2010, a third team (F. Glaw, J. Köhler, P.-S. Gehring, M. Pabijan and F. M. Ratsoavina) explored the lowland rainforest remnants around Ambodivoangy, which are outside but close to the eastern border of the Makira reserve at an elevation of ca. 50–100 m. This survey also revealed numerous new frog species (e.g., *Boophis fayi*, see Köhler et al. 2011).

About ten years later, Martin Bauert from the Zoo Zurich initiated a herpetological survey program of Makira and Masoala in cooperation with F. Glaw and the WCS, which started – with some delay due to the Corona pandemic – with the first field work in December 2021, when J.M. Rafanoharana, A. Rakotoarison & M.H.R. Maheritafika made a first survey around Camp Simpona.

A second survey was conducted in March 2022 by Frank Glaw, J.M.R. Rafanoharana, H.R. & M.H.R. Maheritafika. Most of this survey work was also conducted around Camp Simpona, which is named after a population of the critically endangered lemur species *Propithecus candidus* which occurs around this campsite. This locality is 410 m above sea level and only a few kilometers distance by air from the forest around Ambodivoangy surveyed in 2010. The surveys conducted in 2021 and 2022 were the first ones inside the reserve at an intermediate elevation and revealed many species not recorded from Makira before. These surveys were continued in 2022 at additional localities in Makira and Masoala by J.M. Rafanoharna and H. Raherinjatovo, which revealed even more species not known from Makira before.

In the following we will present some of the species which we captured in March 2022, mostly around the Camp Simpona. These individuals were photographed by Armin Dett using his special method developed for photographing butterflies.

Madagascar frogs (Mantellidae)

Most Malagasy frogs belong to this family, which comprises four subfamilies, the Mantellinae, Boophinae, Laliostominae and Tsingymantinae.

The bright-eyed frogs of the genus *Boophis* (subfamily Boophinae) are the hidden beauties among Malagasy frogs. They occur in all ecoregions of Madagascar including the dry west and the high mountain areas, but their highest diversity is in the eastern rainforests. Only one species occurs outside of Madagascar and has managed to colonize the Comoro Island of Mayotte (Glaw et al. 2019). The iris of their eyes often show colorful patterns during the day, which can often be used to distinguish between the species, although the reasons for this specific eye coloration are poorly understood. Most species are arboreal and nocturnal, but exceptions occur in some montane species. The species-specific advertisement calls of the males can be heard at night along streams but also around stagnant water bodies. The eggs are laid in stagnant or flowing water where the tadpoles live until their metamorphosis.

Boophis albilabris (Boulenger, 1888)

Boophis albilabris

This is a big nocturnal treefrog with a white stripe along the upper lip and a rather variable dorsal coloration, ranging from uniformly green to brown with darker markings on the back. In the mating season, males have spiny nuptial pads on the inner fingers and numerous black spicules on the back. The species can reach a snout-vent length of 100 mm and has large fingers with broad terminal disks. These disks and the webbing between the fingers provide a strong adhesive force, which enables these frogs to jump in the vegetation without falling down. *B. albilabris* was considered as rare and poorly known for 100 years (Blommers-Schlösser & Blanc 1991). However, in the 1990s it turned out that it is among the frog species with the widest distribution range in Madagascar, occurring in the rainforest belt along the whole east coast and also in the Sambirano region.

Boophis praedictus Glaw et. al., 2010

Boophis praedictus

This beautiful treefrog is very similar to *B. albilabris* and has been known as a color variant (with a red posterior iris periphery) of *Boophis albilabris* since the early 1990s. Since it had been expected for many years that this might be a new species, it was named *B. praedictus*, which means "predicted".

People interested in butterflies or evolution may know this species name already from the Malagasy butterfly *Xanthopan praedicta*, which was named due to its existence having been predicted by the famous evolutionary biologists Charles Darwin and Alfred Russel Wallace. When studying the orchid *Angraecum sesquipedale* Darwin noticed the extreme length of its nectaries (which can reach up to 35 cm) and suggested that there must be a pollinator moth with a proboscis long enough to reach the nectar at the end of the nectary. Decades later this moth was actually found in Madagascar and described as *Xanthopan morganii praedicta*, which is today considered to be a full species (see pp. 162–163).

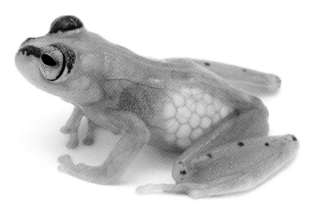

Boophis aff. *mandraka*

This small treefrog is probably a new species of the *Boophis mandraka* group, which is characterized by transparent ventral and lateral skin. As with the glassfrogs of Central and South America, the eggs can be clearly seen in the body cavity. If these frogs are turned on their back, the pumping heart and the blood vessels can be seen as well. Beside the species mentioned above, we also recorded several other *Boophis* species in Makira, including for example *B. marojezensis*, *B. englaenderi*, *B. roseipalmatus* and *B. axelmeyeri*.

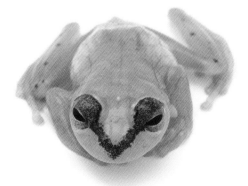

Boophis aff. *mandraka*

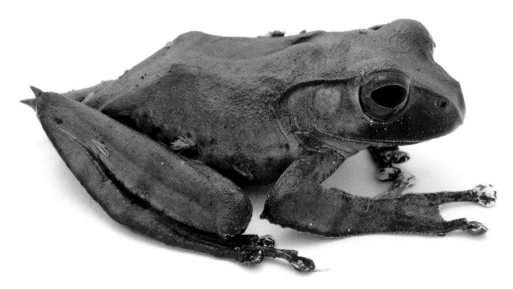

Boophis roseipalmatus Glaw et al., 2010

Boophis roseipalmatus

In terms of their large size (females can reach up to 80 mm snout-vent length), morphology and coloration, this species is rather similar to *B. madagascariensis* and both of them occur sympatrically in Makira. The best feature by which to distinguish them is the color of their webbing between fingers and toes, which is always pink in *B. roseipalmatus* and grayish or brown in *B. madagascariensis*. Since the color of the webbing is not easily recognizable on the photo, it is uncertain which of the two species is depicted here. Both species also have long tarsal skin flaps which look like spines.

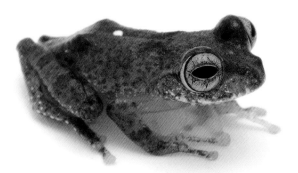

Boophis marojezensis Glaw & Vences, 1994

Boophis marojezensis

A small brown treefrog (adult males reach at most 27 mm snout-vent length), often with a dark-brown hour-glass marking on the anterior back and a blueish posterior iris periphery. Males often call from the vegetation along noisy streams, usually 2 – 4 m above the ground.

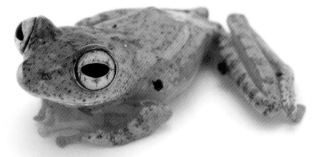

Boophis marojezensis Glaw & Vences, 1994

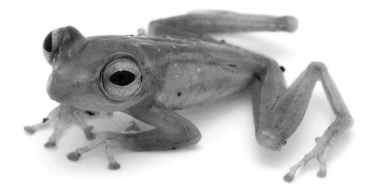

Boophis englaenderi Glaw & Vences, 1994

Boophis englaenderi

A representative of the *B. luteus* group, which currently includes 19 almost uniformly green species, that call from vegetation along streams at night. The calls of these species are often characteristic to distinguish the different species, which are morphologically very similar to each other.

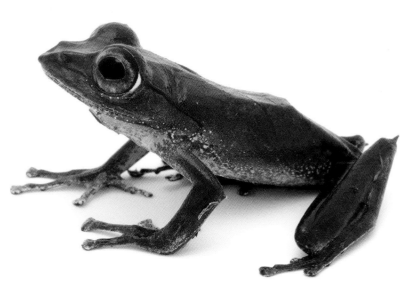

Boophis axelmeyeri Vences et al., 2005

Boophis axelmeyeri

In this brown treefrog the upper part of the iris is red, but there is a similar form or species in which the dorsal part of the iris is brown. Both species also have a tarsal skin flap on the heels, which are distinctly smaller than in *B. madagascariensis* and *B. roseipalmatus*.

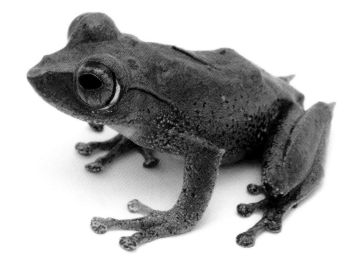

Boophis axelmeyeri Vences et al., 2005

357

Madagascar frogs (Mantellinae)

The subfamily Mantellinae is another species-rich group of the family Mantellidae, including the genera *Blommersia*, *Boehmantis*, *Gephyromantis*, *Guibemantis*, *Mantella*, *Mantidactylus*, *Spinomantis* and *Wakea*. In Makira, we found the highest species diversity in the genus *Gephyromantis*.

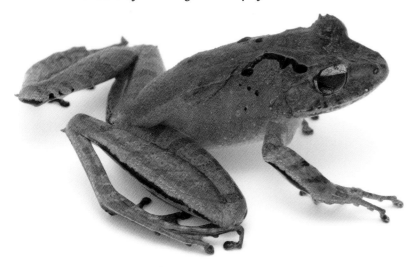

Gephyromantis luteus (Methuen & Hewitt, 1913)

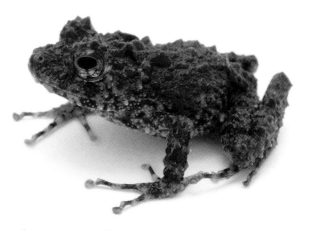

Gephyromantis oelkrugi Vences et al., 2022

Gephyromantis luteus

This is a common long-legged frog, which is often encountered jumping in the leaf litter on the forest floor during the day or calling from leaves ca. 1–2 m above the ground at night. The advertisement calls of this species are the dominating sound of the nocturnal low-elevation rainforest.

Gephyromantis oelkrugi

The subgenus *Laurentomantis* is characterized by a tuberculate skin texture on the back, which gives these frogs a special appearance. This subgenus was recently revised by Vences et al. (2022). In that publication four new species have been described, including *G. oelkrugi*, which is only known from Makira and Masoala.

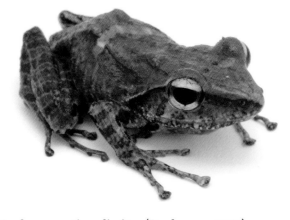

Gephyromantis redimitus (Boulenger, 1889)

Gephyromantis redimitus

With up to 48 mm snout-vent length this is one of the largest species in the genus. This brown frog is usually recognizable by two dark spots or tubercles between the eyes. Males can be found calling at dusk and night from perches 1–2 m above the ground along streams.

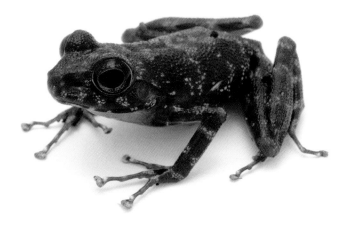

Gephyromantis silvanus (Vences et al., 1997)

Gephyromantis silvanus

This slender species has only traces of webbing between its long fingers and toes. It can be found among boulders and low vegetation along small low-altitude rainforest streams.

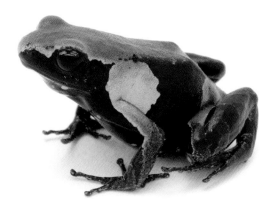

Mantella nigricans Guibé, 1978

Mantella nigricans

Although easily recognizable in photographs by its distinct coloration, this species is genetically very similar or almost identical to *M. baroni* and therefore could be considered a color variant rather than a distinct species. We found this diurnal species only along a beautiful river in the rainforest on the way to the top of the mountain.

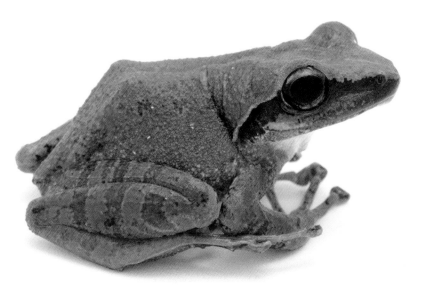

Guibemantis tornieri (Ahl, 1928)

Guibemantis tornieri

is a large, uniformly brown frog with a dark stripe from the nostril to the eye and a dark tympanic region. The broad fingertips indicate that this species is a good climber. Males were calling from bushes along the stream at the campsite. The eggs are deposited on leaves, but also on tree trunks overhanging stagnant water bodies or streams.

Amphibians

Living amphibians comprise three major groups, the orders Anura (frogs), Urodela (salamanders and newts) and Gymnophiona (worm-like caecilians), but only anurans occur in Madagascar, where they are represented by several families.

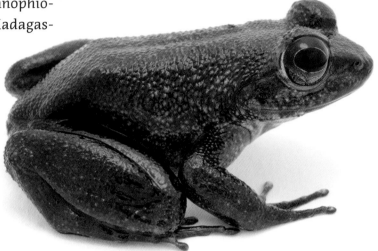

Mantidactylus grandidieri Mocquard, 1895

Mantidactylus grandidieri

This is among the largest endemic frogs of Madagascar and can reach ca. 10 cm snout-vent length. It is often encountered at night along rainforest streams and is sometimes hunted by local people. Rancilhac et al. (2020) used new genetic methods in order to clarify the taxonomy of this species group and found out that the frogs of Makira and Masoala belong to this species.

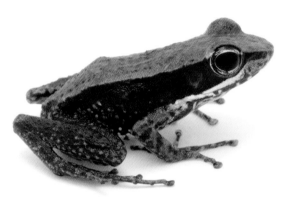

Mantidactylus charlotteae Vences & Glaw, 2004

Mantidactylus charlotteae

A small (snout-vent length 22-32 mm), locally abundant species living along small streams in low-elevation rainforests, where calling males can be heard during the day.

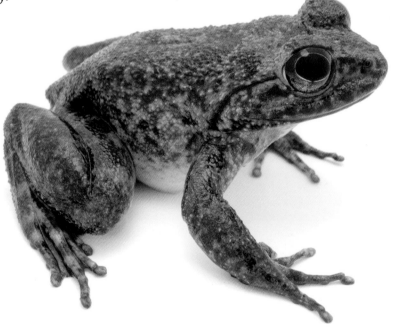

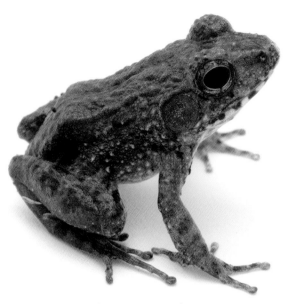

Mantidactylus (Brygoomantis) sp.

Mantidactylus (Brygoomantis) sp.

Frogs of the subgenus *Brygoomantis* are among those very often encountered. They can be found during the day and at night along running and stagnant water bodies. Although it has been clear for more than 20 years that this group contained many undescribed species, their taxonomy remained poorly resolved. A recently published revision of the subgenus used modern genetic methods to obtain DNA from old type specimens, so that the identity of the synonyms was finally clarified and 20 new species were described (Scherz et al. 2022). The species found around Camp Simpona still need to be studied in order to clarify their identity.

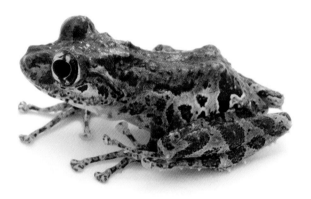

Spinomantis fimbriatus (Glaw & Vences, 1994)
Spinomantis tavaratra Cramer et al., 2008

Spinomantis fimbriatus / tavaratra

These two species are morphologically similar to each other and the exact species identification needs additional studies. We found this species in Makira only at higher elevations above 900 m. Another similar species is *S. aglavei*, which is larger and usually has more soft dermal spines on the outer side of the foot and tarsus and apparently also occurs around Camp Simpona.

Narrow-mouthed Frogs (Microhylidae)

This is another species-rich group with almost worldwide distribution, which includes three Malagasy subfamilies (Cophylinae, Dyscophinae and Scaphiophryninae). The subfamiliy Cophylinae has the highest morphological and genetic diversity, and includes the genera *Anilany, Anodonthyla, Cophyla, Madecassophryne, Mini, Platypelis, Plethodontohyla, Rhombophryne* and *Stumpffia*. Some of these genera are fossorial or live in the leaf litter whereas other species are arboreal, but all of them have non-feeding tadpoles which are unable to eat and use the yolk from the eggs to complete their development. Parental care is widespread in this group, but poorly studied.

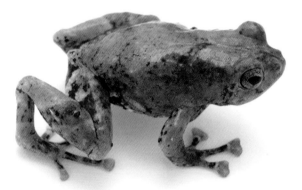

Anodonthyla hutchisoni Fenolio et al., 2007

Anodonthyla hutchisoni

This arboreal species was described from Masoala, but remains very poorly known. Upon seeing this frog we immediately had the impression that this must be *Anodonthyla* and this has been now confirmed by genetic data. Two species, *A. boulengeri* and *A. hutchisoni*, occur in the Masoala and Makira region, but no *Anodonthyla* species seems to live further north (Vences et al. 2010).

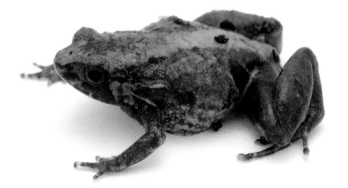

Stumpffia sp.

Stumpffia sp.

The small terrestrial species of the genus *Stumpffia* are very abundant in the rainforests of northern Madagascar, but their identification is difficult without genetic data, since there is substantial variability in the coloration of many species. At least four species have ben recorded from Makira, but more can be expected. In a recent study 26 new species have been described (Rakotoarison et al. 2017).

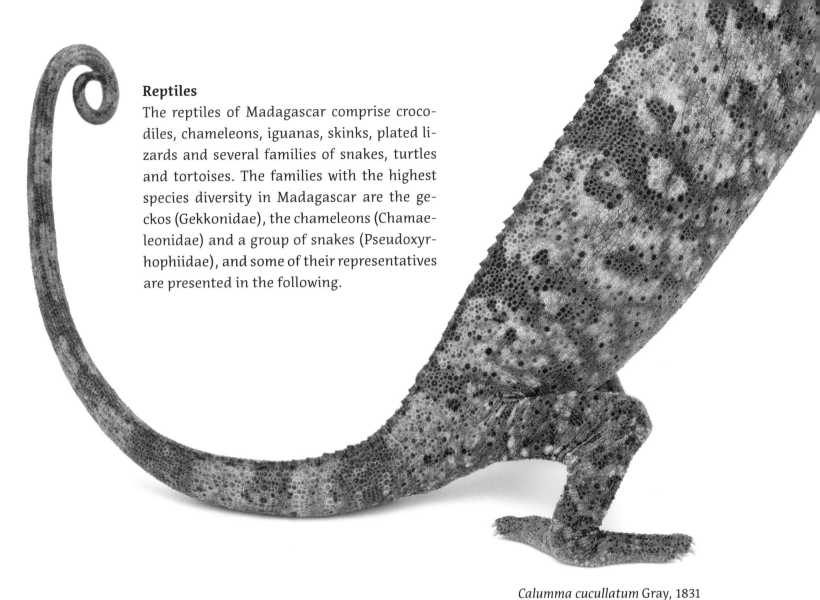

Reptiles

The reptiles of Madagascar comprise crocodiles, chameleons, iguanas, skinks, plated lizards and several families of snakes, turtles and tortoises. The families with the highest species diversity in Madagascar are the geckos (Gekkonidae), the chameleons (Chamaeleonidae) and a group of snakes (Pseudoxyrhophiidae), and some of their representatives are presented in the following.

Calumma cucullatum Gray, 1831

Plated Lizards (Gerrhosauridae)

This lizard family is distributed in Africa and Madagascar. The two genera from Madagascar (*Tracheleloptychus* and *Zonosaurus*) comprise 19 species. In contrast to the related *Z. madagascariensis*, which also lives in and around Camp Simpona, *Z. brygooi* is smaller and restricted to rainforest habitats, where it is active during the day on the forest floor.

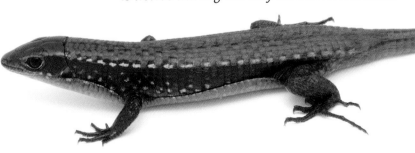

Zonosaurus brygooi Lang & Böhme, 1990

Madagascar geckos (Gekkonidae)

All Malagasy geckos belong to this family, which comprises more than 1,500 species. Almost 10 % of its species diversity (136 species) are found on Madagascar, including spectacular forms like the colorful day geckos *(Phelsuma)*, bizarre leaf-tailed geckos *(Uroplatus)*, and skin-shading fish-scale geckos *(Geckolepis)*. About 50 % of the island's gecko species are active during the day *(Lygodactylus* and *Phelsuma)* whereas the other species are nocturnal. Most geckos have adhesive pads under their fingers and toes, which enables them to climb easily on vertical and smooth structures.

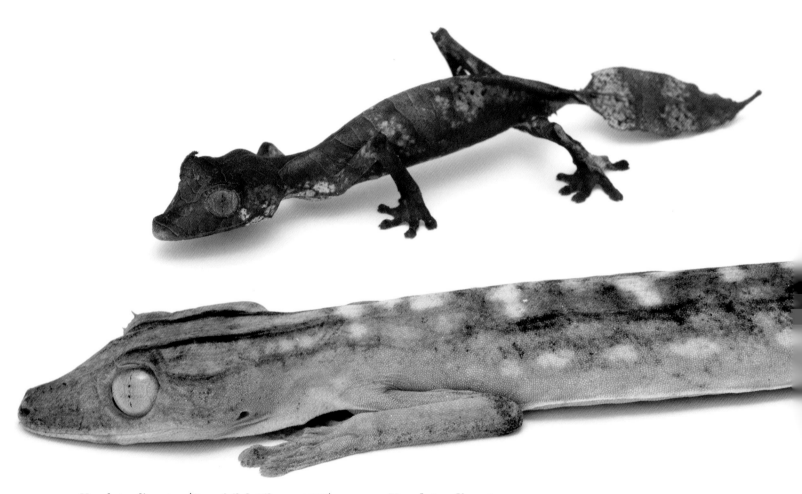

Uroplatus lineatus (Duméril & Bibron, 1836)

Uroplatus lineatus

With its large size (up to 139 mm snout-vent length) and its unique coloration it cannot be confused with any other *Uroplatus* species. We discovered this specimen in the evening in a bamboo stand along the stream not more than 10 meters away from our bungalow in Camp Simpona. The area around the camp is also home to the even more famous *U. fimbriatus* which, however, has a skin resembling the bark of trees (Gehring et al. 2018).

Uroplatus finaritra

This charismatic gecko species resembles *Uroplatus phantasticus* because of its broad, leaf-like tail, but can reach a much larger size (up to 95 mm snout-vent length) and was only described recently from the Marojejy massif in the northeast (Ratsoavina et al. 2019). The individual shown here was found at night along the trail not far from Camp Simpona and demonstrates that *U. finaritra* is not endemic to the Marojejy massif, but is more widespread. It can be easily distinguished from *U. fivehy*, which we also recorded around Camp Simpona, by its much broader tail (Ratsoavina et al. 2020).

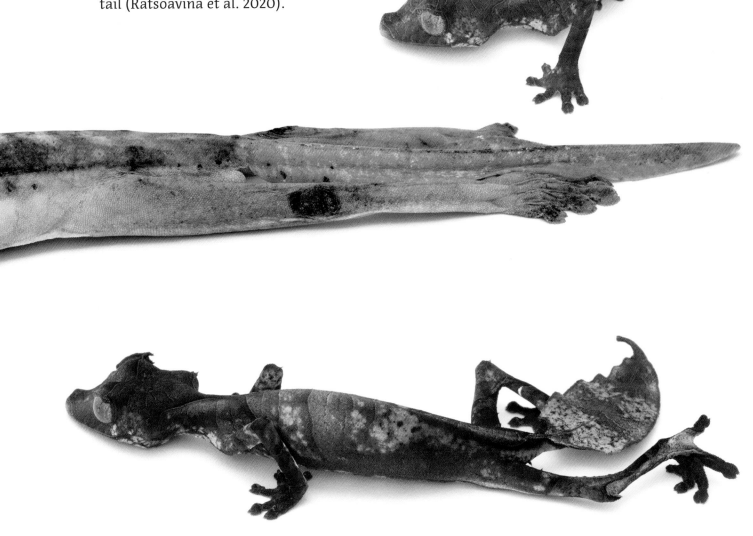

Uroplatus finaritra Ratsoavina et al., 2019

Phelsuma guttata

This day gecko species is widespread in the low-altitude rainforests of eastern and northeastern Madagascar. The genetic differentiation of this species was recently studied by Mohan et al. (2019).

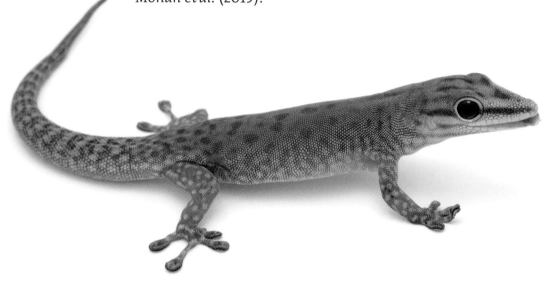

Phelsuma guttata Kaudern, 1922

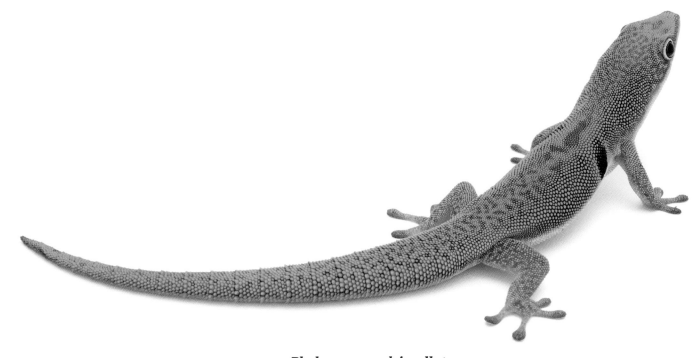

Phelsuma quadriocellata ssp.

A handsome green day gecko with a charac-
teristic blackish spot on the flanks behind
the forelimbs, which is surrounded by a blue
ring. Several subspecies are distinguished
and two of them, *P. quadriocellata bimacu-
lata* Kaudern, 1922 and *P. q. lepida* Krüger,
1993, are characterized by the vertical shape
of this dark spot. However, their taxonomy
needs further studies. This day gecko can re-
ach a total length up to 125 mm and inhabits
rainforest, secondary vegetation, gardens
and houses.

Phelsuma quadriocellata ssp.

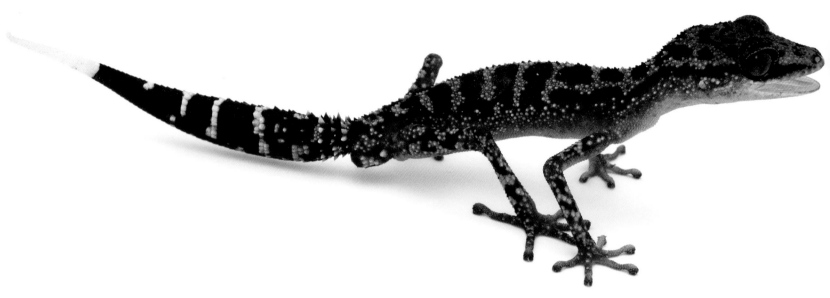

Paroedura gracilis (Boulenger, 1888)

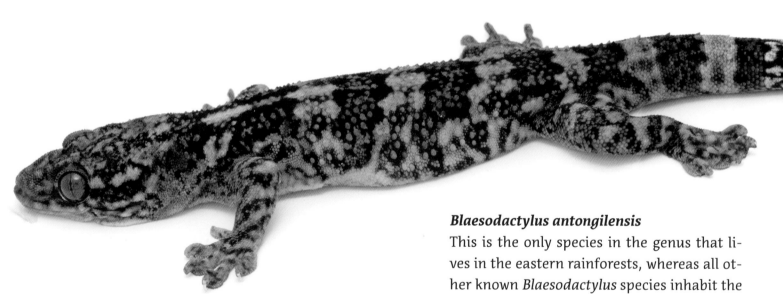

Blaesodactylus antongilensis (Böhme & Meier, 1980)

Blaesodactylus antongilensis

This is the only species in the genus that lives in the eastern rainforests, whereas all other known *Blaesodactylus* species inhabit the deciduous dry forests of northern, western and southwestern Madagascar (Ineich et al. 2016).

Paroedura gracilis

This species was recently studied by Mohan et al. (2019) and turned out to be a complex of species. This species was the most common gecko during our night excursions around Camp Simpona.

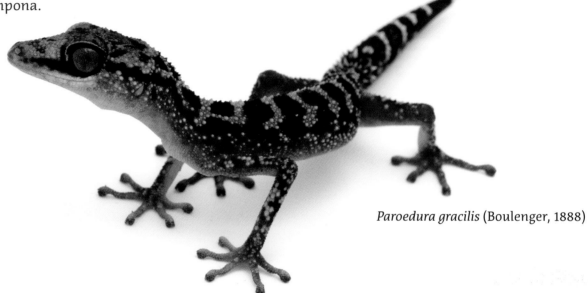

Paroedura gracilis (Boulenger, 1888)

Lygodactylus sp.

The tiny day geckos of the genus *Lygodactylus* are very difficult to identify to the species level, since their body coloration is cryptic and morphological differences like the scale pattern on the throat are difficult to see in living individuals.

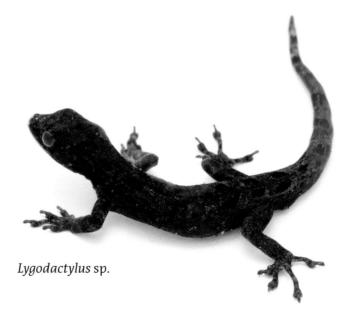

Lygodactylus sp.

Madagascar Snakes (Pseudoxyrhophiidae)

Most Malagasy snakes (ca. 80 species) belong to this family, which has a wide distribution in Madagascar but also includes a few snakes from Africa, the Comoro Archipelago and Socotra Island. Pseudoxyrhophiids exhibit a wide range of ecological and morphological diversity, including spectacular forms like the sexually dimorphic genus *Langaha* and the extremely colorful species *Liophidium pattoni* and *Lycodryas citrinus*. All Malagasy snakes are non-venomous, although localized swelling can occur after a bite.

Liopholidophis oligolepis

Apart from the wormlike fossorial blindsnakes, *L. oligolepis* is one of the smallest and also one of the rarest snakes from Madagascar. Until recently, it was only known from the female holotype which was captured in Marojejy in 2005 in a pitfall (Glaw et al. 2014). The new specimen, also captured in a pitfall, is probably a subadult female and even smaller than the holotype. It shows that the species is more widespread than previously thought. *Lioplidophis* species have an unusual sexual dimorphism with males having much longer tails than females. Unfortunately, the male of this species is still unknown, so that it remains unclear if this dimorphism is less evident in this dwarf species than in the other *Liopholidophis* species, which partly can reach up to 1,5 m total length. It is the only snake in Madagascar with only 15 rows of scales around the midbody (all other snakes have at least 17 rows of scales).

Liopholidophis oligolepis Glaw et al., 2014

Thamnosophis infrasignatus (Günther, 1882)

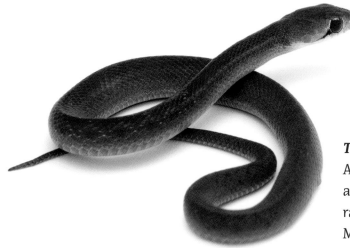

Thamnosophis infrasignatus

A terrestrial and diurnal snake, which can reach a total length of 850 mm. It is common in rainforest and secondary habitats of eastern Madagascar and feeds on frogs and small reptiles.

Lycodryas gaimardii

This distinctly banded rainforest snake with large eyes can reach a total length of 837 mm. It is arboreal and nocturnal and usually found at night in the trees more than 3 m above the ground. It occurs in the rainforests of eastern and also of southeastern Madagascar (Burbrink et al. 2019).

Lycodryas gaimardii (Schlegel, 1837)

Chameleons (Chamaeleonidae)

With almost 100 described species Madagascar is the hotspot of diversity for the family, harboring more than 40% of the world's 228 species, including the largest, *Calumma parsonii* and *Furcifer oustaleti*, as well as the smallest, *Brookesia micra* and *B. nana* (Glaw et al. 2021). Chameleons are famous for their ability to change their color and show numerous adaptations for arboreal life, like a prehensile tail and the tongue-like hands and feet.

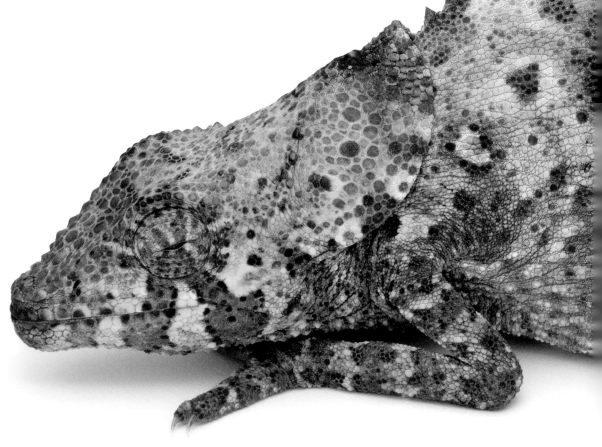

Brookesia vadoni Brygoo & Domergue, 1968

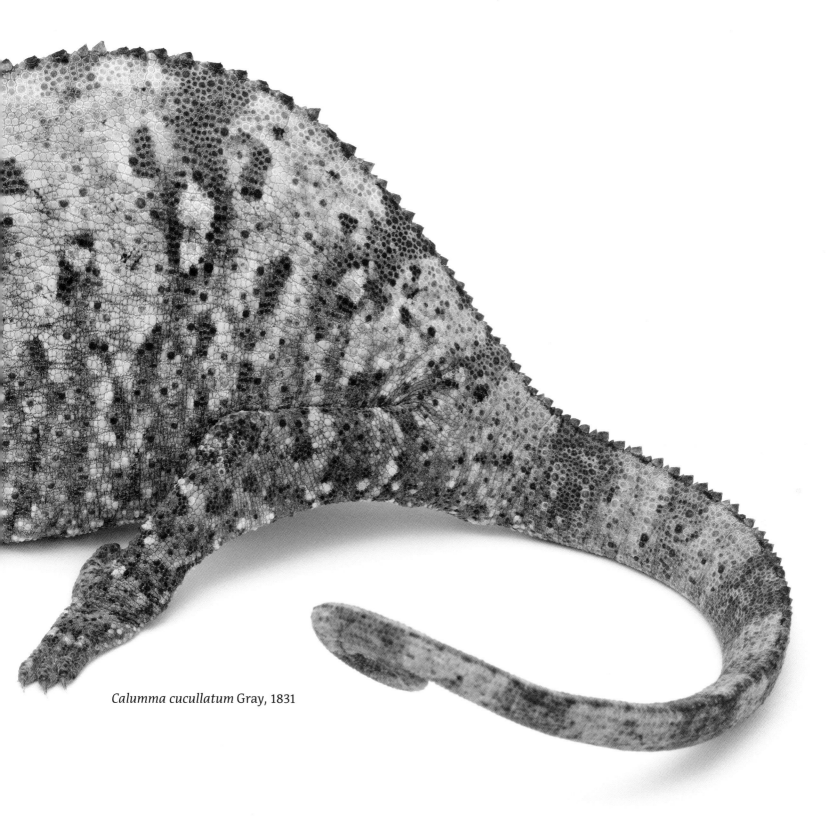

Calumma cucullatum Gray, 1831

Calumma cucullatum

This species is one of several poorly studied chameleons in Madagascar. It occurs from Marolambo in the south to Marojejy in the north in different color morphs. The photo shows an adult female.

Brookesia vadoni

This spiny species is one of the most spectacular chameleons in Madagascar. First described from Iaraka on the Masoala peninsula (Brygoo 1978), it is now known to be more widespread in northeastern Madagascar. In Makira, we did not find this species around Camp Simpona, but only at higher elevations.

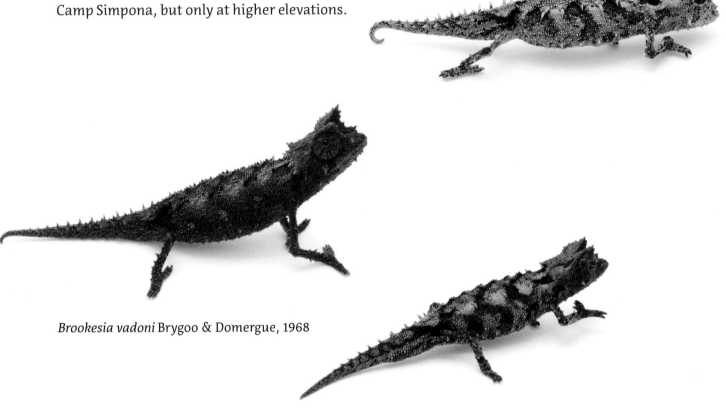

Brookesia vadoni Brygoo & Domergue, 1968

Acknowledgements

We are greatly indebted to Dr. Martin Bauert (Zoo Zurich), Dr. Antonio Boveda (Wildlife Conservation Society), Prof. Dr. Aristide Andrianarimisa (University of Antananarivo). Without their logistical and financial support this project would not have been possible. We are also very grateful for the support of the charitable foundation ACCENTUS through Zoo Zurich's conservation fund.

We also wish to thank the women and guides of Andaparaty as well as Moritz Grubenmann and Edi Day (Verein Freunde Masoalas), and Armin Dett for all their support. They all made our study in Makira not only successful but also a very pleasant experience.

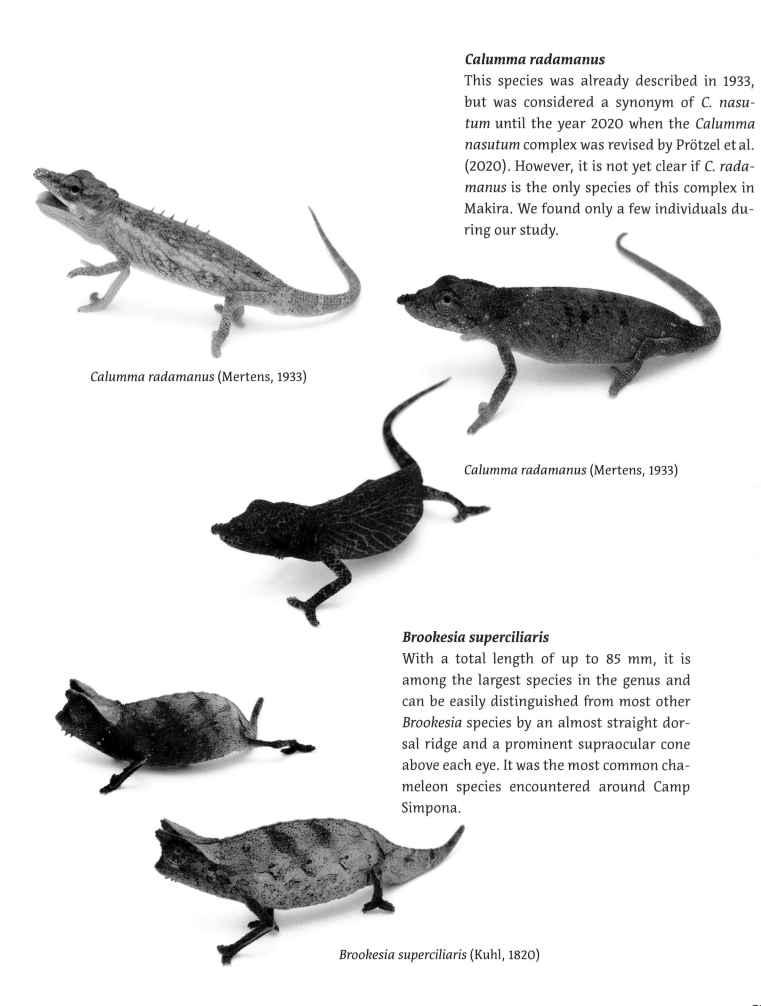

Calumma radamanus

This species was already described in 1933, but was considered a synonym of *C. nasutum* until the year 2020 when the *Calumma nasutum* complex was revised by Prötzel et al. (2020). However, it is not yet clear if *C. radamanus* is the only species of this complex in Makira. We found only a few individuals during our study.

Calumma radamanus (Mertens, 1933)

Calumma radamanus (Mertens, 1933)

Brookesia superciliaris

With a total length of up to 85 mm, it is among the largest species in the genus and can be easily distinguished from most other *Brookesia* species by an almost straight dorsal ridge and a prominent supraocular cone above each eye. It was the most common chameleon species encountered around Camp Simpona.

Brookesia superciliaris (Kuhl, 1820)

Amphibians and reptiles of Masoala

Text by Frank Glaw

Plethodontohyla notosticta

This brownish frog with enlarged fingertips sometimes shows a distinct pattern on the back. It is often found on the forest floor in rainforsts. On the other hand, single males or two adult individuals are often found together with eggs and tadpoles in water-filled treeholes. The parental care of this species is obvious, but not yet well studied.

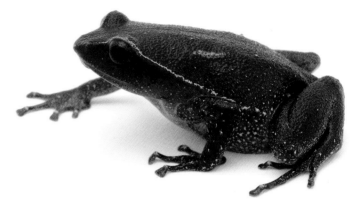

Plethodontohyla notosticta (Günther, 1877)

Blommersia variabilis

This small (snout-vent length 19 – 25 mm), nimble frog is endemic to the Makira-Masoala region and morphologically rather similar to other *Blommersia* species (Pabijan et al. 2011). It is common in cultivated landscapes including ricefields, but rare or absent in dense primary rainforest. The eggs are usually laid on leaves above stagnant water bodies. The hatching tadpoles fall into the water where they develop into froglets.

Complements
Frogs and gekkos documented by the editor during his moth surveys in Masoala 2019 and 2022.

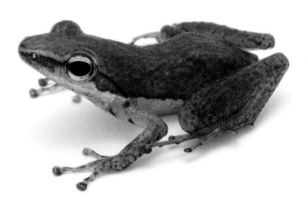

Blommersia variabilis Pabijan et al., 2011

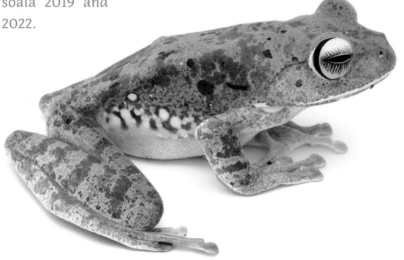

Boophis masoala Glaw et al., 2018

Boophis masoala

This large treefrog species is superficially similar in morphology, size and coloration to *B. albilabris* and *B. praedictus*. Together with *B. praedictus* it is the only Malagasy frog species with blue webbing. It has a characteristic eye coloration and is genetically highly differentiated from the other species of the *B. albilabris* group. Upon capture by hand the holotype of this species emitted several loud distress calls each of them lasting about 1.5 seconds (Glaw et al. 2018).

Phelsuma aff. pusilla

The taxonomy of this species complex is in urgent need of taxonomic revision (Gehring et al. 2013). It includes small green day geckos (total length up to 100 mm) with distinct red spots and markings on the back and a distinct blackish lateral stripe. The species complex as currently understood is widespread along the east coast of Madagascar.

Phelsuma aff. *pusilla*

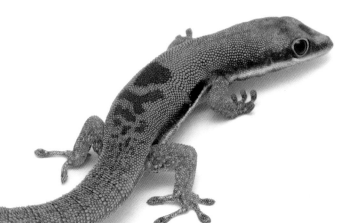

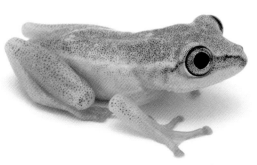

Heterixalus madagascariensis (Duméril & Bibron, 1841)

Heterixalus madagascariensis

A beautiful treefrog of 22 – 30 mm snout-vent length with orange hands and feet and a white or yellow dorsal coloration during the day, which changes to yellow-brown at night. This species does not live in dense forests, but is common in cultivated areas where it can be found around sun-exposed swamps and rice-fields (Glaw & Vences 2007).

Hemidactylus mercatorius

This is a widespread and abundant nocturnal gecko, which is often found in human settlements, but rarely seen in rainforest. As indicated by its species name, it is often introduced to new habitats by human activities. The species seems to occur naturally in Madagascar but is one of the few reptile species not endemic to this island country.

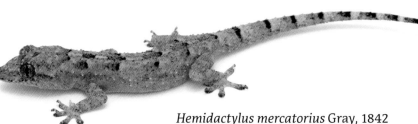

Hemidactylus mercatorius Gray, 1842

Ebenavia boettgeri

The tiny geckos of the genus *Ebenavia* were recently revised by Hawlitschek et al. (2018). Formerly believed to include only two species (one from the eastern rainforest and one from arid southwestern Madagascar), this study revealed that the species diversity in the genus is substantially higher. *Ebenavia* geckos are widespread in the humid forests of Madagascar, but have also managed to populate the Comoro Islands and even Pemba Island (Tanzania) in the western Indian Ocean by overseas dispersal (Hawlitschek et al. 2017).

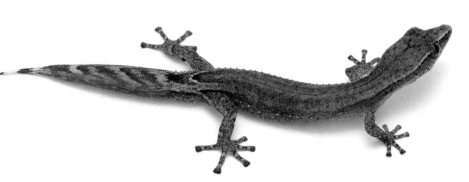

Ebenavia boettgeri Boulenger, 1885

377

Why museum collections are vitally important

Text by Dr. Aristide Andrianarimisa

The events of the past help us understand how everything was organized, explain what we have now, and predict what will happen in the future. Like all human knowledge, natural science is based on what exists now and explores the possibilities for the future. Understanding the past and present of living organisms is one of the pillars of biological science, which uses scientific methods to study nature. It is often based on defining, predicting, and understanding natural phenomena with the help of observation and experimentation. Aristotle, the Greek philosopher and mathematician, contributed greatly to the development of natural science because of his work in studying lifeforms and he was considered the father of biology since its early beginnings, as far back as 400 BC (Balme 1991). Natural science has based its findings on the collection of fossils and descriptions of living organisms at the most fundamental level. Essentially, the collection of specimens serves as evidence that they occurred at a particular time and place.

Generally, a specimen is a dead collection of an organism that can be of various types. Larsen (1996) presents specimens as "manageable pieces of the natural world" that were, however, not "natural" but constructed by naturalists to answer their needs. Such curated specimens serve as a resource for documenting and studying natural history, biodiversity, genetic variation, distributions, ecology, zoonosis, epidemiology, impact of climate change, ecotoxicology, and other topics, relative to increments of time. For example, geological discoveries and evidence from fossil specimens, living millions of years ago have helped to document Madagascar's natural history. Without these fossils, it would be more difficult to understand where much of what we have now comes from. Thus, the birth of Madagascar is estimated to have occurred about 160 to

180 million years ago (Ali et al. 2008; Eagles & Konig 2008) and there is a glaring absence of modern mammal groups, even as fossils, as they spread over that geological period. This early isolation of the island has been considered the principal source of the present uniqueness of the island's biodiversity, where endemism has reached an exceptional percentage for most taxa. These occurrences point to the fact that specimens may provide information on the presence of taxa at a specific time and place. From this point of view, the evidence that only "primitive living organisms" had existed in Madagascar through different geological periods could have explained what we have now. By analogy with this, the specimens collected since the first explorers who visited Madagascar constitute a library of what existed since the 17th Century. Collections amassed by various explorers a century ago can help us understand the changes that have occurred since then. This insight into natural history is irreplaceable, as we cannot go back in time and resample living specimens.

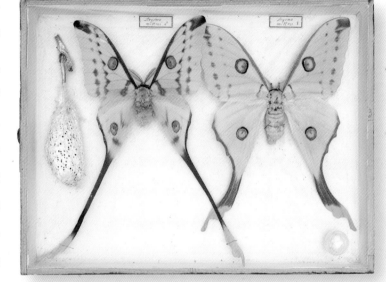

Case from a display collection

This heirloom is more than 80 years old and it aroused in the publisher of this book a child's inquisitiveness and delight in the presence of tropical butterflies. Some 50 years after experiencing his first wonderment at *Argema mittrei*, the author selected this species as a living title image for this moth book.

How important are specimen collections?

At the most fundamental level, specimens represent an entire organism or part of it, preserved at least for scientific use. Previously, specimens represented acquisition by collectors rather than collecting for scientific purposes (Kohler 2007). Early specimens belonged to private and wealthy family collectors to show off rare or curious natural objects and artefacts (Wan-Chen 2012). This desire to display specific objects was among the drivers of the amassing

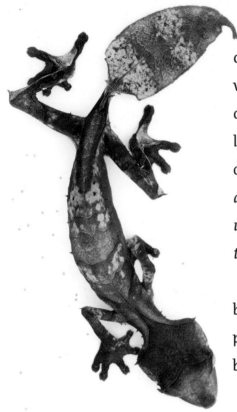

of unexpected objects during expeditions. Over the decades, private collections have helped inform us regarding the presence of a variety of living organisms and through donations they have led to the founding of museums. For instance, Mark Carnall wrote on 4 December 2013 that: *'Many of today's largest museums, including the Natural History Museum London, the Natural History Museum Tring and the British Museum, were founded as private collections that were donated to the nation'*.

The value of specimen collections may be recognized as a valuable source of information for various scientific purposes. Their use provides insight into species classification, evolution and distribution, and other topics such as emerging diseases.

Systematics and biogeography

The desire to show people the wonders of such unknown species and the presence of unusual objects prompted the first explorers to collect specimens. While the publication of Linnaeus's Systema Naturae (first edition 1736) has since 1858 rightly been acknowledged as a breakthrough in the growth of the field of taxonomy, early naturalists struggled to acquire specimens, and then identify and classify them. Thereafter, the development of early taxonomy depended on procuring specimens from all the realms of nature that provided essential materials. Museums have since played a central role in making them available for scientists. For instance, Brooke (2000) has estimated that three billion specimens exist in the world's natural history museums, which undoubtedly support taxonomy and systematic studies of most known and unknown organisms.

In Madagascar, two examples illustrate the use of museum specimens. First, the recent revision of freshwater fish species became

possible by using museum specimens and data from recent species inventories (Sparks & Stiassny 2022). Such revisions allow the exclusion of certain historically reported species that are considered misidentified, thus resulting in a more valid list. Second, the spectacular increase in Malagasy amphibian species richness – from 143 to 203 in 1992 – 2003 (Glaw & Vences 2003) and to the current 365 described and 100 – 150 potential new species (AmphibiaWeb 2022) – is unquestionably the result of extensive biological inventories by many researchers, the use of bioacoustics, and DNA barcoding (Köhler et al. 2015), in which museum specimens played roles (see pp. 354 – 362). The recent book, The New Natural History of Madagascar edited by Goodman, Glaw et al. (2022) mentions on page 1322 that to improve overall understanding of Madagascar's amphibians, it is imperative that voucher specimens continue to be collected and integrated into scientific collections. It highlights the need to gather specimens since they provide a valuable source of information (from morphological features to genetic materials) which is becoming crucial for species delimitation through molecular investigations. Moreover, identification is not the ultimate reason to collect specimens. Studies that look at the evolution of species forms through time are impossible without whole specimens. Preserved specimens also provide real data points for monitoring long-term changes in species health and distribution.

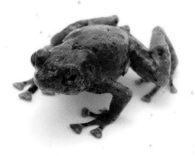

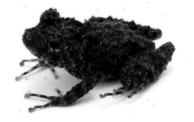

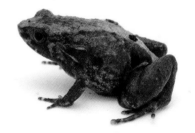

Outside of systematics, associated data such as field notes on habitat, location, and time of collection have served scientists to document the present and historical distribution of species. Access to such information by touring the museums opens a new era for natural history as argued by Nigel Collar (Collar 1991). He conceived the idea of producing Red Data Books for birds and recognized using museums-associated specimen data to refine the range of

some threatened species. Similarly, Navarro et al. (2003) have gathered data on bird species from specimens held in some 58 museums worldwide, and used such data together with those on environmental variables to enable exciting predictions of how distributions might shift when climate changes. The presence of a vast collection of biological specimens grown over centuries is similar to relevant archives of the Earth's natural history. Aggregating data from museum specimens worldwide illustrates the potential increase in understanding the biogeography and systematics of many taxa. Data supplementing collections are, at a minimum, the date, location, collector and habitat notes. In Madagascar, worldwide museum data contributed to recent field data for publication of the bilingual atlas of selected land vertebrates by Goodman and Raherilalao in 2013. Today and in future, modern online databases such as GBIF and iNaturalist will be increasingly helpful to understand the overwhelming biodiversity in Madagascar.

Conservation

Another use of specimens and associated data is as a source of innumerable pieces of information for wildlife conservation. Growth in research that deals with ecological questions such as what determines species distribution and abundance or environmental issues has amplified the use of biological-based collections. For example, research on old egg specimens showed that DDT was drastically reducing the reproductive success of certain bird species (Ratcliffe 1967, Hickey and Anderson 1968), leading to rising interest in its being banned as one of several conservation actions (Grier 1982). Some investigations on specimens can subsequently serve as environmental assessment monitoring tools. The story

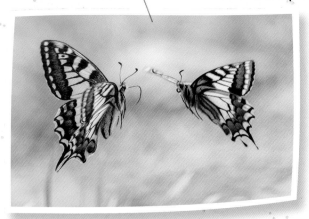

Papilio machaon britannicus Seitz, 1907

of the butterfly British Swallowtail, *Papilio machaon britannicus* is an illustration. Morphometric measurements of its museum specimens have revealed rapid modifications of the species size and shape characters (Dempster et al. 1976), supposed to be part of its responses as populations became isolated by habitat fragmentation and destruction (Collins et al. 2020). Schmitt et al. (2019) discussed the role of museum specimen investigations in documenting and revealing current issues such as the emergence of epizootic diseases, the spread of contaminants across time and space, the effects of environmental stresses on living organisms, and the effects of climate change. All of these highlight how important museum specimens are for documenting change and providing information that can be used to guide conservation actions.

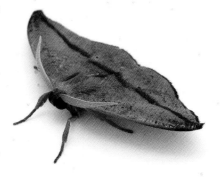

In Madagascar, papers published using museum-specimen associated data from various taxonomic groups related to conservation are significant. Most of them are related to distribution patterns, niche ecological modeling and the identification of important areas for conservation. We can cite the niche modeling of Tapia tree *Uapaca bojeri* (Werkmeister 2016), amphibians (Vieites et al. 2008), reptiles (Raxworthy et al. 2003, Pearson et al. 2007), some bat species (Lamb et al. 2012), birds (Chiatante 2022), and lemurs (Kamilar et al. 2016). All of them target identifying important areas for conservation and partly predicting the effect of climate changes on biodiversity. Once there was a need at the national level, associated data from museum specimens helped identify new protected areas in Madagascar to meet the country's international commitments announced at the 2003 5th World Parks Congress in Durban (Rasoavahiny et al. 2008). In fact, gap analysis using conservation planning tools is mainly based on individual point-locality data, and museum records have great potential to provide valuable informa-

tion, especially when coupled with models to predict species' ranges (Loiselle et al. 2003). This highlights the role associated data from museum specimens can play in nationwide conservation planning to identify priority areas for species and biodiversity conservation.

Genomics, DNA investigations

The improvements in genomic methods have changed the field of phylogenetics, in particular for sequencing ancient DNA or other degraded samples from museum specimens (Burrell et al. 2015). From a scientific standpoint, these new methods have accelerated the study of species genomes and genetic diversity between ancient and current populations, especially for rare species. In a common language, museum specimens can provide more details on the genetics of tissue samples stored at museums with the novel genomic protocols. One of the famous examples was related to the specimen of *Peromyscus mekisturus*, an endemic, rare, and supposed extinct species in Mexico referred to as *deer mice* (Osgood 1909, Carleton 1989). The use of new techniques, among them the next-generation sequencing technology (NGS) (REF), made possible the analysis of one specimen stored as a dry skin in 1947 (Castañeda-Rico et al. 2020). The results revealed that *Peromyscus mekisturus* is definitely a distinct species, highly separated from the other relative species. Therefore, species poorly known or likely extinct in the wild could still be studied through the use of museum specimen materials. In the western Indian Ocean islands, DNA investigations from subfossil remains collected three centuries ago and stored at museums have clarified biogeography and the local extirpation of giant tortoises, which revealed a new species extinct from Madagascar between 1,000 and 600 years ago (Kehlmaier et al. 2023).

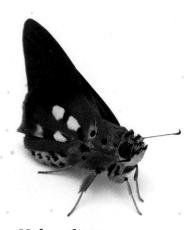

Malaza fastuosus, endemic skipper of Madagascar

Modern DNA investigations of an old type specimen from a museum collection led to a new taxonomic position as a member of a new subfamily of Hesperiidae (Zhang, J., Lees, D. C. et al., 2020). It was thought to be extinct but was found in Masoala in 2019 by the author.

From a conservation perspective, comparing genetic diversity and structure between populations collected in the past and their current populations can reveal potential causes that might explain their decline. Such historic genetic analysis can be applied to improve conservation strategies for decreasing populations (Wandeler et al. 2007). Adonis blue butterfly, *Polyommatus bellargus* (Lycaenidae) from the United Kingdom, is among the case studies in which Harper et al. (2006) found that genetic drift, local extinction, and recolonization explained the changes in the allele frequencies from 1896 to 1998–1999. Having historic information about habitat and genetic structure could permit identification of the factors and mechanisms accountable for the decline, thereby improving conservation strategies more adequately.

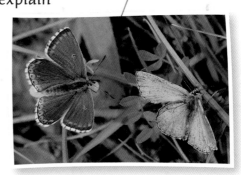

Courting pair of
Polyommatus bellargus
Photo: Charles J. Sharp,
commons.wikimedia.org

Conclusion

The utility of museum collections to the scientific community and general public has been highlighted. The importance of specimens for systematics, genomics, natural history, ecology, zoonoses, ecotoxicology, niche and distributional modeling, and so on were recognized for the development of our knowledge of nature but also for their conservation. Specimens are like archives for the biodiversity story of our planet and part of the proof that life evolves on Earth. Without them, the next generations risk ignoring what we did and why they encounter current diversity. The chronological records that relate past biodiversity and data to the present undoubtedly rank among the powerful tools that inform us about what trends there might be for our planet. It would be difficult to imagine anyone dismissing the value of museum collections for research, education, and training of the next generation of scientists.

How taxonomists identify species

Text by David Lees

The general reader may be curious how some of the specimens in the book can be confidently identified as the given scientific names. It is then necessary to explain a bit about museum collections, and the type specimens of each species.

Natural History Museums have differently colored labels on certain specimens that are the accepted reference basis of scientific names, ever since Linnaeus in 1758 called types. Such specimens are therefore called ‚types‘. When a species is described, the name either is based on a single specimen, or a series of specimens. The case of a single type specimen is the simplest case mentioned here. Usually, such specimens sport a red label on the top of the pin which clearly references the specimen in question as the 'holotype', or the primary type, i.e., the material point of reference for the original scientific name. When though the original author did not single out a particular specimen as the primary type, and when, as often is the case, the type labels are of different colors (or there may not yet even be such a label placed on the pin of a suspected type), the taxonomist's work becomes more complicated.

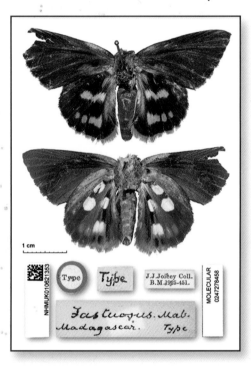

Holotype of *Trapezites fastuosus* (Mabille, 1884)
Picture: Courtesy Trustees of the Natural History Museum, London
Photo: N. Grishin

In the case of *Malaza fastuosus*, the holotype specimen indeed bears such a red label, and there is only one such specimen: it is unique. But it has an interesting history. The specimen was first described by Paul Mabille in 1878 as the female of another species, *Malaza empyreus* (at the time, he put in a different genus, Cyclopides). That means the described female also belongs to this name, and so to clarify the species concept, another kind of primary type, a 'lectotype', eventually needs to be designated. This is especially useful in such a case where more than one species might be involved (indeed, *Malaza* currently has three known species, two of them with crimson-red hindwings!). That would fix the meaning of *'empyreus'* to just the (smaller) male specimen that Mabille had described in 1878, and thus avoid any future confusion. Later, in 1884, Ma-

bille realized his mistake and named the larger, albeit incomplete specimen (it was lacking head, and an abdomen may have been added later) as a distinct genus and species, *Trapezites fastuosus*. This means that the holotype of the later species represents the correct and currently accepted name for the species, even though it was described twice. There are enough details such as crude wingspan dimensions in the original descriptions and from specimens that Mabille subsequently had painted for *Grandidier's Histoire physique, naturelle, et politique de Madagascar* (volume 19, available online in the Biodiversity Heritage Library) – and in the accompanying text volume 18 – to be sure that the broken specimen that is illustrated here (and that eventually had its fragmentary DNA sequenced and assembled into a whole mitochondrial genome), is indeed the holotype specimen of Mabille's *Trapezites fastuosus*. This underscores the importance for taxonomists to check the original description in verifying types, many of which are readily available to check online.

The taxonomists who helped identify the species in this work had only high-resolution pictures of live individuals to go on, since no specimens were collected. In many cases, moth specimens may rest in a very different way from how specimens of them are neatly spread out when conserved in museums, and thus overall shape is not the only clue. A good example of such unusual resting postures and the peculiar wing foldings (like those in Epipleminae) that was challenging for initial identification is the genus *Acremma*. But access to extensive museum collections of Madagascan Lepidoptera such as are held in London, Paris and Munich, or to digital images of the type specimens that are often available today on their data portals, has really helped make identifications in the book more accurate by facilitating the comparison of wing scale patterns. Along with primary works such as the extensive *Faune de Madagascar* series, more modern books with color plates, such as the Moths of Africa series, have proved particularly helpful in narrowing down the identifications to a family and then to a particular species, even if there was not time to double-check images of type specimens or original descriptions.

Species of *Acremma* in cryptic resting postures.

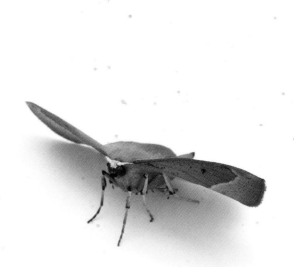
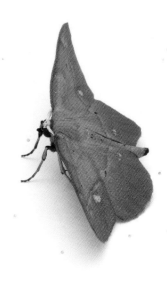
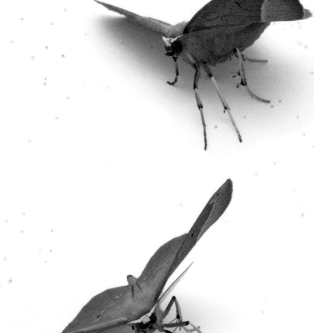

Excitingly, it is likely that some of the specimens illustrated represent species previously unknown to science (the term 'cf.' stands for the Latin 'confer' or 'compare against'). Such species will have to be searched for again in the field or in unsorted collections before they can finally be described. The above points really emphasize the synergistic scientific value of continuing natural history collections and of identifying photos of live specimens such as are available today e.g., on the iNaturalist platform.

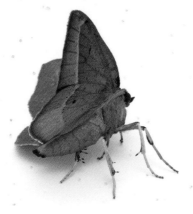
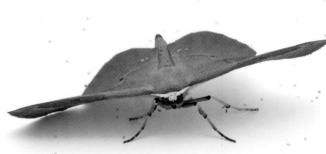

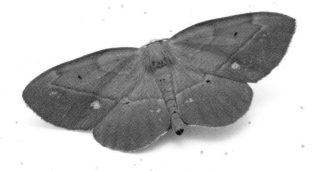

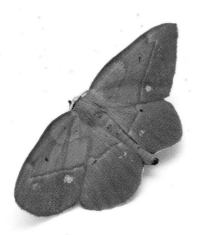

High-resolution pictures enable species identification in the wild

Each species in this book was photographed in a strict photo concept in the form of high-resolution photos from different angles and with its typical behavior in the wild. These views were sent to taxonomists to correct after the author's provisional identifications from AfroMoths, GBIF, iNaturalist and other online platforms showing live insects. The resolution of the images is high enough that they could be printed out in large format and used in a traveling exhibition or other media that help finance this expensive book project.

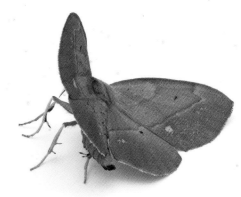

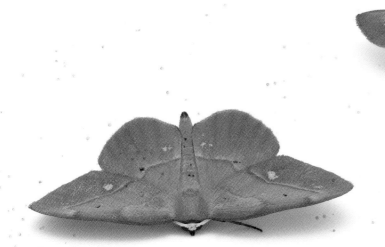

Save 50% of the world's biodiversity

Text by Dr. Martin Bauert

About the Wildlife Conservation Society (WCS)

Founded in 1895 as the New York Zoological Society, the Wildlife Conservation Society (WCS) was one of the first conservation organizations. The Society began with a clear mandate: Advance wildlife conservation, promote the study of zoology, and create first-class zoos to inspire visitors about the beauty of wildlife. In fact, WCS today still runs five living institutions in New York: the Bronx Zoo, Central Park Zoo, Queens Zoo, Prospect Park Zoo, and the New York Aquarium.

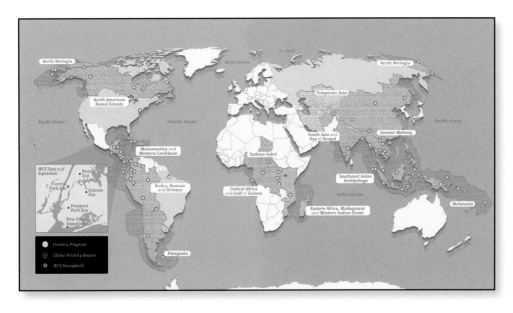

14 global priority regions to save the world's biodiversity.

WCS is committed to conserving 50% of the world's biodiversity

WCS's goal is to conserve the world's largest wild places in 14 priority regions, home to more than 50% of the world's biodiversity. The challenges are greater than ever, but with the focus, dedication, and passion of more than 4,000 committed staff – combined with a unique mixture of field, zoo, and aquarium expertise – WCS will continue to set the bar for science, conservation action, and education in protecting wildlife and wild places in more than 50 countries across the world.

There is no other organization in the world with a greater track record of results in conservation science, policy, and on-the-ground field work – or with a more talented, diverse team of people getting the hard work done every day, hand in hand with Indigenous Peoples, local communities, and governments. This makes WCS uniquely positioned to take on the biodiversity, climate, and zoonotic pandemic crises in this decisive decade for the planet.

WCS Madagascar Program in Partnership with Zoo Zurich and the Malagasy Government

The WCS Madagascar Program works throughout Madagascar to ensure the long-term conservation of the country's unique biological diversity with a focus on activities in the Masoala, Makira and the Antongil Bay landscape and seascapes.

Zoo Zurich and WCS have signed a long-term partnership to foster the protection and management of the Masoala National Park in close collaboration with Madagascar National Parks (MNP) and the Ministry of Environment and Sustainable Development of the Republic of Madagascar.

WCS's interventions are focused in the MaMaBay Landscape/Seascape – where WCS is the delegated manager of the Makira Park and the co-manager of the Masoala National Park. But WCS also works in the southwest and northwest of the country to support the management of a network of locally managed marine areas, environmental education, and community engagement, as well as research and conservation of marine mammals.

WCS achieves its outstanding conservation impact through terrestrial and marine protected area management, engagement with local communities to support them to become effective stewards of natural resources, environmental education, and a program of applied conservation science.

Sustainable wildlife management by integrated conservation

All rural families living in and around the Masoala National Park and the Makira Natural Park depend heavily on natural resources for their wellbeing. Though wild animals are seldom eaten they provide a very important source of micro-nutrients, particularly for growing children. Unfortunately, even when each hunter only takes a few wild animals each year, the very large number of people who live in the area means that hunting of most species is unsustainable. Lemurs are most at risk. These primates, which are only found in Madagascar, breed very slowly, and hunting is driving them to extinction.

To meet this challenge, the Sustainable Wildlife Management Program co-ordinated by WCS aims to improve the management of hunting and fishing by rural communities, and encourage the production and consumption of poultry and farmed fish. By doing so WCS ensures the sustainability of natural resource use, helps protect Madagascar's unique and irreplaceable wildlife heritage, and improves the food and income security of rural families.

The herpetologist Frank Glaw shows eggs of a chameleon to the team, Makira, 2022.
Photo: M. Bauert

Environmental Education and Community Health

WCS Madagascar has an integrated health and conservation education program that aims to empower local populations to build awareness, knowledge, and skills to sustain a healthy environment and assure human wellbeing. Through an innovative approach the program supports environmental education with schools through environmental activities that focus on the use of internet technology. WCS also help youth conservation clubs to address environmental issues through advocacy, practical environmental actions, and youth radio broadcasting, and supports media outreach through weekly radio-programming, magazine production, and yearly cultural and environmental festivals.

WCS's integrated health and nutrition program includes activities on youth reproductive health, healthy nutrition and linkages with landscape/seascape conservation. The Living Environmental Campus in Maroantsetra serves as a unique resource for WCS's education program and provides visitors – including communities, students, teachers, and government officers – with a central location for learning and decision-making.

Science-based conservation approach

WCS is committed to science-based conservation and research activities that focus on the presence of and threats to the emblematic Silky Sifaka, Red Ruffed lemurs and Indri lemurs, the drivers of bushmeat hunting by local communities in Makira Natural Park and Masoala National Park, the status of endemic carnivore species, optimization of connectivity between marine protected areas, and threats and conservation strategies for sharks, rays, and dugongs.

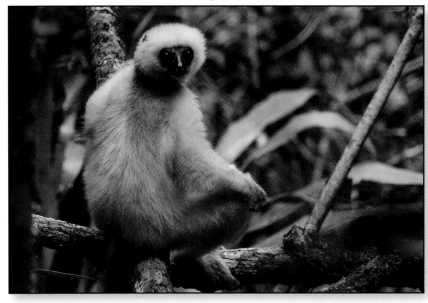

A curious Silky Sifaka observes the team, Simpona Lodge, Antsahabe, Makira, 2019.
Photo: M. Bauert

Online Biodiversity Database: REBIOMA

Rebioma (http://www.rebioma.net) – Madagascar Biodiversity Network – is a web-based tool developed by WCS that aims to promote the use of biodiversity data in conservation and spatial planning, including in climate change analyses. The Rebioma project was established in 2000 and it places a strong emphasis on science-based conservation action and on training Malagasy conservation biologists and professionals. It is an initiative that centralizes biodiversity data in Madagascar and allows a wide range of users to freely access and analyze that data to inform conservation decision-making and spatial planning. Prior to the creation of Rebioma, no common biodiversity database existed in Madagascar despite the exceptional and unique biodiversity that is found in the country.

Rebioma was set up in order to provide open access to trusted and reliable data. Working with the specially created Taxonomy Review Board (TRB), which reviews every database record, Rebioma has assembled marine and

terrestrial taxonomic lists and built the online infrastructure needed to discover, use, and publish high-quality biodiversity data.

Over the last ten years, Rebioma has gained recognition as a leader in major national and regional biodiversity planning and conservation projects. Its major technical achievements include its support in the identification of more than 4 million hectares of terrestrial protected areas in Madagascar through science-based analyses to contribute to the fulfillment of Madagascar's 2003 "Durban Vision".

SMART (Spatial Monitoring and Reporting Tool)

In 2013 WCS initiated training on the use of the Spatial Monitoring And Reporting Tool (SMART) throughout Madagascar, with a focus on nine high-risk terrestrial-protected areas: Makira and Andasibe Mantadia parks, the Tsaratanana Reserve, and the six parks that comprise the Rainforests of the Atsinanana World Heritage Site, namely Masoala, Marojejy-Anjanaharibe Sud, Zahamena, Ranomafana, Andringitra, and Andohahela National Parks. Following this successful piloting of SMART, it has been adopted by Madagascar National Parks and the Ministry of Environment, Ecology and Forests as the national Law Enforcement Monitoring (LEM) tool for Madagascar.

SMART is a key part of the successful law enforcement and threats monitoring (LEM) system. It has the ability to improve the effectiveness of wildlife law enforcement patrols and site-based conservation activities.

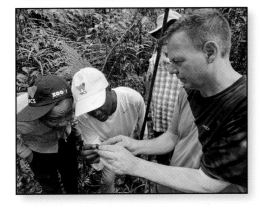

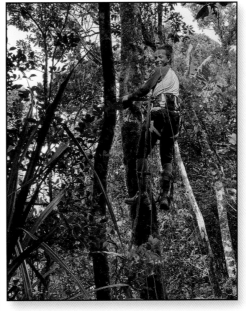

Discussion of the situation in camp after evening meal, between Antonio (WCS Regional Director), Martin (Zoo Zurich) and biologist and tree-climber Hasina.

Dr. Frank Glaw in class with two students. Photos: Edi Day

Lots of action and good planning: out on expedition with the WCS

In 2022 the editor had the good fortune to be able to join an exploratory expedition led by the herpetologist Dr. Frank Glaw to the Simpona Lodge in Makira. The light trapping in Makira added substantially to the list of Lepidoptera species observed in Masoala. During the expedition the organizational skills of the WCS were demonstrated – this is a group that is very familiar with the localities and fosters good relationships with the people of the region. They in turn participate by assisting either as porters, cooks, guides, or future scientists. And they at the same time become familiar with their own natural world in an especially intensive way. Reinforced by the great interest shown by the researchers, they understand and cherish the value of keeping intact their own forest environment.

Happy Guides - successful field researcher

As beautiful and intensive an experience as it certainly was to have abandoned myself, alone, to the rainforest and its breathtaking diversity, my fieldwork was still further enriched through contact with the local guides. This brought me great joy and some wonderful experiences. At all times I had the feeling that I was under their escort, being providentially watched over by them – but at the same time being given enough space, support, and freedom to do my work at the light traps each night. Eric was also always there to reassure me when I was having a bad time of it because of health issues – a high fever that lasted for days on end, hundreds of insect bites, and abrasions caused by rocks and thorny plants all sapped much of my energy. To strengthen me Eric brought avocados of various different colors to my hut with precise instructions as to when each one would ripen and had to be eaten. Even during my bouts of fever, I could tell that he came by regularly to check up on me. But I couldn't speak to him to thank him for it. He had my back – I was not alone. With Ursula I shared the good fortune of capturing a comet moth in Makira, and each afternoon for 2–3 hours I walked with Eric slowly and in perfect silence through the Masoala Rainforest looking for animals of all kinds. Without actually speaking we communicated a lot to each other and had a good understanding. One unforgettable moment was when I had to swear an oath of disclosure on the beach at sunset. When I first arrived at the Masoala Station, I presented to everybody there my idea of attracting moths at night and photographing them. In my clumsy French I described myself as an "artiste". The following evening the whole staff gathered on the beach at sunset and I was invited to come. Someone fished out a guitar and handed it to me with the expectation that, since I was an "artiste", I would be able to give them a sample demonstration of who I was. But the thing is, I can't even read a single note of music! This was then followed by loud laughter as well as with even more beads of sweat on my brow on what was already a very clammy evening.

My guides Ursula and Eric
After just a few attendances at the light trap in Makira, Ursula could already identify many moths and assign them to their respective families. Eric was my 'good genie' during my stays in Masoala. My every wish was his command. With his machete he would build a stable framework for my light trap set-up in a matter of minutes, no matter where or when. It was amazing to see how he went about doing this, staying spotlessly clean, with not a drop of sweat to be seen, and moving light as a feather, barefoot, without getting stung or injuring himself.

Mentors and authors

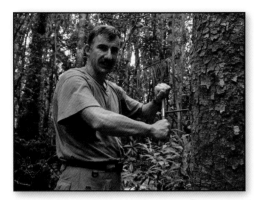

Dr. Martin Bauert

Martin Bauert, 58, grew up in Zurich and earned his doctorate from the University of Zurich with a research project on the genetic diversity and reproductive strategy of arctic-alpine plants. In 2002 he joined the Zoo Zurich with the task of set-

ting up the operating of the Masoala Rainforest, a greenhouse spanning over one hectare and over 30 meters high, inaugurated in 2003 for the public. The integration of diverse animal species into the still young forest and the biological control of insects were the first major challenges. Since then, the Masoala Rainforest has become an authentic ambassador for the then unknown Masoala National Park in Madagascar. Dr. Bauert is also responsible for the partnership that the Zoo Zurich has established with the Masoala National Park and the Malagasy Government. Today, he serves as the Head of Conservation overseeing all eight major nature conservation partnerships of the Zoo Zurich, located on all continents.

"I am fascinated anew by the animals, plants, and landscapes every time I visit Madagascar. I am also impressed by the people who live outside the cities under very basic conditions and are always friendly and very helpful. Deforestation in Madagascar is not driven by the greed of companies for wood or land concessions, but by shifting cultivation by small-scale farmers who provide their families with rice. Unfortunately, "tavy," as the shifting cultivation of rice on cleared forest land is called, is very destructive for the thin fertile soil layer. To protect the biodiversity of the remaining forests in Madagascar, the rural population needs alternatives to practicing tavy. Helping to develop and implement practical alternatives that are gratefully received by the population is both challenging and enriching. It is a great privilege of my work to support young Malagasy researchers and bring them into direct exchange with internationally leading scientists. It is also rewarding to work on documenting the biodiversity of Madagascar, which is still largely unexplored in many areas."

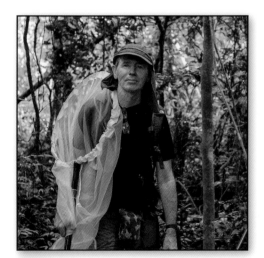

Dr. David Lees

David Lees is a Senior Curator at the Natural History Museum London (NHMUK) responsible for the Microlepidoptera collections. He has visited Madagascar around 20 times and is a specialist on the butterfly and moth fauna. He has a particular interest in Lepidoptera systematics, biogeography and evolution as well as conser-

vation. He has published over 150 scientific papers with high scientific and popular impact. These include studies on such iconic moths as *Xanthopan praedicta* and *Hemiceratoides hieroglyphica* and he recently coauthored a popular book on moths worldwide (Lees and Zilli, 2021).

"Madagascar's fauna and flora have such a magical allure that once you have visited you may always want to return. My thesis and early fieldwork focused on the butterflies and moths of the rich Antongil Bay rainforests of Masoala and Makira and it is simply a delight to be involved in such a vividly illustrated book on their living Lepidoptera fauna".

Consultant and editor

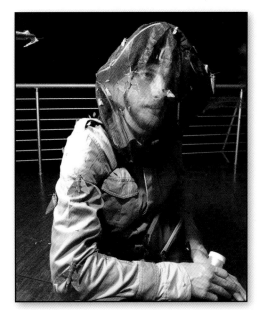

Marcin Wiorek MSc

Marcin Wiorek is a final-year PhD candidate and researcher at the Institute of Systematics and Evolution of Animals at the Polish Academy of Sciences in Cracow, Poland. He started his adventure with insects by studying weevils as a biology student at the Jagiellonian University in Cracow, graduating in 2019. Currently he is interested in the taxonomy, phylogeny, biogeography and ecology of tropical tiger moths. His adventure with Madagascar moths began in 2020 with a research expedition with Dr. Łukasz Przybyłowicz and Dr. David Lees. In colllaboration with them he is realizing a project on the phylogeny and biogeography of a unique and amazing group of Madagascan moths, namely around 100 endemic species of polka-dot moths (Syntomini). They have already published a couple of papers on these moths.

"My research trip to Madagascar in 2019 also happened to be my first visit to the tropics. Staying for a couple of weeks in Kirindy, Ranomafana and Ambohitantely was an exciting way to experience the overwhelming diversity of the Madagascan forests. However, it was not the magnificent rainforest of Eastern Madagascar with its mysterious grandeur that fascinated me the most. Instead, it was a number of forest fragments scattered somewhere in the endless grasslands of the Central Plateau: the Ambohitantely Special Reserve – one of the last remnant forests of that area. For me, this forest is "Madagascar in a nutshell" with its diversity and high local endemism, including for moths. Thus, I was genuinely saddened to learn in spring 2023 that a large area of this forest had simply burned down in the previous months. In my opinion, protection of these last-remaining forest fragments in the Central Plateau should be the priority in order to preserve the biodiversity of Madagascar's forests."

Editor

Armin Dett

Armin Dett, year 1966, is a designer who for the past 34 years has been self-employed, with a design studio in the city of Konstanz on Lake Constance, southern Germany. His work focuses mainly on exhibition design for museums (scenography), illustration, and educational nature-trail design. He has won several international design awards and spent 18 years teaching graphic design as a lecturer. "Eyes of Masoala" is his third self-commissioned book on moths. He collected the respective data in the field and designed both concept and book in the spirit of a private citizen science project. The work on this book took roughly five years to complete.

"At the light traps and on my forays into Madagascar's rainforests, I felt fully alive and with a sense of living each moment in both space and time. Their beauty and diversity are infinitely fascinating – they were my inspiration and fed my hunger for knowledge. I hope that this book will in turn inspire many others to go out into nature and observe – that it will stimulate research and will also argue visually and emotionally in favor of nature conservation. It is meant to deservedly highlight those Madagascar species which tend to receive less publicity. My vision is the establishment of extensive butterfly sanctuaries in Madagascar's breathtakingly beautiful wilderness before the spectacular diversity of its species is destroyed by population growth and climate change."

Authors

Dr. Axel Hausmann

Axel Hausmann is curator at the Bavarian State Collection of Munich (SNSB–ZSM) with research focus on the systematics of Geometridae and on DNA barcoding. He published several hundreds of scientific papers, in the last 20 years more and more focused on the fauna of the Afrotropical region. As a curator he is responsible for the famous collection of Claude Herbulot (1908–2006) which is one of the collections worldwide with the best coverage of Geometridae from Madagascar.

To access Alex Hausmann's publications see: https://zsm.snsb.de/sektion-mitarbeiter/dr-axel-hausmann/publikationen/?lang=en

"It happened repeatedly that I had to check a type locality of a geometrid moth from Madagascar (i.e. the site where the original voucher from the first description had been collected) and from Google Earth I received the sad information that the original forest is no longer present at this site; we urgently need to stop the extinction of so many species!"

Dr. Roland Hilgartner

Roland Hilgartner is primatologist, author and professional photographer. He is director at Affenberg Salem, Germany's largest monkey enclosure. His passion for tropical forests has led him to all significant tropical rainforests of the world (Amazon, Congo, Madagascar, South-East Asia and Papua). Taking all his field stays in Madagascar into account, Hilgartner has spent nearly three years in Madagascar's forests. He has done extensive research on lemurs and described three new lemur species in cooperation with an international research team. However, his most spectacular discovery was with moths. In Madagascar he observed and photographed for the first time a tear-drinking moth that specializes in drinking the tears of birds. His discoveries and spectacular photos can be also admired in his most recent book published in National Geographic Germany "Das Geheimnis der Tränentrinker". For more info: instagram: roland_hilgartner, www.rolandhilgartner.com

"It is a great honor to contribute to such an amazingly illustrated book that gives spectacular insights into Madagascar's treasures and breathtaking biodiversity. Every day and every night that you go out to explore Madagascar's forests you need to be prepared for the unexpected."

Authors

Dr. Rodolphe Rougerie

Rodolphe Rougerie is a researcher and curator for Lepidoptera at the Muséum national d'Histoire Naturelle (MNHN) in Paris, an institution hosting one of the largest collections of Malagasy moths. His research focuses on the evolutionary dynamics and macroecological patterns of species diversity in wild silkmoths (Saturniidae) and hawkmoths (Sphingidae), building on the use of phylogenomics and large-scale databases of species diversity, distribution and traits. He is also involved in the development of DNA-based species identification (DNA barcoding) and its applications (e.g., metabarcoding for biosurveillance) in Lepidoptera and other organisms.

"I started studying the diversity of Madagascan saturniid moths while doing my PhD thesis at MNHN in the early 2000s. It was one of my first experiences with taxonomy and with the discovery and description of new species, made possible by the richness of collections constituted decades before that. This emphasizes the importance of natural history collections as an invaluable resource for our knowledge of Earth's biodiversity.

In 2016, I was lucky to observe some of these species in the field in Madagascar, in the extraordinary landscapes of the Tsingy of Namoroka. What a striking highlight of the uniqueness of the environments in Madagascar, and of the richness of its fauna and flora! Unfortunately, the ravaged surroundings were also a saddening reminder of the fragility of Nature and of how urgent it is to stop its destruction."

Dr. Alexander Schintlmeister

Alexander Schintlmeister earned his doctorate in 1987 from the Humboldt-University, Berlin, on the biogeography and evolution of Notodontidae. He is the author of 14 books and more than 100 scientific papers dealing with Notodontidae worldwide. Numerous expeditions have taken Schintlmeister to almost every country in Asia, to Brazil, and to many African countries. In this way he has built one of the largest collections of Prominent moths.

"Through decades of research including numerous expeditions to Madagascar by the Muséum National d'Histoire Naturelle, Paris (Pierre Viette, Paul Griveaud, Joel Minet and others) and Paul Dubief (collection now in the Muséum d'histoire naturelle de la Ville de Genève) in central Madagascar, the notodontids fauna of this region is fairly well documented. It was therefore all the more surprising for me that Armin Dett's photos of notodontids from the Masaola Peninsula show some species new to science that have yet to be described."

Authors

Dr. Frank Glaw

Frank Glaw (born 1966 in Düsseldorf, Germany) has been fascinated by amphibians and reptiles since early childhood. He studied biology at the University of Cologne and moved after his diploma to the Museum Koenig / University of Bonn where he received his PhD. Since 1997 he has been curator of herpetology at the Bavarian State Collection of Zoology in Munich, Germany (ZSM–SNSB).

During his first trip to Madagascar in 1987 he walked across the Masoala peninsula from Maroantsetra to Antalaha and noticed how little was known about the herpetofauna of this country. Together with Miguel Vences he published a field guide to the amphibians and reptiles of Madagascar (1992, 1994, 2007). So far, he has made 26 field trips to Madagascar and described more than 300 new species of amphibians and reptiles in collaboration with colleagues.

"When I started my research in Madagascar, a highly influential paper had been published by Green & Sussman (1990) in the renowned journal Science. This study compared aerial photographs and satellite images and found that the extent of Malagasy rainforest had decreased by 50% in 35 years, from 7.6 million hectares in 1950 to 3.8 million hectares in 1985. The authors suggested that if cutting of forest continues at the same pace, only forest on the steepest slopes will survive by 2020. Fortunately, this study was too pessimistic: Now, in the year 2023 some larger rainforest areas including Masoala and Makira still exist as protected areas despite poverty, political crises, an enormous increase of human population, and many other problems in the last decades. For me this is one of several reasons to hope that the rainforests of Madagascar with their unique biodiversity can be protected and will continue to survive in future."

Moritz Grubenmann

Moritz Grubenmann was born in Zurich in 1952. He went to school there and later graduated from the University of Zurich as a microbiological laboratory technician. He is the co-founder of "Laborgemeinschaft 1", a medical diagnostics laboratory in Zurich. He has been retired since April 2017.

Until 2014 M. Grubenmann was Vice President of the Association in Support of the Zurich Succulents Collection, one of the largest special collections in the world. Since his retirement from the board, he has been an Honorary Member of the Association. He is a board member of the "Friends of Masoala" Association, which is a partner organization of the Zoo Zurich for the protection of the Masoala Peninsula. For more than 30 years he has been a member of the Zurich Society of Natural Sciences and the Zurich Entomological Society.

"In 1983 I visited Madagascar for the first time and ever since the trip the nature of that large island has fascinated me. My first encounter with the southern thornforest and the totally unfamiliar plants has remained unforgettable to this very day.

The island of Madagascar is the textbook example of an isolated habitat with many endemic plants and animals. Different vegetation and climate zones exist on this mini-continent: dry forests in the west and southwest, spiny thickets of euphorbia/didierea in the south, and rainforests on the island's eastern slopes. A trip to Madagascar leaves behind each time a new indelible impression.

Research (...and surveying) of plants and animals is the cornerstone of nature conservation: Only what we know and understand can we protect."

Authors

Dr. Aristide Andrianarimisa

Malagasy researcher involved in landscape ecology, conservation technology, ornithology, and zoology. I have worked to improve protected areas and conservation practices in developing countries hotspots like Madagascar by implementing technology-based conservation tools for evidence-based conservation practices in order to improve the decision-making efficiency of managers of protected areas. As University Professor, I have been involved in various subjects related to conservation biology, climate change, functional ecology, ecological modeling, marine science, etc. I have enjoyed an accomplished and rich professional life with more than 20 years of hands-on experience in conservation science with international NGOs as a senior staff member.

"Birds have always fascinated me from an early age because they have such radiant colors. It has often occurred to me during my career as an ornithologist that color and pattern reach their extreme apogee in birds and butterflies. No doubt about it! Usually, I spend most of my time answering the questions, why this color and what good will it do these animals? Living in a hotspot country like Madagascar where everything is almost unique is a blessing which I like to share whenever the opportunity arises. That's why I never hesitate to contribute to any effort to raise awareness of the biodiversity of this beautiful country, the land of my ancestors, Madagascar, and to help preserve this unique biodiversity."

Lovy Rasolofomanana

I am an economist by training but have worked mainly for social development in Mali and Madagascar for the last 30 years. I have been involved in a wide range of activities including education, health, microcredit, employment training, habitat, infrastructures, land tenure and conservation.

I have been the Country Director for the Wildlife Conservation Society in Madagascar for the last four years. My work is focused on saving wildlife and wild places worldwide and particularly those in Madagascar. I am contributing towards reducing the threats to biodiversity and ensuring that populations of key species (threatened and locally endemic species, as well other conservation targets) remain stable or increase in protected areas managed by the Wildlife Conservation Society, and that the status of important habitats stabilizes or improves.

"I was born and raised just a few kilometers from Andasibe-Mantadia National Park. That's why I'm so passionate about nature, especially tropical forests. The flora and fauna of these forests have always attracted me. Later, I became very interested in flowers and butterflies because of their colors. My work at WCS has enabled me to get closer to nature again and to focus on key species such as lemurs, birds, chameleons, marine mammals, and butterflies."

Author and translator

Thomas Bucheli

Grew up in Hitzkirch/ LU. After graduating with a high school diploma (Matura), studied Geography at ETH Zurich, graduating in 1988 with a degree in Meteorology, Climatology and Atmospheric Physics. 1988– 94, meteorologist at Meteo-Swiss, the Federal Office of Meteorology and Climatology; 1994/95, at the private weather company Meteomedia AG. Beginning in 1992, working also part-time as moderator for 'Meteo', a new program at that time on Swiss Radio and Television SRF. Transfer in 1995 to SRF and participation in establishing the editorial department, and, since then, head of SRF's editorial team, now consisting of 16 members. Hobbies: reading & travel. Part-time work worldwide serving as scientific editor for the travel company 'Background Tours'.

"A trip to Madagascar has been a great dream of mine since boyhood. It was not fulfilled until 2013, but it happened under the expert leadership of Moritz Grubenmann, an acknowledged connoisseur of the unique flora and fauna of that island. I was awestruck – and for the first time I regretted not having kept up my knowledge of biology after my initial basic studies. But at least I did receive a further refresher course from Martin Bauert on my next trip to Madagascar in 2023. More is needed, however, before I can adequately interlink my knowledge of weather and climate with the entirety of the natural world of Madagascar. I'll keep working on it."

Paul Gerard Pickering

Paul was born in Rotherham, England. He began his professional life working as a technical translator/interpreter in Bradford, England. He subsequently taught English as a Foreign Language in France, Spain, the United States and Costa Rica but spent almost 30 years teaching German, Spanish and French, mostly to older high-school students, in Texas and California. After living for 15 years in Costa Rica Paul is currently back in England working independently as a translator. He has also worked in English, Spanish, French and German as the adaptor for several publications of the French language textbook company Assimil.

"I strongly believe that every language is the chief bearer of its respective culture and that to have some knowledge of a foreign language is the best way to appreciate other countries and their people. I have never been to Madagascar and have had no formal training in the natural sciences. I have nonetheless always maintained a keen interest in the natural world. This was much reinforced during my years in Costa Rica where I had the privilege of helping Armin Dett with the preparation of his earlier book Moths of Costa Rica's Rainforest. Madagascar is another of those "faraway places with strange-sounding names" that so fascinated me as a boy. I'll be there one day."

Cordial thanks!

Maria and Pierre, founders of Masoala Forest Lodge (in white shirts), promoted this book project.

Maria and Pierre Bester

Masoala Forest Lodge is a seven-bungalow eco-lodge in Masoala, Madagascar, one of the remotest and most preserved places in the world, a hotspot of biodiversity, and home to many endemic species that are under threat. The vision of the lodge is to conserve the forest and animals and support the local communities. With over 50 staff employed from the surrounding villages, Masoala Forest Lodge is the biggest employer on the Masoala peninsula. They have a reforestation project and support and encourage projects and research on their premises that follow conservational interests.

Photos: Masoala Forest Lodge

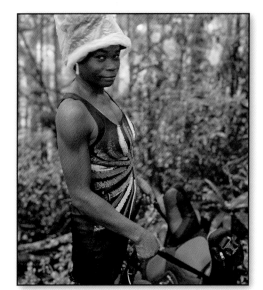

Photos: Edi Day

Simpona Ecolodge, Antsahabe and the village of Andaparaty

Despite weeks of heavy rainfall, good meals were cooked for me and I was well provisioned by the hard-working women of the adjacent village of Andaparaty. What for me were difficult adverse conditions, i.e., heavy backpack, slippery paths, perpetually damp laundry, shoes covered with mold, downpours of unrelenting rain, sudden hot spells, insect bites, etc. – were for them normal daily life, which they handled with ease and grace.

It was a very special experience to discuss the daily and nightly discoveries with my traveling companions Edi Day, Moritz Grubenmann and Frank Glaw, as well as to learn from them about photography and the rainforest. I would love to return one day to Simpona and do further research on Lepidoptera. Hopefully with the same team!

Species list Masoala [2019]*, Makira [2022]**, Masoala+Makira [2022]***, Masoala [2022]****

Abakabaka phasiana (Butler, 1882)	324	**
Aburina dufayi Viette, 1979	278	**
Achaea catella Guenée, 1852	314	**
Achaea cf. *faber* Holland, 1894	314	*
Achaea cuprizonea (Hampson, 1913)	314	**
Achaea dejeanii (Boisduval, 1833)	315	*
Achaea euryplaga (Hampson, 1913)	315	**
Achaea oedipodina Mabille, 1879	314	*
Acherontia atropos (Linnaeus, 1758)	67, 176–179	***
Acontia gloriosa (Kenrick, 1917)	341	***
Acontia viettei Hacker, 2010	341, 24/25	**
Acosmetoptera sogai (De Lajonquière, 1970)	199	**
Acosmetoptera sp. de Lajonquière, 1972	197	*
Acracona pratti (Kenrick, 1917)	112	**
Acremma axerina (Viette, 1988)	298	*
Acremma neona (Viette, 1962)	298	*
Acremma sp. Berio, 1959	298, 299	***
Acremma sp. near *ingens* (Viette, 1968)	298	***
Acremma sp. near *thyridoides* (Kenrick, 1917)	298, 299	*
Acremma thyridoides (Kenrick, 1917)	298, 299	*
Acripia megalesia Viette, 1965	278, 280	**
Acroctena fissura Saalmüller, 1884	264	**
Acroctena pallida (Butler, 1882)	66, 264	**
Agathia malgassa Herbulot, 1978	230	*
Agrioglypta toulgoetalis (Marion, 1954)	114	**
Ambina ochreopicta (Kenrick, 1917)	266	*
Ambina spissicornis (Mabille, 1899)	265	*
Andrianam poinimerina Viette, 1954	300	**
Androlymnia malgassica Viette, 1965	342	***
Anoba malagasy Viette, 1970	278	***
Anomis alluaudi Viette, 1965	316	**
Anomis simulatrix (Walker, 1865)	316	*
Antherina suraka (Boisduval, 1833)	127, 141–143, 152–158	***
Antitrygodes dentilinea Warren, 1897	226	**
Apatelopteryx deceptrix (Kenrick, 1914)	196, 203	*
Archichlora catalai Herbulot, 1954	207, 230	***
Archichlora cf. *chariessa* Prout, 1925	231	**
Archichlora cf. *engenes* Prout, 1922	208, 231	***
Archichlora cf. *malgassa*	230	*
Archichlora cf. *nigricosta* (Herbulot, 1960)	231	*
Archichlora cf. *stellicincta* (Herbulot, 1972)	234	*
Archichlora hemistrigata (Mabille, 1900)	232	***
Archichlora trygodes Prout, 1922	205, 233	***
Archichlora Warren, 1898	230	*
Argema mittrei (Guérin-Méneville, 1847)	135, 138	**
Argyphia arcifera (Mabille, 1881)	307	**
Argyrolopha trisignata (Mabille, 1900)	300	*
Asota borbonica (Boisduval, 1833)	274–277	***
Athetis sp. Hübner, 1821	343	**
Audea agrotidea (Mabille, 1880)	280, 316	***
Avitta cf. *lineosa* (Saalmüller, 1891)	302	*
Banisia myrsusalis (Walker, 1859)	103	**
Batocnema coquerelii (Boisduval, [1875])	180	*
Bertula sandrangato Viette, 1961	300	*
Blechroneromia herbuloti Viette, 1976	236	*
Blechroneromia malagasy Viette, 1976	237	**
Blenina near *hyblaeoides* Kenrick, 1917	336–337	*
Bocchoris inspersalis (Zeller, 1852)	114	*
Borocera cajani Vinson, 1863	195, 198, 202	*
Botyodes andrinalis Viette, 1958	114	**
Botyodes asialis Guenée, 1854	114	**
Brachychira cf. *destituta* Kiriakoff, 1966	268	**
Brithys crini (Fabricius, 1775)	343	*
Bunaea aslauga Kirby, 1877	57, 137, 140	***
Cabera cf. *cadoreli* Herbulot, 2001	215	**
Cacyreus darius (Mabille, 1877)	75	***
Caligatus splendidissima (Viette, 1958)	244, 334–335	*
Calligraphidia tessellata (Kenrick, 1917)	309	*
Callopistria cf. *miranda* (Saalmüller, 1880)	343	*
Callopizoma malgassica (Kenrick, 1914)	193, 200–201	*
Campydelta stolifera (Saalmüller, 1891)	343	***
Cautatha cf. *coenogramma* (Mabille, 1900)	300	*
Chiasmia crassilembaria (Mabille, 1880)	214	*
Chiasmia simplicilinea (Warren, 1905)	214	***
Chiasmia sp. Hübner, 1823	214	*
Chilades pandava (Horsfield, [1829])	75, 85	*
Chiromachla insulare (Boisduval, 1833)	283, 288–289	***
Chlorocalliope antongilensis (Viette, 1955)	261	*
Chlorocalliope dubiefae (Viette, 1978)	253, 255, 259	*
Chlorocalliope grandidieranum (Viette, 1954)	259, 261, 263	*
Chrysiridia rhipheus (Drury, 1773)	209, 210–213	***
Chrysocraspeda cf. *erythraria* (Mabille, 1893)	226	**
Chrysocraspeda tantale (Viette, 1970)	226	**
Chrysodeixis chalcites (Esper, 1798)	245, 339, 342	***
Chrysotypus cupreus Kenrick, 1914	103	**
Cirrhochrista cygnalis Pagenstecher, 1907	114	***
Claterna ochreoplaga Viette, 1966	302	*
Claterna sp. near *berioi* Viette, 1954	302	**
Claterna sp. Walker, 1858	302	**
Claterna sparsipuncta Viette, 1966	302	**
Cleora cf. *macracantha* (Herbulot, 1955)	215	*
Cleora legrasi (Herbulot, 1955)	215, 270	***
Clostera albidilinea (Gaede, 1928)	268	*
Clostera pratti (Kenrick, 1917)	268	*
Closterothrix near *leonina* (Butler, 1882)	196	*
Clupeosoma sp. near *orientalalis* (Viette, 1954)	113	**
Coelonia insularis Basquin, 2021	186, 188	**
Coelonia solani (Boisduval, 1833)	187	****
Coelophoris sogai Viette, 1965	302	**
Collenettema sp. Griveaud, 1977	325	*
Comibaena leucochloraria (Mabille, 1880)	234	***
Comibaena punctaria (Swinhoe, 1904)	234	***
Comostolopsis rufocellata (Mabille, 1900)	235	***
Comostolopsis stillata (Felder & Rogenhoffer, 1875)	235	**
Coptobasoides pauliani (Marion, 1955)	115	*
Corgatha falcigera (Berio, 1959)	300	*
Corgatha fissilinea (Hampson, 1910)	301	**
Corgatha latifera (Walker, 1869)	301	**

Corgatha zotica (Viette, 1956)	300	**
Cossidae sp. Leach, 1815	87	**
Cyana amatura (Walker, 1863)	294	*
Cyclophora metamorpha (Prout, 1925)	226	*
Cyligramma disturbans (Walker, 1858)	317	***
Cyligramma joa Boisduval, 1833	317	*
Daphnis kitchingi Haxaire & Melichar, 2011	126, 161, 166	*
Desmeocraera robustior Kiriakoff, 1960	251	*
Detoulgoetia virginalis (Butler, 1878)	285, 286–287	*
Diaphania indica (Saunders, 1851)	115	**
Drepanogynis alina Viette, 1980	216	**
Drepanogynis alternans Herbulot, 1960	216	**
Drepanogynis near *hiaraka* (Viette, 1968)	216	***
Drepanogynis purpurescens Herbulot, 1954	216	*
Drepanogynis sp. Boisduval & Guenée, 1857	216	*
Dryochlora cinctuta (Saalmüller, 1891)	236	*
Earias biplaga Walker, 1866	340	*
Ectropis basalis Herbulot, 1981	218	***
Ectropis sp. ['perineti Herbulot']	218	*
Ectropis sublutea (Butler, 1880)	218	***
Eilema argentea (Butler, 1878)	295	**
Eilema hybrida Toulgoët, 1957	295	**
Eilema kingdoni (Butler, 1877)	295	***
Eilema marginata (Guérin-Méneville, 1844)	297	*
Eilema recticosta Toulgoët, 1956	295	**
Eilema sp. near *laurenconi* Toulgoët, 1976	295	**
Elaphrodes simplex (Viette, 1955)	269, 42	**
Eois cf. *grataria* (Walker, 1861)	208, 242	*
Eoophyla sp. C. Swinhoe, 1900	110, 111	**
Epigelasma cf. *disjuncta* Herbulot, 1972	237	*
Epigelasma olsoufieffi Herbulot, 1972	237	**
Epigynopteryx colligata (Saalmüller, 1891)	217	*
Epigynopteryx glycera Prout L. B., 1934	218	**
Epiplema cf. *anomala* Janse, 1932	209	***
Episparis malagasy Viette, 1966	313	*
Episparis vitrea (Saalmüller, 1891)	281, 313	*
Erastria madecassaria (Boisduval, 1833)	206, 219	***
Erebus walkeri (Butler, 1875)	1, 272, 317	**
Ericeia inangulata (Guenée, 1852)	318	***
Eublarginea argentifera Berio, 1966	341	*
Euchloron megaera lacordairei (Boisduval, 1833)	167	***
Euchromia folletii (Guérin-Méniville, 1832)	290–293	*
Eudasychira ampliata (Butler, 1878)	66, 324, 326–327	**
Eudasychira aurantiaca (Kenrick, 1914)	329	*
Eudasychira diaereta (Collenette, 1959)	324	*
Eudocima boseae (Saalmüller, 1880)	245, 303–305	**
Eudocima imperator (Guérin-Méneville, 1832)	303–305	**
Eudocima phalonia (Linnaeus, 1763)	303–305	**
Eupagopteryx affinis (Aurivillius, 1909)	199	*
Euphyciodes albotessulalis (Mabille, 1900)	115	**
Euproctis ochrea (Butler, 1878)	324	**
Eurema floricola (Boisduval, 1833)	74	**
Europtera punctillata (Saalmüller, 1884)	199	**
Fodina decussis (Saalmüller, 1891)	306	***
Fodina hayesi Viette, 1981	306	*
Fodina insignis (Butler, 1880)	306, 307	**
Fodina laurentensis Viette, 1966	306	*
Fodina madagascariensis Viette, 1966	306	*
Fodina vieui Viette, 1966	306	**
Fodinoidea rectifascia Collenette, 1930	284	**
Fulda rhadama (Boisduval, 1833)	74	**
Ghesquierellana hirtusalis (Walker, 1859)	115	****
Ghesquierellana sp. Berger, 1955	115	**
Glyphodes paramicalis Kenrick, 1917	116	*
Glyphodes shafferorum Viette, 1987	116	***
Glyphodes sp. Guenée, 1854	114	*
Grammodes bifasciata (Petagna, 1787)	318	*
Graphium cyrnus (Bosiduval, 1836)	71, 73, 74	**
Gynoeryx meander (Boisduval, 1875)	182	***
Hemiceratoides hierogyphica (Saalmüller, 1891)	[collection] 247	
Hemiceratoides vadoni (Viette, 1976)	[collection] 249	
Herbulotiana cf. *bicolorata* Viette, 1954	101	**
Herbulotiana longifascia Viette, 1954	101	**
Herbulotiana sp. Viette, 1954	98–101	**
Heteromala rougeoti Viette, 1979	312	**
Heteropsis fraterna (Butler, 1878)	68, 76	*
Heteropsis pauper (Oberthür, 1916)	76	***
Heteropsis uniformis (Oberthür, 1916)	76	***
Heterorachis insueta (Prout, 1922)	236	*
Heterorachis sp. Warren, 1898	235	*
Hippotion aurora (Rothschild & Jordan, 1903)	170	**
Hippotion butleri (Saalmüller, 1884)	171	***
Hippotion celerio (Linnaeus, 1758)	172	**
Hippotion geryon (Boisduval, 1875)	173	**
Hondryches incertana (Viette, 1958)	307	*
Hondryches sp. Nye, 1975	307	*
Hydrillodes cf. *uliginosalis* Guenée, 1854	312	*
Hymenia perpsectalis (Hübner, 1796)	116	*
Hypena simplicalis Zeller, 1852	312	*
Hyperlopha rectefasciata (Kenrick, 1917)	318	**
Hypobleta sp. Turner, 1908	301	**
Hypocala sp. Guenée, 1852	312	**
Hypocoela abstrusa Herbulot, 1956	238	**
Hypocoela fasciata Herbulot, 1956	238	*
Hypocoela humidaria (Swinhoe, 1904)	238	*
Hypocoela spodozona Prout L. B., 1925	238	***
Hypolimnas misippus (Linnaeus, 1764)	63, 75	**
Hypomecis idiochroa (Prout L. B., 1925)	214	***
Hypopyra capensis Herrich-Schäffer, 1854	314, 315	**
Hypopyra guttata Wallengren, 1856	318, 414	*
Hypopyra leucochiton (Mabille, 1884)	318	**
Hypsoides radama (Coquerel, 1855)	270–271	*
Isorropus tricolor Butler, 1880	296	**
Jabaina ithystropha (Collenette, 1939)	325	*
Jabaina sp. Griveaud, 1976	325	**
Junonia goudotti (Boisduval, 1833)	77	***
Junonia oenone epiclelia (Boisduval, 1833)	61, 77	**
Kenrickodes rubidata (Kenrick, 1917)	340	**

Species list Masoala [2019]*, Makira [2022]**, Masoala+Makira [2022]***, Masoala [2022]****

Kenrickodes rubidata (Kenrick, 1917)	**340**	**
Labordea cf. *hedilacea* (Collenette, 1936)	**325**	*
Labordea marmor (Mabille, 1880)	**325**	***
Lamoria clathrella (Ragonot, 1888)	**122**	*
Lamprantaugia tamatavae (Guenée, 1865)	**194**	**
Latoia catalai Viette, 1980	**90**	***
Latoia sp. Guérin-Méneville, 1844	**90**	*
Latoia viettei (Hering, 1957)	**90, 91**	*
Leptocolpia superba Herbulot, 1965	**240**	***
Leptosia alcesta sylvicola (Boisduval, 1833)	**74**	**
Lomocyma oegrapha (Mabille, 1884)	**190–191**	*
Lophocera flavipuncta Kenrick, 1917	**122**	**
Lophocera vadonalis Marion & Viette, 1956	**122**	*
Lophorrhachia rubricorpus (Warren, 1898)	**241**	*
Lophostola cf. *cara cumatilis* Prout L. B., 1922	**241**	*
Lophotavia near *globulipes* (Walker, 1865)	**319**	*
Luxiaria pratti Prout, 1925	**218**	**
Lymantria fuliginea (Butler, 1880)	**55, 328, 330-333** ***	
Lymantria joannisi (Le Cerf, 1921)	**328**	*
Lymantria malgassica (Kenrick, 1914)	**328**	**
Lymantria polycyma Collenette, 1936	**329**	**
Lymantria rosea Butler, 1879	**328**	*
Lyncestis grandidieri Viette, 1968	**342**	**
Maassenia heydeni (Saalmüller, 1884)	**62, 183**	***
Macella euritiusalis (Walker, 1859)	**319**	*
Madagascarctia cellularis (Toulgoët, 1954)	**285**	**
Madagascarctia madagascariensis (Butler, 1882)	**285**	***
Mafana lajonquierei Viette, 1979	**279**	**
Mafana lemairei Viette, 1979	**279**	**
Malagasanja palliatella (Viette, 1954)	**125, 128-133** *	
Malaza fastuosus (Mabille, 1884)	**72, 79-83** **	
Maltagorea auricolor (Mabille, 1879)	**144-146**	***
Maltagorea cf. *vulpina* (Butler, 1882)	**151**	**
Maltagorea dura (Keferstein, 1870)	**148-149**	***
Maltagorea sp. Bouyer, 1993	**150**	**
Maltogorea rostaingi (Griveaud, 1962)	**147, 151**	**
Marblepsis flabellaria (Fabricius, 1787)	**328**	**
Marcipa callaxantha (Kenrick, 1917)	**279**	**
Marcipa noel Viette, 1966	**279**	**
Marcipopsis Berio, 1966	**319, 410–411** *	
Maronis rivosa Saalmüller, 1891	**308**	*
Maruca vitrata (Fabricius, 1787)	**116**	**
Maxera nova Viette, 1956	**308**	*
Maxetes cowani (Butler, 1880)	**241**	**
Mecodinops anceps (Mabille, 1879)	**308**	**
Meganola sp. Dyar, 1898	**340**	**
Megatarsodes baltealis (Mabille, 1881)	**107, 117**	*
Melanephia vola Viette, 1971	**341**	**
Melinoessa catenata (Saalmüller, 1891)	**220**	*
Mepantadrea reuteri (Saalmüller, 1881)	**308**	*
Metallaxis sp. Prout, 1932	**228**	**
Metallaxis teledapa Prout, 1932	**228**	***
Metallochlora glacialis (Butler, 1880)	**241**	**
Microzada cf. Hampson, 1912	**340**	**
Miniophyllodes aurora Joannis, 1912	**310-311**	**
Miniophyllodes sikorai Viette, 1974	**310**	*
Mnarolitia sp. Viette, 1954	**99**	**
Mocis mayeri (Boisduval, 1833)	**319**	*
Mocis proverai Zilli, 2000	**319, 322**	*
Mpanjaka junctifascia (Collenette, 1936)	**329**	**
Mpanjaka pyrsonota (Collenette, 1939)	**324**	*
Nephele charoba Kirby 1877	**168**	***
Nephele densoi (Keferstein, 1870)	**169**	*
Nephele oenopion (Hübner, 1824)	**169**	**
Noliproctis sp. Hering, 1926	**329**	**
Nyctennomos descarpentriesi (Viette, 1954)	**309**	*
Obtusipalpis rubricostalis Marion, 1954	**117**	*
Ochroplutodes hova Herbulot, 1954	**220**	*
Omocerina cf. Kiriakoff, 1970	**269**	*
Ophiusa pelor (Mabille, 1881)	**319**	**
Palpita jacobsalis (Marion & Viette, 1956)	**117**	**
Pangrapta fauvealis Viette, 1965	**313**	**
Parachelonia cf. *simulans* (Toulgoët, 1971)	**284**	*
Paralephana angulata (Viette, 1966)	**308**	*
Parasa ankalirano Viette, 1980	**92**	*
Parasa reginula Saalmüller, 1884	**92, 96**	****
Parasa valida Butler, 1879	**89, 92**	**
Parotis cf. *prasinophila* (Hampson, 1912)	**117**	**
Parotis prasinalis (Saalmüller, 1880)	**120–121**	***
Pericyma Herrich-Schäffer, 1851	**320**	**
Pericyma near *viettei* (Berio, 1955)	**320**	*
Phaiogramma stibolepida (Butler, 1879)	**237, 241**	**
Phalanta madagascariensis (Mabille, 1877)	**77**	***
Phoenicladocera xanthogramma de Lajonquière, 1972 **198**		**
Phryganopteryx convergens Toulgoët, 1958	**294**	***
Phryganopteryx triangularis Toulgoët, 1958	**294**	***
Pilocrocis sp. Lederer, 1863	**117**	**
Pingasa grandidieri (Butler, 1879)	**242**	***
Pingasa herbuloti (Viette, 1971)	**242**	*
Plecoptera lacinia (Saalmüller, 1880)	**278**	***
Plusiocalpe sericina (Mabille, 1900)	**340**	**
Polypogon descarpentriesi (Viette, 1954)	**309**	**
Pramadea ovialis (Walker, 1859)	**117, 118**	****
Problepsis meroearia Saalmüller, 1884	**208, 228**	***
Prominea porrecta (Saalmüller, 1880)	**309**	*
Protogoniomorpha duprei (Vinson, 1863)	**75**	**
Pseudoclanis grandidieri (Mabille, 1879)	**184–185**	***
Pseudolatoia oculata Hering, 1957	**93**	**
Psilocera barychorda Prout L. B., 1932	**222**	***
Psilocerea ferruginaria pallidizona Herbulot, 1959 **222**		**
Psilocerea jacobi Prout, 1932	**224**	*
Psilocerea monochroma Herbulot, 1959	**223**	**
Psilocerea sp. Saalmüller, 1880	**224**	**
Psilocerea swinhoe Herbulot, 1859	**223**	*
Psilocerea tigrinata Saalmüller, 1880	**222, 223**	**
Psilocerea toulgoeti Herbulot, 1859	**224**	*
Psilocerea vestitaria Swinhoe, 1904	**224**	**
Psilocerea viettei Herbulot, 1954	**223**	*

Pycnarmon sp. Lederer, 1863 — 118 **

Pycnographa viridissima (Kiriakoff, 1958) — 258, 260, 262 *

Racotis cf. *squalida* (Butler, 1878) — 220 *

Racotis madagascariensis Chainey & Karisch, 2017 220 *

Racotis sp. Moore, 1887 — 220 *

Rahona cf. *albilunula* (Collenette, 1936) — 324 **

Rhagastis lambertoni (Clark, 1923) — 174 **

Rhodesia alboviridata (Saalmüller, 1880) — 237 *

Rhodoneura cf. *werneburgalis* (Keferstein, 1870) 103 *

Rhodoneura opalinula (Mabille, 1880) — 102 **

Rhodoneura sp. Guenée, 1858 — 102–105 **

Rhodoneura zophocrana Viette, 1957 — 102 *

Romaleostaura insularis Kiriakoff 1960 — 269 **

Sacada sp. Walker 1862 — 122 **

Saribia perroti Riley, 1932 [photo D. Lees] — 75

Scopula cf. *sparsipunctata* (Mabille, 1900) — 229 *

Scopula gibbivalvata Herbulot, 1972 — 229 **

Scopula internataria (Walker, 1861) — 229 **

Scopula minuta (Warren, 1900) — 229 **

Scopula rubrosignaria rubrosignaria (Mabille, 1900) 229 **

Scopula sp. Schrank, 1802 — 229 *

Serrodes trispila (Mabille, 1890) — 320 **

Siccia nigropunctana (Saalmüller, 1880) — 295 **

Sindris leucomelas Kenrick, 1917 — 123 *

Sindris sganzini Boisduval, 1833 — 123 **

Singara sp. Walker, 1865 — 309 *

Sinomphisa jeannelalis (Marion & Viette, 1956) — 116, 118 ****

Sphingonaepiopsis malgassica (Clark, 1929) — 175 **

Spodoptera mauritia (Boisduval, 1833) — 343 **

Stathmopoda cf. *vadoniella* — 58 **

Stenaroa miniata (Kenrick, 1914) — 329 *

Stenopis cf. *Mabillei* Viette, 1974 — 320, 323 **

Stenopis cf. *reducta* Mabille, 1880 — 321 **

Stenopis sp. Mabille, 1880 — 321 **

Stictoptera antemarginata Saalmüller, 1880 — 334 ****

Stictoptera cf. *semipartita* Saalmüller, 1880 — 334 ****

Stictoptera sp. Guenée, 1852 — 334 ****

Syllepte lanatalis Viette, 1960 — 118 **

Synclera traducalis (Zeller, 1852) — 118 *

Temnora grandidieri (Butler, 1879) — 175 **

Tenuinaclia andapa Griveaud, 1964 — 296, 297 **

Thalassodes cf. *progressa* Prout, 1926 — 243 ***

Thausgea sp. Viette, 1966 — 320 **

Thliptocnemis barbipes Mabille, 1900 — 93 **

Thliptocnemis pinguis (Saalmüller, 1880) — 93 *

Thyas minians (Mabille, 1884) — 320 **

Tolna complicata (Butler, 1880) — 321 *

Traminda obversata atroviridata (Saalmüller, 1880) 227 **

Ugia radama Viette, 1966 — 321 *

Ulopeza crocifrontalis Mabille, 1900 — 119 ***

Utetheisa elata (Fabricius, 1798) — 284 *

Victoria sp. Warren, 1897 — 243 **

Vietteella madagascariensis (Draeseke, 1937) — 252, 254, 256, 258–260 ***

Viettessa bethalis (Viette, 1958) — 108, 113 *

Xanthopan praedicta Minet et al. 2021 — 162–165 ›D. Lees, M. Wiorek‹

Xenimpia fletcheri (Herbulot, 1954) — 209, 221 **

Xenostega ochracea (Butler, 1879) — 224 **

Xenostega sp. Warren, 1899 — 225 *

Ximacodes pyrosoma (Butler, 1882) — 93–95 **

Ximacodes sp. (Hering, 1957) — 92 **

Yxygodes insignis (Mabille, 1900) — 112 ***

Yxygodes vieualis (Viette, 1960) — 108, 112 *

Yxygodes zonalis (Mabille, 1900) — 112 ***

Zamarada oxybeles Fletcher, 1974 — 208, 225 ***

Zamarada sp. Moore, 1887 — 225 ****

Zavana cf. *acroleuca* (Hering, 1926) — 329 *

Zekelita sp. Walker, 1863 — 312 *

Zethes near *humilis* Mabille, 1900 — 309 *

Zeuzeropecten sp. Gaede, 1930 — 86 **

Zitha sp. near *sanguinalis* (Marion, 1954) — 109 *

Field research dates

Masoala 2019: 34 Light trap nights beginning 12.02.

Masoala 2022: 12 Light trap nights beginning 02.04.

Makira 2022: 15 Light trap nights beginning 17.03.

As if taken straight from real life

All butterflies and moths in this book were photographed alive where the author found them and then released unharmed back into the forest. These are wild creatures that were under the respectful care of the author for only a fleeting moment. The moths display their natural movements, rest postures, defensive and mitigation strategies, as well as evidence of their daily fight for survival in the Malagasy rainforests of Masoala and Makira. The moths were not anesthetized for the photo sessions. The images were created in RAW format and were processed by the author for printing. Dirt spots, stains, and scales left on the white paper background have been retouched. All shadows were caused by the photoflash inside the white, homemade 'softbox'. The strict photographic concept – with no other compositional influences that affect the image elements – leaves the Lepidoptera in their natural state as pristine works of art. The images should be something both to admire and to study, but at the same time they constitute a unique 'moth collection' – without any creature having been killed in exchange.

Bibliography (selected references)

A catalogue. Lepidopterists' Society of Africa Jukskei Park;.

Ali, J. R. & Aitchison, J. C. 2008. Gondwana to Asia: Plate tectonics, paleogeography and the biological connectivity of the Indian sub-continent from the Middle Jurassic through latest Eocene (166 – 35 Ma). Earth-Science Reviews, 88: 145 – 166.

AmphibiaWeb (2022): https://amphibiaweb.org. – University of California, Berkeley, CA, USA, accessed 10 February 2023.

Andreone, F., F. Mattioli, R. Jesu & J. E. Randrianirina (2001): Two new chameleons of the genus *Calumma* from north-east Madagascar, with observations on hemipenial morphology in the *Calumma furcifer* group (Reptilia, Squamata, Chamaeleonidae). – Herpetological Journal 11 (2): 53 – 68.

Andreone, F., Randrianirina, J. E., Jenkins, P. D. & Aprea, G. **2000.** Species diversity of Amphibia, Reptilia and Lipotyphla (Mammalia) at Ambolokopatrika, a rainforest between the Anjanaharibe-Sud and Marojejy massifs, NE Madagascar. Biodiversity and Conservation, 9: 1587 – 1622.

Balme, D. M.,(1991), Aristotle. History of Animals, Books VII-X, Cambridge, MA: Harvard University Press.

Basquin, P. and R. Rougerie (2009). „Contribution à la connaissance du genre *Maltagorea* Bouyer, 1993: description d'une nouvelle espèce révélée par la combinaison de caractères morphologiques et de codes barres ADN (Lepidoptera, Saturniinae)." Bulletin de la Société Entomologique de France 114: 257 – 263.

Blommers-Schlösser, R. M. A. & C. P. Blanc (1991): Amphibiens (première partie). – Faune de Madagascar 75 (1): 1 – 379.

Boisduval, J. A., & Sganzin, M. (1833). Faune entomologique de Madagascar, Bourbon et Maurice : lépidoptères. A la Librairie Encyclopédique de Roret. https://www.biodiversitylibrary.org/item/46062, access Feb. 9th, 2023.

Boisduval. (1833). Faune entomologique de Madagascar, Bourbon et Maurice. Lépidoptères. Avec des notes sur les moeurs, par M. Sganzin. :1 – 122.

Brinck B, Konda Ku Mbuta A, Madamo-Malasi F, Nkulu Ngoie L, et al. (2022): Brooke, M. d. L. (2000). Why museums matter. Trends in Ecology & Evolution, 15(4), 136 – 137. https://doi.org/10.1016/S0169-5347(99)01802-9

Brygoo, E. R. (1978): Reptiles Sauriens Chamaeleonidae – Genre *Brookesia* et complément pour le genre Chamaeleo. – Faune de Madagascar 47: 1 – 173.

Burbrink et al. 2019

Burrell, A. S., Disotell, T. R., & Bergey, C. M. (2015). The use of museum specimens with high-throughput DNA sequencers. Journal of Human Evolution, 79, 35 – 44. https://doi.org/https://doi.org/10.1016/j.jhevol.2014.10.015

Carleton, M. D. (1989). "Systematics and evolution," in Advances in the study of Peromyscus (Rodentia), eds G. L. Kirkland and J. Layne (Lubbock, TX: Texas Tech University Press), 7 – 141.

Castañeda-Rico, S., León-Paniagua, L., Edwards, C. W., & Maldonado, J. E. (2020). Ancient DNA From Museum Specimens and Next Generation Sequencing Help Resolve the Controversial Evolutionary History of the Critically Endangered Puebla Deer Mouse. Frontiers in Ecology and Evolution, 8 (April), 1 – 18. https://doi.org/10.3389/fevo.2020.00094

Chiatante, G. (2022). Spatial distribution of an assemblage of an endemic genus of birds: an example from Madagascar. African Journal of Ecology, 60(1), 13 – 26. https://doi.org/10.1111/aje.12917.

Church, G. M. (2006). Genomes for all. Scientific American, 294, 46 – 54.

Collins, N. M., Barkham, P. J., Blencowe, M., Brazil, A., Kelly, A., Oldfield, S., Strudwick, T., Vane-Wright, R. I., & Stewart, A. J. A. (2020). Ecology and conservation of the British Swallowtail butterfly, *Papilio machaon britannicus* : old questions, new challenges and potential opportunities. Insect Conservation and Diversity, 13(1), 1 – 9. https://doi.org/10.1111/icad.12371

Congo. Afr & Trop Entomol Res. 2022: 1(1): 3 – 27.

Correa-Carmona, Y., R. Rougerie, P. Arnal, L. Ballesteros-Mejia, J. Beck, S. Dolédec, C. Ho, I. J. Kitching, P. Lavelle, S. Le Clec'h, C. Lopez-Vaamonde, M. B. Martins, J. Murienne, J. Oszwald, S. Ratnasingham and T. Decaëns (2021). „Functional and taxonomic responses of tropical moth communities to deforestation." Insect Conservation and Diversity 15: 236 – 247.

de Flacourt, E.(1658). Histoire de la Grande Isle Madagascar. Nicolas Oudot, Troyes 1 – 471 (i – xxi).

Decaëns, T., M. B. Martins, A. Feijoo, J. Oszwald, S. Doledec, J. Mathieu, X. A. de Sartre, D. Bonilla, G. G. Brown, Y. A. Cuellar Criollo, F. Dubs, I. S. Furtado, V. Gond, E. Gordillo, S. L. Clec'h, R. Marichal, D. Mitja, I. M. de Souza, C. Praxedes, R. Rougerie, D. H. Ruiz, J. T. Otero, C. Sanabria, A. Velasquez, L. E. M. Zararte and P. Lavelle (2018). „Biodiversity loss along a gradient of deforestation in Amazonian agricultural landscapes." Conserv Biol 32(6): 1380 – 1391.

Delabye, S., R. Rougerie, S. Bayendi, M. Andeime-Ayene, D. Ayala, E. V. Zakharov, J. R. DeWaard, P. D. N. Hebert, R. Kamgang, P. Le-Gall, C. Lopez-Vaamnonde, J. Mavoungou, G. Moussavou, N. Moulin, R. Oslisly, N. Rahola, D. Sebag, E. team and T. Decaëns (2019). „Characterization and comparison of poorly known moth communities through DNA barcoding in two Afrotropical environments in Gabon." Genome 62(3): 96 – 107.

Dempster, J. P., King, M. L., & Lakhani, K. H. (1976). The status of the swallowtail butterfly in Britain. Ecological Entomology, 1(2), 71 – 84. https://doi.org/10.1111/j.1365-2311.1976.tb01207.x Diversity of edible caterpillars and their host plants in the Republic of the Dransfield

J. & Beentje H. 1995 The Palms of Madagascar. Royal Botanic Gardens, Kew.

Eagles, G. & Konig, M. 2008. A model of plate kinematics in Gondwana breakup. Geophysical Journal International, 173: 703–717.

Fenolio, D. B., M. E. Walvoord, J. F. Stout, J. E. Randrianirina & F. Andreone (2007): A new tree hole breeding *Anodonthyla* (Chordata: Anura: Microhylidae: Cophylinae) from low-altitude rainforests of the Masoala Peninsula, northeastern Madagascar. – Proceedings of the Biological Society of Washington 120 (1): 86–98.

Gehring, P. – S., F. Glaw, M. Gehara, F. M. Ratsoavina & M. Vences (2013): Northern origin and diversification in the central lowlands – Complex phylogeography and taxonomy of widespread day geckos (*Phelsuma*) from Madagascar. – Organisms, Diversity & Evolution 13: 605–620.

Gehring, P. – S., S. Siarabi, M. D. Scherz, F. M. Ratsoavina, A. Rakotoarison, F. Glaw & M. Vences (2018): Genetic differentiation and species status of the large-bodied leaf-tailed geckos *Uroplatus fimbriatus* and *U. giganteus*. – Salamandra 54 (2): 132–146.

Glaw, F. & M. Vences (2007): A field guide to the amphibians and reptiles of Madagascar, third edition. – Vences & Glaw Verlag, 496 pp.

Glaw, F. & Vences, M. (2003). Introduction to amphibians. In Goodman S. M. & Benstead J. P., eds. The Natural History of Madagascar. pp. 883–898 Chicago: University of Chicago Press.

Glaw, F., C. Kucharzewski, Z. T. Nagy, O. Hawlitschek & M. Vences (2014): New insights into the systematics and molecular phylogeny of the Malagasy snake genus *Liopholidophis* suggest at least one rapid reversal of extreme sexual dimorphism in tail length. – Organisms, Diversity & Evolution 14: 121–132.

Glaw, F., Crottini, A., Rakotoarison, A., Scherz, M. D. & Vences, M. (2022). Diversity and exploration of the Malagasy amphibian fauna. In The New Natural History of Madagascar, ed. S. M. Goodman, pp. 1305–1322. Princeton : Princeton University Press.

Glaw, F., J. Köhler, I. De la Riva, D. R. Vieites & M. Vences (2010): Integrative taxonomy of Malagasy treefrogs: combination of molecular genetics, bioacoustics and comparative morphology reveals twelve additional species of Boophis. – Zootaxa 2383: 1–82.

Glaw, F., M. D. Scherz, D. Prötzel & M. Vences (2018): Eye and webbing coloration as predictors of specific distinctness: A genetically isolated new treefrog species of the *Boophis albilabris* group from the Masoala peninsula, northeastern Madagascar. – Salamandra 54 (3): 163–177.

Glaw, F., O. Hawlitschek, K. Glaw & M. Vences (2019): Integrative evidence confirms new endemic island frogs and transmarine dispersal of amphibians between Madagascar and Mayotte (Comoros archipelago). – Science of Nature 106: 19.

Gonzalez, C., L. Ballesteros-Mejia, J. Diaz-Diaz, D. M. Toro-Vargas, A. R. Amarillo-Suarez, D. Gey, C. Leon, E. Tovar, M. Arias, N. Rivera, L. S. Buitrago, R. H. Pinto-Moraes, I. S. Sano Martins, T. Decaens, M. A. Gonzalez, I. J. Kitching and R. Rougerie (2023). „Deadly and venomous *Lonomia* caterpillars are more than the two usual suspects." PLoS Negl Trop Dis 17(2): e0011063.

Goodman S. M. & Andrianarimisa A. (eds) 2022 The new natural history of Madagascar. Princeton University Press.

Goodman S. M. & Benstead J. P. (eds) 2003 The natural history of Madagascar. The University of Chicago Press.

Goodman, S. M. & Raherilalao, M J. (eds) (2013). Atlas d'une selection de vértébrés terrestres de Madagascar / Atlas of selected land vertebrates of Madagascar. Association Vahatra, Antananarivo.

Grier, J. W. (1982). Ban of DDT and subsequent recovery of Bald Eagles. Science 218: 1232–1235.

Harper, G. L., Maclean, N., & Goulson, D. (2006). Analysis of museum specimens suggests extreme genetic drift in the Adonis blue butterfly (*Polyommatus bellargus*). Biological Journal of the Linnean Society, 88(3), 447–452.

Hawlitschek, O., E. F. A. Toussaint, P. – S. Gehring, F. M. Ratsoavina, N. Cole, A. Crottini, J. Nopper, A. W. Lam, M. Vences & F. Glaw (2017): Gecko phylogeography in the Western Indian Ocean region: the oldest clade of *Ebenavia inunguis* lives on the youngest island. – Journal of Biogeography 44: 409–420.

Hawlitschek, O., M. D. Scherz, B. Ruthensteiner, A. Crottini & F. Glaw (2018): Computational molecular species delimitation and taxonomic revision of the gecko genus Ebenavia Boettger, 1878. – Science of Nature 105: 49.

Hickey, J. J. & Anderson, D. W. (1968). Chlorinated hydrocarbons and eggshell changes in raptorial and fish-eating birds. Science 162: 271–273.

Hutter, C. R., S. M. Lambert, Z. F. Andriampenomanana, F. Glaw & M. Vences (2018): Molecular phylogeny and diversification of Malagasy bright-eyed tree frogs (Mantellidae: *Boophis*). – Molecular Phylogenetics and Evolution 127: 568–578.

Ineich, I., F. Glaw & M. Vences (2016): A new species of *Blaesodactylus* (Squamata: Gekkonidae) from Tsingy limestone outcrops in Namoroka National Park, north-western Madagascar. – Zootaxa 4109 (5): 523–541.

Janzen, D. H., W. Hallwachs, D. J. Harvey, K. Darrow, R. Rougerie, M. Hajibabaei, M. A. Smith, C. Bertrand, I. C. Gamboa, B. Espinoza, J. B. Sullivan, T. Decaens, D. Herbin, L. F. Chavarria, R. Franco, H. Cambronero, S. Rios, F. Quesada, G. Pereira, J. Vargas, A. Guadamuz, R. Espinoza, J. Hernandez, L. Rios, E. Cantillano, R. Moraga, C. Moraga, P. Rios, M. Rios, R. Calero, D. Martinez, D. Briceo, M. Carmona, E. Apu, K. Aragon, C. Umaa, J. Perez, A. Cordoba, P. Umaa, G. Sihe-

Bibliography (selected references)

zar, O. Espinoza, C. Cano, E. Araya, D. Garcia, H. Ramirez, M. Pereira, J. Cortez, M. Pereira, W. Medina and P. D. N. Hebert (2012). „What happens to the traditional taxonomy when a well-known tropical saturniid moth fauna is DNA barcoded?" Invertebrate Systematics 26(6): 478–505.

Jolly A. (2009): A World Like Our Own. Yale University Press.

Kamilar, J. M., Blanco, M. B., & Muldoon, K. M. (2016). Ecological niche modeling of mouse lemurs (Microcebus spp.) and its implications for their species diversity and biogeography. In S. M. Lehman, U. Radespiel, & E. Zimmermann (Eds.), The Dwarf and Mouse Lemurs of Madagascar (Issue June, pp. 449–461). Cambridge University Press. https://doi.org/10.1017/CBO9781139871822.024

Kehlmaier, C., Graciá, E., Ali, J. R., Campbell, P. D., Chapman, S. D., Deepak, V., Ihlow, F., Jalil, N. E., Pierre-Huyet, L., Samonds, K. E., Vences, M., & Fritz, U. (2023). Ancient DNA elucidates the lost world of western Indian Ocean giant tortoises and reveals a new extinct species from Madagascar. Science Advances, 9(2). https://doi.org/10.1126/sciadv.abq2574

Köhler, J., F. Glaw, G. M. Rosa, P.–S. Gehring, M. Pabijan, F. Andreone & M. Vences (2011): Two new bright-eyed treefrogs of the genus Boophis from Madagascar. – Salamandra 47 (4): 207–221.

Köhler, J., Glaw, F., Pabijan, M., & Vences, M. (2015). Integrative taxonomic revision of mantellid frogs of the genus Aglyptodactylus (Anura: Mantellidae). Zootaxa, 4006(3), 401–438. https://doi.org/10.11646/zootaxa.4006.3.1

Kohler, R. E. (2007). Finders, Keepers: Collecting Sciences and Collecting Practice. History of Science, 45(4), 428–454. https://doi.org/10.1177/007327530704500403

Kremen, Claire, Razafimahatratra, Vincent, Guillery, R. Philip, Rakotomalala, Jocelyn, Weiss, Andrew, Ratsisompatrarivo, Andjean-Solo, (1999) Designing the Masoala National Park in Madagascar, Based on Biological and Socioeconomic Data. Conservation Biology, 13:1055–1068.

Kroon DM (1999). Lepidoptera of Southern Africa. Host-plants & other associations

Lamb, J. M., Naidoo, T., Taylors, P. J., Napier, M., Ratrimomanarivo, F., & Goodman, S. M. (2012). Genetically and geographically isolated lineages of a tropical bat (Chiroptera: Molossidae) show demographic stability over the late Pleistocene. Biological Journal of the Linnean Society, 106(1), 18–40. https://doi.org/10.1111/j.1095-8312.2011.01853.x

Larrey F., Wright P. C. & Girard C. (2010): Madagascar the Forest of our Ancestors. Editions Regard du Vivant.

Larsen, A. (1996). Equipment for the Field. In Cultures of Natural History; Jardine, N., Secord, J. A., Spary, E. C., Eds.; Cambridge University Press: Cambridge, UK, 1996; pp. 358–377.

Lees, D. C. & Minet, J. (2022). Lepidoptera, butterflies and moths: Systematics and diversity. Pp. 1141–1172 and 1221–1244 In Goodman, S. M. (Ed.), The New Natural History of Madagascar, Volumes 1 & 2. Princeton University Press, Oxford and Princeton. 2296 pp.

Lees D. C., Smith, N. G. (1991): Foodplant associations of the Uraniinae (Uraniidae) and their systematic, evolutionary, and ecological significance, Journal of the Lepidopterists' Society, 45(4), 1991, 296–347.

Lees, D. C. & Zilli, A. (2021): Moths. Their biology, diversity and evolution. Second reprint edition. Published by the Natural History Museum, London. ISBN: 978 0 565 09457 7.

Linnaeus, C. (1758). Systema naturae per regna tria naturae, secundum classes, ordines, genera, species, cum characteribus, differentiis, synonymis, locis. Bk. 1. 10th ed. Stockholm: Laurentius Salvus.

Loiselle, B. A., Howell, C. A., Graham, C. H., Goerck, J. M., Brooks, T., Smith, K. G., & Williams, P. H. (2003). Avoiding Pitfalls of Using Species Distribution Models in Conservation Planning. Conservation Biology, 17(6), 1591–1600. https://doi.org/10.1111/j.1523-1739.2003.00233.x

Lopez-Vaamonde, C., L. Sire, B. Rasmussen, R. Rougerie, C. Wieser, A. Ahamadi, J. Minet, J. R. deWaard, T. Decaëns and D. C. Lees (2019). „DNA barcodes reveal deeply neglected diversity and numerous invasions of micromoths in Madagascar." Genome 62(3): 108–121.

Mabossy-Mobouna G, Ombeni JB, Bouyer T, Latham P, Bisaux F, Bocquet E, Minet, J., P. Basquin, J. Haxaire, D. C. Lees and R. Rougerie (2021). „A new taxonomic status for Darwin's "predicted" pollinator: Xanthopan praedicta stat. nov." Antenor 8(1): 69–86.

Mohan, A. V., P.–S. Gehring, M. D. Scherz, F. Glaw, F. M. Ratsoavina & M. Vences (2019): Comparative phylogeography and patterns of deep genetic differentiation of two gecko species, Paroedura gracilis and Phelsuma guttata, across northeastern Madagascar. – Salamandra 55 (3): 211–220.

Navarro-Sigüenza, A. G., Peterson, A. T., & Gordillo-Martínez, A. (2003). Museums working together: The atlas of the birds of Mexico. Bulletin of the British Ornithologists' Club, 123A (January), 207–225.

Osgood, W. (1909). Revision of the mice of the American genus Peromyscus. North American Fauna 28, 1–285. doi: 10.3996/nafa.28.0001

Pearson, R. G., Raxworthy, C. J., Nakamura, M., & Townsend Peterson, A. (2007). Predicting species distributions from small numbers of occurrence records: A test case using cryptic geckos in Madagascar. Journal of Biogeography, 34(1), 102–117. https://doi.org/10.1111/j.1365-2699.2006.01594.x

Prötzel, D., M.D. Scherz, F.M. Ratsoavina, M. Vences & F. Glaw (2020): Untangling the trees: Revision of the *Calumma nasutum* complex (Squamata: Chamaeleonidae). – Vertebrate Zoology 70 (1): 23 – 59.

Pyke, G.H., & Ehrlich, P.R. (2010). Biological collections and ecological/environmental research: a review, some observations and a look to the future. Biological Reviews, 85(2), 247 – 266.https://doi.org/https://doi.org/10.1111/j.1469-185X.2009.00098.x

Rakotoarison, A., M.D. Scherz, F. Glaw, J. Köhler, F. Andreone, M. Franzen, J. Glos, O. Hawlitschek, T. Jono, A. Mori, S.H. Ndriantsoa, N. Rasoamampionona Raminosoa, J.C. Riemann, M. – O. Rödel, G.M. Rosa, D.R. Vieites, A. Crottini & M. Vences (2017): Describing the smaller majority: integrative taxonomy reveals twenty-six new species of tiny microhylid frogs (genus *Stumpffia*) from Madagascar. – Vertebrate Zoology 67 (3): 271 – 398.

Rancilhac, L., T. Bruy, M.D. Scherz, E. Almeida Pereira, M. Preick, N. Straube, M.L. Lyra, A. Ohler, J.W. Streicher, F. Andreone, A. Crottini, C.R. Hutter, J.C. Randrianantoandro, A. Rakotoarison, F. Glaw, M. Hofreiter & M. Vences (2020): Target-enriched DNA sequencing from historical type material enables a partial revision of the Madagascar giant stream frogs (genus *Mantidactylus*) – Journal of Natural History 54 (1 – 4): 87 – 118.

Randrianandrasana, M., S.H. Berlocher, R. Rougerie and M.R. Berenbaum (2016). „Intraspecific Variation in *Antherina suraka* (Lepidoptera: Saturniidae), an Endemic Resident of Endangered Forests in Madagascar." Annals of the Entomological Society of America 109 (3): 384 – 395.

Raselimanana, A.P., M. Vences & F. Glaw. 2018. Liste des amphibiens connus dans 98 aires protégées terrestres de Madagascar/List of the known amphibians in 98 protected areas of Madagascar. In Les aires protégées terrestres de Madagascar : Leur histoire, description et biote/The terrestrial protected areas of Madagascar: Their history, description, and biota, eds. S.M. Goodman, M.J. Raherilalao & S. Wohlhauser. Association Vahatra, Antananarivo.

Rasoavahiny, L., Andrianarisata, M., Razafimpahanana, A. & Ratsifandrihamanana, A.N. (2008). Conducting an ecological gap analysis for the new Madagascar protected area system. Parks, 17(1), 12 – 21.

Ratcliffe, D.A. (1967). Decrease in eggshell weight in certain birds of prey. Nature 215: 208 – 210.

Ratsoavina, F.M., A.P. Raselimanana, M.D. Scherz, A. Rakotoarison, J.H. Razafindraibe, F. Glaw & M. Vences (2019): Finaritra! A splendid new leaf-tailed gecko *(Uroplatus)* species from Marojejy National Park in north-eastern Madagascar. – Zootaxa 4545 (4): 563 – 577

Ratsoavina, F.M., F. Glaw, A.P. Raselimanana, A. Rakotoarison, D.R. Vieites, O. Hawlitschek, M. Vences & M.D. Scherz (2020): Towards completion of the species inventory of small-sized leaf-tailed geckos: two new species of *Uroplatus* from northern Madagascar. – Zootaxa 4895 (2): 251 – 271.

Raxworthy, C.J., Martinez-Meyer, E., Horning, N., Nussbaum, R. a, Schneider, G.E., Ortega-Huerta, M. a, & Townsend Peterson, a. (2003). Predicting distributions of known and unknown reptile species in Madagascar. Nature, 426(6968), 837 – 841. https://doi.org/10.1038/nature02205

Red Data Books: how and why. Watchbird, 18(4), 13 – 16. https://doi.org/10.1017/S0030605300017695

Rougerie, R. (2003). „Description d'une nouvelle espèce du genre malgache *Maltagorea* Bouyer, 1993 (Lepidoptera, Saturniinae)." Bulletin de la Société Entomologique de France 108(2): 177 – 180.

Rougerie, R., A. Cruaud, P. Arnal, L. Ballesteros-Mejia, F.L. Condamine, T. Decaëns, M. Elias, D. Gey, P.D.N. Hebert, I.J. Kitching, S. Lavergne, C. Lopez-Vaamonde, J. Murienne, Y. Cuenot, S. Nidelet and J. – Y. Rasplus (2022). „Phylogenomics Illuminates the Evolutionary History of Wild Silkmoths in Space and Time (Lepidoptera: Saturniidae)." bioRxiv: 2022.2003.2029.486224.

Rougerie, R., I.J. Kitching, J. Haxaire, S.E. Miller, A. Hausmann and P.D.N. Hebert (2014). „Australian Sphingidae – DNA Barcodes Challenge Current Species Boundaries and Distributions." PLoS ONE 9(7): e101108.

Rougerie, R., S. Naumann and W.A. Nässig (2012). „Morphology and molecules reveal unexpected cryptic diversity in the enigmatic genus *Sinobirma* Bryk, 1944 (Lepidoptera: Saturniidae)." PLoS ONE 7(9): e43920.

Rübel A., Hatchwell M., MacKinnon J. & Ketterer P. (2003) Masoala – The Eye of the Forest. Zoo Zürich & Th. Gut Verlag.

Ryan A. St Laurent, Paul Z. Goldstein, Scott E. Miller, Robert K. Robbins, Schatz, G.E. (2001) Generic Tree Flora of Madagascar. Royal Botanic Gardens, Kew & Missouri Botanical Garden.

Scherz, M.D., A. Crottini, C.R. Hutter, A. Hildenbrand, F. Andreone, T.R. Fulgence, G. Köhler, S.H. Ndriantsoa, A. Ohler, M. Preick, A. Rakotoarison, L. Rancilhac, A.P. Raselimanana, J.C. Riemann, M. – O. Rödel, G.M. Rosa, J.W. Streicher, D.R. Vieites, J. Köhler, M. Hofreiter, F. Glaw & M. Vences (2022): An inordinate fondness for inconspicuous brown frogs: integration of phylogenomics, archival DNA analysis, morphology, and bioacoustics yields 24 new taxa in the subgenus *Brygoomantis* (genus *Mantidactylus*) from Madagascar. – Megataxa 7 (2): 113 – 311.

Schintlmeister, A. (2008): Palaearctic Macrolepidoptera 1. Notodontidae – Apollo Books, Stenstrup 481 pp., 40 pls.

413

Bibliography (selected references)

Schmitt, C.J., Cook, J.A., Zamudio, K.R., & Edwards, S.V. (2019). Museum specimens of terrestrial vertebrates are sensitive indicators of environmental change in the Anthropocene. Philosophical Transactions of the Royal Society B: Biological Sciences, 374(1763), 20170387. https://doi.org/10.1098/rstb.2017.0387

Sikes, D. (2015). What is a specimen? What should we count and report when managing an entomology collection? Newsletter of the Alaska Entomological Society, 8(1), 3–8.

Sparks, J.S. & Stiassny, M.L.J. (2022). Introduction to the freshwater fishes. In The New Natural History of Madagascar, ed. S. M. Goodman, pp. 1245–1260. Princeton : Princeton University Press.

St Laurent, Ryan & Goldstein, Paul & Miller, Scott & Robbins, Robert. (2023). Hiding in Plain Sight: Phylogenomics Reveals a New Branch on the Noctuoidea Tree of Life. 10.1101/2023.03.10.529269.

Tattersall, I. (2022). The Itineraries of Alfred Crossley, and Natural History Collecting in Mid-Nineteenth Century Madagascar. American Museum Novitates, 2022(3987). https://doi.org/10.1206/3987.1

van Huis, Arnold (2019): Cultural significance of Lepidoptera in sub-Saharan Africa, article number 26, Journal of Ethnobiology and Ethnomedicine 15

Vences, M., F. Glaw, J. Köhler & K.C. Wollenberg (2010): Molecular phylogeny, morphology and bioacoustics reveal five additional species of arboreal microhylid frogs of the genus *Anodonthyla* from Madagascar. – Contributions to Zoology 79 (1): 1–32.

Vences, M., J. Köhler, A. Crottini, M. Hofreiter, C.R. Hutter, L. du Preez, M. Preick, A. Rakotoarison, L. Rancilhac, A.P. Raselimanana, G.M. Rosa, M.D. Scherz & F. Glaw (2022): A redefinition of *Gephyromantis malagasius* based on archival DNA analysis reveals four new mantellid frog species from Madagascar. – Vertebrate Zoology 72: 271–309.

Vieites, D.R., F.M. Ratsoavina, R.–D. Randrianiaina, Z.T. Nagy, F. Glaw & M. Vences (2010): A rhapsody of colors from Madagascar: discovery of a remarkable new snake of the genus *Liophidium* and its phylogenetic relationships. – Salamandra 46 (1): 1–10.

Vieites, D.R., Nieto-Roman, S., & Vences, M. (2008). Towards understanding the spatial pattern of amphibian diversity in Madagascar. Monografie Del Museo Regionale Di Scienze Naturali Di Torino, XLV, 397–410. http://www.mvences.de/p/p2/Vences_B130.pdf

Wan-Chen, C. (2012). A cross-cultural perspective on musealization: the museum's reception by China and Japan in the second half of the nineteenth century. Museum and Society, 10(1), 15–27. https://doi.org/10.29311/mas.v10i1.2762

Wandeler, P., Hoeck, P.E., & Keller, L.F. (2007). Back to the future: Museum specimens in population genetics. Trends in Ecology & Evolution, 22(12), 634–642.

Werkmeister, G. (2016). MaxEnt modelling of the distribution and environmental constraints of endemic tree species *Uapaca bojeri (tapia)* in Madagascar Georgina Werkmeister September 2016 This research dissertation is submitted for the MSc in Plant and Fungal Taxonomy, Diversi (Issue September 2016). Queen Mary University of London.

Zhang, J., Lees, D.C., Shen, J., Cong, Q., Huertas, B., Martin, G. & Grishin, N.V. (2020). The mitogenome of a Malagasy butterfly *Malaza fastuosus* (Mabille, 1884) recovered from the holotype collected over 140 years ago adds support for a new subfamily of Hesperiidae (Lepidoptera). Genome, 63 (4): 195–202.

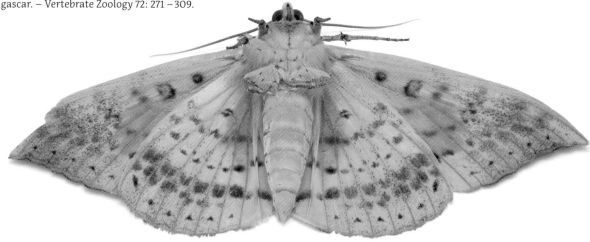

Hypopyra guttata Wallengren, 1856

Websites and Museums

www.africanmoths.com
www.gbif.org
www.boldsystems.org
www.inaturalist.org
www.mothsofindia.org
www.wikipedia.org
www.zsm.snsb.de
www.lemursofmadagascar.com

Natural History Museum,
London, England, United Kingdom

National Museum of Natural History,
France, Paris, France

Bavarian State Collection of Zoology,
Munich, Germany

Institute of Systematics and Evolution of Animals,
Polish Academy of Sciences in Cracow, Poland

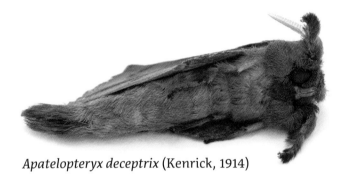

Apatelopteryx deceptrix (Kenrick, 1914)

Photo credits
(All photos by Armin Dett except):
Edi Day: pages 213, 395, 402, 405
Nick Grishin: pages 78, 386
Rodolphe Rougerie: page 247
Roland Hilgartner: pages 246, 248
Harald W. Krenn: page 249
David C. Lees: pages 164 / 165, 75
Marie Evans Picture Library: page 162
Marcin Wiorek: page 163
Martin Bauert: pages 38 / 39, 40, 84, 392 / 393
Zoonar GmbH, Hamburg: pages 158 / 159
Charles J. Sharp: page 385 (commons.wikimedia.org)
Authors: pages 398–401
Joel Sartore / Photo Ark: page 30
Maps: Google Earth Pro, pages 32, 44 / 45
Keith Edkins: page 50, using Wikipedia:WikiProject Tropical
cyclones/Tracks. The background image is from NASA.
Tracking data is from the Joint Typhoon Warning Center.
NASA: page 51, http://rapidfire.sci.gsfc.nasa.gov/realtime/
single.php?T110440700

Imprint

The Deutsche Nationalbibliothek lists this publication
in the Deutsche Nationalbibliografie; detailed biblio-
graphic data are available on the Internet at:
http://dnb.dnb.de

ISBN 978-3-7165-1876-2

© 2024 Benteli, imprint of Braun Publishing AG,
Salenstein, www.benteli.ch

The work is copyright protected. Any use outside of the
close boundaries of the copyright law that has not been
granted permission by the publisher is unauthorized
and liable for prosecution. This especially applies to
duplications, translations, microfilming, and any sa-
ving or processing in electronic systems.

1st edition 2024

Editor, author: Armin Dett
Consultants, superfamilies and texts:
Dr. Martin Bauert, Dr. David Lees,
PhD candidate Marcin Wiorek
Idea, photography, design concept, field research:
Armin Dett
Translation and proofreading: Paul G. Pickering
Guest authors: Dr. Martin Bauert, Dr. David C. Lees,
PhD candidate Marcin Wiorek, Dr. Axel Hausmann,
Dr. Alexander Schintlmeister, Dr. Rodolphe Rougerie,
Dr. Roland Hilgartner, Dr. Frank Glaw, Thomas Bucheli,
Moritz Grubenmann, Dr. Severin Dreessen,
Lovy Rasolofomanana, Dr. Aristide Andrianarimisa

All of the information in this volume has been compi-
led to the best of the editor's/author's knowledge. The
publisher assumes no responsibility for its accuracy
or completeness nor for copyright discrepancies and
refers to the specified sources. All rights to the photo-
graphs are properties of the photographers (please
refer to the photo credits).

Fragile beauties

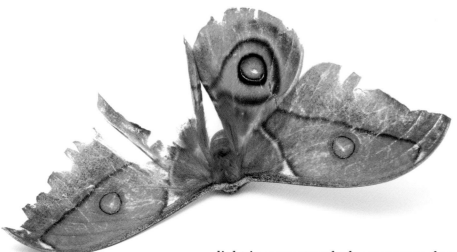

Antherina suraka
(Boisduval, 1833)

Still alive!
This individual presumably survived a predator attack from a bat or bird, which was aimed at the eye on the hindwing.

"This book by Armin Dett is an excellent photobook illustrating the moths of the Masoala rainforest in Madagascar. It incorporates texts by various authors which document from different scientific perspectives their diversity in appearance, their delicate forms, and their often quite surprising color patterns. The "Magic Eyes of Masoala" carry us off into a world on which the author has shed light in a spectacularly unspectacular manner. These creatures, in their nocturnal habitat, are "invited", so to speak, into their nightly photo session. They gather together on a brightly lit white cloth and are then very carefully photographed inside an ordinary white yogurt tub, which has a hole for the camera lens, and are then released. But wait just a minute! What do we mean, photographed inside a yogurt tub!? It means that under precisely these conditions the moth is shown in a completely natural way, because inside this floodlit, small white studio the lighting is optimal and shows the moth to its best advantage. This is the aesthetics of an instantaneous gestalt perception which reveals itself to the astonished observer. Images are thus created that are not simply photographs in the sense of mere illustrations but instead exhibit a presence that leaves us speechless at what is set before our eyes: Concentric, variegated eyes are displayed on the hindwing and for a fraction of a second confuse the predator and give the moth the opportunity to vanish into the darkness. We see moths that in order to deceive the enemy look as if they are dead but that actually are not. Creatures with maimed wings and bodies that mutely show us what has befallen them; and – time and again – an overwhelming exposure of color. Yes, we do know that these creatures exist – but in this book we truly discover them.

I am delighted to have been given the opportunity to support the publication of this book and my wish is that it will be seen in the same fulgent light in which I first discovered it."

Dr. phil. Wolfgang Roell, 12.06.2023, Zurich

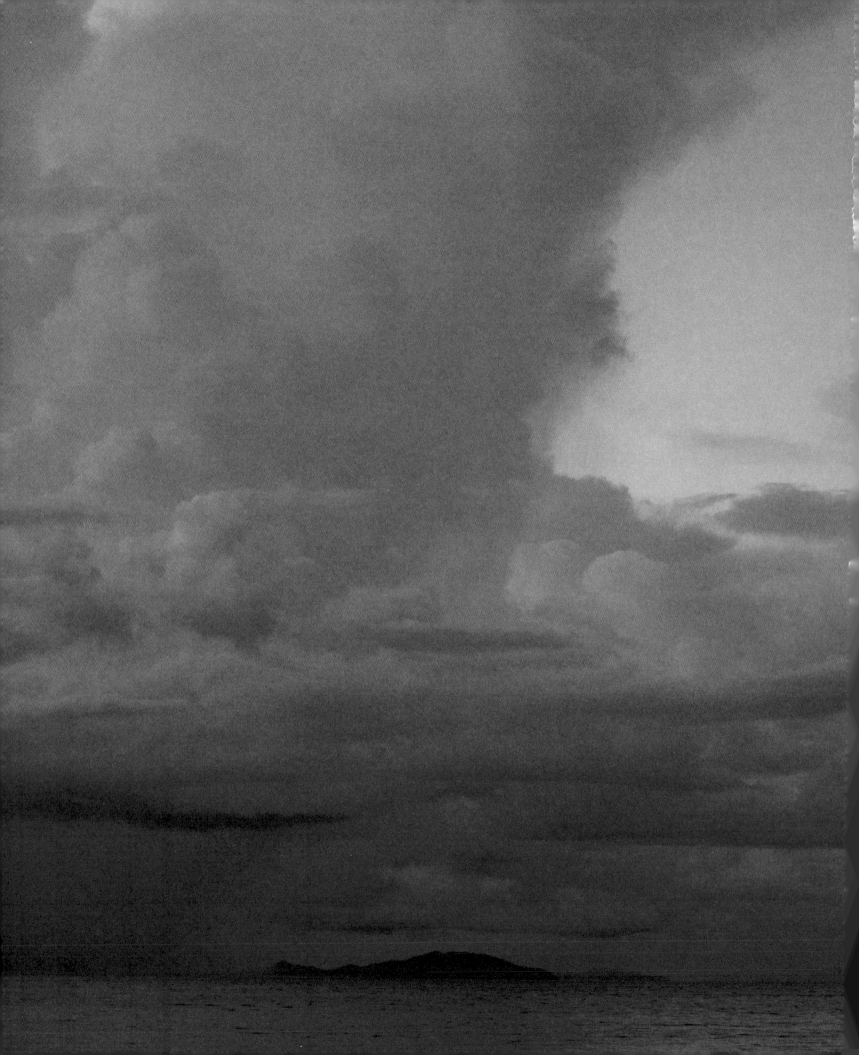